ITALIAN
ART

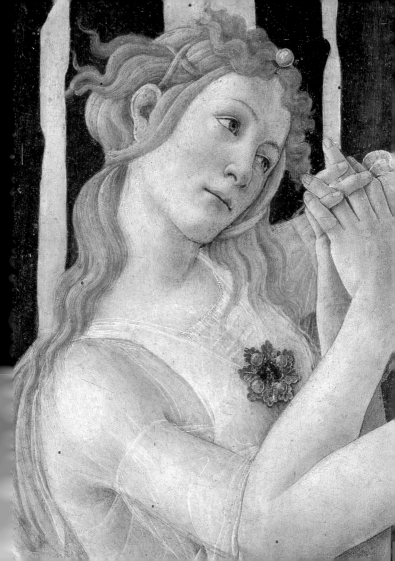

ITALIAN ART

PAINTING, SCULPTURE, ARCHITECTURE
FROM THE ORIGINS TO THE PRESENT DAY

Edited by
GLORIA FOSSI

Texts by
Mattia Reiche
Gloria Fossi
Marco Bussagli

Texts by:
Gloria Fossi (The Middle Ages and the XV Century)
Marco Bussagli (The XVI and XVII Centuries)
Mattia Reiche (The XVIII, XIX and XX Centuries)

Translation:
Catherine Frost

Graphic design and page make-up: Enrico Albisetti
Editing and indexes: Maria Lucrezia Galleschi

Special thanks for his precious advice to Michele Dantini
and for their kind cooperation: Giovanni Bartoli, Rolando Bussi,
Stefania Canta - Renzo Piano Building Workshop (Genoa),
Gianfranco Malafarina.

www.giunti.it

ISBN 88-09-03726-X

© 2000, 2004 Giunti Editore S.p.A., Firenze-Milano
First edition: May 2000

Reprint	Year
6 5 4 3 2 1 0	2007 2006 2005 2004

Printed by Giunti Industrie Grafiche S.p.A. – Prato

Contents

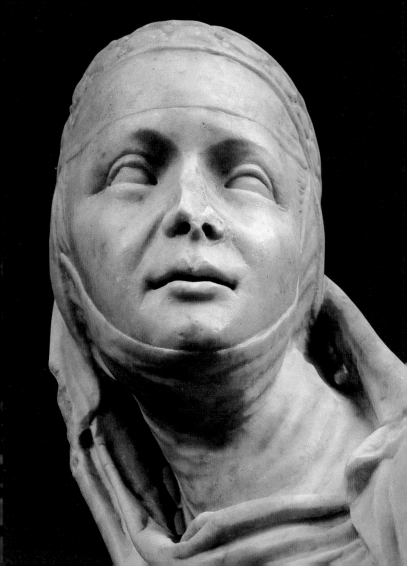

The Middle Ages

Giovanni Pisano
Ascension of the soul of
Queen Margaret of Brabante
c. 1313., detail.
Genoa, Museo di Sant'Agostino.

Around the year one thousand a sort of cosmic chaos seemed to shake all of Europe with a series of portents and catastrophic events: comets, eclipses, earthquakes, conflagrations, famines, even episodes of cannibalism. The order of the world, as has been noted by Georges Duby, "appeared overturned by various perturbations [...] which all proceeded from the same deep malaise". By now the hypothesis that the fear pervading those years sprang exclusively from the apocalyptic millenarian theories on the end of the world has been refuted. Rather it could be said that common man, crushed by a sense of inferiority to the forces of nature and still far from placing himself at the center of the cosmos, was constantly aware in those days of the precariousness of existence, which kept him in a perpetual state of uncertainty. Overwhelmed by nature, man's only chance of salvation lay in divine protection. Accordingly, while daily work measured his time in the slow rhythms of liturgy, every aspect of life was conditioned by eschatological values – the concept of sin staining the origins of man, punishment and atonement through work, fatigue and suffering. Not by chance did the Medieval imagination, and thus also the figurative arts, lay the foundations, more than at any other period in Western civilization, of a complex system of symbols where numbers, colors and musical tones were mystically linked to the harmony (or chaos) of the universe. A deeply fascinating language – whose apparent involution has intrigued 20th century artists such as Chagall, Picasso and Klee – united at least up to the 12th century, albeit with different styles and techniques, almost all of the figurative manifestations of the Christian West, in spite of its dissimilar political situations. In his *Histories*, tracing the story of the known world from the year 900 to 1044, the Bourgogne monk Radulfus Glaber describes the ap-

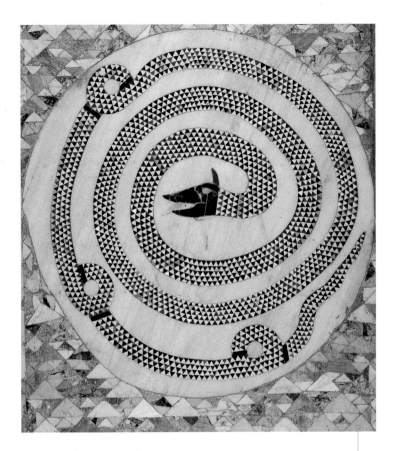

Southern Italian mosaic artist
Serpent
late 11th-early 12th century,
detail of the *opus sectile* flooring.
San Demetrio Corone, Cosenza.

parition in 1014 of a comet like an enormous sword, and comments that "Whenever men see a portent of this kind, it always happens that soon afterward some extraordinary and terrible event befalls them". Accordingly, a fire destroys the Church of Mont-Saint-Michel in Normandy, and in Italy (divided among Imperial, Pontificial and Byzantine rule), violent conflagrations devastate cities, castles and monasteries. Even earlier, at the dawn of the year one thousand, a comet "with a blazing tail" had appeared. It is recorded not by a direct witness, but by a chronicler in the 12th century.

What is most striking in his report, and what ushers us into the atmosphere charged with symbols of Medieval art, is that the enormous meteorite is said to have traced in the sky the image of a serpent. Undoubtedly, to the amazed eyes of the onlookers the comet seemed a sinister announcement; but even more significant is the fact that a century later the collective imagination still retained the vision, certainly more symbolical than real, of a serpent of light. Light is a sign from the heavens, but the serpent, ambiguous expression of the incomprehensible and the mysterious, incarnates negative aspects. The serpent is the seductive beast, often depicted with the face of a woman, who tricks Eve and is condemned for this to crawl upon the earth, and it is also the cosmic dragon of the Apocalypse. Satan, the Devil, the serpent, originally endowed with wisdom, thus becomes a metaphor for evil knowledge, the cause of the vices that lead to death.

Medieval thought, literature, and art used clearly metaphoric expressions. And it is with the apt metaphor of the "white mantle of churches" that Radulfus Glaber describes the artistic and decorative reawakening that occurred around the year One Thousand. "At the approach of the third year after the Millennium, over

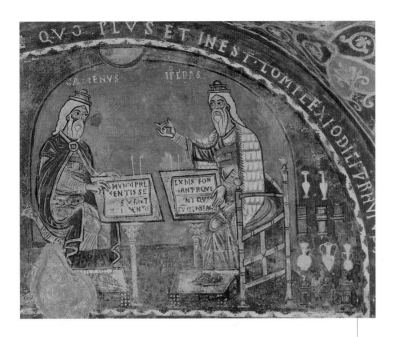

Artist from Lazio
*Hippocrates pronounces
to Galenus the aphorism
on the formation of the world*
second quarter of the 13th century,
detail from the frescoed lunette.
Anagni (Frosinone), crypt of the Duomo.

almost all of the earth, but especially in Italy and in Gaul, churches were being restored and renovated; although most of them were well-built and had no need of restoration, a true spirit of emulation urged every Christian community to have one more sumptuous than those of its neighbors. It might be said that the world itself was quivering to shake off the skin of old age, and to don again, everywhere, the white mantle of churches. Then almost all of the churches of the Episcopal seats, those of monasteries consecrated to all manner of saints and even little village oratories were rebuilt more beautiful than before by the faithful".

Thousands of churches and monasteries, renewed also in their decoration, were to cover again, in the course of the 11th and 12th centuries, Italy, France, Germany, and Christian Spain. And still we wonder at how it was possible that, despite material difficulties, a civilization managed to produce not only buildings and works of art in such great number but also, in many cases, ex-

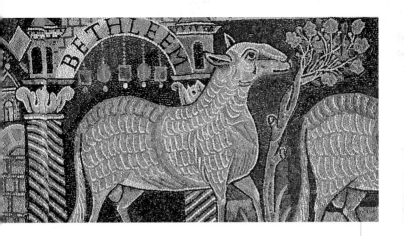

tremely refined and daring structures, almost as if to emulate the grandiose edifices of the Roman Empire.

Although borrowing from other cultures as well, such as the Byzantine, the Arab and later, in the Kingdom of Sicily, the Norman, Italy built monuments of autonomous characteristics (one of these was the bell tower standing beside the church, rather than incorporated in its structure). Como, Milan, Pavia, Florence, Venice, Pisa, Modena, Bari, and Palermo, to name only the most ancient urban centers, saw imposing cathedrals and basilicas arise, some of them so harmonious as to arouse the later admiration of humanist architects such as Leon Battista Alberti, who in completing the façade of Santa Maria Novella in Florence purposely emulated the neo-platonic harmony of the marble inlays in the Basilica of San Miniato al Monte.

In a kind of *horror vacui* each church, from the smallest country parish to the great cathedral, covered itself with decorations.

Mosaics, bas-reliefs, richly carved capitals, pulpits, baptismal fonts, wooden sculptural groups, and frescoes were created according to specific iconographic programs, to show the faithful, with obvious educational and sometimes propitiatory intentions, the path to salvation. Dozens, perhaps hundreds of architects, sculptors, stone-workers, marble-cutters, foundrymen, goldsmiths, have remained anonymous. Very few instead, are the artificers (and among these no painter and no woman) who prior to the 13th century have left their names: Niccolò in Verona, Ferrara and Piacenza, Wiligelmo and Lanfranco in Modena, Antelami in Parma, Bonanno, Buscheto, Rainaldo, and Deotisalvi in Pisa, Biduino in Lucca, Barisano in Trani, Oderisi in Benevento. But the "legend of the artist" was a concept foreign to the times, and nothing is known of the cultural background of these talented personages, apart from a name either signed by them or handed down in eulogies expressed by their contemporaries. Certain it is that their style soon led to the development of different schools over the Italian territory. That ideas, styles, and techniques were circulating in those days, in spite of the hazards and precarious nature of existence, is not surprising. Already for years pilgrimages to holy places, made sacred by the presence of important relicts, and the wide-spread diffusion of monasteries had contributed to an extraordinary mobility of men and materials. In Italy pilgrims were drawn especially to the Sanctuary of San Michele on the Gargano peninsula and to the tombs of the Apostles in Rome.

And Rome was the place that, despite its undeniable decline and its crumbling ancient monuments, still held the fascination of the Eternal City. "Although you now lie in ruins, o Rome, nothing is your equal", declared Hildebertus from Lavardin in a heartfelt eulogy expressed in around 1166. *Roma caput mundi*, Rome

Anonymous sculptor
Lion Cub
early 13th century, detail from the pulpit.
Florence, Basilica
of San Miniato al Monte.

the honor of the world, the resplendent crown, says Amato, a monk from Montecassino.

And so classicism could be salvaged, through the desire for emulation of ancient splendor, through the skillful use of old columns, sarcophagi, and ancient fragments. Moreover, the great teachings of antiquity had not been lost: in the *scriptoria* of the monasteries, vigorous centers of culture as well as of prayer, scribes and miniators were transcribing and illustrating not only sacred texts but also the classics such as Virgil, Ovid, Plautus and Terentius. It is thanks to them that the 15th century knew of the Greek treatises of scientists such as Hippocrates and Galenus and the great encyclopedic *summae* of Isidorus of Seville and Hrabanus Maurus, compiled at the time of the barbarian invasions with the contribution of the most advanced scientific culture, such as that of the Arabs. Illustrations rich in imagination distinguish the miniature schools of the Italian monasteries – Nonantola, Calci, Subiaco, Santa Cecilia and San Gregorio al Celio in Rome, Montecassino and Cava dei Tirreni. Already secular in nature by the 13th century were the vivacious Neapolitan shops from which came the illustrations of naturalistic codexes such as those on the baths of Pozzuoli (*De balneis,* now in the Biblioteca Angelica in Rome), or on hunting, compiled in Puglia by the Emperor Frederick II (*De arte venandi,* now in the Biblioteca Apostolica Vaticana).

The Kingdom of Sicily, first dominated by the Arabs, then by the Normans and the Suevians, was the cradle of renewed culture, open to so many influences that is still debatable whether the mosaics in the sumptuous monuments of Palermo were produced by local or Byzantine masters, and whether these worked first in Florence or in Venice, which, although independent for years, still

Ambrogio Lorenzetti
View of Siena
1337-40, detail.
Siena, Palazzo Pubblico,
Hall of the Nine, Cycle
of frescoes with *The effects
of good government in the city
and the countryside.*

retained close relations with Byzantium. With the decline of Islam's control of the seas, Genoa and Pisa too began to consolidate their power. New horizons were thus opened out to pilgrims and merchants, and new overland itineraries were added to the ancient network of roadways.

Now on the threshold of the 13th century, culture was renewed with the urban universities and theological schools, while the Cistercian reform and the spread of the mendicant orders led to new artistic developments. Urban life took on new vigor and many Italian cities – Venice, Genoa, Pisa, Lucca, Rome, Florence, and Siena – assumed increasingly distinctive aspects which were also reflected in the development of their schools of art, while in Puglia, Campania and Sicily, Suevian domination renewed the Imperial dream, favoring a culture rich in classicizing traits which were to irradiate throughout Central Italy.

It is only on the basis of these premises, albeit highly summarized, that we can understand the transformations occurring in the 13th and 14th centuries in art, urban planning, the social organization of cities, the development of financial activity, and lastly the development of secular political organizations and the emergence of new social classes which, along with Ecclesiastical power, became increasingly important in commissioning monuments and works of art of all kinds. The 13th century closes with sculptural works that are highly innovative, as regards both "architectural" aspects (as in pulpits, fountains, and funerary monuments) and stylistic elements. The solemn classicism of the all-round statues and reliefs of Arnolfo and Giovanni Pisano, capable also of potent realism, determined a crucial transformation in the Medieval plastic tradition. It is through masters such as Tino di Camaino and Giovanni di Balduccio, heirs of the artistic legacy of Giovanni

Cimabue
Christ Crucified
c. 1270, detail.
Arezzo, San Domenico.

Pisano, that sculpture of classicizing trend was to spread as far as the Italian South and the Northern region of Lombardy.

In painting, at Rome, in Umbria and Tuscany, artists such as Pietro Cavallini, Duccio, and Cimabue were progressively freeing themselves from Byzantine tradition, dominant up to the middle of the 13th century. It was to be Giotto, with the Sienese Simone Martini and the Lorenzetti brothers, to take the first decisive steps toward a new conception of man and of space.

The 14th century, which boasts among its other splendors a formidable literary triad – Dante, Petrarch, and Boccaccio – was however a century of unrest as well as of profound transformations, rocked by natural catastrophes such as the flood of 1333 in Florence, the Black Plague of 1348, and famine, undermined by the struggle between Pope and Emperor and by contrasts within the Church. While the economic conquests of the "new men" suddenly enriched through commerce and banking were striking, the bankruptcy and decline of entire families was equally abrupt. A gilded world of precious fabrics and magnificent (and priceless) works of art was still counterposed to the violence of everyday life, always threatened by the terror of death. All of this can be read, by an attentive viewer, in the art of these great masters, who for the first time forcefully and decidedly emerged from the shadows of anonymity.

Pietro Lorenzetti
Crucifixion
c. 1318, detail of a soldier and a lady
under the Cross. Assisi, Basilica
of San Francesco, transept of the Lower
Church, cycle of frescoes with
Stories of the Passion.

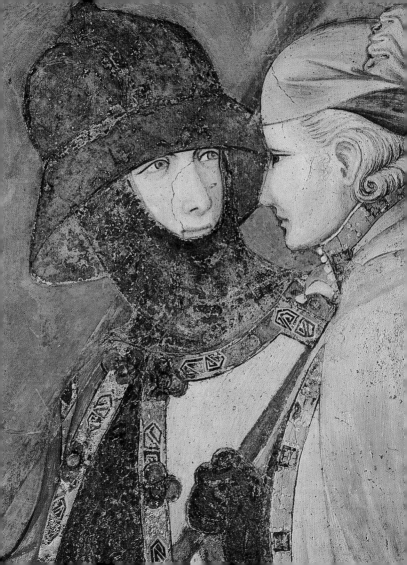

WILIGELMO

active in Modena
from c. 1099 to 1110

Wiligelmo
*Adam and Eve
and the Tree of Evil*
c. 1099-1106,
Vicenza soft stone.
Modena, façade of the
Cathedral.

Of Wiligelmo (or rather Vuiligelmo or Guiligelmo, as suggested by epigraphists and archaeologists), neither the date nor the place of birth is known. Thanks to the commemorative inscription on the façade of the Modena Cathedral it is however certain that he worked in the Modena site in the late 11th and early 12th centuries. "How much honor you deserve among sculptors, Vuiligelmo, is now clearly shown by your sculpture" *(Inter scultores quanto sis dignus onore claret scultura nunc Vuiligelme tua)*: these words can still be read in the last lines of the epigraph, held up by the patriarchs Enoch and Elijah, that commemorates the foundation of the Cathedral. Among the sculptors of his age Wiligelmo thus received from his contemporaries rare and very high praise. His feeling for the art of antiquity studied on Roman sarcophagi and reinterpreted with Christian significance in the winged cherubs on the façade was accompanied by an incomparable sense of the drama and pathos of the story told in Genesis.

Following the Biblical story told in the Book of Genesis, Wiligelmo narrates with urgent immediacy the story of Adam and Eve from the creation to the curse laid on them after their sin. He then continues with the fratricide of Abel and the death of Cain up to the episode of Noah's Arc. To portray sin the artist synthesizes several episodes in a single scene in highly original manner: Eve takes from the evil serpent's fangs the forbidden fruit that Adam is already eating, greedily but fearfully. At the same time the first parents, aware of sin and their nudity, cover themselves with large fig leaves. Eve, who in the preceding scene, as confirmation of her original innocence, is entirely devoid of sensuality, now displays an ample bosom. Her body, like that of Adam, is instead shapeless and covered by heavy garments in the scene portraying them atoning for their sin by hard work in the fields.

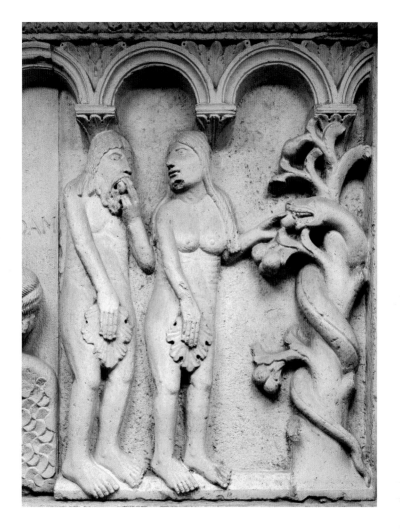

Wiligelmo

Stone slab held up by Enoch and Elijah with epigraph commemorating the foundation of the Modena Cathedral
c. 1099-1106, medium-grain marble. Modena, façade of the Cathedral.

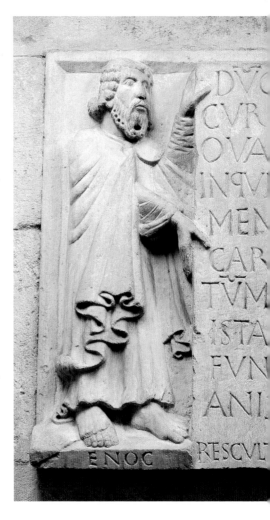

The two patriarchs holding up the stone slab with its inscription are undoubtedly the work of Wiligelmo, who also carved the reliefs with stories from Genesis on the façade, entirely similar in style. Evidently the sculptor had prepared the slab on which others inscribed the date when the church was founded and, perhaps at a later time, the eulogy to the sculptor. Compositions of this type were inspired by Roman sarcophagi, where two funerary cherubs holding a plaque are usually found in place of the Enoch and Elijah portrayed here. The two patriarchs, who were taken up into heaven without undergoing death, symbolically confer immortality on the grandiose Modena church and its rich sculptural decoration.

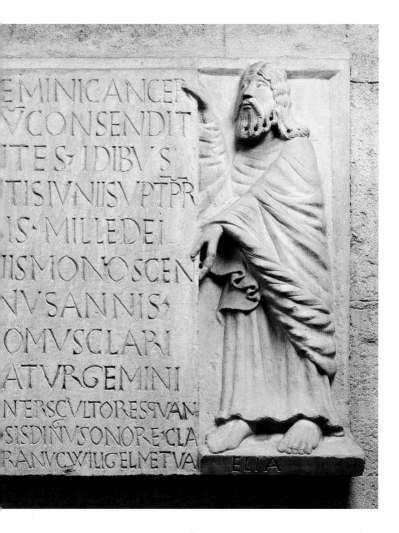

EMINICANCER
VCONSENDIT
ITES·IDIBVS·
TISIVNIISVPTPR
IS·MILLEDEI
IISMONOSCEN
NVSANNIS·
OMVSCLARI
ATVRGEMINI
NTERSCVLTORESQVAN
SISDINVSONORE·CLA
RANVCWILIGELMETVA
ELLA

LANFRANCO

active in Modena
from c. 1099 to 1110

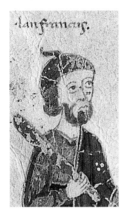

Modenese school
The architect Lanfranco directs work on the Modena Cathedral
early 13th century, illuminated page in the *Relatio de innovatione ecclesie sancti Geminiani, ac de translatione eius beatissimi corporis.* Modena, Chapter Archives, Ms. O.II.11, c. 1 v.

This illuminated page bears precious testimony to the

"**M**irabilis artifex, mirificus edificator". The architect of the Modena Cathedral Lanfranco, whose birthplace is unknown, is described by these words in the illuminated manuscript on this page. It was considered providential to have found a highly talented designer for "such a great work". "Principal and supreme artificer of such an arduous undertaking", he was to have the honor, in 1106, of discovering, with Bonsignore, the Bishop of Reggio, the venerated urn containing the relicts of St Geminianus to be placed in the new crypt. The importance acknowledged Lanfranco in Medieval documents not only as designer and architect but also as director of works is confirmed by an apsidal epigraph in Latin which calls him "famous for ingenuity, knowledgeable and competent director of works, governor and master".

construction activity carried out on the worksite for the Modena Duomo. Standing out among the personages, tallest among them, is the bearded figure of Lanfranco, wearing a sumptuous gown and headdress, and isolated from the others in both of the scenes. Like the angel of the Apocalypse who with his rod measures and constructs the heavenly Jerusalem, the architect, holding a *virga*, instrument of command and measurement, directs the workers and builders (*operarii e artifices*). The two scenes illustrate different stages in the construction of the building; above, diggers are excavating for the foundations; below, the walls are rising, constructed with blocks of stone transported by laborers.

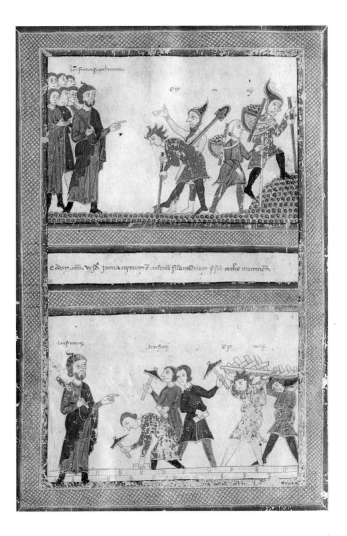

Lanfrancus archiepiscopus.

Opera · m · nij

E dcccc lxxx vijd. Iunia captur̄ē cont̄ai fundament̄m ip̄ius ecc̄lie matinēn.

Lanfrancus.

Artifices.

Opera · mvij

Lanfranco
Modena Cathedral
begun on May 23, 1099;
consecration of the altar
to the Saint, October 8, 1106.

Symbol of the civic pride
of Modena's inhabitants,
who with this innovative
marble-faced building
aspired at the close of the
11th century to erect a
church that would rival the
Pisa Cathedral and the
Florence Baptistery, the
Modena Duomo is one of
the finest examples of
European Romanesque
architecture. Its present-
day appearance is the result
of various reconstruction
initiatives carried out later,
on the northern side in
particular. On the façade
the rose window and the
side doors are subsequent
additions; to construct the
latter, some of Wiligelmo's
reliefs had to be raised.
Despite these changes it is
still clearly evident that the
church's first architect
designed a complex
building, whose exterior
and interior structures are
closely related. To the
rhythm of a system of
arcades that continue from
the apse, the first part to be
built, along the sides and
onto the façade,
Lanfranco's church rises on
the site of the original
cathedral. As compared to
the latter, it is longer, the
interior has three naves
instead of five, and the
urban setting is different.

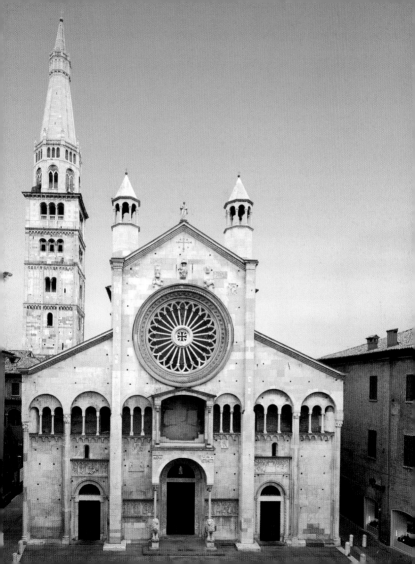

BUSCHETO

information from
1063 – Pisa c. 1110

Anonymous stone-cutter
*Tomb of the Architect
Buscheto*
end of 11th century.
Pisa, Duomo, façade,
first arch in the lower tier.

Buscheto
*View of the Apse
of the Pisa Duomo and
the Bell Tower*
end of 11th century.

Buscheto, "astute as Ulysses, ingenious as Dedalus", was buried with high honors in the façade of the Pisa Duomo. Architect of the building made all of marble (*niveo de marmore templum*), he was the first to have his name acclaimed by contemporaries. As stated in the epigraph on his tomb, an ancient sarcophagus, he invented machines so ingenious as to allow ten boys to lift monolithic columns that could only be moved by a thousand oxen. Buscheto was renowned in Rome too for a machine operated by ten girls to lift the Vatican obelisk. Legends apart, the ambitious project for the Pisa Duomo emerged from a vast cultural background which presupposes, for the dome and its decorations, a knowledge of buildings located in different regions of the Mediterranean basin. The basilical design, enriched with marble from ancient buildings, shows a desire to emulate the architecture of Imperial and Early Christian Rome.

The Pisa Duomo, begun in 1063 after the great victory over the Saracens at Palermo and consecrated in 1118, is a construction virtually unrivalled for its height, its grandiose spaces and its imposing interior colonnade. Neither in Italy nor beyond the Alps had such a colossal monument yet been conceived (the dome is 48 meters high), as well-articulated as harmonious in its proportions. Not even the Basilica of St Mark's in Venice, more or less coeval, hurls such a magnificent challenge to antiquity. Although influenced by Islamic monuments and the Churches of Asia Minor, the Pisa Duomo, with five naves and an elliptical dome over the crossing of the three-naved transept, possesses autonomous characteristics, unique in the architecture of the times. It was soon to become the prototype for many Romanesque churches in the Pisan territory, erected in Lucca, Pistoia and even Sardinia.

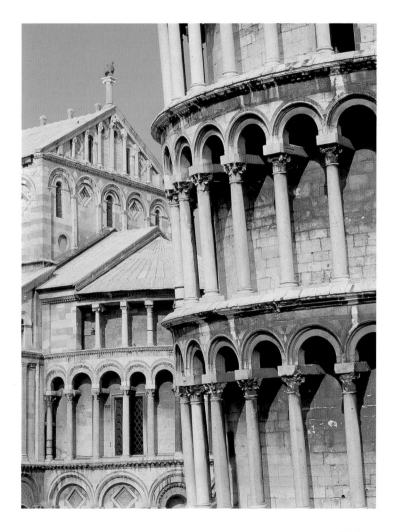

31

Anonymous artist
View of the Pisa Duomo
14th century, panel, detail
of *San Nicola da Tolentino*.
Pisa, San Nicola.

This is one of the first
representation of the Pisa
Duomo and of the famous
bell tower, it too marked
by the rhythm of arches
and loggias. The tower
is shown already leaning.
As the ground under it
continued to yield, its
construction became
increasingly difficult,
lasting from 1173 to
the first half of the
14th century.

Anonymous stone-cutter
*Commemorative
inscription to Rainaldo*
end of 11th century,
polychrome marble.
Pisa, Duomo, façade.

The inscription on the
inlaid colored marble
panel beside the lunette
over the central portal
praises Rainaldo who, after
the death of Buscheto,
continued work on the
Duomo.

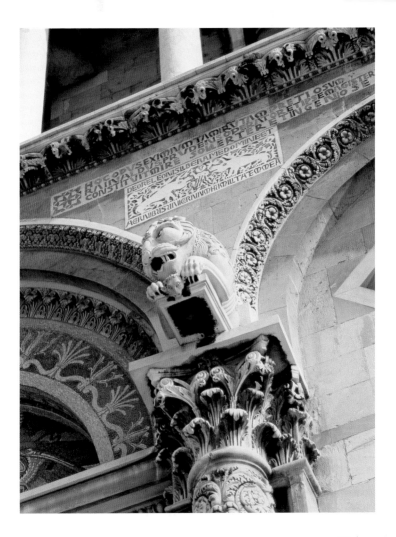

BONANNO PISANO

Pisa, information
between c. 1180 and 1186

Bonanno Pisano
Epigraph
1185 (signed and dated 1186
according to the Pisan calen-
dar), detail with signature.
Monreale (Palermo), Duomo,
left leaf of the main door.

Bonanno Pisano
*Adam and Eve in the
Garden of Eden*
1185 (signed and dated 1186
according to the Pisan
calendar), bronze, detail of
the main door. Monreale
(Palermo), Duomo.

The "royal" door of the Pisa
Duomo having been de-
stroyed by fire, two master-
pieces by Bonanno remain:
St Ranier's Door in the

I n 1595 a fire at Pisa destroyed the bronze frames
of the central door to the Duomo. On this occa-
sion the epigraph in which *Bonannus Pisanus* de-
clares that he has completed the work in only one
year, fortunately handed down to us by Vasari, was
lost. This was the first testimony left by the artist,
once considered, without valid grounds, to be the
architect of the Tower of Pisa.

In 1186, with evident civic pride, Bonanno signs
himself again *civis pisanus* on the bronze door cast
in only six months, probably at Pisa, and sent to
Palermo for the Duomo of Monreale, where it re-
mains today. The Pisan master was not the only ex-
pert in the art of casting bronze doors to leave his
name. Barisano, for instance, signed his name on
the door frames of the Trani Duomo (1175) and
those of Ravello (1179). It was Bonanno however
who renewed the Italian-Byzantine tradition in
this field.

transept of the cathedral,
with evangelical stories in
twenty panels, and the main
door of the Monreale Duo-
mo, with forty scenes from
the Old and New Testa-
ments. Great skill is evident
in the technique of casting
and cold reworking of the re-
liefs modelled by Bonanno,
whose workshop may have
been located in the vicinity
of the Pisa Duomo. The

doors rest on a wooden base
and the panels, cast one by
one, are retained at the back
by a metal frame fixed to the
wood by nails whose heads
are decorated with rosettes.
The master's innovations
were soon recognised. In
1329 a Florentine was com-
missioned to copy the Pisan
doors as model for the one
designed by Andrea Pisano
for the Florence Baptistery.

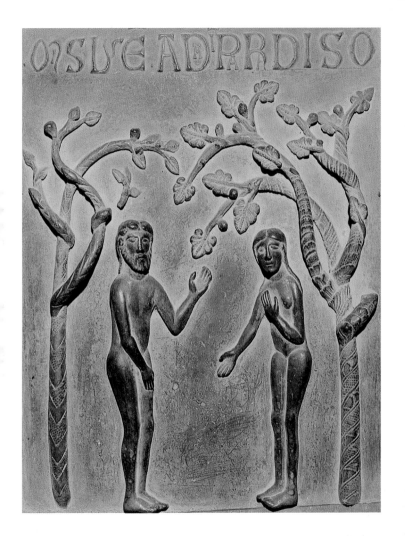

GUGLIELMO

active in Pisa, second half
of the 12th century

Guglielmo
Lion with Dragon
c. 1159-62.
Cagliari, Duomo.

Guglielmo
*Leon bringing
down an Ox*
c. 1159-62, marble.
Cagliari, Duomo.

"Excellent in art", according to an inscription now lost, Guglielmo is considered the forerunner of Pisa's great Medieval sculpture. He is buried in and commemorated on the façade of the Cathedral along with Buscheto and Rainaldo, the designers of the building. The memorial stone cites *Guillelmus* as artificer of the pulpit of Saint Mary, that is, the Pisa Duomo, dedicated to the Virgin. In addition to the work shown here, later transferred to Cagliari, he is attributed with several capitals still in the Pisa Duomo and some plaques for the choir stall, later dismembered, pierced with open-work like fine embroidery. The *Holy Water Stoup of St Ranier* (New York, The Cloisters, Metropolitan Museum) also seems close to his style, which re-elaborates Classical and Middle Eastern themes with originality. His talent emerges in all-round sculpture, showing him to be an early forerunner of Nicola and Giovanni Pisano.

In 1312 a Pisan galley disembarked at Cagliari an ambo supported by sculptured lions. This work, which had been replaced in the Pisa Duomo by Giovanni Pisano's new pulpit, found a place in the Cathedral of Santa Maria di Castello, on the rock where the conquerors of Sardinia had erected one of the strongest medieval fortresses. A change in taste had occurred, and the Pisans must be credited for not having destroyed one of the highest examples of Romanesque sculpture. Such an unusual work may even have reinforced the image of the conquerors, who aspired to the title of heirs to ancient Rome and lords of the sea. It is thus unsurprising to find, in Guglielmo's lions, Syrian origins, classic plasticity and naturalistic details drilled in the marble.

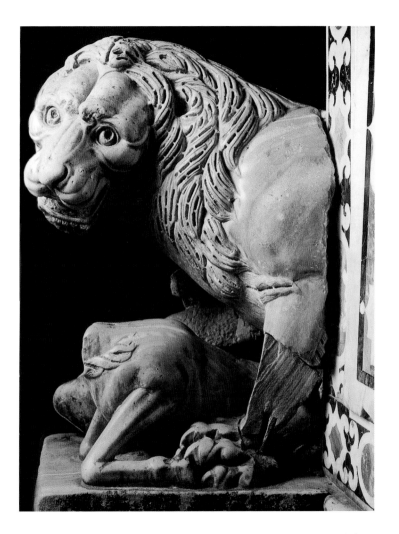

BENEDETTO ANTELAMI

active in Parma
and in Northern Italy
between 1178 and 1230

Benedetto Antelami
Deposition
1178, detail with the
sculptor's signature.
Parma, Duomo.

Benedetto Antelami
Deposition
1178, marble,
detail of *Christ deposed
by Joseph of Arimathea.*
Parma, Duomo.

Almost certainly part of a
pulpit from which the
Gospels were read, the
Deposition is one of the
most important works of
the 12th century, both for
its refined technique and

Enigma and controversial hypotheses still surround the cultural background and artistic career of Benedetto Antelami, the great master who worked at Parma and Borgo San Donnino, near Fidenza. His origin, first of all, is debatable. *Antelamus* (or *Intelvi*) is a Medieval place-name that indicates a valley near Lake Como, which may mean that a corporation of master builders emigrated from there to Liguria in the middle of the 12th century. While several generations of *magistri Antelami* worked in Genoa starting in 1157, no proof exists that Benedetto came from Liguria. His role as architect as well as sculptor is also uncertain, since Benedetto signs himself only *sculptor* in the Parma *Deposition*. His responsibility for the architectural project and for many of the reliefs in the interior and exterior of the Baptistery now seems convincing.

for the equilibrium achieved between spiritual message and dramatic narration. On the entire slab, 230 centimetres long, events linked to Christ's Passion are presented simultaneously: at the left of the deposed Christ, Mary, accompanied by the pious women, lifts her son's hand to her cheek; on the right some soldiers are throwing dice, others are holding Christ's tunic, while Nicodemus on the ladder removes a nail from the Cross. While the influence of the Provençal style seems clear in some details, the *Deposition* as a whole remains a masterpiece without precedent, rich as never before in inscriptions serving as captions which contribute to creating an effect of deep, naturalistic space.

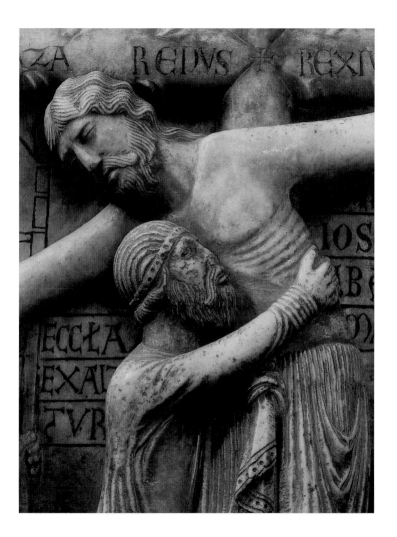

Benedetto Antelami
January and *September*
early 13th century,
stone.
Parma, Baptistery.

January, symbolised by the mythical two-fronted Janus seated on a scranno, and *September*, with a peasant harvesting grapes and the personification of Libra, form part of the famous cycle of *Months*, *Seasons* and the *Zodiac*, originally placed high inside the Baptistery, under the dome. The sculptures formed a cycle of sixteen reliefs corresponding to the sixteen sectors into which the interior of the building is divided. The whole plastic decoration seems inspired by an unitary, precise iconographic program. Starting from the external reliefs on the lunettes above the three doors, which allude to the arduous journey of human life, it continues on the inside with reliefs and sculptures offering a reassuring message: danger and difficulty can be overcome through baptism which frees mankind of original sin. Within this context the fascinating sculptures of the *Months* and the *Seasons*, represented for the first time in such complex, conspicuous manner, refer to the work of man, who through hard fatigue atones for the Biblical malediction. The harmonious combination of sculpture and architecture in the Parma Baptistery, whose project was begun by Antelami in about 1196, after the construction of the Duomo, has often been compared to that achieved during those same years in some Romanesque churches in France, Provence in particular, a region which the artist may have visited.

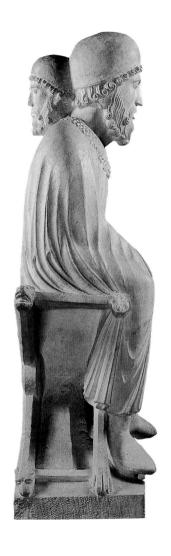
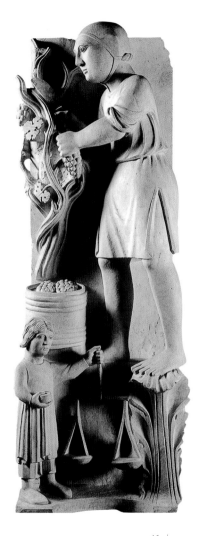

SOUTHERN ITALIAN MINIATOR

active in the middle
of the 13th c.

The Kingdom of Sicily, governed by Frederick II of Swabia (1194-1250) and later by his son Manfredi (crowned in 1258) possessed cultural traits so original as to figure among the most significant in the western world in Medieval times. The opening to architecture and the figurative arts, sculpture in particular, took place under the sign of an ideological return to Roman classicism (within the sphere of the Imperial *renovatio*, the sculptor

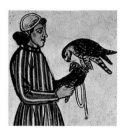

Southern Italian Miniator
The Falcon Hunter
before 1258, detail from *De arte venandi cum avibus* (*The Art of Hunting with Birds*).
Rome, Biblioteca Apostolica Vaticana, Pal. Lat. 1071, c. 81 r.

Southern Italian Miniator
*The Falcon Hunter
in the Lake*
before 1258, parchment, Rome, Biblioteca Apostolica Vaticana, Pal. Lat. 1071, c. 69 r.

The first treatises on falconry in the western world date

from the 10th century; but that of Frederick II of Swabia, who loved hunting in his Apulian estates, is by far the most complete, held in high consideration by naturalists even today. Compiled after thirty years of study even on Arabic texts and those of Aristotle, and consultation with experts called from afar, the original manuscript had disappeared already by 1248. One of its most precious copies is that of the Vatican, commissioned by Manfredi before his coronation (a French variation exists in Paris, National Library, Lat. 12400). The anonymous author of the brightly coloured illustrations manages to follow the text of *De arte venandi cum avibus* faithfully and effectively. In the lake scene, Federico comments that the falconhunter must be a good swimmer to reach his falcon.

Nicola Pisano also trained in Puglia). In illuminated manuscripts, several artists, although anonymous, are worthy of attention. This is the case of the illustrator of the treatise on birds by Frederick II, known in its oldest illustrated version through a copy made for Manfredi. The anonymous illustrator, perhaps Neapolitan, is distinguished by a sensitivity for nature and the vivacious style of his miniatures.

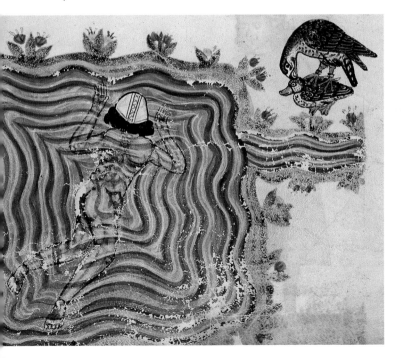

ARNOLFO DI CAMBIO

Colle Val d'Elsa
c. 1245 – Florence c. 1302

Giorgio Vasari
Portrait of Arnolfo di Cambio from the *Lives*, Florence, Giunti, 1568.

Arnolfo di Cambio
Madonna with Child
c. 1296,
marble and glass paste, detail.
Florence, Museo dell'Opera del Duomo.

A disciple of Nicola Pisano, Arnolfo *subtilissimus et ingeniosus magister*, as he was called by the Perugians in 1277, owes his immense fame to his work as architect rather than as sculptor. Up to the 19th century his statues, refined baldachins, tombs, and fountains were considered secondary, if not negligible, as compared to his religious and civil architectural projects (in Florence, Santa Croce, the Cathedral and Palazzo Vecchio). Moreover, on the *Tomb of Boniface VIII* the artist called himself *architectus*, referring also however to his funerary monuments, whose complex and "humanized" structures marked a turning point in this field, almost anticipating the humanistic formula of the early 15th century. Today, his sculptures reveal above all that 'dolce stil novo' which conferred on Arnolfo a dignity equal to that of Giotto and Dante.

Around 1294 Arnolfo was appointed architect of the Florence Duomo. Although now a successful artist, contended of the Anjou sovereigns by the Perugians, and active as sculptor in Rome and Orvieto, he was never mentioned by contemporaries such as Dante, Boccaccio and Sacchetti. The façade of the Duomo designed by him (destroyed in 1587) was described only in 1400 in Gregorio Dati's *Istoria*: "all of white marble and porphyry, with inlaid figures of marvelous beauty". Among the surviving statues, the *Madonna with Child Enthroned* comes from "a lovely, charming niche" above the central door. Here the statue was framed by a marble pavilion, emulating a curtain held open by two angels. The statue with its shining, almost ecstatic eyes, is reminiscent of the gentle *Madonna of San Giorgio alla Costa* by Giotto.

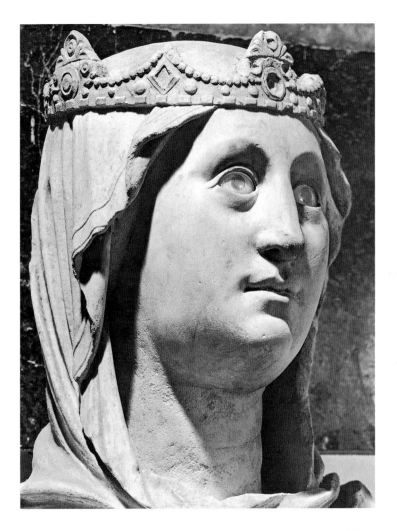

Arnolfo di Cambio
The Thirsty Cripple
c. 1281,
marble.
Perugia, National Gallery
of Umbria.

In 1277 Arnolfo was at the
service of Charles of
Anjou, lord of Naples, who
allowed him to go to
Perugia to direct work on
the Fontana Maggiore, the
great fountain which then,
for unknown reasons, was
to be constructed by
Nicola Pisano and his son
Giovanni. Only in 1281
was Arnolfo to work in
Perugia on a smaller foun-
tain, at the end of the
Piazza del Comune. Of
this structure, removed
twenty years later, some
fascinating fragments
remain, among them the
cripple who draws near to
quench his thirst.
Conceived with sensitivity
to the drama of human
life, the statue seems to
evoke antiquity in the real-
istic plastic representation
of the distorted limbs.

NICOLA AND GIOVANNI PISANO

Nicola, c. 1215 – 1278/84;
Giovanni, c. 1245 –
after 1317

Nicola and Giovanni, father and son, were among the first to study antiquity with eyes attentive to the proportions of the human body. Nicola, whom a document from 1265 mentions as living in Pisa with his son, trained in the Campano-Pugliese classicizing milieu, influenced by the refined, sophisticated court of Frederick II. His main works are found in Pisa and Siena, where he collaborated with Arnolfo and with his son Giovanni. The famous Fontana Maggiore at Perugia, with its rich bas-reliefs, completed in 1278, is also the fruit of close collaboration with Giovanni. The latter, almost certainly born in Pisa, was Master Builder of the Siena Cathedral in 1297, having lived in that city since 1285. Among his works are the Pistoia pulpit (c. 1301), that of the Pisa Duomo (c. 1310) and the *Tomb of Margaret of Brabante* (Genoa, c. 1313).

Giorgio Vasari
Portrait of Nicola Pisano
from the *Lives*,
Florence, Giunti, 1568.

Giovanni Pisano
Pulpit
c. 1310, Carrara marble.
Pisa, Duomo.

The talent of Giovanni, who praises himself in a long inscription on the base, emerges in all its mature complexity in the octagonal structure of the Pisa pulpit, one of the highest achievements of Gothic sculpture. In the lower part the plastic force of the column-bearing lions and the allegorical figures also serving as support is striking. Above, nine panels decorated with historical scenes, slightly convex, appear to form an elegantly decorated crown.

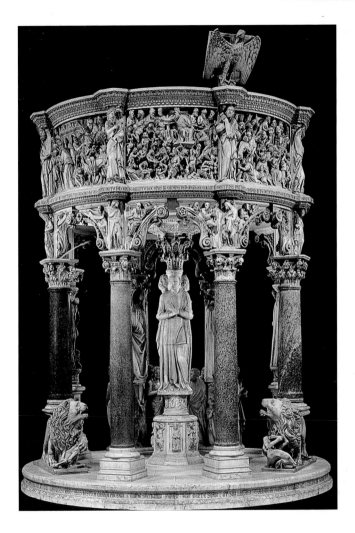

49

Nicola Pisano
Hercules
1260, marble, detail of pulpit.
Pisa, Baptistery.

Nicola Pisano, heedless
of Medieval legends that
attributed to sculpture
the ancient significance
of idolatry, was inspired
for his Hercules by a figure
on a Roman sarcophagus.
In an all-round sculpture
he created the first ideal-
ized nude hero in keeping
with classical canons.

Giovanni Pisano
*Fortitude and
Temperance*
c. 1310,
marble, detail of pulpit.
Pisa, Duomo.

In the pulpit of the
Cathedral Giovanni Pisano
immortalized some of the
most eloquent Medieval
portrayals of women,
including an all-round
nude, extremely rare for
the times. If the fully
clothed woman probably
symbolizes Fortitude, con-
sidering that she is holding
a lion cub by the paw, the
nude woman may repre-
sent Temperance. Evidently
Giovanni was inspired here
by the ancient model of
the *Venus pudica*, which he
had perhaps studied in the
example discovered at
Siena in those years and
then lost, described as a
"marvelous work" by the
sculptor Lorenzo Ghiberti
in his *Commentaries*.

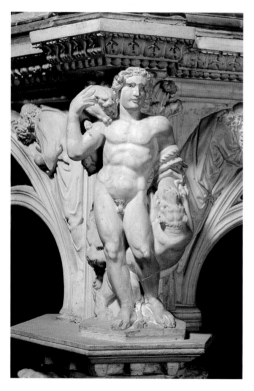

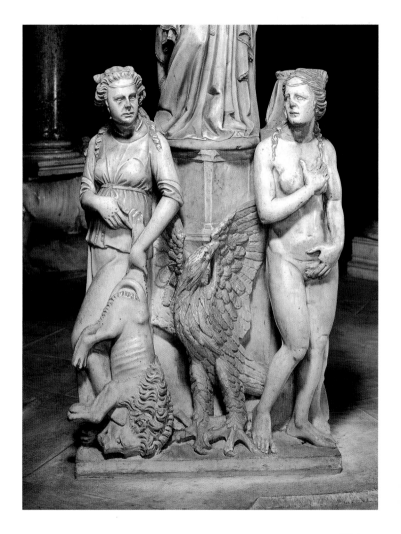

PIETRO CAVALLINI

active in Rome and Naples
between 1273 and 1321

Thanks to the strengthening of papal power and the sophisticated openness of the cosmopolitan court of Naples, the art of Central/Southern Italy was enlivened in the 13th and 14th centuries by patrons who encouraged experimentation crucial to the development of the Italian figurative civilization. While Iacopo Torriti and Filippo Rusuti in Rome showed their skill in various pictorial and sculptural initiatives, outstanding among them all was Pietro Cavallini. Although nothing is known of this early training, his hand is certain in the mosaics and frescoes of several Roman churches, whose decoration testifies to a new feeling for classical art and for the problems of representing space. Perhaps in contact with Arnolfo di Cambio, at the time when both artists were working in Santa Cecilia in Trastevere, he was called to Naples by Robert of Anjou in 1308, and richly compensated for his work.

Pietro Cavallini
Seraphims
c. 1293, fresco, detail of the
Last Judgement, Rome.
Santa Cecilia in Trastevere.

Due to numerous modifications made in the interior of the Church of Santa Cecilia in Trastevere, Pietro Cavallini's masterpiece is now located in the choir of the cloistered nuns, which can be reached only by passing through some rooms in the convent. Discovered in 1900 in fragmentary conditions the surviving frescoes, restored in the past and already highly praised by Lorenzo Ghiberti in the 15th century, cover three walls with an extraordinary *Last Judgement*, an *Annunciation* and some episodes from the Bible. The artist's talent leaps to the eye for the richness of his palette still evident in the gaily coloured wings of the seraphim, for the firm modeling of the faces, and for the individualization and exceptional plastic power of the figures. Although almost illegible today, some of the damned, portrayed with realistic anatomical details, are among the most powerful nude figures of the times.

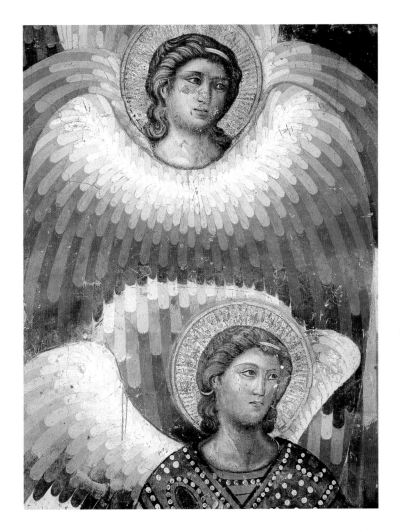

CIMABUE

(Cenni di Pepe, or Pepo)
Florence 1240? – 1302

Giorgio Vasari
Portrait of Cimabue
from the *Lives*, Florence,
Giunti, 1568.

For its expressive power and the intense colors that heighten the plastic effect of the bodies, Cimabue's painting marks a progressive detachment from Byzantine flatness toward an independent figurative language that was at last Occidental, already partially launched in Florence by another highly original master, Coppo di Marcovaldo, who died in 1280. The fortune of Cimabue, overshadowed by the rising star of Giotto according to the platitude reported by Dante, is however clouded first by a lack of documents and then by recent disasters which have severely damaged some of his masterpieces: the *Crucifix* of Santa Croce in Florence (c. 1275), irreparably spoiled by the flood of 1966 (ironically enough, it had been safe in the Uffizi Gallery until a short time before); and the *Ceiling of the Evangelists* in Assisi, some extraordinary details of which were destroyed by an earthquake in 1998. Of his activity

Cimabue
Ytalia
1277-80, fresco, detail
of the vaulting cell with
St Mark the Evangelist.
Assisi, Basilica of St Francis,
Upper Church,
Evangelists' Ceiling.

Ytalia: for the first time
this name appears in clear
letters in a figurative
context. The allegorical

image, with a rare old view
of Medieval Rome, adorns
one of the four vaulting
cells of the ceiling at the
transept crossing,
dedicated to the
Evangelists and the
countries christianized by
them: John for Asia with
Ephesus, Luke for Greece
with Corinth, Matthew for
Judea with Jerusalem. In
the cell dedicated to Mark,

along with the name Italy
appear the emblematic
monuments of Rome:
the Pantheon, the
Senatorial Palace, the
façade of St Peter's and
Castel Sant'Angelo.
The frescoes were painted
at the desire of Niccolò III,
to proclaim the
universality of Christianity
and the central power
of the Papacy.

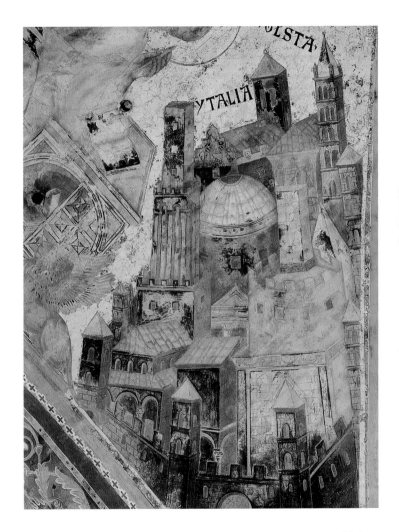

55

Cimabue
Santa Trinita Maestà
1280 – 1290, panel, whole
and detail.
Florence, Uffizi Gallery.

To fully comprehend the
imposing power of this
altarpiece it must be imag-
ined in its original place.
With its frame, now lost, it
stood 465 centimeters high
above the altar of the
Church of Santa Trinita at
Florence, as was calculated
during restoration
completed in 1993. The
most striking innovation of
the composition, a
precursor of Giotto's three-
dimensional experimenta-
tion, is the flared recess of
the throne, where four
prophets are portrayed with
precise symbolic meanings.
At the far ends Jeremiah
and Isaiah gaze upward
toward the Christ Child to
confirm the prophecies
inscribed on the scrolls,
concerning the virgin birth
of Jesus. The central posi-
tion of Abraham and
David, immediately below
the throne, seems instead to
refer to the birth of the
Saviour, descended from
their house.

as artist, only two dates are certain: in 1272 he was
in Rome, and between 1301 and 1302, the year of his
death, in Pisa. Surviving in addition to the Assisi
works, and to some drawings for mosaics in the Pisa
Cathedral and the Florence Baptistery, are panel
paintings of some of the most intense Crucifixes
and Virgins in Medieval Art.

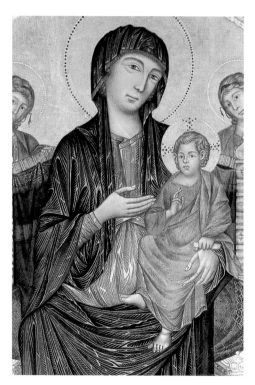

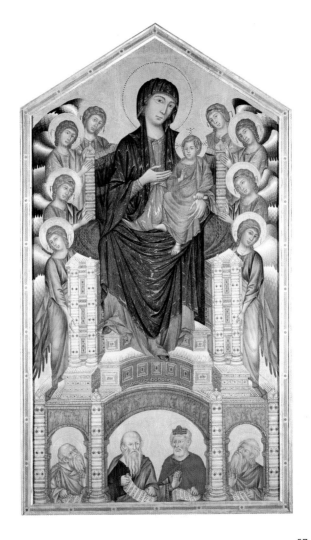

DUCCIO DI BUONINSEGNA

Siena c. 1260 – 1318

The prolific career of the Sienese artist is variously documented. In 1278 the municipal Ufficio della Biccherna paid him to paint chests for documents; later he was commissioned to paint, according to a typically Sienese custom, small panels (now lost) to decorate ledgers. The Altarpiece of Santa Maria Novella for the Brotherhood of the Laudesi dates from 1285, and the great stained-glass window for the Siena Duomo from 1285-88. Although the *Maestà* for the Chapel of the Nine in Palazzo Pubblico (1302) is lost, the great *Maestà* of the Duomo can still be admired in the Museum of Cathedral Works. A complex painting on which Duccio worked for three years, it portrays the Virgin enthroned surrounded by angels in strictly symmetrical order on the front panel. Now Duccio is appreciated for his early attention to the three-dimensional experimentation of the young Giotto.

Duccio di Buoninsegna
The Laudesi Maestà
1285, panel, entire (*at right*)
and detail (*at upper*)
of the frame with medallion
of a saint.
Florence, Uffizi Gallery.

Painted for the chapel of
the Brotherhood of the
Laudesi in the Basilica of
Santa Maria Novella at

Florence, as stated in the
contract dated April 15,
1285, this is the Sienese
painter's first known masterpiece. Six angels symmetrically surround the
colossal figure of the
Madonna enthroned, her
face still as vaguely enigmatic as an icon but
already softened by the hint
of a smile. Even the mould-

ed frame has a fundamental
role in the composition.
The 1989 restoration has
revived the luminous glow
of the thirty medallions
depicting Biblical figures
and saints (among them St
Peter Martyr, founder of
the Laudesi Brotherhood)
characterized, even in their
reduced size, by individual
features.

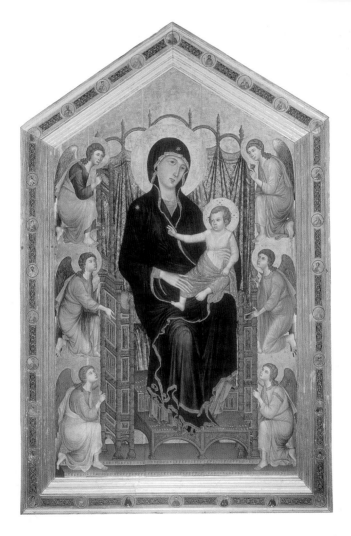

Duccio di Buoninsegna
*The Washing
of the Feet*
1308-11,
panel, detail from
back of the *Maestà*.
Siena, Museo dell'Opera
del Duomo.

On the back of the *Maestà*,
painted to adorn the high
altar of the Siena Duomo,
Duccio painted twenty-
six scenes of Christ's
Passion, expressing his
highest talent as illustrator.
Among the memorable
details are the cloth
hanging overhead and
the Apostle's dark sandals.

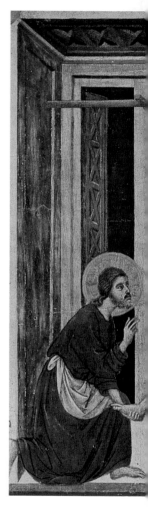

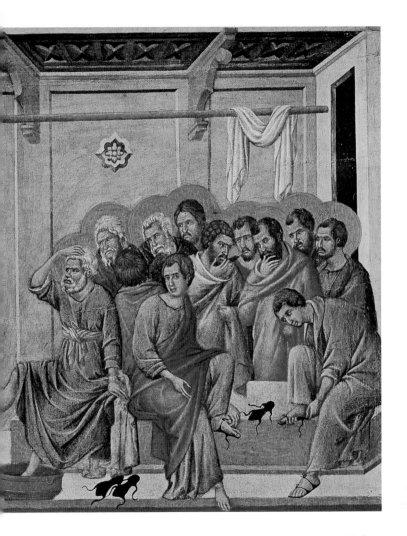

GIOTTO

(Agnolo di Bondone)
Colle di Vespignano
(Florence) c. 1266 –
Florence 1337

Paolo Uccello (attr.), *Giotto*
c. 1450, detail of the *Portrait
of Five Illustrious Men.*
Paris, Louvre.

Representing a crucial turning point in Medieval painting, Giotto is by unanimous consensus the most genial, versatile artist of his age. His contemporaries already compared him to the great masters of antiquity, even declaring him superior for his rare talent, his unrivaled skill in depicting the passions. More than any other Giotto was to "transmute art from Greek to Latin", as the theorist Cennino Cennini was to write of him at the end of the 14th century. This statement alone suffices to reveal how Giotto's contemporaries were already aware of the revolutionary nature of his painting. From the "Greek" language, the Byzantine modes handed down over the centuries, through him a new style, "modern and natural", was to emerge. Giotto renewed the conception of pictorial space, which appears three-dimensional in his paintings. Equally innovative was his representation of figures – solid,

Giotto
*Expulsion of the Devils
from Arezzo*
1296-1304, fresco, detail.
Assisi, San Francesco,
Upper Church.

In twenty-eight scenes the *Stories of St Francis* cover the walls of the nave in the Upper Church, dedicated to the founder of the Franciscan order. The iconography follows the *Legenda Maior*, compiled by St Bonaventura (c. 1260). The episode of the expulsion of the devils from Arezzo, the tenth scene in the cycle, is particularly striking for the bold angles of the towered city, where some houses have typical Medieval jetties.
The winged demons with falcons' feet are fleeing in exasperation, and the pathos is emphasized by the embittered features of the bearded, anthropomorphic faces. Giotto's authorship of the cycle has been often questioned due to stylistic differences from the Padua frescoes, and is still denied by some experts, although unconvincingly.

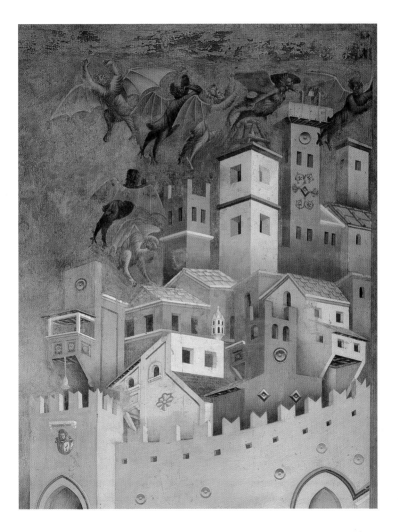

Giotto and Assistance
The Greccio Crèche
1296-1304,
fresco, detail.
Assisi, San Francesco,
Upper Basilica.

The skill of the wood-
workers in dealing with
heavy works to be hung
with campanas is clearly
evident here.

volumetric, no longer ethereal bodies fluctuating in an improbable space devoid of perspective but flesh-and-blood personages with realistic features. Like his artistic nature, Giotto's human character was marked by a strong practical sense and a certainty of his own gifts which allowed him to maintain excellent relations with clients and a perfect entrepreneurial organization. It seems probable that he was apprenticed in Florence to Cimabue, who according to tradition, mentioned also by Dante, was to be outstripped by his pupil ("Cimabue thought himself master in painting/and now the cry is Giotto", Purg. XI, 94-95). Between 1290 and 1304 it is believed, in a hypothesis subject to debate, that Giotto frescoed the *Stories of St Francis* in the Upper Basilica of Assisi. Before the end of the century he stayed in Rome and Rimini. By 1305 he had completed the Arena Chapel for Enrico Scrovegni in Padua. Returning to Florence, now famous and highly esteemed (and very well paid), he worked in Santa Croce for wealthy clients such as the Bardi and Peruzzi families. At Naples in 1329 at the court of Robert of Anjou with his pupil Maso di Banco, he was now "principle master and painter". He died at Florence where in the meantime he had also been appointed superintendent of fortifications and master builder of the Duomo.

Giotto

Ire

1303-1305,
fresco, from the cycle
on the moulding with
Allegories and Vices.
Padua, Arena
(or Scrovegni) Chapel.

The lower tier of the
Padua chapel is painted
like a false moulding with
marble panels alternating
with figured ones.
Here Giotto evokes a sense
of reality and space
by having emerge from
the background, almost
like sculptures, the
personifications of the
Virtues and Vices
portrayed in monochrome.
In this forerunner of the
cycle of *Illustrious Men*
frescoed over a century
later by Andrea del
Castagno (now in the
Uffizi) the 14th century
artist reveals himself a
keen observer of the
human soul.

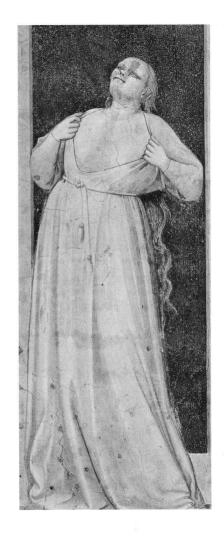

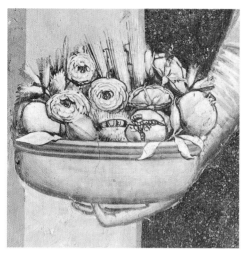

Giotto
Two Women
1303-1305,
fresco, detail of the
Birth of Mary
from the cycle of
Stories of the Virgin.
Padua, Arena
(or Scrovegni) Chapel.

Within a theatrical set that is bare and essential but always endowed with some element of striking impact on the spectator, Giotto's figures are delineated by simple, clear borders, which nonetheless reveal the physical nature of their bodies. A few traits, a few gestures, are enough to render the atmosphere of a fleeting moment, as in the case of the urgent, anxious exchange of a bundle between two women who meet at the entrance to the house where Mary has just been born. The eye moves from the face of the younger woman to the masterly play of hands – hands that offer and hands that grasp – up to the wrinkled face of the old woman emerging from the darkened doorway.

Giotto
Bowl with Flowers and Fruit
1303-1305, fresco, detail of *Charity*, from the cycle of *Allegories and Vices*. Padua, Arena (or Scrovegni) Chapel.

The allegories of Virtues and Vices are a continuation of the iconographic program of the Paduan cycle. The frescoes along the walls of the chapel, culminating in the grandiose *Judgement* on the inner façade, allude to mankind's Christian journey of salvation, and were dictated by the need of the client Enrico Scrovegni to atone for the sins of his family, stained by the offense of usury. In the personages painted in monochrome Giotto emphasizes the gestures, indulges on the symbolic attributes of the allegories, and offers us incomparably fine details, such as the still life with roses, pomegranates and chestnut husks resting lightly and gracefully on the fingers of *Charity*: a detail that was to strike the imagination of Proust on his journey to Italy in 1900.

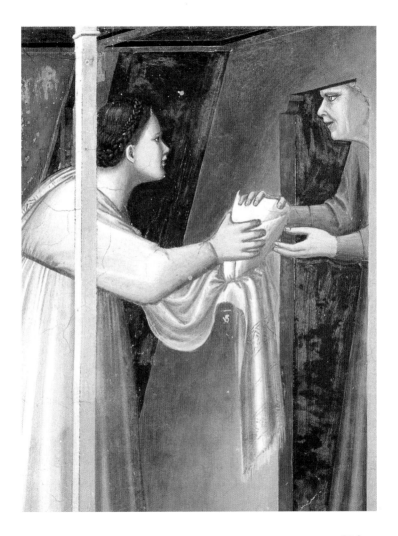

Giotto
*Maestà
(Ognissanti Madonna)*
c. 1310,
panel, whole and detail.
Florence, Uffizi Gallery.

In the great pentagonal
altarpiece painted for the
Umiliati altar in the
Church of Ognissanti at
Florence, the throne on
which the Madonna with
Child sits seems almost
an open triptych, or rather
a canopy, decorated in
the Gothic manner with
refined marble overlay.
The space is rendered
lifelike by a three-
dimensional architectural
structure, heightening the
effect of the typical
"perspective box" used
by Giotto, who still retains,
however, the traditional
gold-leaf background.
The obvious disproportion
between the Virgin and
the other figures may be
due to the need to show
to the greatest possible
number of faithful an
image of the majestic
Virgin, who like that of
Duccio formerly in Santa
Maria Novella is designed

to be seen from an
off-center point of view.
The ampulla with roses
and lilies, both Marian
symbols, are among the
first Medieval examples
of still life.

*Back of Giotto's
Ognissanti Madonna*
c. 1310, poplar wood.
Florence, Uffizi Gallery.

A true masterpiece
of carpentry, documented
by recent restoration.

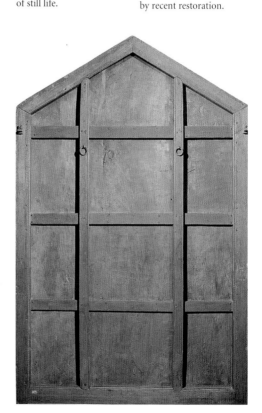

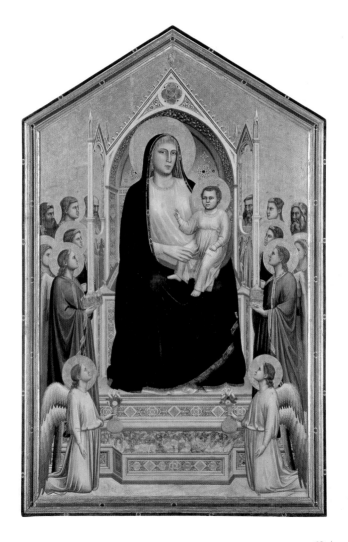

THE LORENZETTI BROTHERS

Pietro
Siena 1280 ca. – 1348?

Ambrogio
Siena, documented
from 1319 to 1348

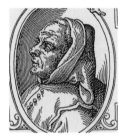

The fame of the two Sienese brothers spread beyond the boundaries of their city to arrive as far as Florence, where Ambrogio painted his first datable work: the beautiful, strange *Madonna of Vico l'Abate* (1319, Florence, Diocesan Museum). Ambrogio, enrolled in 1327 in the Florentine Guild of the Physicians and Apothecaries, was to be esteemed by Ghiberti "most singular master", "most noble draftsman", "more learned than any other". Of Pietro's work, the frescoes for the Scala Hospital (1335) have been lost but many panels and the Assisi cycle of *Stories of the Passion* remain. By Ambrogio, who after Simone's departure for France became the official painter of the Republic, there remain at Siena a famous fresco in the Hall of the Nine in Palazzo Pubblico.

Giorgio Vasari
Portrait of Ambrogio Lorenzetti from the *Lives*, Florence, Giunti, 1568.

Ambrogio Lorenzetti
Presentation of Jesus in the Temple
signed and dated 1342, panel. Florence, Uffizi Gallery.

A few years before his death Ambrogio painted for the altar of San Crescenzio in the Siena Duomo one of the masterpieces of 14th century art. The composition (originally accompanied by two side panels) is arranged around a single vanishing point which from the richly inlaid polychrome flooring in the foreground slopes toward the apse of a magnificent church. Even the marble of the columns changes color according to the depth of the space. The false statues standing on the columns to protect the temple call to mind the ideals of heroic classicism.

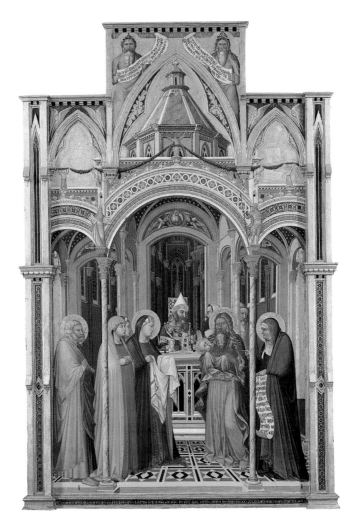

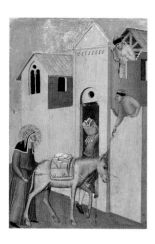

Pietro Lorenzetti
*The Beata Umiltà
bringing Bricks
to the Monastery*
c. 1340,
panel, detail of the
Beata Umiltà Altarpiece.
Florence, Uffizi Gallery.

The altarpiece, some of its
parts missing, is dominated
by the standing figure of
the Blessed Rosanese dei
Negusanti, who died in
1310. The surviving panels
are rich in many scenes of
daily life.

Ambrogio Lorenzetti
*Four Stories from
the Life of St Nicholas
of Bari*
c. 1332,
panel.
Florence, Uffizi Gallery.

Painted for the Florentine
church of San Procolo, as
stated by the sources, the
four scenes probably
formed part of a lost altar
frontal or tabernacle.
Ambrogio's highest gifts as
analytic narrator and exper-
imenter in perspective are
displayed here. He pauses
with naturalness on details
of daily life, ventures to
depict figures turning their
backs or emerging between
the columns of a church,
challenges the eye in a dar-
ing herring-bone perspec-
tive in a marine landscape
where the horizon is broken
by the profile of sails in the
wind. And it is entirely
credible that for this work,
as Vasari was to report, the
Sienese artist immediately
received "infinite reputa-
tion" among the
Florentines, accustomed to
the essential lines of
Giotto's compositions.

SIMONE MARTINI

Siena c. 1284 –
Avignone 1344

Giorgio Vasari
*Portrait of Simone
Martini* from the *Lives*,
Florence, Giunti, 1568.

In a sonnet by Francesco Petrarch, Simone flies up to Paradise to paint the "lovely face" of the mythical Laura beloved by the poet. Nothing is known of that portrait on parchment, which would be the first example of portrait painting in the history of the western world. Certainly, the friendship of Petrarch contributed significantly to the immediate fame of the refined Sienese artist. For the poet Simone also illustrated an erudite *Virgilian Allegory* in the frontispiece of a codex now at the Biblioteca Ambrosiana in Milan. Expert in both large and small formats, Simone, who with several "chompagni" had a shop in Siena, worked also in Pisa, Orvieto, Assisi and the Angevin court of Naples. While in the Assisi frescoes he almost seems willing to compete with Giotto, more often he remained faithful to a personal, aristocratic language, where color plays a primary role in conferring luminosity and depth.

Simone Martini
Virgin with Child
signed and dated 1315,
fresco, detail of the *Maestà*.
Siena, Palazzo Pubblico,
Hall of the Mappamondo.

Restored in 1994, the fresco is dominated by the Madonna with angels and saints. The first patron saint of Siena sits on a golden throne, wearing a queenly crown, under a baldachin of rich fabric. Restoration has been unable to preserve the precious colours of the clothing, applied "dry", which have been almost entirely lost. The first known work undoubtedly by Simone, it displays a complex iconography along with the composed detachment of Byzantine style.

The entire composition, over seven meters high and almost fifteen wide, remains the most grandiose fresco of the age, covering an entire wall of the hall where the General Council of the Republic met. The scroll held by the Child Jesus exhorts governors to love justice: *Diligite iustitiam qui indicatis terram.*

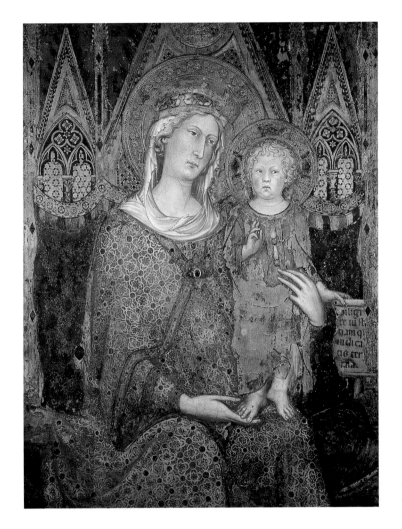

Simone Martini
Two Singing Choir-boys
1315-18, fresco, detail
of the *Funeral*, from the cycle
of *Stories of St Martin*. Assisi,
Basilica of San Francesco,
Lower Church,
Chapel of St Martin.

While an echo of Giotto
can be felt in the fore-
shortened faces and
the architectural setting
divided by spiral columns,
the overall effect is that
of an enchanted, courtly
world. In the Chapel
of St Martin, like a jewel
casket dominated by
the blue of lapis lazuli,
Simone narrates with lyri-
cal detachment the life
of the chivalrous saint
born in Pannonia
in the 4th century.

**Simone Martini
and Lippo Memmi**
Annunciation
signed and dated 1333, panel.
Florence, Uffizi Gallery.

The result of the combined
efforts of Simone and
his brother-in-law Lippo
Memmi, the altarpiece
comes from the Siena
Duomo. Typically Sienese
in the linear borders,
precious in the details
standing out against the
dazzling gold-leaf back-
ground, the composition
has a strong theatrical
accent. The Virgin, timid
and frightened, draws back
from the angel, whose
announcement is printed
on the panel like a
balloon in an *ante litteram*
comic strip.

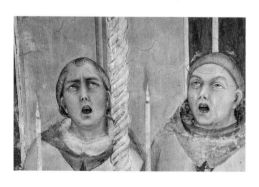

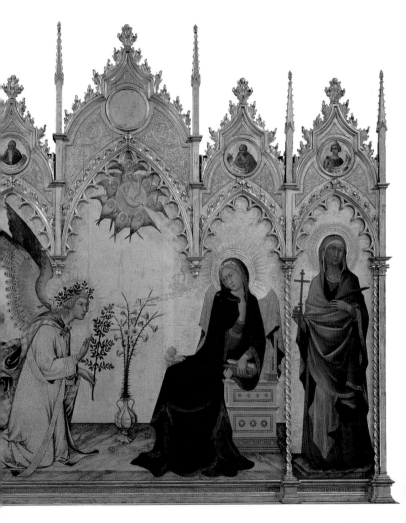

VITALE DA BOLOGNA

(Vitale degli Equi) c. 1308 –
died between 1359 and 1361

Vitale da Bologna
*A Story of
St Anthony Abbot*
c. 1340-45,
panel, whole (*above*) and
detail (*on the right*). Bologna,
Pinacoteca Nazionale.

The vertical lines are
emphasized by the steep
slant of the flooring.

Displaying pungent realism and acute expressiveness, an excellent talent for composition and soft, precious, at times brilliant colours, Vitale (or Vitalino) di Aymo de Equis worked in the university town of Bologna, as important as Paris at the time and highly stimulating culturally and artistically. Documented in 1330 for the decoration in the Church of San Francesco, he continued his frenetic activity in Ferrara, Udine and Pomposa as fresco artist, panel painter and perhaps even sculptor, assisted by a well-organized shop.

GIOVANNI DA MILANO

Caversaccio (Como) c. 1320
– active at Florence and
Rome from 1346 to 1369

A long with Taddeo Gaddi, Giovanni da Milano, painter of frescoes and panel paintings now dispersed throughout the world, is the most interesting of all the painters active in Florence in the mid-14th century. The artist came there from Lombardy in about 1346, and later went to Rome, called to the Vatican. His style, typical of the Po Valley artists in its pleasantly worldly scenes, is enhanced by spatial solutions which reveal an understanding of Giotto's highest achievements.

Giovanni da Milano
Two Women
c. 1365,
fresco, detail from
the cycle of the *Stories
of Mary Magdalene
and the Virgin.*
Florence, Basilica of Santa
Croce, Rinuccini (formerly
Guidalotti) Chapel.

Commissioned of
"*Johannes pictor de
Kaverzaio*", the frescoes
were believed to be by
Taddeo Gaddi by Vasari:
although mistaken in his
attribution, he praises the
figures and the "clothing of
that time, beautiful
and extravagant".

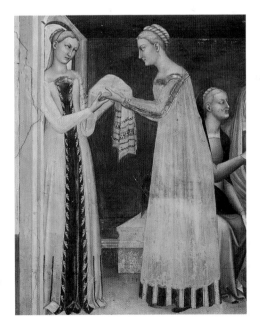

BUONAMICO BUFFALMACCO

documented
from 1315 to 1340

Giorgio Vasari
Portrait of Buffalmacco
from the *Lives,*
Florence, Giunti, 1568.

Buffalmacco
*Young Woman
with a Dog*
c. 1340, fresco, detail of the
Triumph of Death.
Pisa, Camposanto.

"Buonamico Buffalmacco, Florentine painter, who was a disciple of Andrea Tafi and, as a droll man, celebrated by Messer Boccaccio, was known to be a very dear friend of Bruno and Calandrino, jovial and pleasant painters themselves; and, as can be seen in his works scattered all over Tuscany, a man of very good judgement in his art of painting". So Vasari recalls Buffalmacco, already praised as outstanding artist by Boccaccio and Franco Sacchetti. The inventor of outlandish practical jokes, Buffalmacco incarnates in the *Decameron* and the *Trecentonovelle* one of the first portraits of the skillful, ingenious artist. In the workshop of Andrea Ricchi known as Tafo in 1320, he was among the first enrolled in the list of Florentine painters. While much is known of his personality and his reputation as excellent master, the certain works in his career are instead few.

Formerly attributed to the so-called Master of the Triumph of Death, the cycle of frescoes in the Pisa Camposanto, although fragmentary and in poor condition, is now considered to be Buffalmacco's masterpiece. Three vast scenes depicting the *Triumph of Death,* the *Judgement with Inferno* and the *Thebaide* (or *Stories of the Holy Fathers*) cover the eastern and southern walls of the monumental complex. Buffalmacco, perhaps assisted in the undertaking, expresses himself in an original language, varied and syncopated, emphasizing facial features and showing himself to be a keen observer of botanical species and animals. An artist who can be seen as "in opposition" to the Florentines of the Giottesque school, he was closer to the expressionism of Emilian painting of the times, and to the style of important painters and miniaturists.

PAOLO VENEZIANO

Venice, c. 1290 – c. 1362

**Paolo Veneziano
and Assistance**
*Translation
of the Body of St Mark*
1345, panel, detail of the
Pala Feriale.
Venice, St Mark's Museum.

At the time of the Doge
Andrea Dandolo, a learned
humanist, these panels were
painted to cover the famous
Pala d'Oro, masterpiece of
Italian Byzantine gold-work,
on week-days.

The chief painter of Venice in the early 14th century, Paolo is also the first name identifiable in Venetian painting. In a document dated March 30, 1341, he signs himself "Paulus pictor" and states that he lives in the San Luca quarter. Even earlier, in 1335, the Treviso notary Oliviero Forzetta mentions as being near the Frari Church the workshop of "Paolo da Venezia" and his brother Marco, also a painter, who specialized in stained glass windows and embroidery. The notary, it seems, wished to buy from Paolo some cartoons of *The Death of St Francis and of the Virgin*, painted "ad modo Theotenicum in pano" (painted on cloth in the Teutonic, or northern European, manner). This would seem valid proof, in the eyes of such an astute contemporary as Forzetta, of the artist's tendency to paint in the "Gothic", Occidental manner. Although not entirely abandoning the traditional Byzantine orientation of Venetian art, Paolo was the first to show, even in youthful works such as the *Palione* in Santa Maria e Donato at Murano (1310) vivacity and a strong naturalist sense clearly inspired by Giotto. Still closely linked to the Byzantine manner are the panels of the *Pala Feriale* (St Mark), painted with his sons Luca and Giovanni, who continued to paint after his death.

Paolo Veneziano
*Madonna with Child
and Two Donors*
c. 1325, panel.
Venice, Gallerie
dell'Accademia.

The panel, still in its original frame, shows Syrian influence in the oval surrounding the Child. The "humanized" portraits of the donors are instead inspired by the Giotto of the Scrovegni.

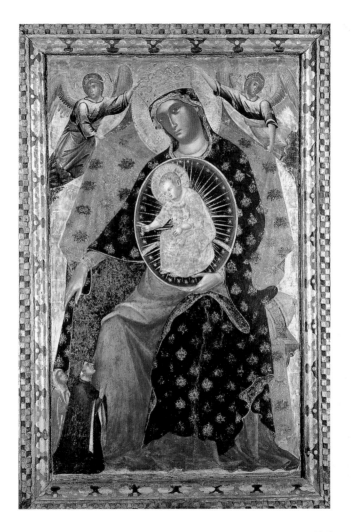

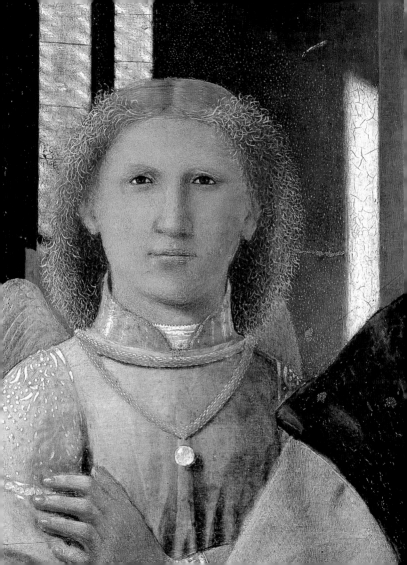

The XV Century

Far from his homeland – in years marked by political instability in all of the Italian cities – the young Leon Battista Alberti, Florentine by descent but born in Genoa in 1406 while his father was in exile, repeatedly wondered that "such excellent and divine arts and sciences", once so abundant, "were now so lacking and almost wholly lost". And he grieved that there now existed "neither giants nor geniuses". His pessimistic view was to change radically when he finally came to know his own city. In 1434 Alberti discovered Florence dominated by Brunelleschi's dome then being constructed, "a structure so great, rising above the heavens, so ample as to cast its shadow over all of the Tuscan peoples". And he was to see in Donatello, Ghiberti, Luca della Robbia and Masaccio, and above all Brunelleschi, a genius not inferior to any from antiquity. It was no coincidence that he dedicated to "Pippo", the great architect, his treatise on painting (1436), an imposing theoretical structure of primary importance for the whole century, up to the time of Leonardo.

It is unsurprising that Alberti, a sensitive adolescent living in exile, felt the decadence of civilization. He was not the first to feel it. Pessimism had dominated for years, even in Florence, as exemplified by the poet Franco Sacchetti bidding farewell to his century in 1399: "I see the universe with such evil signs of decline, that I believe that the divine trumpet will assign each to that valley from which, once having entered, there is no return". This apocalyptic vision is reflected also in the artistic climate of the mature 14th century. In one of his novellas Sacchetti has Taddeo Gaddi, Giotto's last great follower, express an opinion shared by many after the Black Plague of 1348: the "worthy painters" no longer existed; art had vanished and was "lacking

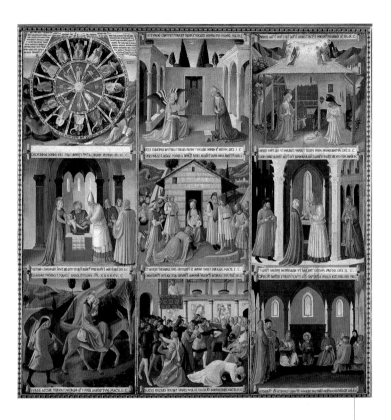

Beato Angelico

Silver Cabinet

1450-52, detail of the first nine stories, depicting, from upper left: *Mystic Wheel with the Vision of Ezechiel*, *Annunciation*, *Nativity*, *Circumcision*, *Adoration of the Magi*, *Presentation in the Temple*, *Flight into Egypt*, *Slaughter of the Innocents*, *Jesus Disputing with the Doctors*.
Florence,
San Marco Museum.

all the day". But even amid such crisis and latent disquiet Florence, like other cities, had in reality carried out initiatives of great civic value such as the Loggia dei Lanzi and Orsanmichele, the symbolic church of the city's guilds; while in painting, the tradition of Andrea Orcagna (member of the commission for the cathedral left unfinished by Arnolfo) was enriched by new stylistic traits, like those introduced by Lorenzo Monaco. In the North, which had boasted such original painters as Altichiero and Giusto de' Menabuoi, civic monuments were being erected under the sign of a growing urban vitality. In the Venice of Andrea Dandolo (Doge since 1343, waging war against Genoa and the Turks), construction was continuing on Palazzo Ducale, symbol of the concentration of power. The Lombardy of Giangaleazzo Visconti (Duke since 1395) held the grandiose international worksite of the Milan Duomo, where even French and German architects worked, and that of the Certosa at Pavia. This was the atmosphere surrounding Michelino da Besozzo and Pisanello, attentive to nature and also, in the case of the latter, to antiquity. Already as the 14th century came to an end, in Tuscany and in Veneto interest in antiquity, never entirely extinguished as has been seen with the Pisan sculptors, was flourishing. Now this interest was incremented by humanists such as the Florentine Niccolò Niccoli, a collector of ancient gemstones and codexes, and the Chioggian Giovanni Dondi, who at Rome in 1375 transcribed epigraphs and measured ancient monuments (opening the way to the tradition within which Rome was to be visited by Donatello and Brunelleschi, among the first in the new century); or like the Carrara family, whose house in Padua was decorated with medallions imitating Roman Imperial coins, collected with fervent enthusiasm (in this tradition of his-

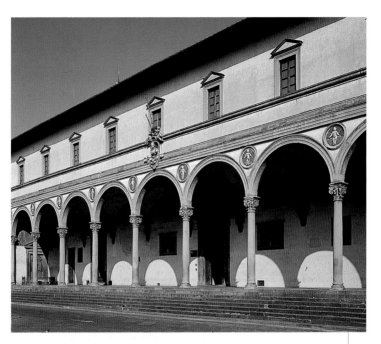

Filippo Brunelleschi
Portico of the Spedale degli Innocenti,
begun in 1419. Florence,
Piazza della Santissima Annunziata.

Leon Battista Alberti
Detail of the façade of Santa Maria Novella,
commissioned between
1439 and 1442, finished
in 1470. Florence.

89

torical and heroic re-evocation of the antique Mantegna was to attain the highest level, in full Quattrocento times).

With the new century, antiquity was increasingly regarded as a culture to be "revived"; and even more, to be studied, in the case of art, for its similitude, harmony and proportions. The study of sculptures, fragments of architecture and monuments became a constant pursuit among artists, even in their different approaches, conventionally summarized under three headings: the "archaeological" Humanism of Padua, the "philosophical and philological" one of Florence and the "mathematical" one of Urbino. It is interesting to note that the use of the term "rinascita" (rebirth) of Greek and Roman arts and culture is the only one, from among those conventionally used in historical classification, to date more or less from the same epoch to which it refers today.

But antiquity was not the only new reference point. A different conception of the relations between men, and between mankind and God, predominated in the 15th century. Finally occupying the center of the universe, no longer subjugated to divine forces, *homo faber* emerged, the artificer of himself, capable of emulating and even challenging the past with his own culture and techniques. Man was capable at last of attaining in art "a spatial clarity, a psychological truth" which could explain him to himself, "helping him to understand his essence, to free himself from metaphysical myths and social conventions", as Zeri has noted in relation to Masaccio and Donatello. Thanks to these artists, and to the mathematical genius of Brunelleschi, the new experimentation had begun. Brunelleschi "had found this law", explains his biographer Antonio Manetti: a point of view is fixed, in relation to which the proportions and dimensions of the figures repre-

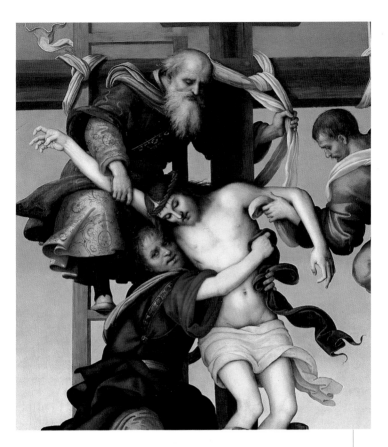

Filippino Lippi
and **Pietro Perugino,**
Deposition from the Cross
1504-1507, detail.
Florence, Accademia Gallery.

91

sented, and the distances between them, are established geometrically and precisely. The problem of representing depth in space was not really a new one (Giotto and the Lorenzetti brothers had already confronted it), nor was Brunelleschi's law the only method accepted in the 15th century, since variations quickly appeared: first in Florence, then in Venice, Padua, Mantua, Urbino, Perugia, Rome, Naples and as far as Sicily. Artists moreover, who were still artisans above all, often expert in many disciplines, were called increasingly often from one city to another, from one patron to another, in spite of the different political and social situations pertaining in the colorful mosaic of the Italian states.

Cultural exchange and enrichment was favored by the mobility of the masters, foreign ones as well, and the refined, eclectic taste of many patrons (private citizens, secular and religious institutions, princes and dukes). This is clearly shown by the interest in Flemish art, whose analytical description of reality was first admired by humanists such as the Neapolitan Facio, by great lords like the Medici, and by the artists they favored, Antonello da Messina and Filippo Lippi among others.

But the element which played the unifying role, "symbolic" of 15th century aspirations, was perspective: the urge to find a rational system for the world, to achieve harmony and proportion. It was only later, with the speculative mind of Leonardo, that a different conception of art and the world was to emerge; perspective was then to become the "daughter and not the mother of painting". With Leonardo's multi-faceted genius and the new manner of producing art, of being an artist, exemplified by Raphael and Michelangelo, masters who were already largely "16th century", a century so productive as to appear, paradoxically, longer than the others comes to a close.

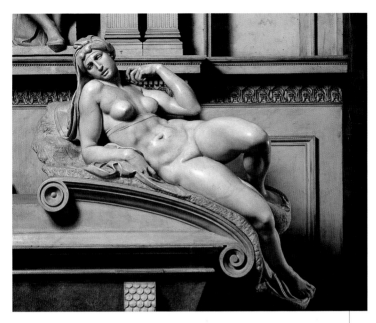

Michelangelo
Dawn
1524. Florence, Medici
Chapels.

Leonardo da Vinci
*Study of a Head for
the Battle of Anghiari*
c. 1504. Budapest,
Szépművészeti Múzeum,
inv. no. 1774 r.

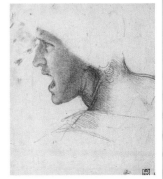

LORENZO MONACO

(Piero di Giovanni)
Siena? c. 1370 – Florence c.
1425

Giorgio Vasari
Portrait of Lorenzo Monaco
from the *Lives*,
Florence, Giunti, 1568.

Don Lorenzo, a Camaldolensian monk, painter and miniator, is one of the outstanding figures in the transition between late Gothic and early Renaissance art, characterized in Florence by studies on the motion of bodies and precious colors, in his case gelid, almost metallic. Perhaps Sienese (a document calls him "dipintore de Siene"), he was a novitate in the Florentine Santa Maria degli Angeli Monastery in 1390, becoming a deacon six years later. Here he worked as miniator (his intense images of prophets decorate choir-books now in the Biblioteca Laurenziana). His *corpus* of panel paintings includes works of various formats now in museums all over the world. The largest core, documenting his activity from the beginning, is in the Florence Accademia Gallery, while two more recently restored masterpieces, the *Adoration* illustrated here and a grandiose *Coronation of the Virgin*, are in the Uffizi.

Lorenzo Monaco
(with subsequent
intervention
by Cosimo Rosselli)
Adoration of the Magi
c. 1420-22,
panel, entire and detail.
Florence, Uffizi Gallery.

The altarpiece, its colors enhanced by enamel and lapis lazuli, probably comes from the high altar of the Florentine Church of Sant'Egidio, reconsecrated by Martin V in 1419. Like the *Coronation*, also in the Uffizi (signed and dated 1414), the work confirms Don Lorenzo as

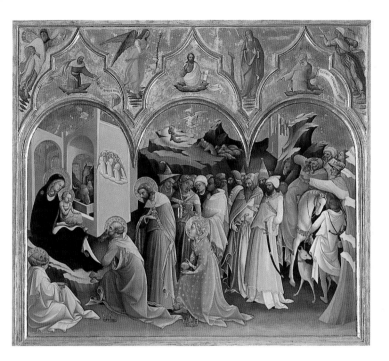

an original artist, already sensitive to Ghiberti's innovations in sculpture. His stylistic "reform", based on the mature achievements of Giotto's school (later followers such as Orcagna and Agnolo Gaddi in particular), can be seen in the extenuated elongation of the bodies, whose movements involve every limb. Exotic details appear, such as the pseudosufic (ancient Arabic) characters embroidered on some of the mantles. The panel also testifies to the alterations frequently made in paintings due to a change in taste. In the second half of the 15th century, between the three pinnacles depicting Christ bestowing blessings and two prophets, Cosimo Rosselli added two more prophets and the two figures of the Annunciation, transforming the tricuspid altarpiece into a rectangular one, more consonant with Renaissance style.

MICHELINO DA BESOZZO

(Michelino Mulinari)
Besozzo (Varese) information from 1388 to 1450

Michelino da Besozzo
St James
early 15th century, detail.
Paris, Louvre.

C alled by his contemporaries "supreme painter", "most illustrious among those of his age", "stupendous in painting animals", Michelino at the end of the 14th century was in Pavia, then a European art center, later in Venice and the Milan of the Visconti. Little is known of the early training of this eclectic artist who excelled in drawing, miniatures, frescoes, panels, gonfaloni, chests, many now lost. Praised by the Humanist Uberto Decembrio and his son Pier Candido, Michelino suffered a *damnatio memoriae* starting with Vasari, who erroneously thought him Agnolo Gaddi's pupil. In the 20th century Pietro Toesca and Roberto Longhi reevaluated him as master of the "tender style" in which he was "unrivaled", writes Longhi, even by great contemporary artists such as Lorenzo Monaco and the Cologne school painters.

Michelino da Besozzo
The Marriage of St Catherine
c. 1420, panel.
Siena, Pinacoteca Nazionale.

The only work signed by Michelino, and the only certain testimony, along with the *Marriage of the Virgin* in the New York Metropolitan Museum, of the artist's production of panel paintings, this gold-leaf work painting the signature *Michelinus fecit*, in gilded pastille like the haloes of the personages and the relief wording with the names of John the Baptist and Anthony Abbot, saints who act as witnesses to the mystic marriage of Catherine of Alexandria. Spatial effects are almost non-existent, only vaguely hinted at in the profile of the throne on which sits the Virgin with Child. Michelino focuses instead on a fairy-tale atmosphere, suspended in time.
The two saints, almost bewildered, seem to witness with detachment the marriage of the child saint with her delicate features.

GENTILE DA FABRIANO

Fabriano c. 1370 –
Rome 1427

Giorgio Vasari *Portrait
of Gentile da Fabriano*
from the *Lives*, Florence,
Giunti, 1568.

Gentile da Fabriano
*Adoration
of the Magi*
signed and dated 1423,
panel.
Florence, Uffizi Gallery.

The altarpiece was painted
for the chapel of the
wealthy Palla Strozzi in
Santa Trinita, then being
built by Ghiberti. Palla, a
rival of the Medici once

"In painting his hand was like his name", said
Michelangelo of the restless, wandering artist
from the Marches. As a youth he left Fabriano for
Orvieto, "exquisite workshop of enamels and
stained glass", as Roberto Longhi supposes, or per-
haps for Lombardy, as may be indicated by his first
known signed work, the *Madonna* of the Berlin
Museums. In 1408 he was in Venice, paid the dou-
ble of the local artist Niccolò di Pietro, where he
painted a fresco finished by Pisanello in the Great
Council Hall. In 1414 he worked for Pandolfo III
Malatesta in Brescia. Returning to Fabriano, he
then moved to Siena, Orvieto, Florence, where he
painted the *Adoration* assisted by other artists: Ar-
cangelo di Cola da Camerino, Giovanni da Imola,
Michele d'Ungheria. In 1427 he was in Rome,
where he painted frescoes in San Giovanni in Lat-
erano, also finished by Pisanello, later destroyed.

exiled to Padua, steeped
in Greek culture, was "soft
and gentle", "more fitted to
the delicacy of banquets
and the leisure of his
chambers than to the care
of armies", commented the
historian Giovanni
Cavalcanti in about 1400.
The *Adoration* was a
demanding work.
Completed after three
years, in May of 1423,

embellished by gold applied
also in relief, it was a public
manifesto of the erudition
and wealth of Palla, the
richest Florentine according
to the census of 1427.
A fairy-tale cavalcade,
illuminated in the night
by a comet, culminates in
the foreground in a scene
of sumptuous fabrics,
elegant trappings and
minute details.

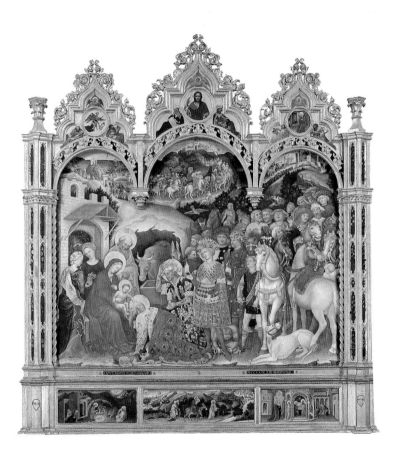

Gentile da Fabriano
*The Miraculous Tomb
of St Nicholas*
signed and dated May 1425,
panel, from the predella
of the *Quaratesi Polyptych*.
Washington,
National Gallery.

Arriving at Florence in
1420, Gentile remained
there for several years.
In 1421 he was enrolled
in the Physicians and
Apothecaries Guild,
in which the painters
of the times were
registered, and in 1425
he signed the polyptych
painted for the Quaratesi
family which once
decorated the altar of the
high chapel in San Niccolò
sopr'Arno. Composed
of five pinnacled panels
with the Madonna and
Child at center flanked by
five saints, it is completed
by a predella with five
stories of St Nicholas.
Dismembered already in
1836, the polyptych is now
dispersed between the
Uffizi, Hampton Court, the
National Gallery of
Washington and the
Pinacoteca Vaticana.
In the detail shown here,
originally the right-hand
element of the predella,
the pilgrims and invalids
who venerate the tomb
of St Nicholas are
vivaciously portrayed.
In the apsidal mosaic,
under the effigy of the
saint, Gentile has
reproduced an exceptional
painting within a painting:
the same predellas as those
of the painting, including
this one, appear.

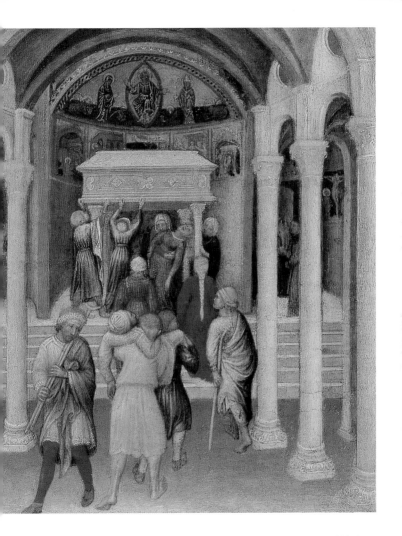

PISANELLO

(Antonio di Puccio)
Pisa c. 1390 –
Mantova? c. 1455

Pisanello
Lust
c. 1420-30, detail.
Vienna, Graphische
Sammlung Albertina.

Pisanello
The Hanged Men
1433-38, fresco, detail of
St George and the Princess.
Verona, Sant'Anastasia.

For five years, starting in
1433, Pisanello stayed in
Verona, where his family
lived. To that period date
the frescoes in the
Dominican Church of
Sant'Anastasia, above the

Among the masters of the early Quattrocento, Pisanello was praised by contemporaries such as Bartolomeo Facio, who in 1456 placed him on the same level as Gentile da Fabriano and the Flemish van Eyck and van der Weyden. A magnificent draftsman, he studied nature in line with the experimentation conducted in the 14th and 15th centuries by the Lombards Giovannino de' Grassi and Michelino da Besozzo, and by Gentile da Fabriano, some of whose frescoes he was to complete, at Venice in 1415 and Rome after 1427. Born in Pisa, the young man moved at his father's death to Verona, his mother's city, where the chief artistic model was still Altichiero, who worked until 1384 for the Scaligeri and in Sant'Anastasia. Working at different times for the Gonzaga in Mantua and for Lionello d'Este, Pisanello reflects in his portraits his skill as the finest medallion maker of the 15th century.

entrance arch to the
Pellegrini Chapel. In this
highly deteriorated work
the figures of St George,
the Princess and the
dragon have survived.
Of the Pellegrini family,
patrons of the chapel
and commissioner
of the frescoes, there also
remains a beautiful
"speaking" coat-of-arms,
with one of the century's

most expressive images
of a pilgrim. Many
drawings now in the
Louvre document the
artist's studies from life for
the numerous animals
appearing in the main
scene. The preparatory
sheet for the two hanged
men swinging from the
gibbet in the background
is now in New York
(Frick Collection).

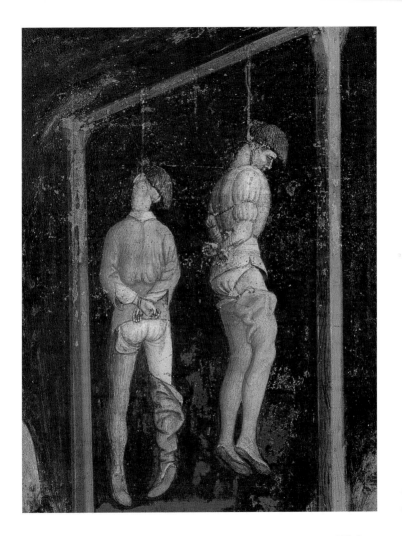

Pisanello
St George
1433-38, fresco, detail of
St George and the Princess.
Verona, Sant'Anastasia.

Against the background
of the Libyan city of Silena
with its high towers, half
Gothic, half Oriental in
style, rising on the hillside,
Pisanello portrays a St
George inspired by the
Golden Legend narrated
by Jacopo da Varagine
in about 1260, at the
moment when the saintly
knight is about to confront
the dragon in defense of
the princess. The painting
reveals the maturity
achieved by the artist,
whose passion for the
antique, demonstrated
by numerous studies of
sarcophagi, is re-elaborated
in the key of fine
chivalric poetry.

Pisanello
*Temptation of
St Anthony Abbot*
signed, variously dated
between 1430 and 1450, panel.
London, National Gallery.

The origins and patron of
this panel, the only one
signed from among the few
attributed with certainty to
Pisanello, are unknown. The
dating too is uncertain.
According to one of the var-
ious hypotheses, this is the
Madonna mentioned in a
letter by Lionello d'Este,
Lord of Ferrara, in 1432,
promised to him by Pisanel-
lo upon his return from
Rome. Even the iconography
is singular and obscure: the
Madonna with Child, sur-
rounded by a luminous ha-
lo, looks down from heaven
at St Anthony Abbot,
accompanied by his usual
attributes – a stick, a bell
and a pig. The saint almost
seems to threaten the young
man dressed in refined
armor and wearing a wide-
brimmed straw hat who
grasps his sword as the drag-
on twines about his legs.
It is thought that the youth
represents Lionello d'Este,
or perhaps Ludovico Gonza-
ga, a devotee of St George.

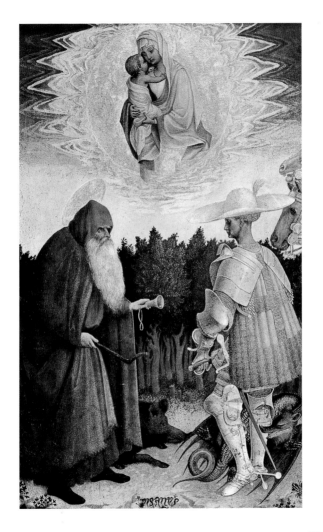

JACOPO DELLA QUERCIA

Siena c. 1371 – 1438

Giorgio Vasari
Portrait of Jacopo della Quercia from the *Lives*,
Florence, Giunti, 1568.

Jacopo della Quercia
Announcing Angel
signed, c. 1421-26,
inlaid and colored wood,
detail.
San Gimignano, Collegiate.

The life-size angel comes
from an *Annunciation* of
which the *Madonna* has
also survived. The coloring
of the two sculptures is
the work of another artist,
Martino di Bartolommeo.

Son of the Sienese goldsmith Piero di Angelo, Jacopo moved to Lucca with his father in 1391. After sculpting statues in wood he produced a superb masterpiece in 1406, the famous funerary monument to Ilaria del Carretto, where he re-elaborated in the classical sense the traditional sepulchral typology, with a refined antique-style sarcophagus embellished by a relief frieze of cherubs bearing garlands. After a stay in Ferrara he went to Siena where in 1409 he created another work of exceptional beauty and complexity, the Gaia Fountain for Piazza del Campo, at which he worked in several stages (his slowness to finish his works was proverbial) up to 1419 (the original fragments are now in the upper loggia of Palazzo Pubblico). Another of his masterpieces is the bronze portal of San Petronio in Bologna, begun in 1425 and left unfinished.

Jacopo della Quercia
Ilaria del Carretto
1496, marble, detail
of the funerary monument.
Lucca, Duomo.

The strikingly gentle effigy of Ilaria del Carretto, the wife of Paolo Guinigi, lord of Lucca, who died in childbirth on December 8, 1405, has entered the collective imagination as the most moving funerary monument of the 15th century.

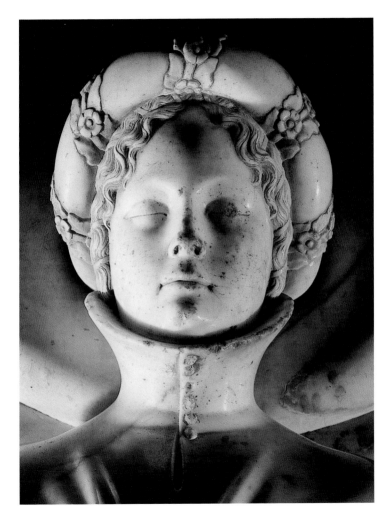

LORENZO GHIBERTI

Florence 1378 – 1455

Lorenzo Ghiberti
Self-portrait
1425-52, detail from
the left leaf of the door.
Florence, Baptistery,
Doors of Paradise.

Lorenzo Ghiberti
Sacrifice of Isaac
1402, gilded bronze.
Florence, Bargello
Museum.

In 1401 the Arte di
Calimala announced
a contest for the second
door of the Baptistery
(the first, on the south
side, has been completed

Sculptor, goldsmith, architect, and man of learning, Ghiberti fully incarnates the image of the artist and theoretician of the early 15th century: student of antiquity, curious, investigative and ambitious. His reputation as sculptor was confirmed in 1402 when he won the contest for the second door of the Baptistery.

Leaving the worksite of the Cathedral dome, where he had collaborated and quarreled with Brunelleschi, he organized an efficient shop (in which the young Donatello was also to work), assigned commissions for major projects, including the statues for Orsanmichele and the Doors of Paradise (1452). His *Commentaries* (1447-55), containing judgments on the great contemporary and 14th century masters as well as ancient texts and scientific theories on optics, anatomy, proportions, exemplify his artistic and literary experimentation in those years.

by Andrea Pisano in 1336).
Among the other
competitors, in addition
to Ghiberti, were Jacopo
della Quercia and
Brunelleschi. The subject
was to be the same for all:
a bronze plaque depicting
the *Sacrifice of Isaac*.
With the work now in
the Bargello Ghiberti was
declared winner.

He proudly reports that
the judges, "men highly
expert in painting
and sculpture", had felt
no doubt: "I was granted
the palm of victory by all
of the experts".
And probably this was
really the case: his balanced
composition fully satisfied
the standard requisites
of the time.

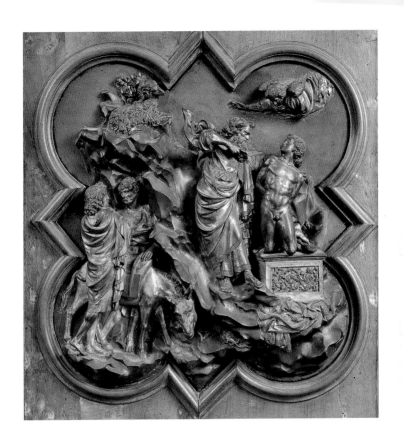

FILIPPO BRUNELLESCHI

Florence 1377 – 1446

Andrea di Lazzaro Cavalcanti
Filippo Brunelleschi
1446, detail. Florence, Duomo.

Goldsmith, sculptor and architect, "Pippo" as Leon Battista Alberti called him, is the dominant figure in early 15th century Florentine art. "He himself", wrote his biographer Manetti, "put in act what the painters now call perspective and from him was born the rule and those who could have taught it to him have been dead for centuries". Thanks also to his friendship with the scientist Paolo dal Pozzo Toscanelli, he progressed from intuitive experimentation to a scientific system of measuring space, first applied in two perspective panels of piazza Signoria and piazza Duomo. In addition to the Cathedral dome he designed harmonious structures such as the Portico of the Spedale degli Innocenti, the Churches of San Lorenzo and Santo Spirito and the Pazzi Chapel in Santa Croce. His sculptures include figures for the altar of San Jacopo in Pistoia and the Santa Maria Novella *Crucifix*.

Filippo Brunelleschi
Sacrifice of Isaac
1402,
gilded bronze.
Florence, Bargello Museum.

The great loser in the contest for the Baptistery doors, Brunelleschi realized a composition even too innovative for the times. The drama of the event is emphasized by the excited gestures of the angel and of Isaac, whose scream can almost be seen to issue from his open mouth. By contrast, in the foreground dominated by the placid mule, the silence of the figures at either end, heedless of the tragic episode, seems almost tangible. The boy on the left, bending over, emulates the posture of the ancient sculpture of the *Boy Removing a Thorn from his Foot* (*Spinario*), confirming the artist's early interest in antiquity.

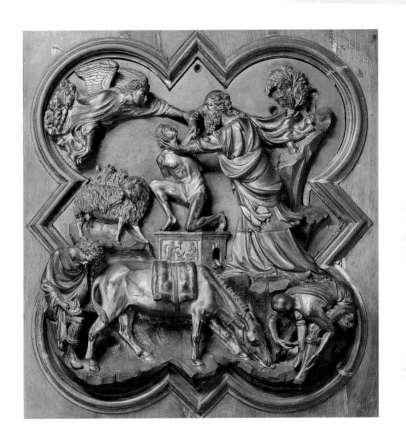

Biagio di Antonio
*Tobias and
the Archangels*
c. 1470,
canvas, detail.
Florence, Bartolini
Salimbeni Collection.

The Cathedral dome was
now complete, except for
the immense copper ball
produced by Verrocchio's
shop, hoisted to the top
on the scaffolding visible
around the lantern.

Filippo Brunelleschi
*Dome of Santa
Maria del Fiore*
1423-38.
Florence, Duomo.

In 1418 a contest was
proclaimed for the model
of the dome, the first
projects for which dated
from a century before, but
no winner was declared.
Brunelleschi, who had
journeyed to Rome with
his friend Donatello to
study ancient monuments,
intensified his travels in the
search for techniques that
would allow him to "vault"
a dome of great size
without external

reinforcement. Appointed
superintendent together
with Ghiberti in 1420,
Filippo was now sure of his
technical superiority to his
rival, who became the
object of his derision.
The herring-bone system
he designed, in part
inspired by Roman building
techniques, allowed the
dome to stand alone as the
work gradually progressed,
supported by the counter-
thrust of the ribbing. He
continued the work on his
own, designing devices to
hoist the materials and
scaffolding to build the
lantern, completed after
his death.

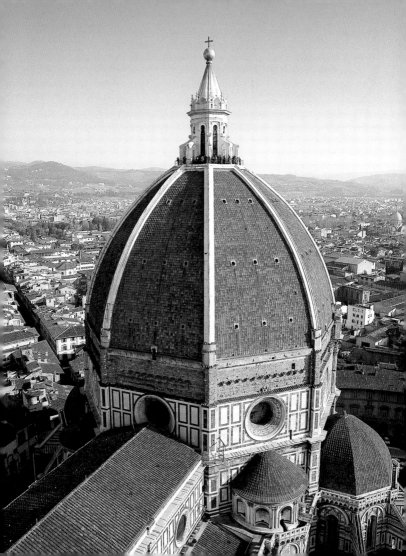

MASOLINO DA PANICALE

(Tommaso di Cristoforo Fini)
Panicale in Valdarno
(Arezzo) 1383 – Florence
1440

Masaccio
Presumed Portrait of Masolino
c. 1425, detail of *St Peter Healing the Ill with his Shadow*.
Florence, Santa Maria del Carmine, Brancacci Chapel.

The critical neglect of this fine master, only in part linked to late Gothic tradition as has often been thought, stems from the fact that after beginning with Ghiberti and Starnina he collaborated with the younger, revolutionary Masaccio, working with him in Florence on one of the most important cycles of the early 15th century, the Brancacci Chapel in the Carmine. Still memorable is a passage by Roberto Longhi, who imagines Masaccio tearing the brush from the hand of the older artist to show him how one of his scenes should be painted. Masolino was in reality an artist of great sensitivity, highly esteemed by Cardinal Branda, in whose entourage he journeyed to Hungary (1425), Rome (1428), and Castiglione Olona (in Lombardy) in 1435, where he painted luminous, dramatic frescoes for his chapel.

Masolino da Panicale
Head of a Woman
1424-25, fresco, detail.
Florence, Santa Maria del Carmine, Brancacci Chapel.

Among the recent attributions to Masolino, after the restoration of the chapel, is the delicate face of a young woman appearing in one of the medallions on the friezes decorated with plant motifs, unfortunately badly damaged.

Masolino da Panicale
Our Lady of the Annunciation
1428-31, fresco, detail.
Rome, San Clemente, Branda Chapel.

In decorating Cardinal Branda's chapel in San Clemente in Rome, Masolino expressed himself with impeccable elegance in fine facial expressions.

MASACCIO

(Tommaso di Giovanni
Cassai) San Giovanni
Valdarno (Florence) 1401 –
Rome 1428

Masaccio
Self-portrait
c. 1424-25,
detail of *St Peter in his
Chair*. Florence, Santa
Maria del Carmine,
Brancacci Chapel.

"We have had a very great loss", declared Brunelleschi upon hearing that Masaccio had died in Rome at the age of twenty-six in mysterious circumstances, after having followed Masolino there. "Pure without ornament", perceptively noted Cristoforo Landino in 1481 in regard to the artist, reflecting Vitruvius' definition of the Doric column (*sine ornatu, nudam speciem*). Still debated is the chronology of the rare surviving works by this revolutionary artist, called "Giotto reborn" for the plastic solidity of his figures, an ideal reflection of the great 14th century painter. Extraordinary also for having immediately assimilated the experimentation of Brunelleschi, Masaccio was the first to translate into painting the new rules on perspective, with a rigorous construction of space always dominated by the human presence.

Masaccio and Masolino
St Anne Metterza
c. 1424, panel.
Florence, Uffizi Gallery.

Painted in collaboration with Masolino, this work was fundamental to the development of early Renaissance art. It portrays the mother of the Virgin holding Maria and the Child on her lap.

The angel at the upper right and the group of the Virgin with Child have generally been attributed to Masaccio. In the singular, apparently static composition, the three solid figures seem superimposed on the same axis. Dominating all is St Anne who protects her daughter and grandson with a reassuring gesture.

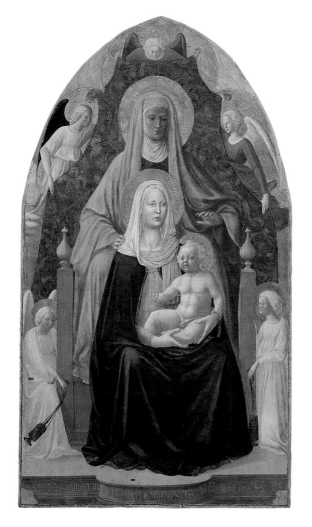

Masaccio
The Trinity
c. 1426-27,
fresco, whole and detail.
Florence,
Santa Maria Novella.

Almost theatrical in its dramatic setting, the *Trinity* was frescoed by Masaccio perhaps at the request of Fra Lorenzo Cardoni, Prior of Santa Maria Novella from 1423 to early 1426; and perhaps also for the Gonfaloniere Domenico Lensi, who may be the man shown kneeling in prayer with his wife. Below is a powerful *memento mori* with a crudely realistic skeleton lying in the tomb. It has also been suggested that the fresco may have been painted for the erudite Alessio Strozzi, adviser of Ghiberti and Brunelleschi, who was named successor to Fra Cardoni but refused this position. Brunelleschi's perspective laws are manifested in painting for the first time, as a harmonious classicizing architectural ideal is re-evoked within a strict geometric scheme.
The depth of space is rendered so effectively that the chapel seems real, painted in *trompe-l'oeil*.

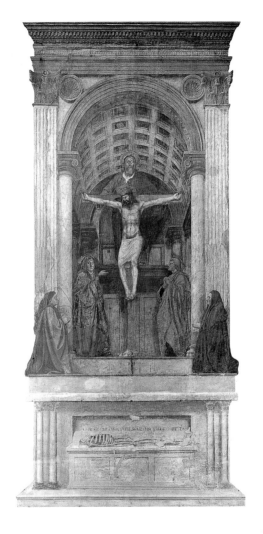

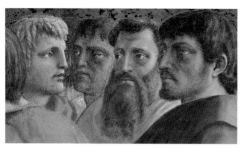

Masaccio
St Peter Paying Tribute
c. 1424-25, fresco, detail.
Florence, Santa Maria
del Carmine, Brancacci
Chapel.

Profiles like ancient
Roman medallions and
individualist features, even
in their synthetic plasticity:
these are the faces of the
Apostles, depicted by
Masaccio in the Evangelical
episode narrated by
Matthew (17, 24-27).
At Capernaum Jesus tells
Peter to look for a coin, in
the mouth of the first fish
he catches, that will serve to
pay the tribute demanded
for the temple. Masaccio
represents the scene with
"a close circle of weighty
men accented by a stormy
light" (Longhi).

**Masolino da Panicale,
Masaccio, Filippino Lippi**
*View of the left wall
of the Brancacci Chapel*
c. 1424-25 and c. 1485,
fresco. Florence, Santa Maria
del Carmine.

The decoration of the
chapel, commissioned
of Masolino and Masaccio
who left it unfinished,
was requested by Felice
Brancacci. A politician,
diplomat, enterprising
merchant and father-in-
law of the wealthy Palla
Strozzi, Felice fell into
disgrace in 1436, was exiled
and declared a rebel.
For this reason all of the
portraits of his family
members were deleted.
Only in about 1485 were
the frescoes completed
by Filippino Lippi.

BEATO ANGELICO

(Guido di Piero) Vicchio
di Mugello (Florence), late
14th century – Rome 1455

Giorgio Vasari
Portrait of Beato Angelico
from the *Lives*, Florence,
Giunti, 1568.

"Beato" since 1982, the painter received his popular pseudonym much earlier. Known to the English-speaking world as Fra Angelico, he entered history with this attribute in 1469, thanks to Fra Domenico di Giovanni da Corella, who called him *angelicus pictor*, divine painter. "Divine and affected" in Cristoforo Landino's *Comment* (1481), Guido di Piero (Fra Giovanni after taking Dominican vows) was according to Vasari "a truly divine father", "no less supreme painter and miniator than excellent monk", "most humble and modest", "in his painting easy and devote". This misleading label has persisted up to recent critical examination, which now assigns him a preeminent role in early 15th century painting. Active also in Cortona, Orvieto, Perugia and the Rome of Niccolò V, he was a cultured, refined interpreter of Masaccio's heritage, endowed with a strongly evocative language.

Beato Angelico
*Madonna with
Child and Saints
(San Marco Altarpiece)*
1438-43, panel.
Florence, San Marco Museum.

In poor condition due to past restoration, this work comes from the high altar of the Dominican church where the painter-monk lived and worked for years.

Turning toward the spectator is Cosmas, the saint for whom Cosimo de' Medici was named. Cosimo had planned an ambitious project, secretly self-laudatory, that of rebuilding the church and monastery to which he often retired, where his trusted architect Michelozzo had designed

a harmonious library containing a wealth of ancient codexes. Striking elements in this ordered composition are the analytic description of the carpet, on which rests a *trompe-l'oeil panel* of the *Crucifixion*, confirmation of this attentive artist's early interest in Flemish art.

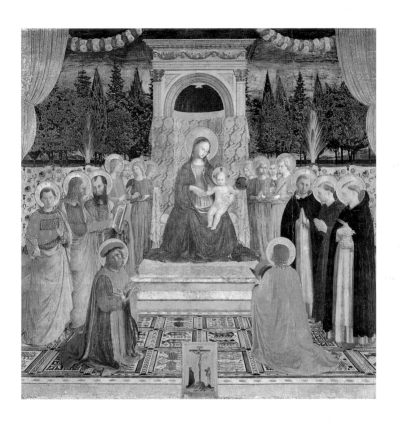

Beato Angelico
*Martyrdom
of St Mark*
1433,
panel, detail from
the predella of the
Linaiuoli Tabernacle.
Florence, San Marco
Museum.

This vivid little scene
appears in the predella
of the tabernacle
commissioned by the
Wool Merchants and
Weavers Guild for their
headquarters near the Old
Market. The importance
of the commission and
the collaboration between
various shops is confirmed
by the fact that the
marble frame is by
Ghiberti, while the
woodwork is by "Papero
di Piero", whose name
has luckily survived from
among those of many
skillful artisans now lost
to memory.

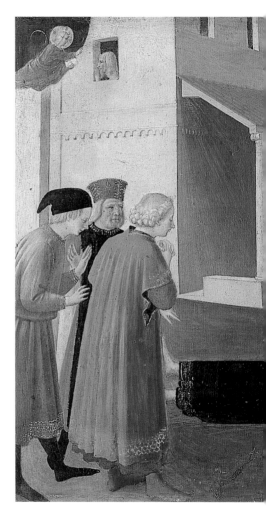

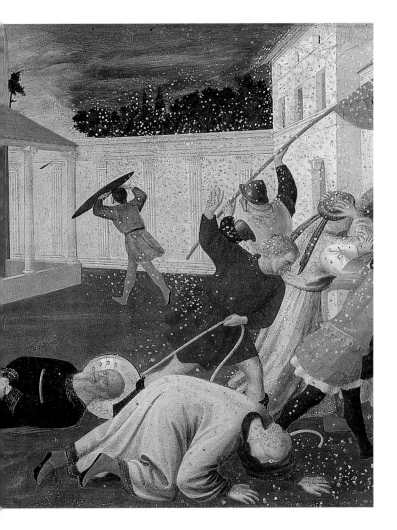

DONATELLO

(Donato di Niccolò di Betto Bardi) Florence 1386 – 1466

Paolo Uccello (attr.)
Donatello
c. 1450, detail of *Portrait of Five Illustrious Men.*
Paris, Louvre.

Donatello
San Lussorio
1425-27, bronze, partially gilded. Pisa, Museo Nazionale di San Matteo.

This is the only known representation of the Roman soldier beheaded in Sardinia under the Emperor Diocletian, venerated also in the territory of Pisa where

A lready praised by Alberti in 1436, today deemed the greatest sculptor of the century, Donatello had a long career marked by incessant activity which saw him still working when almost eighty, the tireless sculptor of the *Judith* and the bronze pulpits in San Lorenzo. A friend of Brunelleschi which whom he journeyed to Rome several times between 1402 and 1404 to study antiquity, he produced his first independent work in 1416, the *St George* for a niche in Orsanmichele (Florence, Bargello), whose bas-relief, executed "a stiacciato" and with the first "atmospheric" sky with clouds in the background and trees moving in the breeze, represents the first translation into sculpture of Brunelleschi's laws on perspective. He also worked "in company" with Michelozzo (1425-34), and was active in Pisa, Prato, Siena, Venice and Padua, where the high altar in the Basilica is one of his masterpieces.

he is popularly known as San Rossore. Donatello sculpted the bronze, which assumes the aspect of a real portrait, for the reliquary that was to contain the head of the saint, transferred to the Ognissanti Monastery in Florence in 1422. The bronze was cast by Giovanni di Jacopo in five pieces joined by screws.

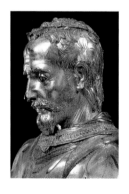

Donatello
David-Mercury
c. 1440-50,
bronze.
Florence, Bargello
Museum.

Life-size, originally
placed on a column at
the center of the courtyard
in Palazzo Medici, where
it was mentioned in 1469,
the statue was taken
from the Medici family
in 1494 at the time of
their expulsion from
Florence and brought
to Palazzo Vecchio,
perhaps to symbolize
republican freedom.
Its dating is still
controversial, and the
traditional identification
of the hero as David has
recently changed in the
mythological direction:
the statue probably
represents Mercury.

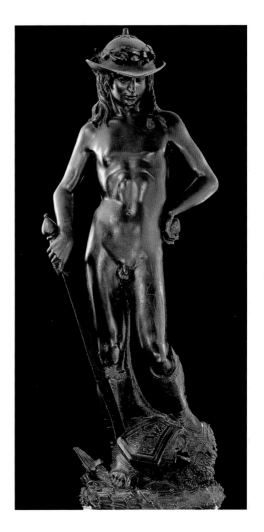

Donatello
Choir
1433-39, marble, detail.
Florence, Museo dell'Opera
del Duomo.

Sculpted by Donatello for
the Santa Maria del Fiore
Cathedral, contemporane-
ous with Luca della Robbia's
Choir, the work is a clear
manifesto of Donatello's love
of antiquity, which however
he re-elaborates with imagi-
nation and highest pictorial
and decorative skill. In the
continuous frieze behind the
little columns, where even
the color of the marble en-
crustation has a significant
role, the convulsive dance of
cherubs recalls a Dionysiac
festival. Although his pas-
sion for antiquity makes Do-
natello one of the champi-
ons of the humanistic re-
birth of the arts, his interpre-
tation of the antique is ab-
solutely subjective. Today
Reymond's comment (1898)
that the sculpture of Do-
natello "whether he wished it
or not, represents the most
energetic protest ever made
by an artist against the doc-
trines of antiquity" may
seem no longer paradoxical.

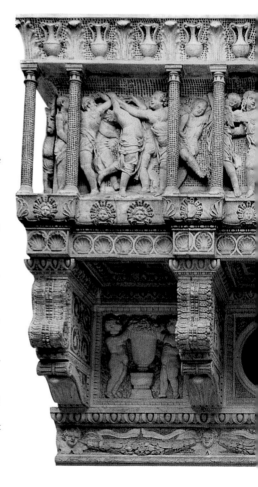

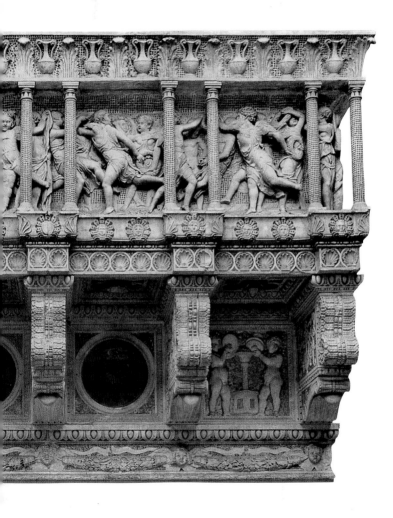

ANDREA
DEL CASTAGNO

(Andrea di Bartolo)
Castagno (Florence) c. 1421
– Florence 1457

Giorgio Vasari
*Portrait of Andrea del
Castagno* from the *Lives*,
Florence, Giunti, 1568.

"Andreino of the hanged men", he was called by the Florentines for having accepted an unrewarding task in 1440: that of painting the rebellious exiles led by Ormanno degli Albizzi hanging head down in the Podestà Palace. The "infamous paintings", with bodies swinging in dynamic poses amid twisting drapery, was an excellent exercise for the young artist, who was to repeat the experiment in the angels of the *Pazzi Madonna* (Florence, Uffizi). Sensitive to the plasticity of figures and with intense, original psychological realism, Andrea frescoed for the Carducci family a "magnificent" loggia as reported by Francesco Albertini in 1510, whose fragments, salvaged in 1847, show almost sculptural personages projecting from false frames simulating compartments in the wall, an experiment recognizable also in the *Last Supper*, his masterpiece.

Andrea del Castagno
Niccolò da Tolentino
1456, fresco.
Florence, Duomo.

In the humanistic atmosphere of 15th century Florence man, now viewed as defender of the city without the aid of any supernatural power, was glorified for his earthly virtues. Along with the renewed interest of biographies in illustrious men, condottieri and politicians who had contributed to the republican values of the city, the Florentine art of the times also celebrated its great historical figures. For the Duomo Andrea portrayed Niccolò da Tolentino, who led the Florentines to victory against the Sienese in the Battle of San Romano in 1432. In place of the initial marble project, this fresco of the knight posing proudly on his charger above an antique-style structure became the companion piece of Paolo Uccello's *Giovanni Acuto*.

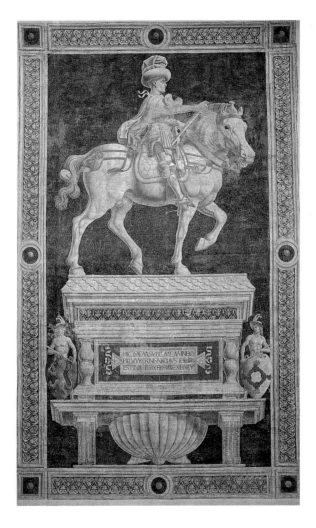

131

Andrea del Castagno
Pippo Spano
c. 1449-50, detached fresco.
Florence, Uffizi Gallery.

For the villa of the
Gonfaloniere Carducci
at Legnaia, near Florence,

Andrea frescoed a loggia
with a cycle depicting
personages from Florentine
history, along with heroic
figures from the Bible
and antiquity. Pippo Spano,
whose real name was
Filippo Scolari, was a

Hungarian of Florentine
origin who died in 1426, a
courageous captain at arms
against the Bosnians and
skillful diplomat of Sigis-
mund of Bohemia, who
appointed him Governor
of Bosnia.

Andrea del Castagno
Last Supper
c. 1445-50, fresco, detail.
Florence, Museo
del Cenacolo di
Sant'Apollonia.

Just opened to the public
after long restoration
(March 2000), the
grandiose fresco with its
foreshortened perspective,
the first Last Supper of
Renaissance stamp,
displays all of the finest
traits of Andrea's art, and
in particular the almost
cutting sharpness of the
faces and the fabrics, the
care dedicated to depicting
the multi-colored false
marbles and the winged
sphinxes at the sides of the
bench, draped in a woven
flower-patterned cloth, as
further confirmation of the
artist's refined taste for
precious details.

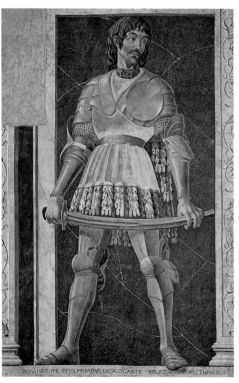

DOMINVS·PHILIPPVS·HISPANVS·DESCOLARIS··RELATOR·VICTORIE·THEVCROS

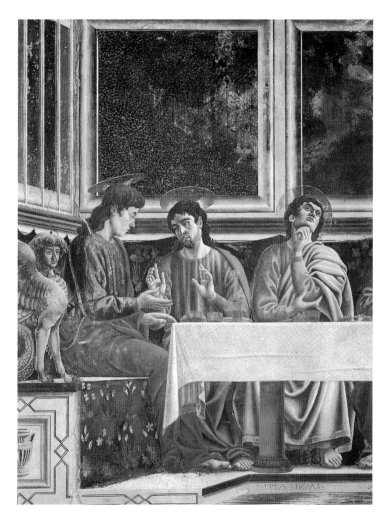

PAOLO UCCELLO

(Paolo di Dono)
Pratovecchio (Arezzo) 1397
– Florence 1475

Paolo Uccello (attr.)
Self-portrait
c. 1450, detail of the
*Portrait of Five Illustrious
Men*. Paris, Louvre.

"What a sweet thing is this perspective" Paolo Uccello answered his wife who was calling him to bed. The anecdote is reported by Vasari, who saw this great artist as a "subtle, sophisticated genius" who "delighted only in investigating some difficult, impossible matters of perspective". Even Donatello his friend admonished him: "Oh, Paulo, this perspective of yours will make you leave the certain for the uncertain". The painter of the famous lunettes in the Green Cloister of Santa Maria Novella and the famous *Battles* for a member of Bartolini family, Paolo carried to exasperation the space "rationalized" by Masaccio, accentuating the figures in the foreground, falsifying the perception of distance through strong illusionist effects. Active also in Prato, Venice and Urbino, where he worked for Federico da Montefeltro, he died at the age of eighty, poverty-stricken and forgotten.

Paolo Uccello
Giovanni Acuto
signed 1436,
fresco.
Florence, Duomo.

A cenotaph to the Englishman Sir John Hawkwood, at the service of the Florentine Republic, who died in 1394, was planned already before the death of this condottiero, but the monument was to be executed only later. Requested of Paolo Uccello in "green clay", imitating bronze, the fresco was not accepted by the Workers of the Fabric of the Duomo, and Paolo was obliged to paint another one. Having completed the work, he also had to change the inscription, now of evident humanistic concept.

Paolo Uccello
Clock
1443, fresco, detail.
Florence, Duomo.

For the inner façade of
the Duomo Paolo frescoed
the magnificent dial
of a clock, surrounded
by medallions enclosing
extraordinary
foreshortened heads.
The work dates more or
less to the period in which
the artist was preparing
the cartoons for three
stained-glass windows in
the lantern on the dome.

Paolo Uccello
Battle of San Romano
c. 1438,
panel.
Florence, Uffizi Gallery.

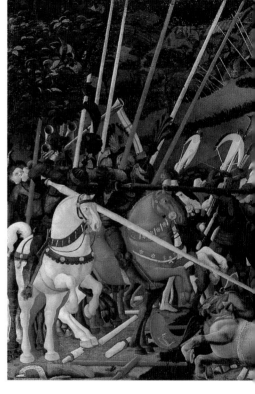

Along with two panels in
London and Paris, that of
the Uffizi forms part of a cy-
cle portraying different
stages of the Battle of San
Romano, where in Valdelsa
the Florentines defeated the
Duke of Milan, ally of the
Sienese and the Emperor in
1432. In 1492 an inventory
of the belongings of Loren-
zo the Magnificent listed
this painting as existing in
Palazzo Medici, and this was

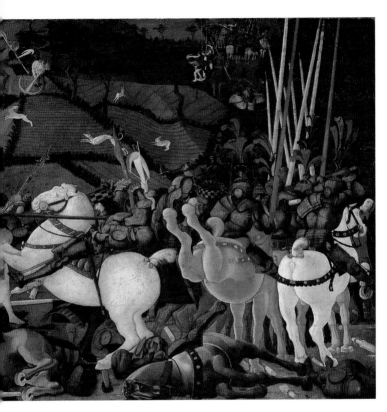

thought to be its original provenance, having been commissioned by Cosimo the Elder. An important discovery has now put an end to a discordant whirl of hypotheses on the dating of the cycle. Its intriguing history, only briefly outlined here, has been traced on the basis of incontrovertible archival data. The series was painted for a certain Bartolini, perhaps Lionardo, a leading figure in Florentine politics, who refurnished his home in Porta Rossa around 1438. After some decades the panels were forcefully acquired by Lorenzo the Magnificent.

DOMENICO VENEZIANO

(Domenico di Bartolomeo)
Venice c. 1410 –
Florence 1461

His name is shadowed by the legend, highly unreliable, that he was killed by his pupil Andrea del Castagno, as reported by Vasari. In reality Domenico died in 1461, after the death of Andrea, as recorded in the "book of the dead" of the Church of San Pier Gattolino. Venetian by birth, Domenico worked in Florence while still very young, perhaps with some assistants of Gentile da Fabriano. In 1438 he went to Perugia, from where he wrote Piero de' Medici asking for work. Back in Florence, he frescoed the choir of the Church of Sant'Egidio, working beside the young Piero della Francesca. With the latter he went to the Marches, where he left unfinished the cycle for the Church of the Madonna of Loreto. Although the delicate luminism of his painting exerted a strong influence in those years, and not in Florence alone, he was to die in poverty.

Domenico Veneziano
St John the Baptist
c. 1445, detail of *Altarpiece of Santa Lucia dei Magnoli*.
Florence, Uffizi Gallery.

Domenico Veneziano
St John in the Desert
c. 1445, panel,
(predella della *Pala di Santa Lucia dei Magnoli*).
Washington, National Gallery of Art.

A harsh landscape brightened by a few touches of green and a thicket of trees on the banks of the river, a blue sky streaked by clouds; in this luminous panel Domenico Veneziano portrays his John the Baptist: nude, a camel skin thrown over his shoulder, as he abandons on the ground the red robe that alludes to martyrdom.

PIERO DELLA FRANCESCA

(Pietro di Benedetto dei Franceschi) Sansepolcro (Arezzo) c. 1411 – 1492

Piero della Francesca
St Julian
c. 1450, detail. Sansepolcro, Museo Civico.

Piero della Francesca
Montefeltro Altarpiece
1472-74, panel.
Milan, Pinacoteca
di Brera.

This altarpiece was painted for Federico da Montefeltro at about the time when his wife, Battista Sforza, died in childbirth. It thus assumes a dual symbolic significance: the Duke's

Piero was not only an extremely talented painter but also a theoretician and mathematician, author of treatises on perspective and geometry. Born at Sansepolcro near Arezzo, he trained with Domenico Veneziano in Florence, with whom he worked in 1439 on the lost frescoes of Sant'Egidio, his only work accomplished in Florence. The chronology of his paintings, charged with still obscure symbolic meanings, is debatable where no certain documents exist. From his work in Ferrara nothing has survived, while in Rimini he signed the fresco of *Sigismondo Malatesta* in the Tempio Malatestiano in 1451. Starting in 1452 he painted one of the greatest cycles of the Renaissance, the *Legend of the True Cross* in the choir of San Francesco in Arezzo, whose restoration, revealing all of the luminosity of the frescoes, has just been completed.

thanksgiving for the birth of his long-awaited heir Guidobaldo, and a commemoration of the mother who has died; and also, perhaps, glorification of the Montefeltro family, who had conquered Volterra in 1472 (not by chance, the kneeling Duke is dressed in splendid armor). The egg hanging from the shell symbolizes birth and eternal life. The

Duchess' name is evoked by the figure of John the Baptist on the left. Federico's hands were not painted by Piero who, it seems, used the cartoon of the Montefeltro diptych now in the Uffizi for the Duke's portrait. This may be an indication of the artist's poor state of health reported by Vasari (who mentions blindness, not confirmed by the sources).

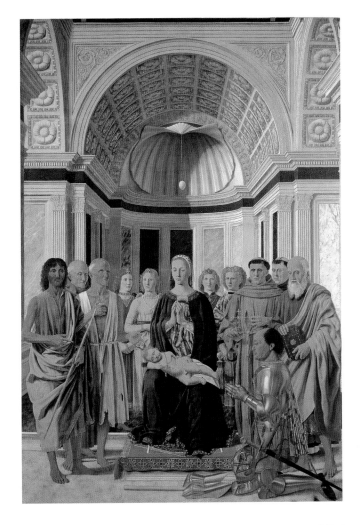

Piero della Francesca
The Flagellation of Christ
signed, after 1459?,
panel. Urbino, Galleria
Nazionale delle Marche.

This work, one of the most
enigmatic of the Quattrocento, is signed by Piero on the
base of the throne where Pilate sits. It is improbable that
the personages on the right
are Federico da Montefeltro,
his son Guidobaldo, and
Oddantonio, Federico's half-
brother, as was thought in the
past. Nor is it certain that Pilate, who watches the flagellation of Christ under a
solemnly classic loggia inspired by Alberti, can be identified with the Emperor of the
East John VIII Paleologus, nor
the bearded man in the foreground with his brother Tommaso Paleologus, who may be
meditating on the sad fate of
Constantinople. The painting
may allude to the plan for a
crusade against the Turks
proposed in 1459 by Pope
Pius II Piccolomini, and in
this case the blond youth gazing into the distance would be
the Hungarian King Matthias
Corvinus, among the few to
adhere to the project.

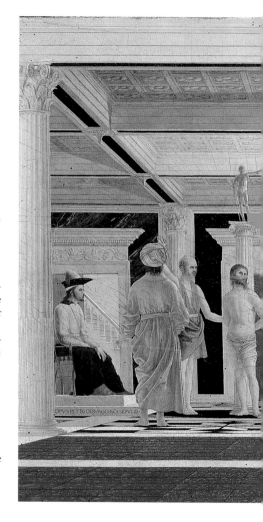

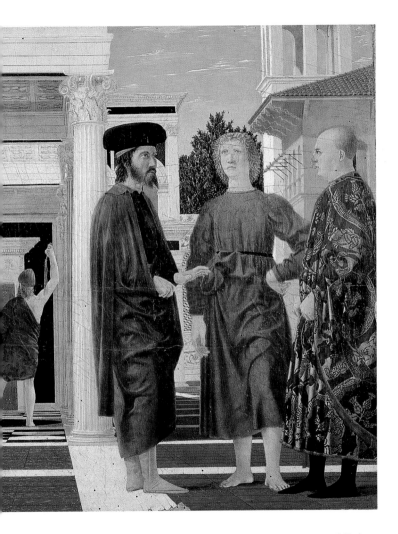

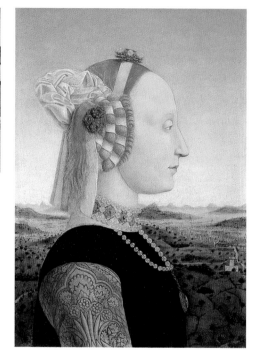

Piero della Francesca
Diptych of the Duke and Duchess of Urbino
c. 1467-72,
panel.
Florence, Uffizi
Gallery.

Painted on both sides, originally hinged to open like a book, the diptych portrays on the inside the Duke and Duchess facing each other in solemn profile like classical medallions.
The precise physiognomy,

indulging in realistic details like Federico's nose, broken in a tournament, reveals Piero to be one of the most sensitive interpreters of Northern art.
The crystal-clear landscape in the

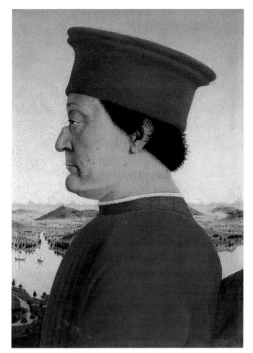

QVE·MODVM·RERVS·TENVIT·SECVNDIS·
CONIVGIS·MAGNI·DECORATA·RERVM·
LAVDE·GESTARVM·VOLITAT·PER·ORA·
CVNCTA·VIRORVM·

background, painted with an almost miniaturist technique, slopes back to distant hills on the horizon and continues even on the back. The magnificent birds' eye view unites the two panels in perspective without the customary expedient of a curtain or a window.
On the back, the Virtues accompanying the triumphant chariots of Battista and Federico allude to their moral values.

BENOZZO GOZZOLI

(Benozzo di Lese di
Sandro) Florence c. 1421 –
Pistoia 1497

Benozzo, called Gozzoli only by Vasari, is known mainly for the decoration of the Medici's private chapel on the first floor of the palace in Via Larga. In this cycle of frescoes commissioned for commemorative purposes in 1458 by Piero, son of Cosimo, an enchanted cavalcade, embellished by exotic details and filled with contemporary portraits, parades majestically across the wall. Admired already in 1459 by Giangaleazzo Sforza, the chapel was an important element of representation for the Medici, manifesting the virtues of their house. Although Vasari considered Benozzo excellent at perspective, landscapes and animals, he nonetheless relegated him to a minor role, that of decorative and descriptive artist. Collaborating with Fra Angelico on various initiatives in Rome and Orvieto, Benozzo achieved his finest results in the churches of Montefalco.

Benozzo Gozzoli
*Self-portrait with
Signature on his Cap*
1459, detail of the *Cavalcade
of the Magi.*
Florence,
Palazzo Medici Riccardi,
Chapel of the Magi.

Benozzo Gozzoli
*Cavalcade
of the Magi*
1459, fresco, detail.
Florence, Palazzo Medici
Riccardi, Chapel of the Magi.

Among the numerous
members of the Medici
family portrayed by
Benozzo in the sumptuous
cavalcade of the Magi,

Piero de' Medici (1416-69)
is generally identified as
the cavalier grasping his
horse's mane, and his
father Cosimo il Vecchio
(1389-1464) as the older
man holding the reins, to
symbolize, in a fitting
interpretation, the different
roles held by the father and
son in family life and above
all in the political sphere.

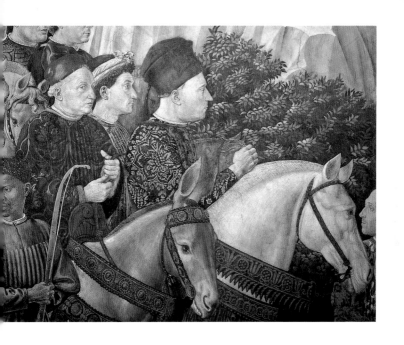

LEON BATTISTA ALBERTI

Genoa 1406 – Rome 1472

Masaccio *Presumed Portrait of Leon Battista Alberti* c. 1424-25, detail of *St Peter in his Chair*. Florence, Santa Maria del Carmine, Brancacci Chapel.

For the events that brought the Albizzi to power in Florence the wealthy Alberti family were in exile when Leon Battista was born. He was to see his city only in 1434, after studying in Bologna and Rome. In Florence, while he completed the façade of Santa Maria Novella, he wrote some fundamental works, *Della Famiglia* and *De Pictura*, dedicated to Brunelleschi. He worked in Florence, Bologna, Ferrara and Rome where in 1452 he dedicated to the Pope a copy of *De Re Aedificatoria*, structured like Vitruvius' text. In 1447 he began the Tempio Malatestiano in Rimini. In 1459 he was in Mantua, returning several times for Sant'Andrea. In Rome in 1471 he accompanied Lorenzo de' Medici and Bernardo Rucellai to visit antiquities. A gifted intellectual, he studied optics, mathematics, history; a perceptive writer, he interpreted classicism with an antiquarian's taste.

Leon Battista Alberti *Façade of Santa Maria Novella* commissioned between 1439 and 1442, completed in 1470. Florence.

The building plans of the rich, erudite Giovanni Rucellai were influenced by his knowledge of antiquity and Alberti's theories. For him Alberti designed the palace in Via della Vigna, the loggia facing it asymmetrically, and the marble-encrusted family templet in San Pancrazio, which imitates the Holy Sepulcher in Jerusalem. With his financing Alberti completed the façade of Santa Maria Novella, integrating it with the medieval part. The tympanum, with its sun in white and green inlaid marble, became the manifesto of the neo-platonic ideas diffused by Marsilio Ficino, author of *De Sole*, "the greatest of the celestial gods and the father of all things".

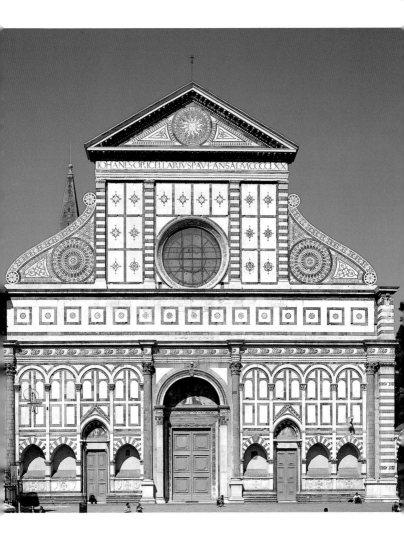

COSMÈ TURA

Ferrara c. 1430 –1495

Among the most original, autonomous artists of the Italian Quattrocento, Cosmè Tura represents, with his sharp, haunting images, the most advanced stage of the "Ferrara workshop" of which he was the leader. Born in the Emilian city, he was to work almost exclusively in his native town apart from a trip to Padua in the 1450s, where he encountered the antiquarian culture of an eccentric painter and collector of "anticaglie", Francesco Squarcione (1397-1468), with whom the young Mantegna was training. Returning to Ferrara, he worked at the vivacious, eclectic court of Ercole and Borso d'Este. In addition to many paintings now dispersed in museums all over the world, he supervised the decoration of the d'Este residences, including the Hall of Months in Palazzo Schifanoia, in which another great Ferrarese master his contemporary, Francesco del Cossa (c. 1436-c. 1478), also participated.

Cosmè Tura
Annunciation
1469, panel, detail.
Ferrara, Museo dell'Opera
del Duomo.

In 1469 Cosmè painted the doors of the organ in the Ferrara Cathedral with the *Stories of St George and the Dragon* on the outside and the *Annunciation* on the inside, of which recent iconographic analysis has revealed complex esoteric meanings. The *Annunciation* is set in a Mantegna-like architecture with a harsh landscape in the background. While the Madonna's composed attitude contrasts with the usual convulsive action of Cosmè's figures, the classicizing bas-reliefs on the walls contain sculptured, almost real figures, animated by such delirious motion that they seem about to step out of the painting.

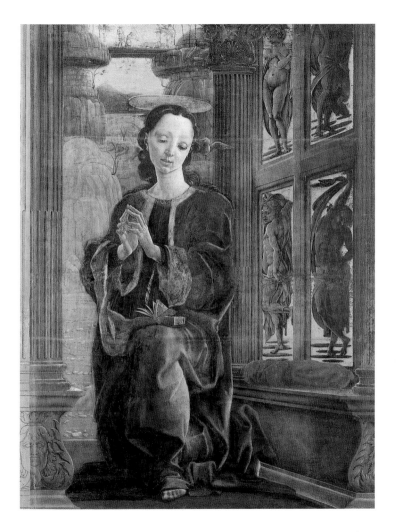

151

CARLO CRIVELLI

Venice c. 1430 –
Fabriano c. 1495

Carlo Crivelli
Vase with Flowers
signed, c. 1490,
panel, detail of the
Madonna of the Candle.
Milan, Pinacoteca di Brera.

A splendid still life rests
at the foot of the
variegated marble throne
on which the Virgin sits.
The lilies and roses are
typical Marian symbols
of purity.

Admired by the English Pre-Raphaelites for his technical virtuosity, enthusiastically collected abroad, perhaps more for the curious details than for his particular features of totally unique artist in the panorama of the mature 15th century, Crivelli has recently been the subject of attentive critical review. After training in the school of the Venetian Vivarini and then at Padua, he left Venice for Zara in 1459 under the threat of a penal sentence for living with a seaman's wife whom he kept secluded, Crivelli moved in 1468 to the Marches, along the routes frequented at the time by Slavonian merchants and Albanians. Here he was to remain until his death, finding good possibilities for work through wealthy families and ecclesiastical commissions. In Ascoli in 1473, now a successful artist, he painted one of his most famous works, the splendid, opulent *Polyptych* for the Duomo.

Carlo Crivelli
Madonna with Child
signed, 1473, panel,
details of the *Ascoli Polyptych.*
Ascoli, Duomo.

At the center of the polyptych sits the Virgin with Child, her throne encrusted with precious marble and porphyry, the arms shaped like two fantastic dolphins. Above is a garland of fruit, whose brilliant yellows and greens stand out against the red of damask fabric.

A striking figure among the saints is the blond, dandy-like St George wearing a red cap and dressed in the latest fashion.

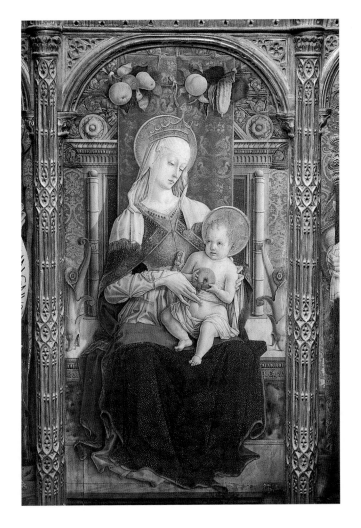

VINCENZO FOPPA

Orzinuovi (Brescia)
1427/30 – Brescia 1515/16

Vincenzo Foppa
Flight into Egypt
1476, panel, detail of the
predella of the
Brera Polyptych.
Milan, Pinacoteca
di Brera.

Foppa's grace and delicacy
appear at their finest in the
Brera Polyptych, from the
Church of the Grazie in
Bergamo. Here the quiet
gestures and looks of
Joseph, Mary and the
Angel all seem focused on
protecting the newborn
child from the fatigue of
traveling.

An outstanding personality in the panorama of
15th century Lombard painting is the Brescian
Foppa, a delicate, sensitive artist who, starting from
the same Paduan bases as the youthful Mantegna,
independently re-elaborated a style of his own dis-
tinguished by a skillful modulation of light, misty
distances, and a sweetness that is never cloying. His
first documented work is the Bergamo *Crucifixion*,
which he signed *Vincencius Brixiensis* and dated
1456, month of April. His youthful works include
the *Madonna of the Angels* in the Berenson Collec-
tion (Settignano). From 1458 Foppa lived in Pavia.
From here he journeyed to Genoa and Milan,
where in about 1468 he frescoed the Portinari
Chapel in Sant'Eustorgio. Returning to his native
city in 1490, he was granted a pension in return for
teaching young artists.

Vincenzo Foppa
Crucifixion
signed and dated 1456,
panel. Bergamo,
Accademia Carrara.

The three crucifixes are
framed by a arch of
evident classical style,
not unlike the
architecture of
Mantegna, with two
profiles in the upper
medallions inspired by
antiquity. But the drama
of the event is tempered
by the beautiful, serene
landscape, where the
tree-lined country road
that guides the eye to
the distant towers seems
almost the setting for
a fairy tale.

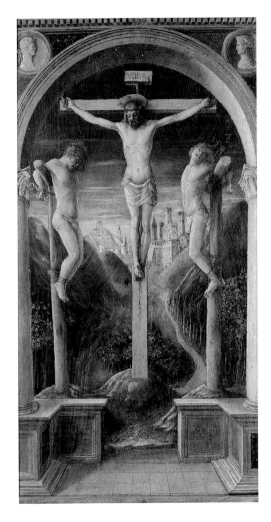

ANDREA MANTEGNA

Isola di Carturo (Padua)
1431 – Mantua 1506

Gianmarco Cavalli
Portrait of Andrea Mantegna
c. 1480, detail. Mantua,
Sant'Andrea.

When in about 1470 Raphael's father Giovanni Santi listed the finest artists of the times at the court of Urbino, he placed Mantegna before Leonardo, confirming the great fame accorded this artist in his lifetime. Apprenticed to the shop of Francesco Squarcione in Padua, filled with antiquities, in 1448 he frescoed the Ovetari Chapel in Padua (destroyed during the war), where his mastery of perspective was already striking. A genial innovator of perspective foreshortening, which was to be determinant for Correggio, Mantegna revived antiquity in the heroic sense: his allegories, unlike those of other artists who modernized their compositions, were set in the past.

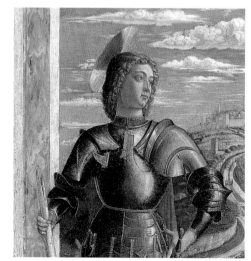

Andrea Mantegna
St George
c. 1460-70, detail.
Venice, Gallerie
dell'Accademia.

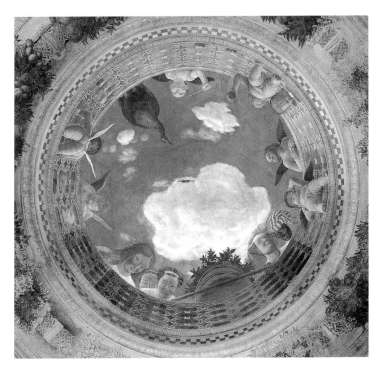

Andrea Mantegna
Oculus with Cherubs and Ladies Looking Down
1465-74, fresco, detail
of the oculus in the ceiling.
Mantua, Palazzo Ducale,
The Bridal Chamber.

Starting in 1460 Mantegna was at the Mantuan court of Ludovico Gonzaga, whose archaeological and antiquarian interests he shared. For him he frescoed the Bridal Chamber, celebrating the numerous Gonzaga family with various symbolic allusions and many portraits of contemporaries. Painted as if it were really an opening in the ceiling, the oculus represents the first bold experiment by an Italian artist in foreshortened illusionist perspective viewed from below.

157

Andrea Mantegna
*Pallas Drives
the Vices from the
Garden of Virtues*
c. 1499-1502,
canvas.
Paris, Louvre.

The second of two
paintings (the other is the
Parnassus, also in the
Louvre) for Isabella
d'Este's Studiolo in the
San Giorgio Castle
illustrates with a wealth
of figures a *fabula antica*,
whose symbology is
explained in writing on
scrolls (the first appears
at the left, wound around
a Virtue transformed into
a laurel tree). The four
cardinal Virtues have
abandoned the garden
when Minerva bursts
in threatening the Vices
who have occupied it.
They flee into a swamp,
led by Avarice, Ingratitude
and Ignorance.

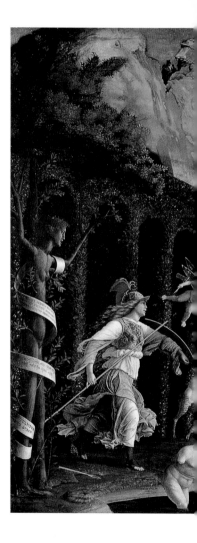

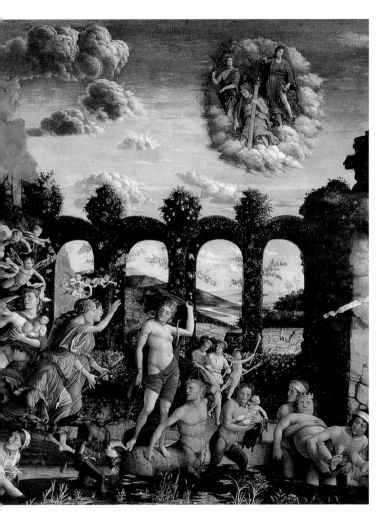

Andrea Mantegna
San Zeno Altarpiece
1456-59, panel, detail.
Verona, San Zeno.

It was in Padua that
Mantegna painted for
the protonotary
Gregorio Correr, Abbot
of San Zeno, the great
altarpiece for the choir
of the Verona church.
The work engaged him
at length, and in the
meantime Lodovico
Gonzaga was sending
numerous missives
summoning him to the
Mantuan court. The
frame, strictly functional
to the painting, was also
designed by Mantegna.
Its four half-columns at
the front only apparently
divide the composition
like a traditional trip-
tych. In reality they
function as the architec-
tural supports of a
loggia, opening out into
the magnificent unitary
setting of the sacred
scene. This is the first,
majestic example of this
kind in the figurative
panorama of Northern
Italian art.

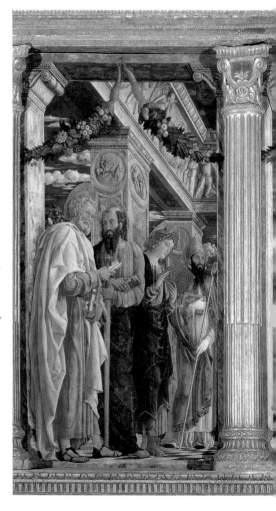

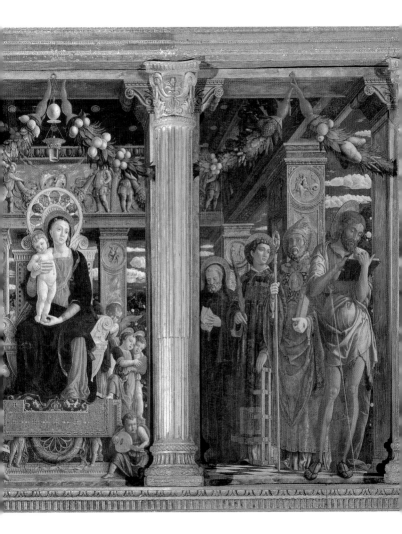

ANTONELLO DA MESSINA

Messina c. 1430 – 1479

Giorgio Vasari *Portrait of Antonello da Messina* from the *Lives*, Florence, Giunti, 1568.

An artist apparently at a disadvantage due to having been born in a relatively isolated area far from the great Italian art centers of the 15th century, Antonello was in reality highly stimulated by the vivacious, international atmosphere of Naples at mid-century. It is here that he probably encountered Flemish art, of which the Neapolitan Bartolomeo Facio was also a passionate admirer. Excelling also at portraiture, Antonello made a crucially important journey to Venice in about 1475, from where he went on to Milan. His *San Cassiano Altarpiece* (fragments in Vienna, Kunsthistorisches Museum) was to be a fundamental reference point for Veneto artists.

Antonello da Messina
Crucifixion
c. 1475-76,
panel, detail.
Antwerp, Musée
des Beaux Arts.

A body tensely contracted in the last moment of suffering before death is rendered even more dramatic by the harsh, bare tree trunk.

Antonello da Messina
Our Lady of the Annunciation
1474, panel. Palermo, Galleria Nazionale della Sicilia.

The striking innovation of the most singular and fascinating 15th century representation of the Madonna lies all in that hand stretched out toward the spectator.

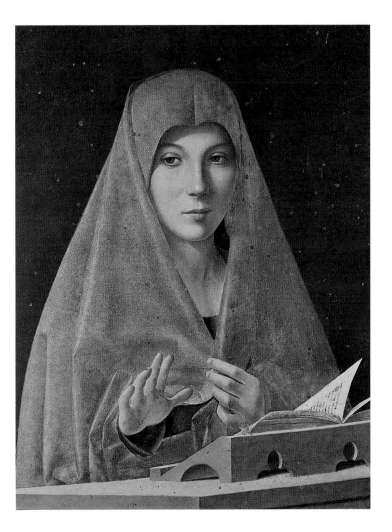

GIOVANNI BELLINI

Venice 1430 – 1516

Giorgio Vasari *Portrait of Giovanni Bellini* from the *Lives*, Florence, Giunti, 1568.

Bellini's long career was to form the backbone of Venetian Renaissance painting. The brother of Gentile (c. 1429-1507), also a painter, he learned the first rudiments from his father Jacopo, head of a prolific workshop. Giovanni was the first of the Venetians to make color and light the atmospheric essence of painting, which was to become distinctive of the Venetian school, traditionally opposed to that of Tuscany and Central Italy, based on linear drawing. Considered by Vasari the greatest Venetian artist of his day, from the 1490s he had a successful shop producing great altarpieces as well as portraits and allegories. His early style was influenced by his brother-in-law Mantegna and by the arrival of Antonello in Venice. From the latter he was inspired to turn from tempera to oil and toward a softer sfumato. He was to be innovative to the end, as proven by the *San Zaccaria Altarpiece* (1505).

Giovanni Bellini
Coronation of the Virgin (Pesaro Altarpiece)
signed, c. 1474,
panel, reconstruction.
Pesaro, Museo Civico.

Highly controversial is the dating of this famous altarpiece, which belongs in any case to the central period of the Venetian master's career. Note that only the central panel and pilasters now in the Pesaro Civic Museum are original, while the predellas are a reconstruction (the authentic ones are now in the Pinacoteca Vaticana). Painted with the oil technique for the high altar of the Church of San Francesco in Pesaro, the work is extraordinarily beautiful. The elaborate frame encloses a painting within a painting, the sacred representation, which in turn delimited by splendid architecture, frames the landscape in the background, another masterly painting within a painting.

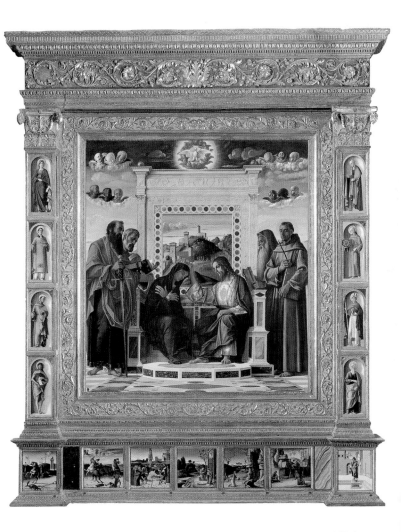

165

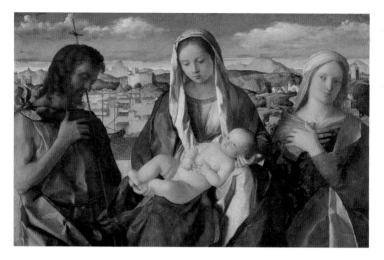

Giovanni Bellini
*The Giovanelli
Holy Conversation*
signed, c. 1504, panel.
Venice, Gallerie
dell'Accademia.

This work from the artist's
last stage (painted when he
was over seventy)
demonstrates his enduring
vitality and capacity for
renewal. A striking
background to the three
monumental figures is
provided by a stupendous
landscape with a city
overlooking the sea at left
and distant mountains

painted in bluish, lighter
tones, almost as if the
painter were applying
the indications given by
Leonardo in his *Book
of Painting*. The painting
takes its name from
Prince Giovanelli, its
last owner.

**Gentile and
Giovanni Bellini**
*Preaching of St Mark
in Alexandria*
1507, canvas, detail.
Milan, Pinacoteca di Brera.

This great canvas, painted for
the Scuola Grande di San
Marco in Venice, is the work
of both Giovanni (or rather
"Zuan" as he was called by the
Venetians in documents) and
his brother Gentile, of whom
it was originally commis-
sioned but who died before
completing it. A wealth of
exotic details enliven the
grandiose theatrical setting.

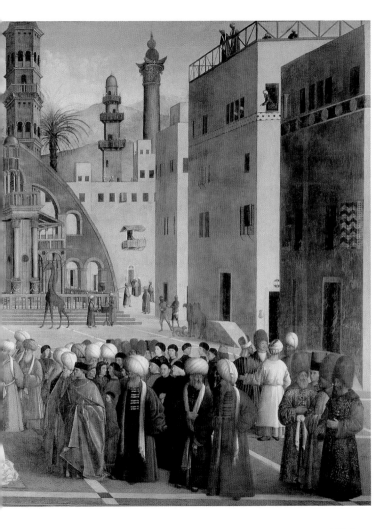

167

VITTORE CARPACCIO

Venice c. 1460 – c. 1525

Giorgio Vasari
Portrait of Vittore Scarpaccia from the *Lives*, Florence, Giunti, 1568.

The career of "Vetor Scarpaza de la Zudecha", as he was called by the Venetians, unfolded mainly in Venice, where he set up his own shop. He is famed chiefly for his talent as perceptive narrator in four important Venetian cycles, the so-called "teleri": the *Stories of St Orsola* (1490-96) for the brotherhood of the same name; the *Stories of Christ and the Dalmatian Saints* for the Scuola di San Giorgio degli Schiavoni (1502-07); the *Cycle of the Scuola degli Albanesi* (1504); the *Stories of St Stephen* for the Scuola dei Lanieri (1511-20). His magical spirit of observation, which Ruskin was one of the first to admire, is expressed in intense portraits, altarpieces, and profane subjects such as the enigmatic *Young Cavalier* (1510, Madrid, Thyssen Foundation) and the so-called *Courtesans* (Venice, Correr Museum), once united to the *Hunt in the Lagoon* (Malibu, Paul Getty Museum).

Carpaccio
Departure of the English Emissaries
signed, 1495-96, canvas.
Venice, Gallerie dell'Accademia.

The traditional narrative tendency of Venetian art, tracing back to the Byzantine mosaics in St Mark's Basilica, reached its culmination in the late 15th century with the *teleri*: vast mural cycles painted on canvas (from the Venetian *telèr*, or canvas). Carpaccio (like the Bellini brothers) evokes an imaginative Venice, swarming with life in sumptuous architectural scenarios. The cycle for the Brotherhood of St Orsola is the first of those painted by him, still very young but already expert in this field, perhaps having collaborated with the older Bellinis. The *Departure* illustrates the outcome of diplomatic negotiations in Brittany for the marriage of the English King's son, Ereus, to Orsola, Princess of Brittany.

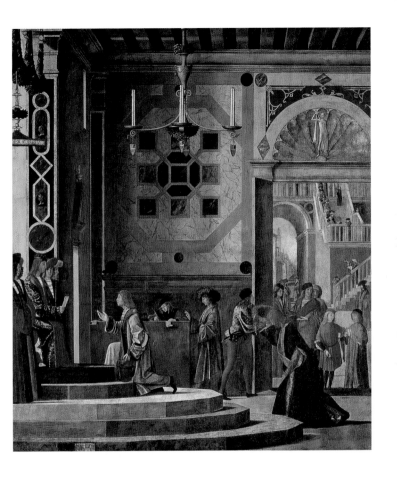

Carpaccio
Return of the English Emissaries
signed, c. 1493-95, canvas.
Venice, Gallerie
dell'Accademia.

For her heroic devotion the martyr Orsola has always captured the popular fantasy. Requested as bride for the pagan son of the powerful King of England, she asked for three years of time to make a pilgrimage to Rome with her companions. But on the return voyage she disembarked at Cologne with Pope Cyriac and was martyred by King Maurus. Carpaccio, for what reason is unknown, painted over a period of time seven "teleri" without following any sequential order of events (the *Arrival at Cologne* is the first of the series, bearing the date 1490 inscribed by Carpaccio himself).

The *Return of the English Emissaries* to the court of the King of England is set in a fully Venetian scenario: on the left, accompanied by a page sounding a trumpet, is seated the "scalco", whose role in Venice was that of introducing ambassadors to the Doge.

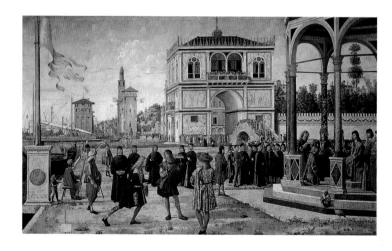

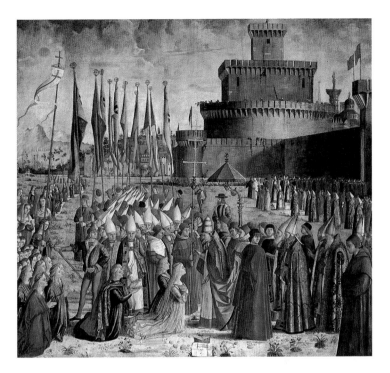

Carpaccio
*Meeting
of the Pilgrims
with the Pope*
signed, after 1493,
canvas.
Venice, Gallerie
dell'Accademia.

The episode, which takes
place against the
background of Castel
Sant'Angelo, is enriched by
contemporary portraits
such as that of the
Humanist philosopher
Ermolao Barbaro who died
in Rome in 1493, depicted
standing behind the Pope.

Invaluable testimony of
a typical scene of Roman
pilgrimage, the canvas
suggests that the Venetian
artist may also have
journeyed to the great city.
As in other "teleri" of the
series, the composition is
marked by a strong
theatrical note.

FILIPPO LIPPI

Florence c. 1406 –
Spoleto 1469

Filippo Lippi
Self-portrait
c. 1439-47, detail of the
Coronation of the Virgin.
Florence, Uffizi Gallery.

Known for his liaison with Lucrezia Buti, who gave birth to their son Filippino, the artist trained as novice in the Carmine Monastery where he copied Masaccio's frescoes, more interested in them than in studying (running away from the monastery, he was imprisoned by the Moors, whom he enchanted with his portraits). Cosimo il Vecchio, his patron, pardoned his transgression with this justification: "Great minds are heavenly forms and not dray-horses for hire". These anecdotes have appealed to romantic authors, but Filippo's role in the transition of art to the mature Renaissance stage is complex and important. Among the first to be influenced by Flemish painting (as shown by the youthful *Madonna of Corneto Tarquinia*, Rome, Palazzo Venezia Museum), he created novel, inventive compositions in imposing altarpieces, many painted for the Medicis. He also worked in Prato and Spoleto, where he died.

Filippo Lippi
Madonna with Child and Two Angels
c. 1465,
panel.
Florence, Uffizi Gallery.

The profile of the Madonna, her hair entwined with precious pearls, may be that of Lucrezia Buti, the nun beloved by the painter. The group stands out from the frame with a delicacy reminiscent of the classical-style reliefs of Donatello and Luca della Robbia (here the angel in the foreground derives from the cherub on an ancient sarcophagus). The background, a painting-within-a-painting, anticipates the expansive landscapes of Leonardo.

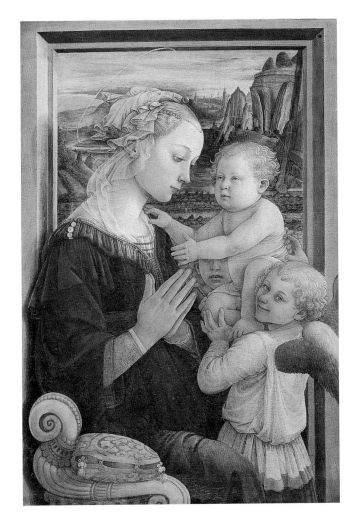

**Filippo Lippi
and Assistance**
*Coronation
of the Virgin*
signed, c. 1439-47,
panel. Florence,
Uffizi Gallery.

A number of "dipintori"
and at least two skilled
carpenters are
documented as having
participated in this work.
The original frame has
been dispersed and a
part of the predella is
in the Berlin Museums.
In 1446 the altarpiece
was moved from the
painter's home to the
Sant'Apollonia
Monastery, where the
blue pigment used to

complete it was kept.
A year later it finally
reached the high altar
of Sant'Ambrogio.
Admiring awe must have
been aroused by the
crowded scene of Mary's
coronation upon her
arrival in heaven, perhaps
alluded to by the intense
blue and azure diagonal
stripes. Standing at the
far left is St Ambrose;
kneeling below him is a
self-portrait of the monk,
gazing idly at the
spectator. In the center is
St Eustachius with his
two children and his wife
Theophista; at right the
donor, Prior Francesco
Maringhi, beside the
words "Is perfecit opus".

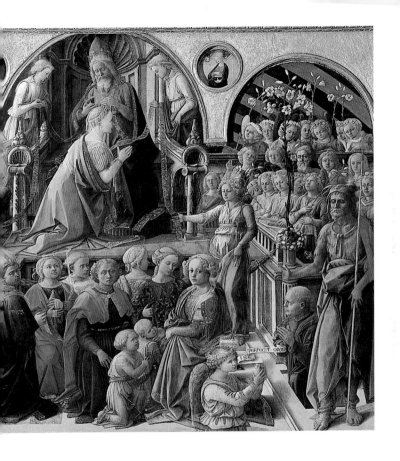

ANTONIO AND PIERO DEL POLLAIOLO

(Antonio Benci)
Florence c. 1435 – Rome 1498;
(Piero Benci)
Florence c. 1441 – Rome 1496

Giorgio Vasari
Portrait of Antonio del Pollaiolo
from the *Lives*, Florence, Giunti, 1568.

In the Florence of the late 15th century the two brothers, sons of a poultry vendor (the origin of their pseudonym), ran a prolific, versatile shop, expert in every artistic technique. In addition to paintings it produced drawings for other painters, sculptors and goldsmiths, as reported by Benvenuto Cellini, and created jewels, fabrics, embroidery, goldwork, bronzes, terracottas and engravings. The brothers' mastery of the use of such varied materials procured them public commissions not only in Florence – where among other things Piero painted the *Virtues* for the Merchants' Guild (1469, Uffizi) and Antonio, a superb goldsmith, executed works in silver for the Opera del Duomo and embroidery patterns for the Baptistery vestments – but also in Rome, where they both collaborated on the Papal tombs of Sixtus IV and Innocent VIII.

Piero del Pollaiolo
Portrait of a Woman
c. 1475, panel.
Florence, Uffizi Gallery.

Against a precious lapis lazuli background the woman is heraldically portrayed in profile, while Botticelli's portraits painted in those same years were already turning to face the spectator. A fine veil covers the woman's ears and elaborate coiffure. The jewel and the embroidered fabric may be inspired by products from the shop of the Pollaiolo brothers themselves, skilled goldsmiths and embroiderers.

176

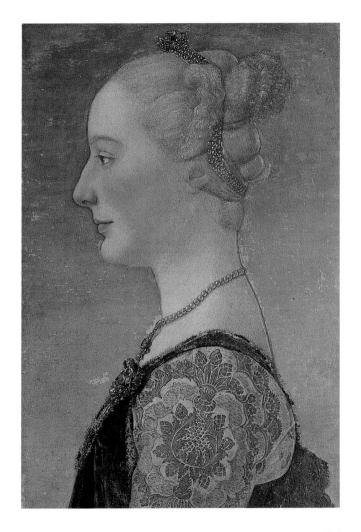

Antonio del Pollaiolo
Hercules and Anteus
c. 1478, bronze. Florence,
Bargello National Museum.

The dynamic impulse of
Anteus' muscular body is
opposed to the tension of his
rival's muscles, equally
powerful and nervous. This
famous small bronze is
exemplary of Antonio's
experimentation with the
jointing of limbs and the
movement of bodies. Vasari
reports that Antonio "had a
more modern understanding of
nudes than any other before
him, and dissected many bodies
to see the underlying anatomy".
The study of cadavers was to
become frequent with
Leonardo and Pontormo.

Antonio and Piero
del Pollaiolo
*Cardinal of Portugal's
Altarpiece*
1466-68, panel.
Florence, Uffizi Gallery.

In 1459 the Cardinal of Lisbon
Jacopo di Lusitania died in
Florence. A chapel in San
Miniato al Monte was
dedicated to him, to be
decorated by the finest artists
of the times – Luca della
Robbia, Alesso Baldovinetti,
and Antonio Rossellino. The
Pollaiolo altarpiece displays a
tendency toward richly varied
composition and refined
details, as in the garments
studded with jewels and the
lovely Flemish-style landscape.
On the hat at the feet of St
James of Compostela, for
whom the deceased Cardinal
was named, is a shell, the
saint's attribute and emblem of
the pilgrims of whom he is the
patron. Restoration has
revealed that the Cardinal's
coat-of-arms appearing at the
center of the frame, gilded and
inlaid by Giuliano da Maiano,
is a real jewel in enameled
bronze.

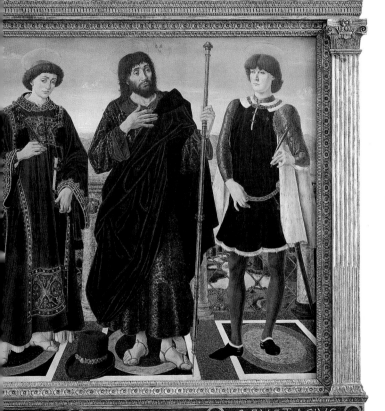

ATVM EST NOSE O MISTERIVM RENGNI DEI

ENTIVS O S IACOBVS AP O S EVSTACIVS

DOMENICO GHIRLANDAIO

(Domenico Bigordi)
Florence 1449 – 1494

Domenico Ghirlandaio
Self-portrait
c. 1483., detail of the
Miracle of the Revived Boy.
Florence, Santa Trinita,
Sassetti Chapel.

Apprenticed to Alesso Baldovinetti (1426-1499) but influenced from the start by Domenico Veneziano, Andrea del Castagno and Verrocchio, Ghirlandaio was an independent artist by 1470, a skillful portraitist and successful fresco painter. The last great narrator among those attentive to Flemish art, his inspiration for landscapes and decorative touches, he interpreted his stories with details from daily life and contemporary portraits. Vasari, who praised the Archangel Michael's armor in the St Justus altarpiece, credited Ghirlandaio with having invented a technique for representing the shine of precious metals not by gilding but by color alone. From 1475 Ghirlandaio headed a shop where his brothers Davide and Benedetto also worked. His most famous cycles are in Santa Maria Novella and Santa Trinita (Florence), in San Gimignano and in the Sistine Chapel.

Domenico Ghirlandaio
Portrait of Giovanna degli Albizzi
c. 1489, panel.
Madrid, Thyssen-Bornemisza Foundation.

The Latin epigraph painted in *trompe-l'oeil* in the background of his most famous portrait, a commemorative profile of Lorenzo Tornabuoni's beautiful wife who died in childbirth in 1488, derives from Martial. The wording is ambiguous: perhaps it is the artist's humble admission that he is unable to render the moral qualities of the woman in painting, or it may allude to his skill: "Oh art, if you could only paint the customs and the soul, no picture on earth would be more beautiful".

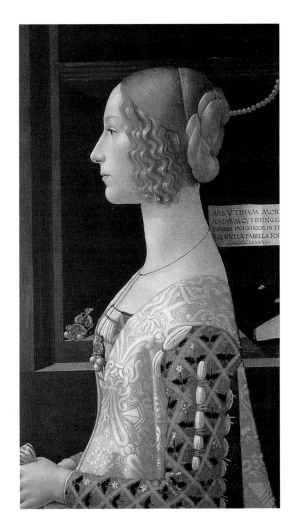

ARS VTINAM MOR
ANIMVM QVE EFFINGE
POSSES PVLCHRIOR IN TE
RIS NVLLA TABELLA FOS
M·CCCC·LXXXVIII·

Domenico Ghirlandaio
Last Supper
1477-80, fresco, detail.
Florence, Monastery
of San Marco, small
refectory.

Ghirlandaio shows
himself a keen observer
of reality in his accurate
representation of the
table-cloth and the objects
on the table.

Domenico Ghirlandaio
*Madonna Enthroned
with Angels and Saints
(Altarpiece of San
Giusto degli Ingesuati)*
c. 1480,
panel.
Florence, Uffizi Gallery.

Against the background of
a crystal clear sky, in a
composition now
consolidated in those
years in Florence, a
balustrade covered in
jewels supports the
enthroned virgin,
surrounded by four
garlanded angels.
The Child is blessing
St Justus, the patron saint
of the Florentine
church from which the
altarpiece comes.
Standing out against the
serene landscape in
the background are
cypresses, a hibiscus and
an orange tree.

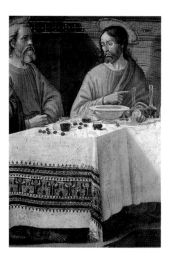

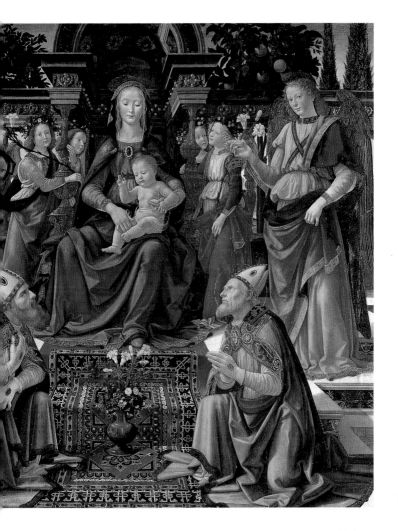

SANDRO BOTTICELLI

(Alessandro
di Mariano Filipepi)
Florence 1445 – 1510

Sandro Botticelli
Self-portrait
c. 1475, detail of the
Adoration of the Magi.
Florence, Uffizi Gallery.

Sandro Botticelli
*Portrait of a Youth
with a Medal*
c. 1470-75, panel.
Florence, Uffizi Gallery.

A beautiful youth, who has
now entered the collective
imagination as one of the
most enigmatic models of
the Renaissance, fixes the
spectator with a vaguely

Various hypotheses have been advanced to explain the pseudonym of Botticelli – son of a leather tanner – who was first apprenticed to a goldsmith, perhaps a certain "Botticello". His brother Antonio was instead a "battigello", or goldbeater, a trade at which Florentine artisans excelled. Sandro, almost twenty, was apprenticed to Filippo Lippi, remaining with him until the painter-monk departed for Spoleto in 1467. The next year he was apprenticed a second time to Verrocchio, and it is then that he produced his first autonomous works such as the *St Ambrose Altarpiece* (Uffizi), still revealing the influence of his two masters. Starting in 1470 Sandro, now independent, worked for private clients and public institutions. In 1475 he began to collaborate with the Medici family, the most powerful family in Florence, for whom he painted his most famous works, now all in the Uffizi, which contains the largest core of his paintings and draw-

melancholy gaze against the background of a landscape inspired by Flemish painting, much admired by the Florentines. The gilded stucco mould portraying the profile of Cosimo the Elder, *Pater Patriae*, accompanied by the wording MAGNVS COSMVS MEDICES PPP, is that of a medal coined in

1464. Since the young man displays the effigy of the founder of the Medici family, it has been thought that he may be a personage close to Medici circles. Another possibility, suggested by the ring he wears on his little finger, is that he may be Sandro's brother Antonio Filipepi, a goldsmith and medallist.

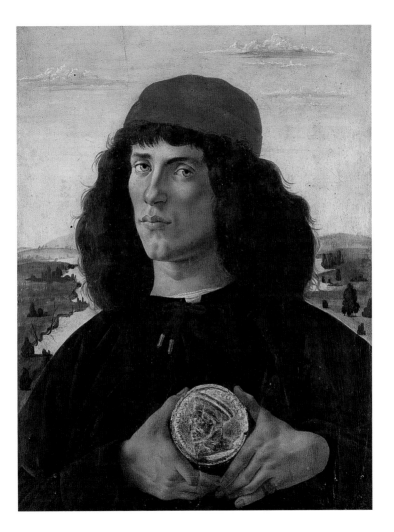

Sandro Botticelli
Pallas and the Centaur
c. 1482-83, canvas.
Florence, Uffizi Gallery.

Lorenzo di Pierfrancesco de' Medici, cousin of Lorenzo the Magnificent, commissioned this canvas, which originally hung above the door of a room in his Florentine palace. The meaning of the painting is highly enigmatic: against the background of an aquatic landscape a centaur stands beside a young woman armed with a lance, who grasps a lock of his mane. Her body is thinly veiled by a light robe adorned with olive wreaths and embroidered with the Medici emblem of interwoven diamonds (from their motto DEO AMANTE, "to God devoted"). Perhaps this is an allegory inspired by the contrast between two natures: Chastity and Lust, or Instinct and Reason, or again, Humility and Pride.

ings. In addition to allegorical subjects such as the *Primavera*, the *Birth of Venus*, *Pallas and the Centaur* are others of religious nature such as the *Adoration of the Magi*, rich in symbolic allusions and portraits of contemporaries. In 1481 he was summoned to Rome by Pope Sixtus IV, where he painted three frescoes for the Sistine Chapel. Returning to Florence the following year, he was now one of the most prominent artists in the gilded city of Lorenzo the Magnificent. But political upheavals leading to the expulsion of the Medici and a personal spiritual crisis influenced by the preaching of Savonarola, of whom he became a follower, wrought changes in his soul and in his art. Sandro withdrew into a depressive, almost hallucinatory reticence, dedicating himself to mystical works already presaged by the imposing *St Mark's Altarpiece* (1490). Then came the *Calumny* (1495, Uffizi), the *Crucifixion* (c. 1497, Cambridge Fogg Museum), the *Mystic Nativity* (1501, London, National Gallery). With the changing taste of the new century, Sandro was to die almost forgotten and in disgrace. Much later, Romantic criticism was to revive the myth of this great master, some of whose creations, namely the *Primavera* and the *Venus*, now arouse the almost fanatical veneration of visitors from all over the world in the Uffizi.

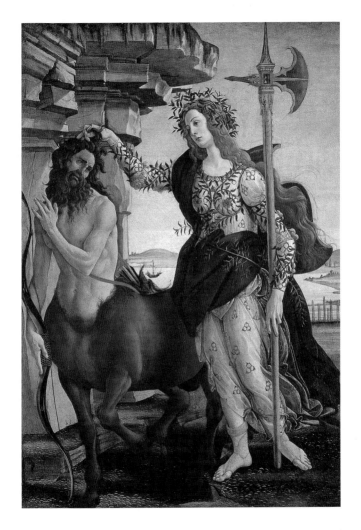

Sandro Botticelli
*Punishment
of the Rebels*
1482, fresco, detail.
Vatican City, Sistine
Chapel.

For the walls of the chapel erected for Pope Sixtus IV della Rovere in 1481, Botticelli frescoed three Biblical episodes: *Moses and the Daughters of Jethro*, the *Trials of Christ* and the *Chastisement of Chore*. At the same time three more famous artists, two of them Florentines, were working on the cycle of frescoes in the chapel – Pietro Perugino, Domenico Ghirlandaio and Cosimo Rosselli. But the ambitious undertaking (which, with obviously self-laudatory intentions, called for the illustration of ten episodes from the Old and the New Testament), could not be finished within the date set, March 15, 1482, also due to the well-known tendency of this Pope to leave his debts unpaid. Sixtus IV, one of the greatest theologians of his time, was particularly drawn to the philosophy of

St Augustine, on which he based an esoteric interpretation of the Scriptures with comparison and symbolic links between the Old and the New Testament. The decorative scheme of the frescoes in the chapel is thus based on this theme. Even the architecture of the chapel is conceived according to the proportions of Solomon's Temple, with which the Pope wished to establish an ideal link. The Sistine Chapel, as stated by wording in Perugino's famous fresco of the *Consignment of the Keys*, is less magnificent than Solomon's Temple but is superior to it in religion and spirituality. Botticelli's fresco shown here, which faces Perugino's *Consignment of the Keys*, depicts the Biblical episode of the punishment of Chore, Datan and Abiron, rebels against Moses and Aaron, who had been invested with the authority of God the Father. While in Perugino's painting the prestige of the Pope designated by Christ is symbolized by the Church

Triumphant, here instead the buildings are in ruins to signify the inferiority of the Old Testament. The fresco may also allude to the attempt made in 1481 to convene a council against the Pope by the Archbishop of Cranea, a "rebel" like Chore, Datan and Abiron.

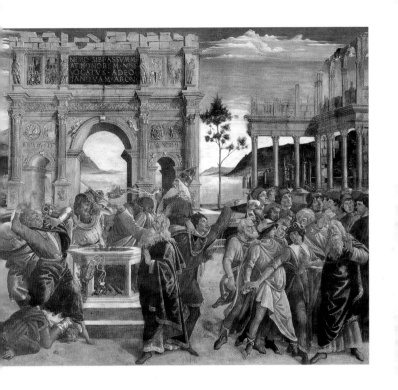

Sandro Botticelli
Primavera (Spring)
c. 1482,
panel.
Florence, Uffizi Gallery.

In 1498 this famous painting, among the highest expressions of the ideal return of the golden age to Lorenzo's Florence, hung above a chest in the home of Lorenzo and Giovanni di Pierfrancesco de' Medici, cousins of the Magnificent. The allegory seems to have been inspired by Ovid and Lucretius, and by certain verses of Agnolo Poliziano (1475), friend of the Medici and of the artist, who describes a garden with the three Graces garlanded with flowers and the springtime breeze Zephyrus, recognizable here in the winged genie on the right who pursues and possesses the nymph Chloris, bestowing on her the power to germinate flowers (blossoms are falling from her mouth). The smiling figure clothed in flowered robes probably represents the transformation of Chloris into Flora, the Latin goddess of Spring, while the woman at the center is possibly Venus, and this is her garden. The three women weaving a dance around her, derived from the ancient image of the Three Graces, may be the symbol of Liberality. Above is Cupid, the blindfolded god of Love, and at the left Mercury, the herald of Jove, scattering the clouds with his stick. The allegory of Spring, the season in which the invisible world of Forms descends to shape matter, may allude to the marriage between the erudite Lorenzo di Pierfrancesco, friend of Botticelli, and Sermaide Appiani, a relative of Simonetta Vespucci, legendary for her beauty and for her presumed liaison with Giuliano de' Medici. A more recent interpretation sees the painting as a metaphorical celebration of the Liberal Arts, to be read in a nuptial key.

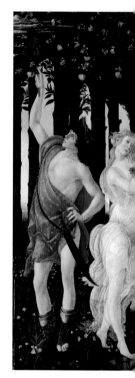

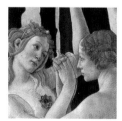

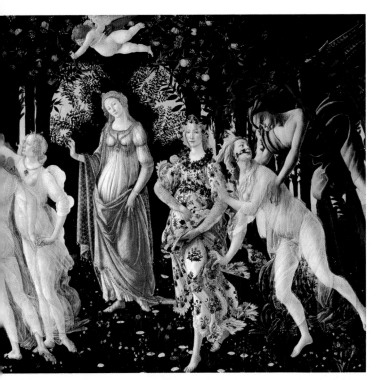

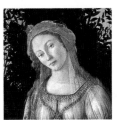

Sandro Botticelli
The Birth of Venus
c. 1484,
linen.
Florence, Uffizi Gallery.

While roses drop from the sky, in an idealized seascape the nude Venus, standing on a seashell, lands – rather than being born, as indicated by the 19th century title – on the shore of the Island of Cyprus (or perhaps Kythera), borne over the waves by the breath of the winds Zephyrus and Auras. A young girl, perhaps one of the Graces or the Hora of Spring, welcomes her with a richly embroidered mantle. While the figures on the left may be taken from the *Tazza Farnese*, then in Lorenzo the Magnificent's gem collection (Naples, Archaeological Museum), the pose of Venus is inspired by the ancient sculpture of the *Chaste Venus*, copied in the past by Giovanni Pisano. Like the *Primavera*, the canvas bears witness to the most serene and graceful phase of Botticelli's art. The neo-Platonic atmosphere of Lorenzo's age is reflected here in the probable allusion to the fusion of Spirit and Matter, of Idea and Nature.

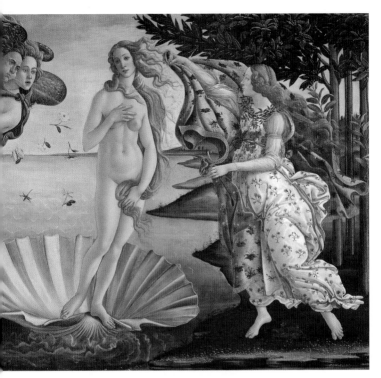

PIETRO PERUGINO

(Pietro Vannucci)
Città della Pieve (Arezzo)
1450 – Perugia 1523

Giorgio Vasari
Portrait of Pietro Perugino
from the *Lives*, Florence,
Giunti, 1568.

Perugia, near which the artist was born, gave him his pseudonym. His art was soon copied, "so popular in its time that many came from France, Spain, England and other provinces to learn it", reports Vasari, noting that "many traded in his paintings... before the appearance of Michelangelo's style". But Vasari's comments are harsh: the artist was venial, "of little religion", skeptical and stubborn, with a "rock-hard brain". His painting, after having inspired neo-classics and romantics, has been recognized only in the early 20th century as innovative, harmonious and monumental. After training at Florence, where he returned to work several times, he ran two shops contemporaneously, in Florence and Perugia, working also in Venice, Milan, Rome, where in 1481-83 his fine frescoes on the walls of the Sistine Chapel included the famous *Consignment of the Keys*.

Pietro Perugino
Pietà
c. 1490, panel.
Florence, Uffizi
Gallery.

The altarpiece of the Florentine church of the Ingesuati is imbued with intense spirituality, perhaps inspired by the sermons of Gerolamo Savonarola, who arrived in Florence in 1489. Framed by a harmonious portico with arches degrading toward the almost infinite space of a landscape barely visible in the distance, the Madonna holds on her lap the rigid, ashen body of Christ, supported by John the Evangelist: "a dead Christ all stiffened as if He had been hanging on a cross so long that time and cold had reduced Him to such a state", notes Vasari.

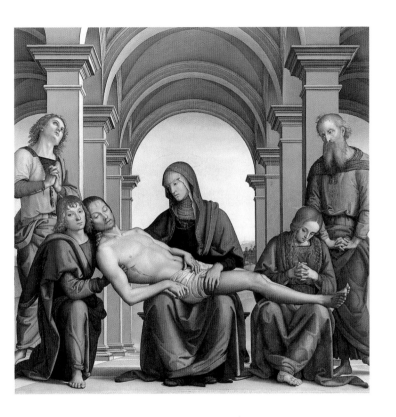

Pietro Perugino
Last Supper
c. 1485-90,
fresco, detail.
Florence, Cenacolo di
Foligno.

Painted for the Florentine
monastery of an erudite,
aristocratic group of
Franciscan Tertiaries
whose mother house was
the Monastery of
Sant'Anna di Foligno, the
frescoes of the *Last Supper*
are exemplary of
Perugino's balanced
composition, combining

a monumental conception
of the whole with great
delicacy in each part. It is
understandable that he
continued to use these
figures, so well conceived
and painted, a fact Giorgio
Vasari was not to pardon
him in the 16th century:
"he had such an
abundance of paintings to
complete that he often
placed the same details
in his figures, and reduced
the theory of his craft to
such a fixed style that he
gave them all the same
expression".

Pietro Perugino
*Portrait of Francesco
delle Opere*
signed and dated
on the back, 1494, panel.
Florence, Uffizi Gallery.

The subject of the portrait,
Francesco delle Opere,
whose name is written on
the back of the panel, was a
Florentine artisan who
died in Venice in 1496, the
brother of a friend of the
painter, Giovanni delle
Corniole, like him a master
gem cutter and a friend of
Perugino. The scroll which
the man holds in his hand,
bearing the words TIMETE
DEVM, alludes to the
incipit of a prayer
by Savonarola.
The "photographic"
precision of the features,
the position of the figure
with its hand leaning on
the balustrade, and the
landscape in the
background are clearly
inspired by Flemish art,
particularly by Memling's
portraits which were
already known in Florence.

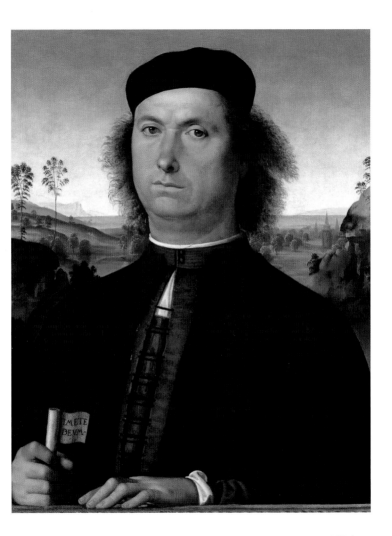

PINTURICCHIO

(Bernardino di Betto)
Perugia c. 1454 – Siena 1513

Pinturicchio
Presumed Self-portrait
1505, detail of the
Canonization
of St Catherine.
Siena, Duomo,
Piccolomini Library.

A pupil of his fellow citizen Bartolomeo Caporali (1420-1506), Pinturicchio then assisted Perugino, with whom he worked on the *Stories of San Bernardino* (1473, Perugia, Galleria Nazionale) and the Sistine Chapel in Rome. He is famous for the frescoes in the Piccolomini Library in Siena, a profane cycle among the most important of the times, where among magnificent vedutas he displays his talent as pleasant narrator. The frescoes depict stories of Pope Pius II, a humanist and accomplished diplomat. Pinturicchio also worked, with many assistants, on other important projects: in Rome, on Ara Coeli and Santa Maria del Popolo, as well as the della Rovere palace and the Borgia Apartments (1492-94); in Spoleto on the Eroli Chapel in the Duomo.

Pinturicchio
Enea Silvio Piccolomini
presents Eleonora of
Portugal to Frederich III
1505, fresco.
Siena, Duomo,
Piccolomini Library.

In 1492 Cardinal Francesco Todeschini Piccolomini, later Pope Pius III, decided to honor his maternal uncle Enea Silvio with a library that would house the exceptional collection of the great Humanist Pope. In the old presbytery annexed to the Duomo the frescoes were painted by Pinturrichio alone starting in 1505.

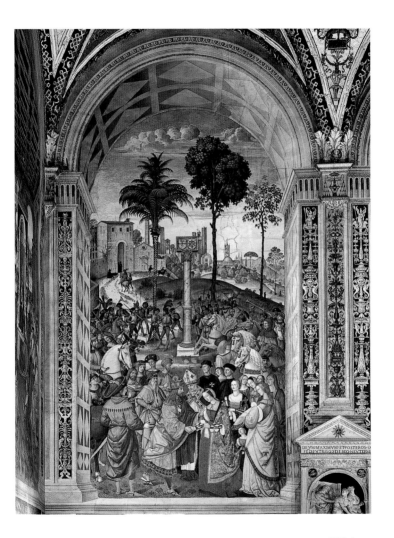

199

LUCA SIGNORELLI

Cortona (Arezzo) c. 1445 – 1523

Giorgio Vasari
Portrait of Luca Signorelli
from the *Lives*, Florence,
Giunti, 1568.

Luca Signorelli
Martyrdom of St Sebastian
1498, panel, detail.
Città di Castello, Pinacoteca
Nazionale.

Painted for the Church
of San Domenico in Città
di Castello, in 1832 the panel
still bore the date and names,
later lost, of the patrons,
Tommaso and Francesca de'
Brozzi. The dynamic poses of
the two archers standing at
the feet of the martyred saint

A painter endowed with "ingenuity and a pilgrim spirit", according to the *Chronicles* (1470-80) of Santi, Raphael's father, he was one of the finest artists of the whole century (not by chance, his figures were copied by Raphael himself). In the evolutionist theory of Vasari, who saw Michelangelo as the peak of artistic perfection, Signorelli's style was deemed a crucially important precedent, a judgement that was to favor the critical fortunes of the master from Cortona. His works, painted during a long career in central Italy, show a skillful blending of different elements: the linear drawing of Florence, the luminist effects of Piero della Francesca, and the dynamism of bodies, always depicted with great mathematical precision.

were admired and copied
by Raphael (drawings at
Lille and Oxford).

Luca Signorelli
The Blessed
1499-1502, fresco, detail.
Orvieto, Duomo,
San Brizio Chapel.

Signorelli's masterpiece in
fresco, the famous cycle of
Orvieto, with *Stories of the
Anti-Christ*, *Resurrection of
the Flesh*, *The Damned*,
The Blessed, *Paradise* and
Inferno, reveals in its
numerous nudes masterful
studies from life.

FILIPPINO LIPPI

Prato c. 1457 – Florence 1504

Filippino Lippi
Self-portrait
c. 1485, detail of the
Crucifixion of St Peter.
Florence, Santa Maria del
Carmine, Brancacci
Chapel.

The son of Fra Filippo and the nun Lucrezia Buti, in Spoleto as a boy with his father, at the latter's death he assisted Fra Diamante in finishing the frescoes in the Duomo. From 1472 in Florence he was "dipintore with Sandro Botticello", a former pupil of Filippo's, in a fruitful alliance lasting ten years. Becoming independent, he was assigned important projects such as the frescoes in the Brancacci Chapel. For powerful patrons he painted works of capital importance for the art of the times, such as the *Vision of St Bernard* for Francesco del Pugliese (now in the Badia Fiorentina) and the great altarpiece for the Council Hall in Palazzo Vecchio (Uffizi), paid 1,200 lire at the decree of the Magnificent. Thanks to Lorenzo, he frescoed the Carafa Chapel in Rome, dense in classical allusions. In 1502 he completed for the Strozzi the frescoes in Santa Maria Novella, now displaying the symptoms of the new century's disquiet.

Filippino Lippi
Vision of St Bernard
c. 1485.
panel, detail.
Florence, Badia
Fiorentina.

In one of his intense religious paintings, Filippino left the finest example of the analytic taste, derived from Flemish art, characteristic of Florentine painting in those years. Many artists were strongly influenced by the arrival in Florence in 1483 of the grandiose Flemish triptych *The Adoration of the Shepherds* (Florence, Uffizi), painted at Bruges in about 1478 by Hugo van der Goes. The work was placed above the high altar of the Church of Sant'Egidio, and Filippino must have studied it attentively.

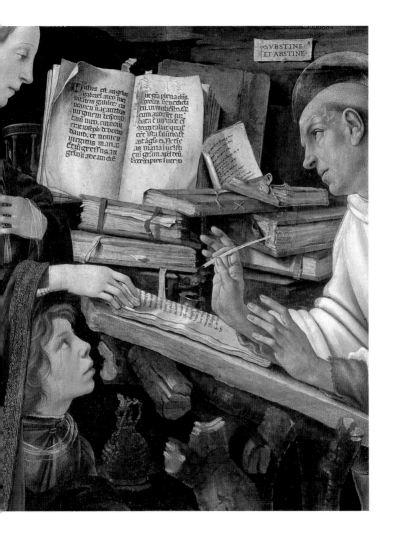

Filippino Lippi
Triumph of
St Thomas of Aquinas
c. 1492, fresco, detail.
Rome, Santa Maria sopra
Minerva, Carafa Chapel.

Requested for the chapel of
the Neapolitan Cardinal
Olivieri Carafa, friend of the
Magnificent, the frescoes cost
2,000 gold ducats "without
counting the blues and the
shop boys". Filippino
decorated the ceiling with
Sibyls, and the walls with the
Triumph and Calling of
Thomas, *Assumption of the*
Virgin and *Annunciation*.
There are many
contemporary portraits and
views of a vanished Rome,
such as the Dogana of Ripa
Grande, landing place of
pilgrims and merchants.

Filippino Lippi
Nerli Altarpiece
c. 1494, panel.
Florence, Santo Spirito.

The wealthy politician Tanai
Nerli appears in the
foreground at the feet of
St Martin, facing his wife
who kneels below St
Catherine of Alexandria.
In the background, in the
lively neighborhood of San
Frediano, Tanai can be seen
beside his horse, on the
threshold of his palace in
Borgo San Jacopo, embracing
his daughter Caterina
(alluded to by the saint in the
foreground). The rich frame,
inlaid and gilded, is now
attributed to the woodworker
Chimenti del Tasso, who
collaborated in those years
with the Da Maiano shop.

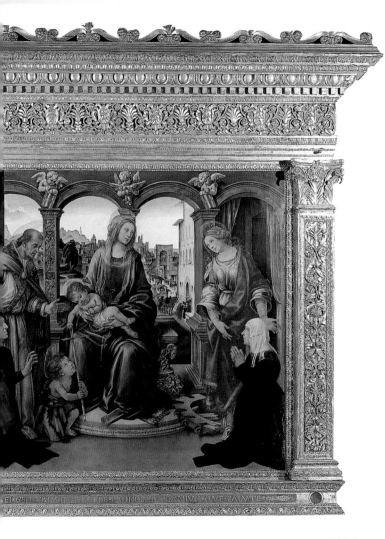

LUCA DELLA ROBBIA

(Luca di Simone)
Florence c. 1399 – 1482

Giorgio Vasari
*Portrait of Luca
della Robbia*
from the *Lives*, Florence,
Giunti, 1568.

The fame of Luca, deemed one of the century's greatest artists by Alberti, is linked to the invention of glazed terra-cotta: "a new art", says Vasari, "useful and beautiful", which could be used for the decoration "with beauty and without great expense of any damp, aquatic place" and which in sculpture rendered figures glossy and resistant. Trained also as goldsmith, Luca collaborated with Donatello on Ghiberti's *Doors of Paradise*. His classicizing style, already apparent in the marble *Choir*, developed through friendship with Brunelleschi, Nanni di Banco and the learned humanist Niccolò Niccoli. In the early 1420s Luca abandoned marble for his new technique, launching a prolific shop continued by his grandson Andrea, Giovanni's third child, and then by other members of the family.

Luca della Robbia
Choir
1431-38, marble, detail.
Florence, Museo dell'Opera
del Duomo.

The two great "masters of carving" of the times, Luca and Donatello, found themselves almost competing in the important choirs commissioned by the Opera del Duomo of Florence. The two works, now displayed in the same room in the museum, clearly reveal the different styles of their makers. Luca chose a classicizing model with panels framed by architectural elements, while Donatello conceived a single scene as if set within a portico. The wild dance, the panic throng of Donatello's children, although "rough-hewn and not finished" as noted by Antonio Billi in about 1530, is "more striking" when seen from below, "than the figures of Luca". Today Luca's revival of classicism is acknowledged to be more homogeneous and typical than the innovative, transgressive vision of Donatello.

VERROCCHIO

(Andrea di Francesco
di Cione)
Florence 1435 – Venice 1488

Giorgio Vasari
Portrait of Verrocchio
1568, from the *Lives*,
Florence, Giunti.

Andrea, who took his pseudonym from the goldsmith Giuliano Verrocchi to whom he was apprenticed, often infringed the law. As a youth he killed a worker in the street with a stone, perhaps by accident, and later was accused of illicit relations with his shop boys, among them Leonardo (whose delicate 13-year-old features he may have incarnated in the Bargello's bronze *David*, 1465), and the beloved Lorenzo di Credi, named his heir. "Goldsmith, perspective artist, sculptor, engraver, painter and musician", as Vasari reports, he headed an eclectic shop rivaled only by that of the Pollaiolos. Many youths who were to become famous, not Florentines alone, trained with him at the turn of the century – Perugino as well as Leonardo and Lorenzo di Credi. In addition to his works in Florence and Pistoia is the monument to Colleoni in Venice, left unfinished in 1488.

Verrocchio
*Lady with
a Bouquet*
c. 1475, marble.
Florence, Bargello
Museum.

The identification of the smooth, polished sculpture of a lady, one of the most highly admired marble busts, is still today mysterious. It has been hypothesized that the subject is Lucrezia Donati, the legendary Platonic love of Lorenzo the Magnificent, who kept a portrait of her in his bedchamber; and even that she is Ginevra de' Benci, also portrayed by Leonardo in about 1475. It may really be the young Leonardo, as is still sometimes suggested, who carved the delicate hands with their long tapering fingers holding the bouquet of wild roses, or perhaps primulas.

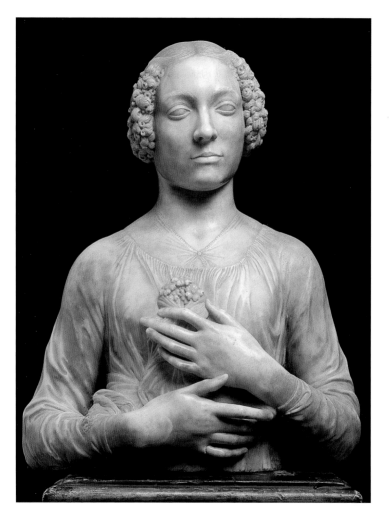

LEONARDO DA VINCI

Vinci 1452 – Amboise 1519

Leonardo da Vinci
Self-portrait, after 1515.
Turin, Biblioteca Reale.

For the most famous, fascinating artist/scientist of all time it is impossible to avoid the cliché of "universal genius": tireless investigator of nature, anatomy, science and technology, philosopher and poet, although calling himself a "man without letters", Leonardo incarnates the highest ideals of Renaissance man. A free spirit, he was seemingly indifferent to the political situations around him but sensitive to the horrors of violence, despite his studies of war machines, and more interested in planning revolutionary projects than in carrying them out. For this reason he has left an impressive number of drawings but few finished works, as noted already by his contemporaries. His life was spent between Florence, Laurentian and then Republican, and the Milan of the Sforza lords; then Venice, Emilia (with Cesare Borgia), Pavia and Rome, and lastly the France of Francis I.

Verrocchio, Leonardo and other artists
The Baptism of Christ
variously dated between 1473 and 1478, panel.
Florence, Uffizi Gallery.

This is the most telling example of the vitality of Verrocchio's shop. According to Vasari the artist gave up painting "offended that a young boy [Leonardo] knew more than he". The angel on the left and the background have been traditionally attributed to Leonardo, but stylistic differences are even more evident since the restoration of 1998, which has also revealed the detail of the ducks in the water behind the Baptist's elbow. Now it is clear that the dry style of the palm tree and the rocky outcrop behind the Baptist, as well as his own figure, can be attributed neither to Verrocchio nor to Leonardo, whose mountains fade softly into the distance. It now seems that not only apprentices but at least one other great artist, perhaps Botticelli for the angel on the right, must have worked on the painting.

Leonardo da Vinci
*Study of church
with circular plan*
1487-90, paper.
Paris, Library
of the Institut de France,
Manuscript B, c. 95 r.

*Study of two plants
for the Leda*
c. 1508-10,
paper. Windsor,
Royal Library, c. 23 r.

Homo Vitruvianus
c. 1490, paper.
Venice, Gallerie
dell'Accademia.

Three examples of
Leonardo's enormous
graphic production: the
famous study of
proportions with the
human figure inscribed in
a circle and in a square; a
testimony to the many
architectural projects
never carried out, and
a study from life for the
Leda painting, lost but
known through copies by
various artists, among
them the Lombard Cesare
da Sesto (1477-1523) and
the Sienese Sodoma
(1477-1529).

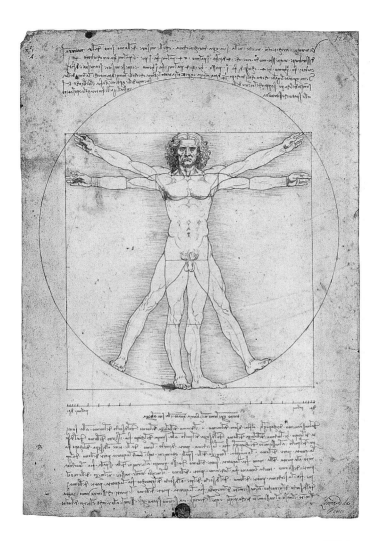

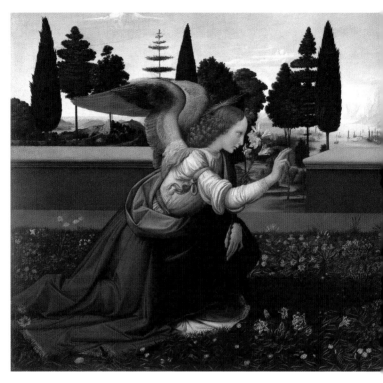

Leonardo
Annunciation
c. 1475-80, panel.
Florence, Uffizi Gallery.

New hypotheses for the reading of this painting have been stimulated by its restoration, completed in March 2000, which has revealed not only its luminosity and clarity of detail but a stronger sense of perspective in the architectural foreshortening on the right (the door, of which both doorjambs can now be seen, gives a clearer glimpse of the baldachin in the room). Still controversial is the dating of the work painted in Florence for the Church of San Bartolomeo a Oliveto. Hypotheses range from the early 1460s, when the artist was only a little over twenty, almost up to the beginning of the next decade. In some details the influence of Verroc-

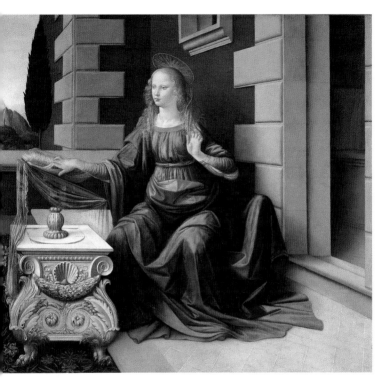

chio, or perhaps Leonardo's homage to his master, can be recognized (especially in the base supporting the lectern, reminiscent of the Sepulcher of Giovanni and Piero de' Medici in San Lorenzo). The Virgin's arm seems disproportionately elongated, un-able to reach the book on the lectern, and the angel's shadow is too dark for the light of dawn, which restoration has shown to be the hour chosen by Leonardo as the setting, perhaps with symbolic overtones, for the Annunciation. The meadow is sprinkled with a myriad of flowers studied from life; in the beautiful landscape, typical Tuscan cypresses trail off into the distance where the minute details of a lake-side city blend into the bluish tones of the bare mountains in the background.

Leonardo da Vinci
The Last Supper
1495-98, fresco.
Milan, refectory
of Santa Maria
delle Grazie.

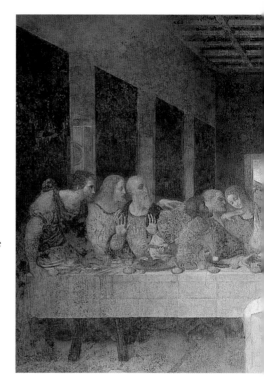

Completed by 1498, as shown by the dedicatory letter to Ludovico il Moro, Duke of Milan, in the *De divina proportione* by the mathematician Luca Pacioli, nothing is known of the commissioner of the fresco, for which Leonardo adopted such an unsuitable technique that he himself was obliged to restore it soon afterward. Retouched many times over the centuries, it was now almost illegible when the American writer Henry James visited it in 1869, describing it as "the shadow of a shadow", "the saddest and the greatest masterpiece". Restoration having been completed in 1999 after decades of work, *The Last Supper*, although difficult to read, shows in the apostles' faces a careful, specific study of physiognomy, aimed at defining on the one hand the "permanent" and scientific traits based on the artist's incessant anatomical research, and on the other the temporary passions, the so-called "mental motions". It has recently been observed by Carlo Pedretti that Christ's shadow resembles that of Leonardo himself, as it appears in one of his drawings.

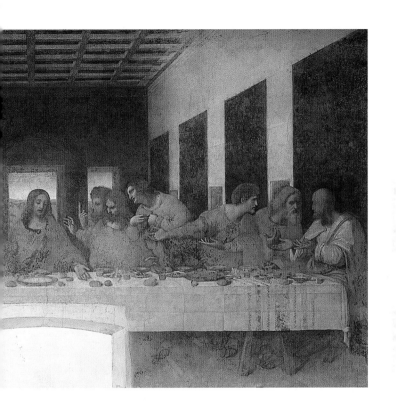

Leonardo da Vinci
The Lady with an Ermine
c. 1488-90, panel. Crakow,
Czartoryski Muzeum.

This is probably a painting
of Cecilia Gallerani, the fa-
vorite of Ludovico Sforza,
later married to Count
Bergamini. The ermine, in
Greek *galè*, may allude to
her name. If so, this would
be the portrait of Cecilia

painted "at such an imper-
fect age", sent to Isabella
d'Este Duchess of Mantua
in 1498 to allow her to com-
pare it with portraits by the
Venetian artist Giovanni
Bellini. The dating of this
famous "shoulder portrait"
can be deduced also from a
sonnet describing it by the
Florentine poet Bernardo
Bellincioni.

Leonardo da Vinci
Portrait of a Lady
(La Gioconda or Mona Lisa)
1506/10 or 1513/16,
panel. Paris, Louvre.

"The literature on the *Mona
Lisa* is boundless, like her
fame. For a century now she
has offered only two ele-
ments easy to grasp: the exal-
tation of sentiment or sar-
casm, effusion or derision.
Under the name of the 'Gio-
conda myth' the strange situ-
ation of 'the most famous
painting in the world' has led
to various attempts to classi-
fy the fantasies, fables, and
derision of which the paint-
ing has never ceased – and
will never cease – to be the
subject". Thus Chastel com-
ments on the "illustrious un-
known", as he calls her, in the
book dedicated to the for-
tunes (or misfortunes) of
Mona Lisa, who from Corot's
re-evocation to Duchamp's
ready-made has arrived at
our own times drinking
through a straw, slyly wink-
ing and running away naked
to kiss the nearest portrait.
Such is the fascination of this
masterpiece, whose many
unsolved mysteries add to its
enchantment.

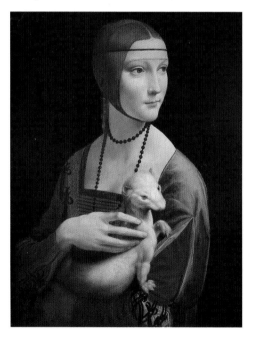

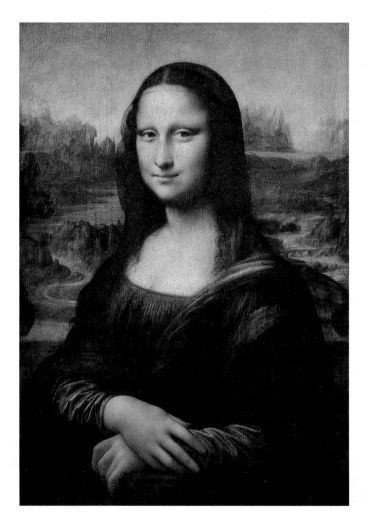

Piero di Cosimo

(Piero di Lorenzo
di Chimenti)
Florence c. 1461 – 1522

Giorgio Vasari
Portrait of Piero di Cosimo
from the *Lives*, Florence,
Giunti, 1568.

In 1480 apprenticed to the shop of Cosimo Rosselli (1439-1507) from whom he took his nickname, Piero was called by Vasari "distracted and deformed intellect", perhaps for his indifference to official circles. Today he has been reevaluated as "highest example of that line which carried down to the early 16th century the authentic spirit of the Founding Fathers [of the Renaissance], renewing it with touches of vivacious, profound lyricism", as noted by Federico Zeri. He collaborated with Cosimo Rosselli in frescoing the walls of the Sistine Chapel, but soon left his master, more attracted, like Filippino Lippi, to northern influences. Although he approached the new language of Leonardo and Raphael in his last stage, his style remained autonomous, marked by a fantastic reelaboration of landscapes and physiognomies.

Piero di Cosimo
Vulcan and Aeolus
c. 1485-90, canvas.
Ottawa, National Gallery
of Canada.

The painting probably forms part of the cycle dedicated to the *Stories of Vulcan*, requested for his bedchamber by the Florentine Francesco del Pugliese, who also commissioned works from Filippino Lippi in those years. An eccentric politician, Francesco had a magnificent home adorned with works of art. A passage from Vitruvius describing the birth of human civilization seems to have inspired the cycle: "Men, like wild animals, were born in the forest, in the woods and in caves, and fed on wild foods" (*De architectura*, II, 1).

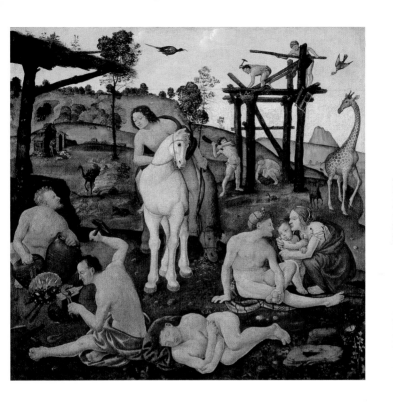

RAPHAEL

(Raffaello Sanzio)
Urbino 1483 – Rome 1520

Raphael
Self-portrait
c. 1506. Florence,
Uffizi Gallery.

The personality of Raphael, more famous as painter than as architect although equally important in the latter field, seems in many aspects an antithesis to that of Michelangelo, only slightly older but active much longer: the one extroverted and friend of the powerful, lover of company, surrounded by a flock of followers and admirers; the other solitary and disdainful of power, reluctant to have pupils around him. Raphael exemplified the Renaissance figure of court artist at its highest, while Michelangelo rarely allowed any interference in his projects. The careers of both, however, broke the boundaries of the traditional 15th century workshop system. Raphael, son of the painter Giovanni Santi, was already working independently in Urbino while still very young. In about 1500 he collaborated with Perugino and four years later, with a letter of presentation to the Gon-

Raphael
Transport of Christ
(The Borghese Deposition)
signed and dated 1507,
panel.
Rome, Galleria Borghese.

The altarpiece was commissioned for the family chapel in the Church of San Francesco at Perugia by Atalanta Baglioni, the mother of Grifone, assassinated in 1500 in a tragic feud between Perugian families. The sacred subject clearly refers to the dramatic end of the young man, who at death's door had pardoned his assassins at the desire of his mother. While the strongly rhythmic composition derives from an ancient sarcophagus portraying the *Death of Meleager*, one of the women supporting the fainting mother is clearly inspired by the pose of the Madonna in the *Doni Tondo*, just painted by Michelangelo.

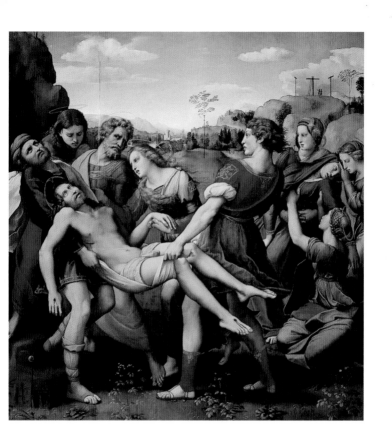

Raphael
The Veiled Lady
c. 1513, panel.
Florence, Palatine
Gallery.

The virtuoso masterpiece
of the mature Raphael,
painted after the frescoing
of the Vatican Stanze,
has gone down in history
for the magnificent silk
sleeve comparable only to
those magically produced
by the brush of Titian.

faloniere of the Republic Soderini, he arrived in Florence at a crucial moment: for some months Leonardo and Michelangelo had been preparing the cartoons for the frescoes of the Battles of Anghiari and of Cascina that were to be painted in Palazzo Vecchio (Leonardo's was lost before being finished, Michelangelo's was never executed). The young Raphael studied those cartoons, called "the school of the world" by Benvenuto Cellini. He frequented various shops and painters such as Ridolfo del Ghirlandaio (1483-1561); received commissions, although not public ones, from wealthy families such as the Doni, also patrons of Michelangelo, and the Nasi (*Madonna of the Goldfinch*, c. 1506, Uffizi). Called to Rome by Julius II to fresco the rooms of his apartment in the Vatican (originally the Pope's "secret library"), he began in 1508 with the Stanza della Segnatura, continuing with that of Heliodorus (1511-13). During this time Raphael painted numerous portraits, altarpieces and frescoes. Only under Pope Leo X, and especially after the death of his rival Bramante in 1514, did Raphael dedicate himself to architecture, leaving many painting commissions to his pupils and becoming the official architect of the Fabric of St Peter's. He died at the age of only thirty-seven.

Raphael
The Madonna
of the Chair
c. 1513-16, panel.
Florence,
Palatine Gallery.

The tondo, greatly
loved and copied
innumerable times
by other artists,
was painted in Rome,
perhaps for Pope Leo X.

Within the circular
form the three figures
are masterfully
portrayed in a
composition of
monumental beauty.

Raphael
La Fornarina
signed, c. 1518-19,
panel.
Rome, Galleria Nazionale
d'Arte Antica, Palazzo
Barberini.

The painting, on which
Giulio Romano may have
collaborated, traditionally
represents the mythical
woman loved by Raphael
in Rome, although this is
not confirmed by any
documentation. More
probably she is a
courtesan.

Raphael
*The Triumph
of Galatea*
1512, fresco.
Rome, Villa Farnesina.

The fresco, painted for
the Sienese banker
Agostino Chigi for his
Roman villa at Lungara,
alludes to verses in
Poliziano's *Stanze* (118, I)
which describe Galatea and
her companions passing
before Polyphemus: a Neo-
platonic re-elaboration of
the myth according to
which the young woman
is looking toward divine
Love and the others,
pierced by arrows, toward
sensual love.

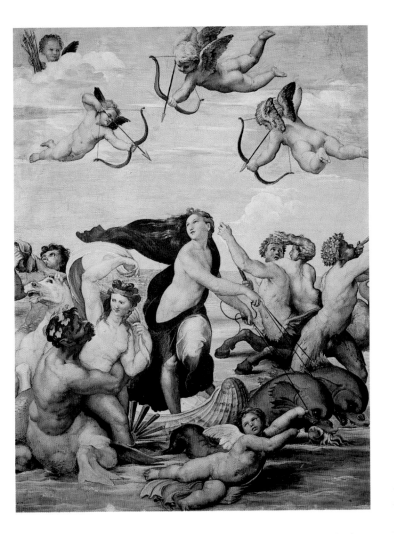

Raphael
*Leo X with Cardinals
Giulio de' Medici
and Luigi de' Rossi*
1518, panel.
Florence, Uffizi Gallery.

The portrait of Pope Leo X, in the world Giovanni de' Medici (1475-1521), elected Pope in 1513, arrived in Florence from Rome in 1518. The painting was to be exalted by Vasari for the figures "not false, but in rounded relief", for the damask gown "which gleams and shimmers", for the skins of the lining "soft and living", for the glossy knob that reflects "the light from the windows, the Pope's shoulders, and the interiors of the rooms".

Restoration in 1996, which has brought out the different tones of red and the extraordinary luminosity of the work, has also led to new hypotheses concerning the two Cardinals, who seem to have been added later by another hand (it has been suggested that they are the work of Sebastiano del Piombo).

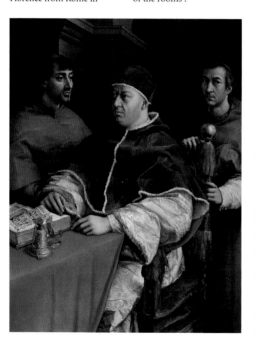

Raphael
School of Athens
1510, fresco, detail.
Rome, Vatican Palaces, Stanza della Segnatura.

In the vast rectangular hall of the Segnatura, entirely decorated by Raphael, including the ceilings (apart from the eight scenes already painted by Sodoma), the great *School of Athens* represents the culminating point of the structural harmony and compositional clarity achieved by the artist.

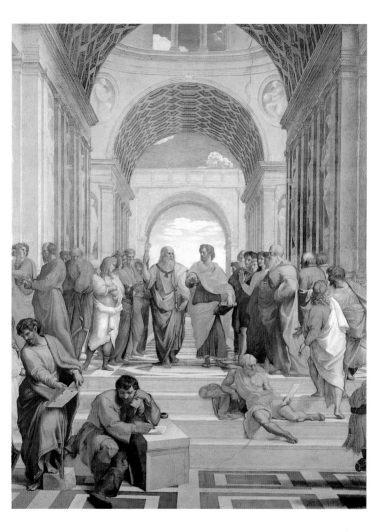

MICHELANGELO

(Michelangelo Buonarroti)
Caprese (Arezzo) 1475 –
Rome 1564

Michelangelo
*Presumed Self-portrait
as Nicodemus,* 1550-55,
detail of the *Bandini Pietà.*
Florence, Museo
dell'Opera del Duomo.

Michelangelo
*Holy Family with
the Infant St John
(Doni Tondo)*
c. 1506-1508,
panel (inlaid and gilded
coeval frame, attr. to Marco
and Francesco del Tasso).
Florence, Uffizi Gallery.

"I say that painting may be considered better the more it approaches relief, and relief may be considered worse the more it approaches painting; and so I used to believe that sculpture is the lamp of painting, and the first related to the second as the sun to the moon", wrote Michelangelo in a letter to Benedetto Varchi, promoter of an academic discussion "on which is the noblest, Sculpture or Painting". These words reveal the intimate essence of a long, laborious career of painter and sculptor (as well as architect, man of letters and poet). It is unusual that, as in his case, an artist's work is linked to a tormented personality, a dramatic, eventful life, as he himself described it to his brother: "I have been traipsing around all Italy, borne all kinds of disgrace, suffered every calamity, lacerated my body with cruel toil". And again, he writes to Martelli: "I see that you have imagined that I am what God wished me to be. I am a poor man of

The work was painted for the Doni spouses, perhaps at the birth of their daughter Maria (September 8, 1507), and certainly after January 1506, date of the discovery of the *Laocoon* from which derives the pose of the nude behind St Joseph. Michelangelo interpreted the *Holy Family* with gelid colors and a strange serpentine composition. The Virgin offering the Child to St Joseph is counterbalanced by five young nudes behind a low wall, beyond which is a misty landscape. The meaning of the work is obscure, perhaps alluding to the birth of Jesus and to baptism, suggested by the Infant St John and the all-round medallions with Christ, angels and prophets in the splendid frame.

231

Michelangelo
*Head of a God
(Cleopatra)*
c. 1535, paper.
Florence, Casa
Buonarroti Museum.

Discovered during recent restoration on the back of another drawing by Michelangelo, it too portraying a woman's head with braided hair and a serpent at her breast, the drawing appears on the sheet donated to Duke Cosimo dei Medici in 1562 by Tommaso dei Cavalieri, the young Roman whom Michelangelo met in 1532. This is one of the so-called *presentation drawings*, according to the term coined by the German scholar Johannes Wilde, that is, designed to be donated as a gift, with compositions that are often complex. This may be one of the "heads of gods" mentioned by Vasari.

little value, laboring over that art which God has given me, to lengthen my life as much as I can". Working in republican Florence, then for the Medici and in the Rome of many popes, all of whom gave him enormous problems, he nonetheless created one masterpiece after another. Even in his last thirty years spent in Rome in voluntary exile from the Florence of the Medici he produced crucially important works, although Vasari's evolutionary theory, that after him no further progress would have been possible, has proved untrue.

Michelangelo
David
1501-04,
marble.
Florence, Accademia
Gallery.

In the years when Pier
Soderini was Gonfaloniere
the marble colossus, which
confirmed the thirty-year-
old Michelangelo as the
greatest sculptor of his
times, was commissioned
by the Opera del Duomo
for the Cathedral of Santa
Maria del Fiore. But when
it was finished, in June
1504, after sharp debate
among the greatest artists
of the day (Leonardo,
Botticelli, Filippino Lippi,
Giuliano and Antonio da
Sangallo, Andrea della
Robbia) the statue
was placed before the
façade of Palazzo Vecchio,
in substitution for
Donatello's *Judith*. It thus
assumed the values, in
republican Florence, of
freedom and civic virtue.

Michelangelo
Tomb of Giuliano de' Medici Duke of Nemours, with the statue of the deceased, Night and Day
1526-34, marble. Florence, San Lorenzo, New Sacristy (Medici Chapels).

"I work as much as I can", wrote Michelangelo in 1526 to Clement VII referring to the sculptures for the New Sacristy. He had been commissioned by Cardinal Giulio de' Medici and by Leo X to build the sacristy designed to house the last Medici tombs in the Laurentian Basilica. After an interruption during the siege of Florence and before he definitively abandoned the city in 1534, the undertaking was completed by him only in part and was finished by other artists. Referring to the *Night* accompanying the personification of *Day* below the statue of the Duke, Michelangelo wrote verses revealing his sorrow at the uncertain situation of his city: "Dear to me is sleep; still more to sleep in stone while harm and shame persist; not to see, not to feel, is bliss; speak softly, do not wake me, do not weep".

Michelangelo
*Ceiling of
the Sistine Chapel*
1508-12,
fresco, detail.
Vatican City,
Sistine Chapel.

The contract for the
immense ceiling having
been stipulated in 1508,
Michelangelo undertook
the titanic project under
pressure from Julius II and
with enormous difficulty.
The first project called for
only a few figures as
replacement for the gilded
stars against a blue
background that then
decorated the ceiling rising
above the frescoes from the
time of Sixtus V; but the
design was gradually
changed to include a
scheme of enormous
complexity with about
three hundred figures. The
famous *ignudi* were to
inspire generations of
artists for centuries, up to
Cézanne and beyond.

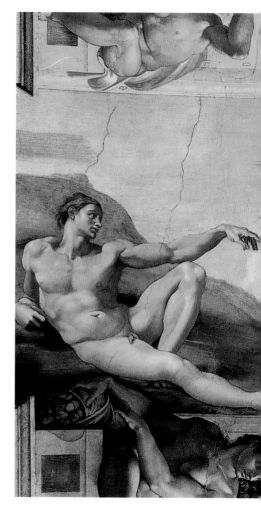

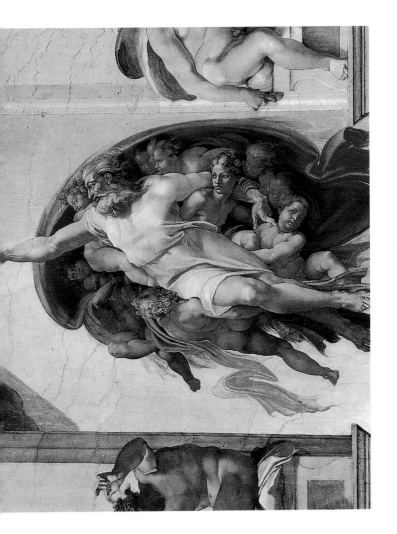

237

Michelangelo
Tomb of Julius II
1513, completed in 1547,
marble.
Rome, San Pietro in Vincoli.

In 1505 Pope Julius II
della Rovere summoned
Michelangelo to build his
funerary monument, origi-
nally destined to occupy
the choir of St Peter's
Basilica. The initial project
was designed like an
ancient mausoleum free on
all sides, and the artist
immediately journeyed to
Carrara to choose the
marble. But in the mean-
time the Pope was
distracted by plans for
rebuilding St Peter's
Basilica, entrusted to
Bramante, and refused
even to receive Michelan-
gelo, who left Rome and
took refuge in Florence.
Work on the monument
was repeatedly interrupted
and only after the Pope's
death in 1513 was the
project resumed, severely
scaled down, and now
including the famous
Moses as well as the figures
of the *Slaves* that were to
remain in the artist's
Florence workshop until
his death.

Michelangelo
Last Judgement
1536-41,
fresco, detail.
Vatican City, Sistine
Chapel.

On the wall originally
decorated by Perugino,
Michelangelo painted the
Last Judgement, at the
desire of Clement VII and
the later urging of Paul III.
The gigantic composition
centers around the colossal
Christ the Judge, whose
gesture seems to dominate
the movement of all of the
other figures.

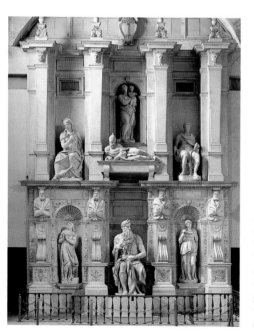

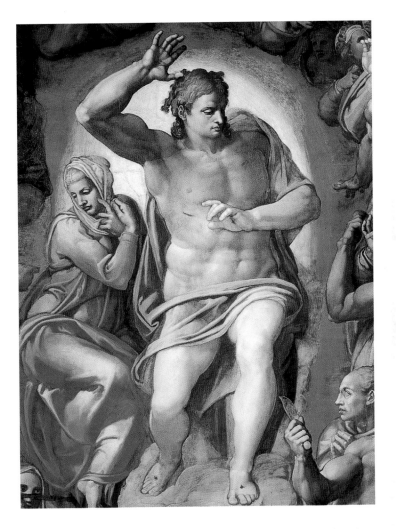

The XVI Century

At the dawn of the new century the world awoke to find itself profoundly transformed, and during the course of the sixteenth century other changes were to occur. With the discovery of those new lands that were called the Americas in honor of Americus Vespucci, the nations bordering on the Mediterranean lost all geographic, and thus political, centrality, leaving the field free to those lapped by the Atlantic Ocean. This could even be called a sign, since in the brief span of a few decades other certainties, taken for granted in the preceding centuries, began to crumble. Even the monolithic image of the Catholic Church started to break up. Biting criticism was addressed to the Roman Curia by Martin Luther, whose ninety-five theses nailed to the door of the church in Wittenberg (site of the university where the Augustinian monk taught) were translated from Latin to German, printed and diffused all over Germany. Modes of communication had changed and the printing press, invented by Gutenberg in 1456, had reaped its first illustrious victim. The year was 1517, and the unity of the Church had been destroyed forever. Even man's view of the universe was to change in the course of the sixteenth century. Nicolaus Copernicus, a Polish physician and canon, published in 1543, the year of his death, the *De revolutionibus orbium coelestium*, in which the Ptolemaic model of the cosmos was abandoned. Copernicus maintained that the center of the universe was not the Earth, as had been thought for cen-

Rosso Fiorentino
Marriage of the Virgin
1523, detail. Florence,
San Lorenzo Basilica.

turies after Ptolemy, but the Sun. In other words, the cultural foundation stones that had guided untold generations for hundreds of years were no longer valid. Man's place in the world had to be totally reconsidered. Reactions to such radical changes were not lacking. The Church questioned itself for eighteen long years, from 1545 to 1563, giving origin to what historians call the Counter Reformation, centered around the city of Trent; but its efforts were not to obtain – due also to its own errors – the desired effect. Nor was the situation improved by the founding of the Company of Jesus by Saint Ignatius of Loyola, in 1540. New political powers were arising instead, such as the Spain of Charles V and Philip II or the England of Elisabeth I, a nation which had already escaped from the spiritual domination of the Roman Church to form an exclusively Anglican clergy. Italy, broken up into small states and potentates, was relegated to a minor role in political affairs, especially after the invasion of Charles VIII in 1498, which inaugurated the period of the so-called Italian wars, with the presence of foreign powers on the peninsula.

The worst crisis came in 1527, with the violation of the Holy City of the West, the "Babylonian whore" of the Protestant peoples – the Sack of Rome. The Lansquenets, Lutheran mercenaries from Frundsberg, laid siege to Pope Clement VII in Castel Sant'Angelo, and history would undoubtedly have taken another path except for an epidemic that broke out among the invading

Giambologna
The Apennines
c. 1580.
Pratolino, Florence, Park
of the Medicean Villa.

troops, forcing them to retreat. But after this date Rome was never to be the same again. Of the supreme artistic triad of the Renaissance, only Michelangelo was still alive. Leonardo had died in France in 1519 and Raphael one year later, leaving to Rome the heritage of his school and his shop headed by Giulio Romano. After the Sack, this immense heritage of art and ideas was dispersed throughout Italy and elsewhere, diffusing the pictorial, architectural and decorative models that had been developed in Rome. Giulio Romano had anticipated this trend, moving to Mantua in 1524. After the Sack, however, the Diaspora of the artists was total: Perin del Vaga moved to Genoa, Rosso Fiorentino went first to Venice, then to Fontainebleau in France, Parmigianino took refuge in Bologna, Giovanni da Udine left for Venice, while Polidoro da Caravaggio stayed first in Naples, then in Sicily. This conferred a national (and ultra-national, considering that Fontainebleau was a point of attraction to which Rosso, Primaticcio and Niccolò dell'Abate were drawn) dimension on that artistic phenomenon known as Mannerism, which involved not only painting but also architecture, sculpture and the decorative arts.

Without pausing to trace the complex critical events that were to lead to the coining of this term in the 20th century, we may note that the first to use it was Giorgio Vasari. "Bella maniera" (beautiful manner) was the term used by the historiographer from Arezzo to indicate that the basic paradigm was no longer nature, but the art of Leonardo, Raphael and above all Michelangelo. The phenomenon, nourished by the fervent activity of Michelangelo, who died in 1564, and by the stylistic evolution of his work, consisted of experimentation in color rich in luministic effects such as those of Domenico Beccafumi and Tintoretto, and in the use of twisting, serpentine forms, considered by the theorist Lomaz-

Titian
Sacred and Profane Love
1514, detail. Rome, Borghese Gallery.

zo to be the Mannerist canon par excellence. A good example can be seen in the sculptures of Giambologna, where the human figure is elongated and twisted. At the basis of this new aesthetics may be placed the concept expressed by Vasari, who explains: "The most beautiful style comes from constantly copying the most beautiful things, combining the most beautiful hands, heads, bodies or legs together to create from all these beautiful qualities the most perfect figure possible....". Architecture too, while strongly influenced by the heritage of Michelangelo, could not escape the fascination of the "Manner", as confirmed by the flourishing revival of Vitruvian studies. It was not by chance that the architect and treatise writer Vignola published, in 1562, the *Rule of the Five Orders of Architecture*. And in 1570, just one year before the Battle of Lepanto in which the Venetians drove the Turks out of the Mediterranean, Palladio published his *Four Books of Architecture*. It would be erroneous, however, to consider the 16th century as exclusively Mannerist, since along with Salviati and Zuccari we find Giorgione and Titian, Correggio and Lorenzo Lotto, Alessandro Moretto and Veronese in a variety of trends that make this one of the richest centuries in Italian art – an art which achieved superb effects using costly materials such as semi-precious stones, glass and metal and which also, thanks to the new geographical discoveries, renewed interest in naturalist and scientific investigation.

Paolo Veronese
The Battle of Lepanto
c. 1573. Venice, Gallerie dell'Accademia.

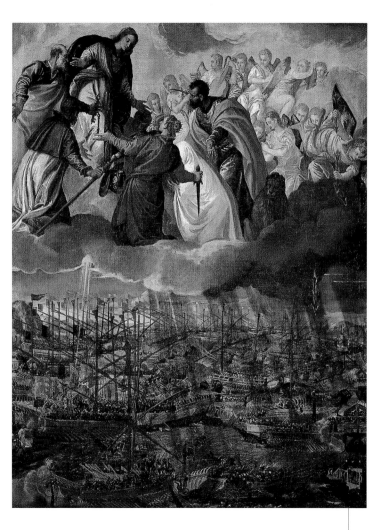

GIULIO ROMANO

(Giulio Pippi)
Rome 1499 – Mantua 1546

Titian (Tiziano Vecellio)
Portrait of Giulio Romano
1536.

Painter, decorator and architect, Giulio Pippi, known as "Romano" due to the fact that he was born in the Papal city, entered Raphael's shop as a boy, only ten years old. Increasingly involved in the master's major works, he participated with other assistants in frescoing the Stanza of the *Conflagration* and the Logge in the Vatican, as well as in the decoration of the Psyche Loggia in the villa of Agostino Chigi, known today as the Farnesina. With the early death of Raphael in 1521, Giulio remained the unquestionable head of the shop which was to complete the works left unfinished by the master, such as the Hall of Constantine in the Vatican Palaces. In 1524 the artist moved to Mantua where he designed and frescoed Palazzo Te, the Duomo, his own house and the Fish Market.

**Giulio Romano
and Assistance**
*Hall of Cupid
and Psyche*
c. 1526-28,
frescoes, detail.
Mantua, Palazzo Te.

The well-known fable by Apuleius tells of Psyche, the beautiful girl loved by Cupid, who has however forbidden her to look at him. Incapable of obeying, Psyche spies on Cupid while he sleeps, but is left no time to enjoy his beauty, as he disappears immediately. The desperate girl wanders about searching for her love. After endless adventures she manages to find him, and joins him forever when Jove bestows on her the gift of immortality. The artist depicts the salient stages of the story, but dedicates to the nuptial banquet in particular the great frescoes covering the northern and western walls.

251

DONATO BRAMANTE

(Donato di Pascuccio di Antonio) Monte Asdruvaldo (Pesaro) 1444 – Rome 1514

Giorgio Vasari
Portrait of Donato Bramante from the *Lives*, Florence, Giunti, 1568.

Donato Bramante
Templet of St Peter in Montorio
1502-1506, Rome.

P robably a collaborator of Piero della Francesca (he may have painted the background of the *Montefeltro Altarpiece* now at Brera), Donato seems to have trained in the Urbino milieu and worked in Perugia and Ferrara. One of the most important painters and architects of the early Renaissance, he undoubtedly decorated the Palazzo del Podestà in Bergamo in 1477. Of this undertaking, fragments of frescoes with philosophers and architectural perspectives, now in the Bergamo Civic Museum, remain. From 1480 to 1492 he designed notable buildings such as Santa Maria presso San Satiro in Milan and the Duomo of Pavia. At Rome from 1490, he constructed works of fundamental importance such as the courtyard of Santa Maria della Pace (1500) and the Vatican Belvedere (1504-1505). He also designed the new St Peter's, later modified by Michelangelo and others.

The date of 1502 confirmed by an epigraph should probably be considered as that of the start of the work, while the erection of the church dates from after 1505. With circular plan, the building – which, it seems, served as inspiration to Raphael for the construction appearing in the background of the *Marriage of the Virgin* (1504, Milan, Brera) – reflects the ideals of harmony rediscovered by the Renaissance through its study of Vitruvius. The *ratio* between the diameter and the total height of the temple, for example, is 3 to 4, according to the consonance established between the theory of music and architecture.

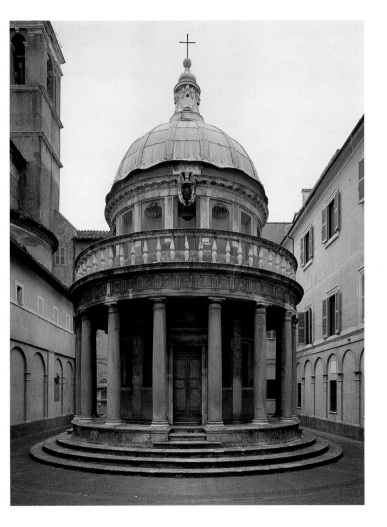

DOMENICO BECCAFUMI

(Domenico di Giacomo
di Pace) Siena 1486 – 1551

Domenico Beccafumi
Self-portrait
c. 1527. Florence, Uffizi
Gallery.

The primary source for information on the life and works of Beccafumi is the second edition of Vasari's *Lives*. Nicknamed Il Mecherino, perhaps for his short stature, Domenico took the pseudonym of Beccafumi from the name of the landowner for whom his family worked. Attracted by esoteric disciplines such as alchemy, according to Vasari, the painter developed his style through a prolonged stay in Rome (c. 1510-13). Returning to his native city, he became the outstanding figure in sixteenth century Sienese art. He designed the cartoons for the flooring of the Duomo (in the area of the transept and apse, 1518), and frescoed Palazzo Pubblico (1529-35) and the apse of the Duomo (1544). He also worked in Genoa and Pisa.

Domenico Beccafumi
*Madonna with Child,
St Jerome and
the Infant St John*
c. 1519, panel.
Madrid, Thyssen-Bornemisza
Collection.

The work, recently discovered (1983), presents a subject frequently reiterated in Beccafumi's production. The little Christ Child gazes at the repentant St Jerome while the Virgin watches over him with maternal care. Behind her, at her left, is the infant St John. The iridescent palette utilized by the artist testifies to his Roman experience, already assimilated, while the iconography is very similar to that of the Uffizi *Holy Family*, of which even the arrangement of the mantle over Mary's head it is reminiscent; a detail which may be traced back to Jacopo della Quercia.

ANDREA DEL SARTO

(Andrea d'Agnolo)
Florence 1486 – 1530

Andrea del Sarto
Self-portrait
1528-30. Florence, Uffizi
Gallery.

When Andrea, known as "del Sarto" from the profession of his father Agnolo di Francesco, a tailor, finally opened his own shop in Florence in 1508, Raphael had just left for Rome, leaving him a figurative heritage which he tempered with that of Leonardo and Fra Bartolomeo. A pupil of Piero di Cosimo, Andrea was always attentive to the newest innovations in painting, adopting them without exaggeration. A painter of tranquil, pleasant style, he moved frequently, to Rome (1511 and 1514), to Venice and as far as the court of Francis I of France, although the center of his activity was always to remain Florence, where his projects included the frescoing of the cloisters of the Annunziata and the Scalzi churches. His importance to the development of Italian painting lies also in the artistic heritage received from him by the Mannerist generation, from Pontormo to Vasari.

Andrea del Sarto
*Madonna of
the Harpies*
1517, panel.
Florence, Uffizi Gallery.

The name of the painting comes from an error made by Vasari, who thought the figures appearing on the pedestal the Virgin stands were harpies. In reality they are, as has been demonstrated by critics, locusts, depicted as they are described in the Apocalypse (IX, 7-10), as having faces "of men" and "hair like that of women". Apart from the complex symbolism, the reference is justified by the presence of St John the Evangelist, traditionally held to be the author of the Apocalypse. The other saint is Francis, rather than the Bonaventura originally requested by the patrons.

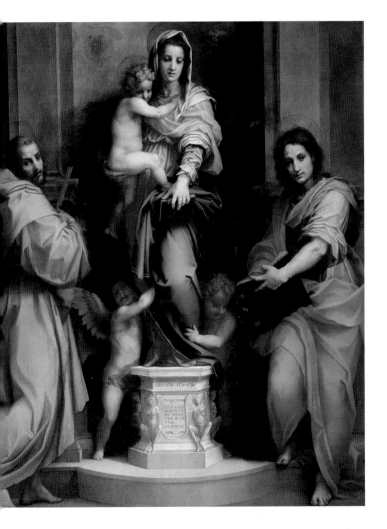

PONTORMO

(Jacopo Carucci) Pontorme
(Florence) 1494 – Florence
1550

Pontormo
Study for a Self-portrait
1516, paper.
Florence, Cabinet of Prints
and Drawings, Uffizi.

This red chalk drawing is
Michelangelesque not only
in the monumental effects,
the abrupt turn of the head
and the powerful shoulder,
but also through the artist's
desire to physically
resemble the unrivaled
master.

Achild of art – his father Bartolomeo was a pupil of Ghirlandaio – Jacopo is considered the founder of the Mannerist figurative culture, capable of blending Michelangelo's forceful colors and monumental figures (as in the ceiling of the Sistine Chapel) with the metallic rigidity of the Northern painters, such as Dürer. Trained at Florence, he worked with Rosso Fiorentino (1512) in the shop of Andrea del Sarto, which he soon abandoned consequent to disagreements. Pope Leo X, passing through Florence on a journey (1515), gave him important commissions, including the frescoing of the Pope's Chapel in Santa Maria Novella. He traveled to Rome but worked mainly in Florence, where he participated with the *Stories of Joseph* (London, National Gallery) in the decoration of the nuptial chamber of Pierfrancesco Borgherini (1515-19).

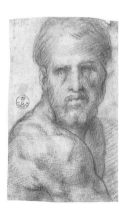

Pontormo
The Halberdier
c. 1529-30, canvas. Malibu,
The J. Paul Getty Museum.

"He also painted, during the time of the siege of Florence, Francesco Guardi dressed as a solder, which was a magnificent work; and then on the cover to this painting, Bronzino painted Pygmalion praying to Venus", reports Vasari. Archival documents have identified a certain Francesco Guardi, born in April 1514, who is in all probability the model for the young man portrayed by Pontormo in one of his most fascinating portraits. On the back of the picture, as mentioned by Vasari, there was originally a panel with the myth of Pygmalion and Galatea painted by Bronzino (now in Palazzo Vecchio).

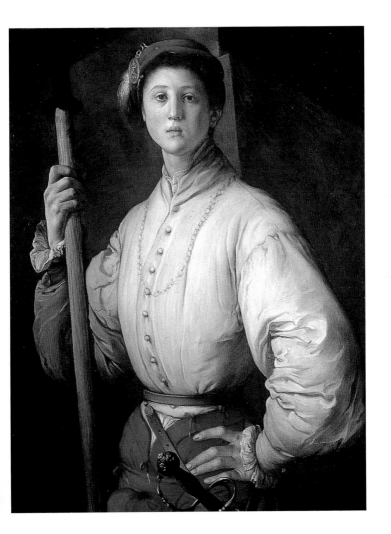

259

Pontormo
Visitation
c. 1528-29, panel.
Carmignano, Prato,
Pieve di San Michele.

The composition, simple
but highly effective, was
inspired by Dürer's famous
print known as *The Four
Witches* or *The Four Nude
Women*, from 1497.
Imitated by Nicoletto
da Modena in an engraving
from 1500, the German
artist's work had in turn
been modeled on the
traditional group of the
three Graces, to which
a fourth was added.
Pontormo insistently
plays on the symmetry
and the opposition
between the two pairs
of women who are
presented, coupled, in
full-face and in profile.
To this the Florentine
painter adds a skillful,
parsimonious use of color,
basically limited to tones
of red and green.
Furthermore, for the
figures in the foreground
Pontormo adopts the
solution of heraldic nature
employed by Piero della
Francesca in the *Madonna
del Parto*, that of dressing
the two women in
symmetrically inverted
colors.

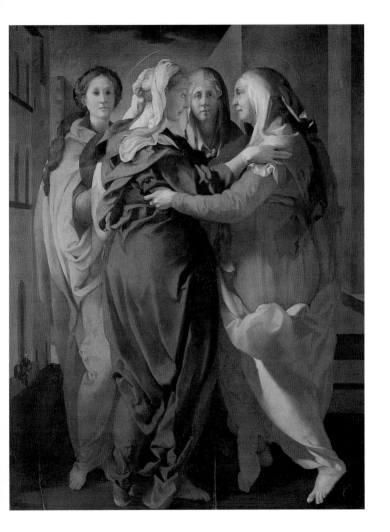

261

Pontormo
Deposition
c. 1527, panel, details.
Florence, Santa Felicita,
Capponi Chapel.

Unanimously held to be
Pontormo's masterpiece, the
work belongs to the cycle of
paintings decorating the
Capponi Chapel in Santa
Felicita, on which the artist's
friend Bronzino also
worked. The panel is a sort
of manifesto of Mannerist
poetics where the figures,
devoid of any architectural
or environmental setting
(apart form the cloud),
come alive through their
acidulous color and
intensely spiraling forms.

Rosso Fiorentino

(Giovan Battista di Jacopo)
Florence 1495 –
Fontainebleau 1540

The human life and artistic career of Rosso Fiorentino can be roughly divided into three stages. The first, that of his training and the period spent in Andrea del Sarto's shop, led to the painting of the frescoes in the cloister of Santissima Annunziata in collaboration with Pontormo. This is the period of the famous *Deposition* of Volterra (Pinacoteca). In 1523 Rosso was in Rome, where he frescoed Santa Maria della Pace and was struck by the impact of Michelangelo's Roman works. A bizarre, obstinate character, he left the city after the Sack of 1527. Following a brief period spent wandering through Northern Italy, he reached the court of France (where Andrea del Sarto had already worked) and became the official painter of Francis I. The gallery he designed in the Castle of Fontainebleau was to serve as cornerstone for diffusion of the Mannerist style throughout Europe.

Giorgio Vasari
Portrait of Rosso Fiorentino
from the *Lives*, Florence,
Giunti, 1568.

Rosso Fiorentino
Deposition
c. 1529, canvas.
Sansepolcro, San Lorenzo
alle Orfanelle.

The subject of the *Deposition* or the *Lament for Christ Dead* is a recurrent theme in the history of art, that of the 16th century in particular, as exemplified by Andrea del Sarto's *Pietà* now in the Pitti Palace. However, the work of Rosso Fiorentino takes on highly unusual dramatic connotations. Profoundly struck by the vicissitudes ensuring on the Sack of Rome, the artist invests the painting with all of his anxiety, and Christ's asphyxious chest is the emblem of a civilization that has risked death by suffocation.

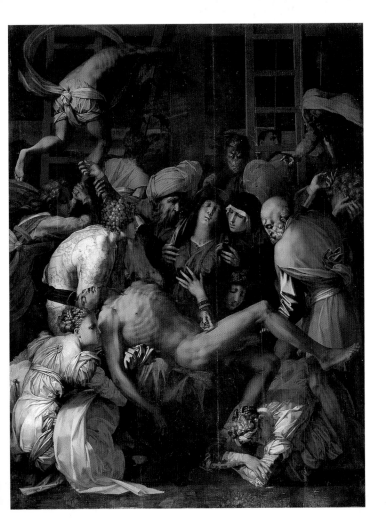

265

Rosso Fiorentino
Marriage of the Virgin
1523, panel.
Florence, Basilica
of San Lorenzo.

Painted slightly before the
artist moved to Rome, the
panel shows a solid
compositional structure.
A theatrical effect is created
by the figures, closely
ranked at the sides of the
bride and groom. Joseph, a
young man, holds in his
hand the flowering branch
that designates him as the
chosen bridegroom.
Mary instead is wholly
concentrated on the act of
receiving on her finger the
wedding ring offered by her
future husband. The
solemnity of the moment is
emphasized by the light that
falls on the Virgin's face.

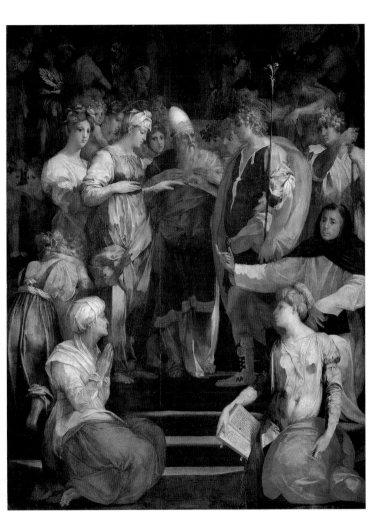

CORREGGIO

(Antonio Allegri)
Correggio (Parma) 1489 –
1534

Correggio
St Anthony of Padua
presumed self-portrait,
1514-15, detail of the *San
Francesco Madonna*.
Dresden, Gemäldegalerie.

Correggio's painting is a demonstration of the great creative potential of the so-called "Italian provinces", and their enormous contribution to the national art. Living almost always between Parma and his home town, from which he took his pseudonym, Antonio trained in the shop of the Modenese painter Francesco Bianchi Ferrari and then in the schools of Mantegna and Lorenzo Costa. His painting, with its soft golden colors, looks however in the direction of Raphael and Leonardo. Critics have assumed that the artist journeyed to Rome in about 1519, or in any case after the election of Pope Leo X. Correggio painted works crucial to the development of the Italian Renaissance, such as the Abbess' Chamber in the Convent of San Paolo at Parma (1519), the frescoes of San Giovanni Evangelista (1520-23) and those of the Duomo (1526-30) in the same Emilian city.

Correggio
Io
1531, canvas. Vienna,
Kunsthistorisches Museum.

The work forms part of a series on the loves of Jove, commissioned by Duke Federico II Gonzaga (1519-40) as a gift for the Emperor Charles V on the occasion of his coronation at Bologna in 1530. It seems however that the canvases were never consigned to the illustrious personage for whom they were painted. The subjects, *Danae*, *Leda*, *Ganymede* and *Io*, are taken from Ovid's *Metamorphosis*, which narrates Jove's love for Io, the daughter of the priestess Hera and the King of Argos Inaco. Jove visits the girl under the form of a cloud and Juno, his wife, revengefully transforms her into a cow. The child Epaphus, who was to become the King of Egypt, was born of Jove's love for Io.

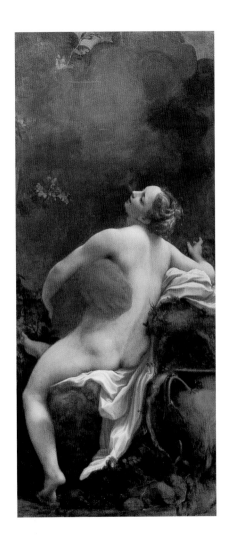

Correggio
*Vision of St John
at Patmos*
1520-23,
fresco, detail.
Parma, San Giovanni
Evangelista.

Inspired by the passage in
the Apocalypse (I, 7) which
states: "Behold, he is
coming with the clouds
and every eye will see him",
the decoration of the dome
is based on the pictorial
models of Mantegna's
Bridal Chamber and
the dome of the Chigi
Chapel by Raphael in
Santa Maria del Popolo
at Rome. The absence
of architectural structures
in the composition and the
exaggeratedly low
viewpoint from below
anticipate the heavens
typical of Baroque
painting.

PARMIGIANINO

(Francesco Mazzola)
Parma 1503 – Casal-
maggiore (Parma) 1540

Parmigianino
*Self-portrait in a Convex
Mirror*
1523-24, detail. Vienna,
Kunsthistorisches Museum.

Parmigianino
*Madonna
of the Long Neck*
c. 1534-39, panel.
Florence, Uffizi Gallery.

When Filippo Mazzola, Francesco's father, died in 1503 the newborn infant was entrusted to his uncles, Michele and Pier Ilario, also painters. Highly precocious, according to Vasari, he received his first important commission at the age of seventeen. In 1520, in fact, he frescoed the private chamber of Paola Gonzaga in the Rocca Sanvitale at Fontanellato, near Parma. Two years later we find him, together with Correggio and others, engaged in decorating the Duomo of his native city. From 1524 to 1527 he was in Rome, where he was admitted to the circle of Pope Clement VII. Here he not only admired the work of Michelangelo and Raphael, but became personally acquainted with Rosso, Perin del Vaga, Giulio Romano, and Giovanni da Udine. After the Sack of Rome he went to Bologna and from 1531 he was in Parma (frescoes, unfinished, for the Church of Santa Maria della Steccata).

The panel, which takes its name from the unusual length of the Virgin's neck, shows Maria and the Christ Child surrounded by angels. In the background is the figure of St Jerome with his scroll and, behind him, the foot of what was to have been another saint. The columns allude to Solomon's temple, to the Medieval hymn *Collum* *tuum ut columna* and to the Immaculate Conception. Painted for the Church of the Servi at Parma, but left unfinished (as stated in the inscription on the steps at the bottom), the panel is permeated with alchemist symbolism, where Christ is seen as the philosopher's stone and Mary as the *vas*, the most pure vessel which contains it.

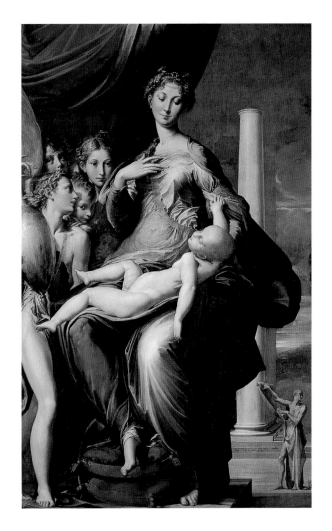

273

LORENZO LOTTO

Venice 1480 – Loreto 1556

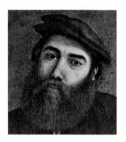

Lorenzo Lotto
Portrait of Mercurio Bua
c. 1530, detail, previously
thought to be a *Self-
portrait of Lorenzo Lotto*.
Rome, Borghese Gallery.

Unjustly considered a minor artist up to the 1950s, Lorenzo Lotto is instead one of the most interesting, eclectic and autonomous person-alities of the Italian 16th century. After first working at Treviso for Bishop de' Rossi (1503), he came in-to his element in the Marches. In 1509 he was in Rome for work (now lost) to decorate the apart-ments of Pope Julius II (1503-13). After another stay in the Marches (1511-12) he went to Bergamo where he received important commissions, among them that of frescoing the Oratory of Battista Suar-di at Trescore (1524). Returning to Venice in 1525 he concentrated mainly on portraits for private in-dividuals, while retaining his contacts with Berg-amo and the Marches. In 1544, now elderly, poor, and disappointed, he became an Oblate at the San-ta Casa di Loreto, where he painted canvases for the basilica.

Lorenzo Lotto
Venus and Cupid
1513, canvas.
New York, The Metropolitan
Museum of Art.

This is one of Lotto's rare paintings of mythological subject. The circumstances of its commissioning are however unknown. It may

have been requested by the artist's nephew, Mario D'Armano, whose name appears in his uncle's ledger as the purchaser of a "Venus", usually identified as the *Venus Adorned by the Graces*. The unquestionably high quality of the painting is accompanied by a

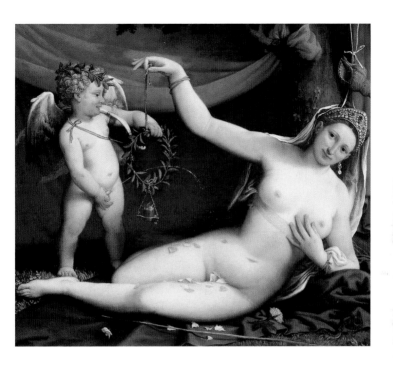

certain complexity in the iconography, typical of the Venetian artist. The goddess, whose body is scattered with rose petals symbolizing love, holds a wreath of myrtle (another symbol of love) through which an impertinent Cupid is urinating.

In the simplest reading, this could be an omen of good luck and fertility. Deeper investigation could explain the urinating Eros as mercurial water and Venus as the Alchemist's *athanor*, or crucible in which the *opus* is created.

Lorenzo Lotto
The de' Rossi Allegory
1505, panel. Washington,
National Gallery,
Samuel H. Kress Collection.

The work was to have
served as cover to the
portrait of Bishop
Bernardo de' Rossi, now
at Capodimonte.
This is demonstrated
not only by the

compatibility of the
dimensions and the style,
but also by the Latin
inscription (now
unfortunately illegible)
that appeared on the back
of the panel. Thorough
iconological studies have
revealed the meaning
of the composition: a sort
of spiritual profile of the
bishop and an invitation to
chose the path of virtue.

Lorenzo Lotto
*The Chastity
of Susannah*
signed and dated 1517,
panel. Florence, Uffizi
Gallery.

The Biblical episode
narrated in the Book
of Daniel (XIII, 1-63) is
depicted by Lotto with
hearty gusto. To render
the scene immediate, the
artist adopts the expedient
of scrolls bearing the
dialogue between the
chaste Susannah and the
lecherous old men. As in a
modern comic strip, the
spectator is immediately
informed of the intentions
of Susannah, who does not
want to sin, while the
spiteful men accuse her of
adultery.

277

GIORGIONE

(Giorgio Zorzi) Castel-
franco Veneto (Treviso)
1477 – Venice 1510

Giorgione
Self-portrait
c. 1508, detail.
Braunschweig, Herzog
Anton Ulrich Museum.

Giorgione
The Tempest
1507-1508, canvas.
Venice, Gallerie
dell'Accademia.

Famous already in its time, Giorgione's work is the 16th century root of Venetian painting, which was to unfold in all its splendor with Titian (called by the master to work with him on the frescoes of the Fondaco dei Tedeschi), and then with Tintoretto and Veronese. Despite an almost total lack of documentation, the most recent criticism believes the artist to have been Jewish, also on the basis of the Braunschweig *Self-portrait*, where he is presented as David. A man of vast culture, he decorated Casa Marta at Castelfranco (1502-1503) with a moralizing frieze of astrological subject intended to affirm the supremacy of virtue over fate. This is one of the artist's first works which has survived to our day. The astrological theme was to appear recurrently in his production, as in the *Three Philosophers* (1504-1505) of the Kunsthistorisches Museum in Vienna.

Over this work the proverbial rivers of ink have flowed. The ambiguity of the subject has triggered the conjectures of iconologists and iconographers. In one of the most convincing hypotheses, the painting represents the condemnation of Adam and Eve after the original sin, a reading which now takes on new light if we accept the Jewish origins of the artist. This also explains the redeeming nature of the bridge and the presence of the bolt of lightening, a sign of divine wrath. From a purely pictorial point of view, however, the painting is a milestone in Venetian art.

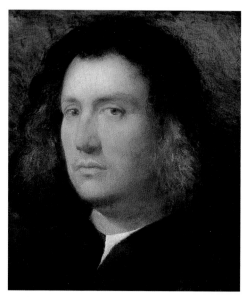

Giorgione
*Portrait of a Gentleman
(Terris Portrait)*
1508-10, panel.
San Diego, San Diego
Museum of Art.

Although much restored,
the portrait displays
stylistic canons linked to
the artist's last period.

Giorgione
*Madonna with Child
and Saints Francis
and George*
1502, panel.
Castelfranco Veneto, Duomo.

Better known as the *Castel-
franco Altarpiece* for its
collocation in the Duomo of
the Venetian town, the
painting was commissioned,
as shown by the coat-of-
arms appearing on the
upper part of the base on
which rests Mary's throne,
by Tuzio Costanzo, a Knight
of Jerusalem, for his chapel.
The Virgin is depicted in a
sober back-lit scene, viewed
from a slightly lowered
perspective. Standing below
her, the two saints bring
closer to the spectator a
Madonna who, in spite of
the tenderly sleeping child,
seems rather distant. The
so-called St. George could
be either Liberale, the saint
for whom the Duomo is
named, or Nicasio, martyr
of the Knights of Jerusalem,
or again, and this is perhaps
the most credible hypoth-
esis, he may personify all
three of these personages in
a single figure.

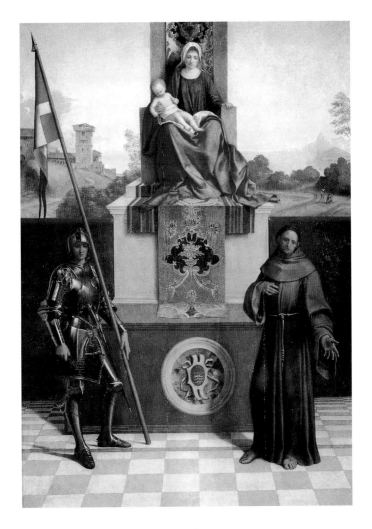

**Giorgione
and Assistance**
*The Judgement
of Solomon*
1502-1508, panel.
Florence, Uffizi
Gallery.

The episode narrated in
the First Book of Kings
(III, 16-28) is known to all.
The scene is rendered in

fresh, vivacious manner,
immersed in an animated
landscape thought to be
painted by the master
himself (the personages are
attributed to his
assistants). Solomon is
seated on a throne to the
right. The true mother is
the kneeling woman, while
to her left the executioner
brandishes his sword.

Giorgione
*Portrait of
a Young Bride (Laura)*
1506, canvas.
Vienna, Kunsthistorisches
Museum.

The inscription on the
back, which calls Giorgione
the "colleague" of the
Bellinian painter Vincenzo
Catena, is one of the few
certain documents
allowing us to trace
Giorgione's artistic career.
From the stylistic point of
view, on the contrary, the
allegorical portrait of
Laura (her head is framed
in laurel branches) leaves
behind it the 15th century
tradition of Bellini
to turn in the direction
of Leonardo.

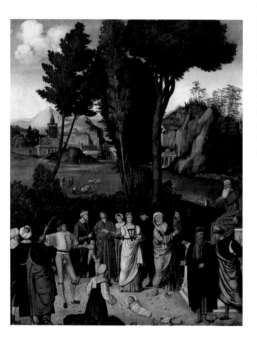

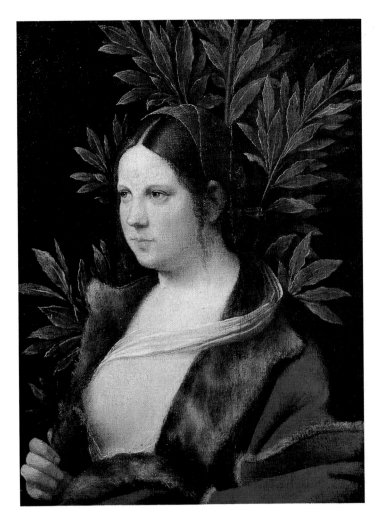

SEBASTIANO DEL PIOMBO

(Sebastiano Luciani)
Venice c. 1485 – Rome 1546

Giorgio Vasari
Portrait of Sebastiano del Piombo from the *Lives*,
Florence, Giunti, 1568.

When, in around 1505, Sebastiano entered the shop of Giovanni Bellini, he was about twenty years old and already an accomplished musician who played the lute as soloist. Influenced by the manner of Giorgione, he happened to meet the Sienese banker Agostino Chigi, who in that same 1511 brought him to Rome where he assigned him part of the decoration of his villa on the Tiber, now known as the Farnesina. Here the artist entered the fervent atmosphere of Rome, becoming a friend of Michelangelo, who even gave him some of his drawings (those of the *Resurrection of Lazarus*, 1519). In 1516 he began the frescoes of San Pietro in Montorio. Fleeing from the city during the Sack of Rome, he returned in 1529, to remain for the rest of his life. In 1534 his friendship with Michelangelo waned, but his stylistic dependence remained unchanged.

Sebastiano del Piombo
The Death of Adonis
c. 1512, canvas.
Florence, Uffizi Gallery.

The work is particularly interesting insofar as it marks, we might say *ad annum*, Sebastiano's abandonment of the Venetian figurative tradition for that of Rome. Critics have noted how the arboreal side-scene

framing the figure of the dying young man is practically identical to that of the *Polyphemus* in the Farnesina. The use of color and the golden atmosphere of the landscape are again Venetian. The monumental quality of the drawing, instead, already tends toward the Roman, making it easy enough to detect in the nymph pointing toward

Pan a hint of the *Erithrean Sibyl* painted by Michelangelo on the ceiling of the Sistine Chapel and unveiled expressly in 1512. From this same figurative repertoire comes the little Cupid reminiscent of the cherubs/caryatids decorating the Prophets' seats. The pose of Venus is derived from the ancient sculpture of the *Spinario*.

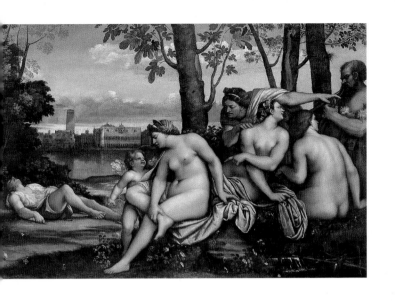

MORETTO

(Alessandro Bonvicino)
Brescia 1498 – 1554

The human life and artistic career of the Brescian painter Moretto followed a linear path, marked by the slow rhythms of the provincial Po Valley. Not by chance, after an apprenticeship in Venice or, more probably, Padua, the artist practically never again left his native city where, among other things, he had the good fortune to serve as master to Giovan Battista Moroni, another great portrait painter of the Venetian-Lombard 16th century. A member of the brotherhood of the Most Holy Sacrament, linked to the reformist circles that rotated around Bishop Ugoni and Sister Angela Merici, Moretto is famous not only for his intense portraits but also for having revitalized the Christian message by bringing alive the Evangelical episodes he depicted. Obviously, his unrestricted access to the local ecclesiastical milieu was favorable to commissions. Accordingly, he was chosen to fresco the Chapel of the Most Holy Sacrament in San Giovanni at Brescia and to paint a number of canvases in the sanctuary of Paitone and in the Church of San Francesco di Brescia (1530).

Moretto
Portrait of Count Sciarra-Martinengo Cesaresco
1545-50, canvas.
London, National Gallery.

A splendid portrait painter, Moretto was able to render extremely expressive and natural even an official portrait such as this one. Instead of posing haughtily Count Sciarra, the page of Henry II the King of France, appointed by him Knight of St Michael when only 18 years old, is surprised by the painter in a meditative attitude. Gazing indolently away from his personal commitments (traces of which, coins and gloves, appear on the table), he turns toward the spectator with a trace of annoyance. A masterpiece of psychological analysis, the portrait seems to echo the style of Lorenzo Lotto.

DOSSO DOSSI

(Giovanni di Niccolò
di Lutero) ? c. 1490 –
Ferrara 1542

Dosso Dossi
Jove Painting Butterflies
c. 1529, detail of *Jove,*
Mercury and Virtues.
Vienna, Kunsthistorisches
Museum.

Unfortunately, most of the works of Dosso Dossi and his brother Battista were lost in the siege and conquest of Ferrara by Papal troops in 1598. The court of Alfonso I (1505-34) and Ercole II d'Este (1534-59) was in fact the stage on which the two artists performed. Probably born in Ferrara, Dosso, the more famous of the two, trained in Mantua and Bologna, while Battista – says tradition – was in Rome working in Raphael's shop. Dosso was clearly influenced by the vivid colors of Giorgione and Titian. His activity extended, however, to Pesaro and Trent, where paintings and cycles of frescoes, also from his youthful period, are preserved (Castello del Buonconsiglio). He was also acquainted with the painting of Rome and Central Italy, as well as that of Florence.

Dosso Dossi
Witchcraft or
Allegory of Hercules
c. 1535-38, canvas.
Florence, Uffizi Gallery.

Listed in the inventory of Cardinal Leopoldo, who had it purchased at Siena in 1665, as a "picture with portraits of the Duke of Ferrara's jesters", the painting should be considered the masterpiece of Dosso's later years. The

canvas is distinguished by sharply contrasting light and shadow, but its subject is far from clear. It has been suggested that it is an allegory of Hercules choosing between vice and virtue. This subject, quite common in the Renaissance, becomes even more significant when we consider that in the Ferrara of the times, Hercules was the eponymous hero of Ercole d'Este, the lord of the city.

GIOVAN GEROLAMO SAVOLDO

Brescia c. 1480 –
Venice, after 1548

With the pictorial lesson of Savoldo, Venetian-Lombard illuminism was accentuated, with light and shadow assuming sharp contrasts, to the point that critics have seen in him one of the roots of Caravaggio's future distinctive traits. The training of the artist from Brescia was various and complex. He was in Florence at the time when Raphael has just gone to Rome (1508). Later, in 1520, Giovan Gerolamo was in Venice where he became acquainted with Giorgione and Titian, as well as with Flemish culture. Having settled in Venice, he was to remain in contact with his native Brescia, although he was fully accepted in Venetian cultural circles thanks to his friendship with Pietro Contarini, a refined literate of the times and patron of the painter.

Giovan Gerolamo Savoldo
Adoration of the Pastors
c. 1538, detail.
Brescia, Civica Pinacoteca Tosio Martinengo.

Giovan Gerolamo Savoldo
Shepherd with a Flute
c. 1525-30, canvas.
Malibu, The J. Paul Getty Museum.

The painting, presenting complex esoteric and religious aspects which link it to Contarini's literary circle, portrays a shepherd wearing a wide-brimmed hat and holding a flute in his hand. In the background is a landscape darkening into twilight. Identified as the work of Savoldo since the late 19th century (it had formerly been attributed to Sebastiano del Piombo), the painting is one of the highest achievements of the Brescian artist. Its fascinating sense of mystery is accentuated by the back-lighting and the beam of sunlight striking the figure, leaving his face in half-shadow.

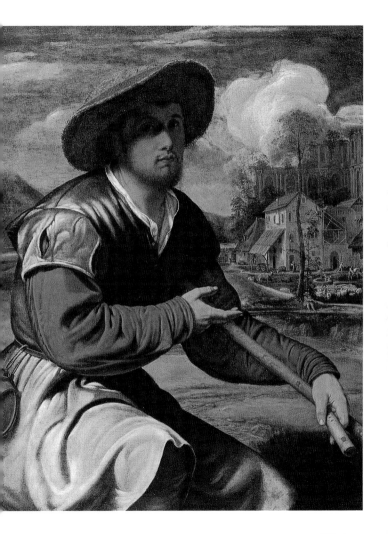

TITIAN

(Tiziano Vecellio)
Pieve di Cadore 1480/85 –
Venice 1576

Titian
Self-portrait
1562. Berlin,
Staatliche Museen.

A pupil of Giovanni Bellini, Titian did not limit himself to "ferrying" Venetian art across the stream from the luminous equilibrium of the fifteenth century to the brilliant splendor of the sixteenth. Ultimately the great artist, thanks also to the gift of a very long life, completely redesigned the panorama of Venetian painting. Moreover, his approach were to have an impact on future generations of artists, not Italian alone, whose ranks include such eminent figures as Velázquez (1599-1660) and Manet (1832-83). It can even be said without fear of contradiction that after Titian the way of applying color to a canvas and the very conception of how color should be used in a painting were never again to be the same. Involved by Giorgione in the undertaking of frescoing the Fondaco dei Tedeschi at Rialto (1508), some detached parts of which have come down to us (Venice, Franchetti Gallery), Titian remained for some time linked to the other great Venetian master's pictorial world; and to such an extent that critics have disagreed as to the correct attribution of the famous *Country*

Titian
The Slave
c. 1511, canvas.
London, National Gallery.

Now unanimously attributed to the young Titian (as also proven by the initials T. V. engraved on the end of the parapet), although considered in the past to be the work of Giorgione, this portrait is one of the most original from the 16th century. The artist has amused himself by creating a kind of dialogue between the profile of the head carved in relief on the wall appearing in the fore-ground and the woman portrayed, who rests her hand on the wall in a gesture of complacent approval. Perhaps the painter wished to contrast the ideal classical features of the relief and the physical carnality of the woman.

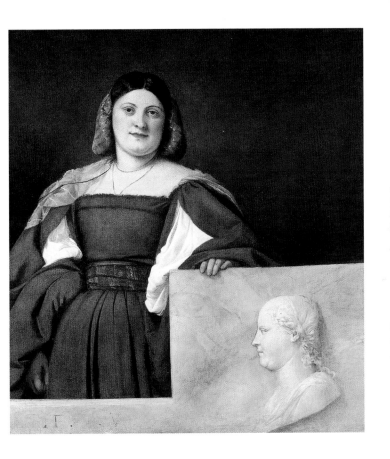

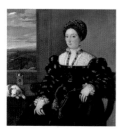

Titian
*Eleonora Gonzaga
della Rovere*
1536-38, canvas.
Florence, Uffizi Gallery.

The portrait is a
companion piece to the
one of Francesco Maria
della Rovere, Duke of
Urbino, also painted by the
master and preserved in
the same collection.
The little dog on the left
alludes to the one quality
indispensable for a wife,
fidelity. The ornate alarm
clock is a status symbol.

Concert in the Louvre (1509-10). Now definitively attributed to Titian, the painting, while retaining a theme (that of musical symbolism, rich in philosophical and literary implications) linked to Giorgione, already shows Titian's splendid mastery of color with the red spot of the man playing the lute sensitively placed against the green background of the landscape. Equally complex from the iconological point of view, the Borghese Gallery's *Sacred and Profane Love* hinges around the same chromatic problem (1514). With the *Assumption* painted for the high altar of the Church of the Frari (1518), Titian's fame exploded. Contacts with the courts of Mantua and Ferrara (for which the artist painted a *Bacchanal*) were established, while even the Doge requested a portrait of him. The artist then entered the favor of the Gonzaga and the Emperor Charles V. While influenced by the seductive power of Mannerism, his painting became increasingly looser and more luminous. In his last years the artist abandoned himself to a solitary, isolated research of great visual impact.

Titian
Flora
c. 1515-17, canvas.
Florence, Uffizi Gallery.

In the refined Renaissance culture a special value was attributed to certain mythological figures. Flora, for instance, was the prototype of the bride, and the work is very probably a portrait of a young wife portrayed in the guise of the goddess of springtime. That the subject is conjugal love is demonstrated by the wedding ring displayed on the hand holding the bouquet of flowers which are, significantly, roses.

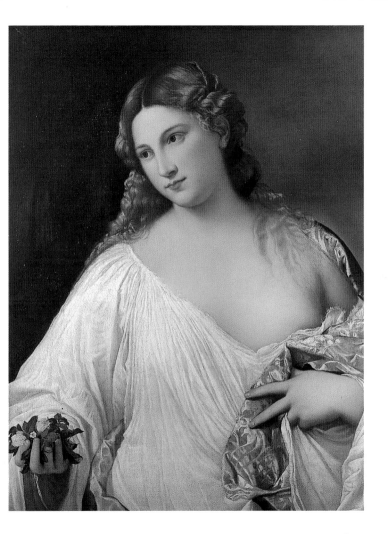

Titian
*The Venus
of Urbino*
1538, canvas.
Florence, Uffizi
Gallery.

Almost an archetype of
feminine sensuality (the
model for painters such as
Ingres, Renoir and, above
all, Manet, especially in his
Olympia), this canvas was
commissioned by Tiziano
da Guidobaldo della
Rovere who had just
become Duke of Urbino.
The panting was to have
served as example for his
young bride Giulia Varano;
a sort of inspirational
source on what conjugal
love should be. Not by
coincidence, curled up on
the side of the bed, is a
little dog, an obvious
symbol of fidelity. This
then is legitimate, but
nonetheless ardently
passionate love, as
reiterated by the roses and
the myrtle on the
windowsill.

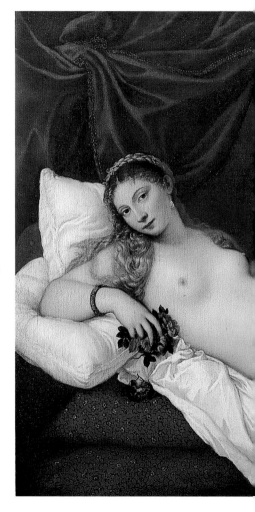

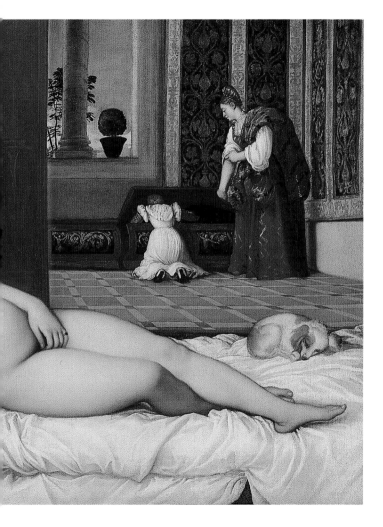

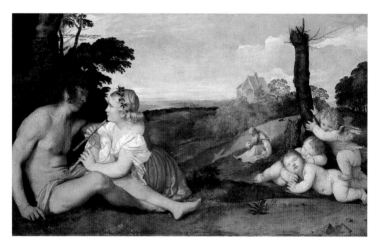

Titian
The Three Ages of Life
1511-12, canvas.
Edinburgh, National
Gallery of Scotland.

The young man and
woman on the left are
improvising a musical
duet which alludes to an
amorous skirmish, while
the flute evokes the mascu-
line sex. Love, however, is
an ephemeral pleasure, as
the old man meditating on

the end of existence well
knows. The two skulls are
in reality those of the two
young people. Even infancy
appears as a couple, bliss-
fully unaware of the
dangers foreshadowed by
the withered tree, provi-
dentially held up by Eros.

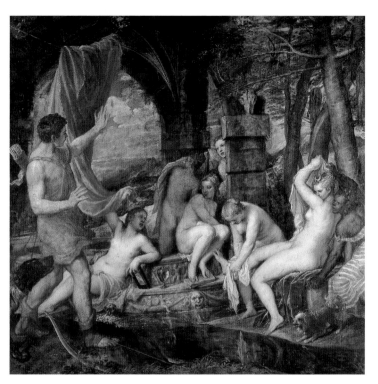

Titian
Diana and Acteon
1556-59, canvas.
Edinburgh, National
Gallery of Scotland.

Sent to Philip II in late
1559, the painting
illustrates an episode
poetically narrated by Ovid
in his *Metamorphosis*. The
mythical hero and Trojan
huntsman, educated by the
centaur Chiron, chanced to
come upon Diana (the

Artemis of the Greeks, the
virgin goddess par
excellence) bathing naked
in a pool. This is the
moment chosen by Titian.
Transformed into a deer by
the angry goddess, Acteon
was torn to pieces by his
own dogs.

GIOVAN BATTISTA MORONI

Albino (Bergamo)
c. 1520 – Bergamo 1578

Through Moroni's work the evolution in social status occurring in the territories of Bergamo and Brescia can be traced, at least in part. Up to at 1560 if not later, in fact, Giovan Battista received commissions for portraits not only from noblemen and high-ranking personalities but also from the mercantile middle class that had made this Italian province rich. A pupil of Moretto at Brescia, Giovan Battista also had a production of religious nature which brought him to work at Trento (1548) and then in the churches around Bergamo. After 1560, due to the progressive decline of the great families of clients and protectors, Moroni sought work in the ecclesiastical sphere. Moroni's presence at Trento during the Council probably made him the first artist to absorb the principles of the Reformation.

Giovan Battista Moroni
*Portrait of Pietro
Secco Suardo*
signed and dated 1563, canvas.
Florence, Uffizi Gallery.

The portrait contains practically all of the elements characteristic of the genre. It is reminiscent of certain works of Titian (the *Portrait of Philip II* in the Prado) and Tintoretto (the *Portrait of a Gentlemen in Fur*, Stuttgart, Staatsgalerie, in which the element of the window appears). This may

not be mere coincidence, since Pietro Secco Suardo had been ambassador to Venice since 1545. This is however a "speaking" portrait, with the man pointing to the brazier on which are engraved words from the Gospel of Luke (XII, 49: "How I wish it [the fire] were blazing already"). The Latin words NISI VT ARDEAT conceal in acrostic the nobleman's surname. When the letters NI, I, T, AT are removed, the name SVARDE remains.

Giovan Battista Moroni
Gentleman of the Avogadro Family (The Knight of the Wounded Foot)
c. 1555,
canvas.
London, National Gallery.

Coming from the Avogadro Palace at Brescia, the portrait could be that of either Pietro or Faustino Avogadro, men-of-arms and sons of Gerolamo II. Military activity is alluded to by the details of the armor fallen to the floor and the metal binding on the left knee, obviously the sign of a wound.

BRONZINO

(Agnolo di Cosimo
di Mariano)
Florence 1503 – 1572

Bronzino
Lust
c. 1545, detail.
London, National Gallery.

A pupil of Pontormo, apprenticed to him when only fifteen, Bronzino is one of the outstanding figures in second-generation Mannerism, at a time when the political conditions of Florence were changing and the Medici family was taking great steps toward establishing the Grand Duchy of Tuscany (1569). A collaborator of Pontormo from 1526 to 1528 in the Santa Felicita project, Bronzino moved to Urbino after the siege of Florence by Imperial troops. He frescoed the Chapel of Eleonora da Toledo (1540-46) in Palazzo Vecchio and in 1541 entered the Florentine Academy newly founded by Duke Cosimo I. Here he was to remain for seven years. In 1548 he was in Rome, while already for some time he had been working for the Ducal tapestry factory. In 1566 Bronzino, who was also a refined poet, was readmitted to the Academy, and was even appointed Consul shortly before his death.

Bronzino
*Portrait of Lucrezia
Panciatichi*
c. 1541, panel.
Florence, Uffizi
Gallery.

The portrait of Lucrezia di Gismondo Pucci, wife of the wealthy merchant Bartolomeo Panciatichi, whose portrait Bronzino had painted in that same year, is a sort of programmatic manifesto of the artistic ideals of the period. The Mannerist poetics was evolving toward a search for cold formality expressed in smoothest color and an almost metallic surface. A portrait, it was believed, should display above all the decorum of the person portrayed. Accordingly, Lucrezia appears as an effigy incarnating the poised, chaste beauty pursued at the time as an ideal.

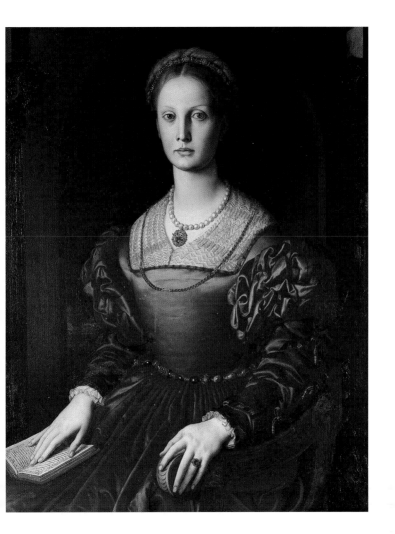

BENVENUTO CELLINI

Florence 1500 – 1571

Engraving of Benvenuto Cellini's portrait.

With his restless, eventful life, Cellini embodies the Renaissance ideal of the artist. A highly versatile personage, he passed effortlessly from the goldsmith's bench to the foundry and from the scalpel to the pen. A brilliant writer, Cellini was the author of his famous autobiography as well as two treatises on gold-working and on sculpture. A child of art – the son of an engraver, Giovanni – he was directed toward the study of music. Gold-working was, however, his passion. From 1519 to 1540 Cellini was in Rome at the service of the popes. The five following years he spent in France at the service of Francis I, between Fontainebleau and Paris. Returning to Florence he worked fervently on the *Perseus*, which occupied him for nine years, during which he created other masterpieces as well. The changing fortunes of his life brought him from the dazzling, ephemeral atmosphere of courts to the squalor of prison.

Benvenuto Cellini
Perseus
1545-54, bronze.
Florence, Loggia
dei Lanzi.

"Before I die I will leave of myself such a proof to the world, that more than one will remain astounded", states the *Life* (II, 76), begun by Cellini two years after having finished his masterpiece.

Commissioned by Cosimo I in May of 1545, when the artist went to visit the future Grand Duke at his villa of Poggio a Caiano, the immense bronze, more than three meters high, was to make life difficult for Benvenuto up to the end. He himself relates the episode in which he was forced to sacrifice all of the pewter table and kitchenware he owned to make the molten metal flow at the right speed (*idem*, II, 77).

Refined in every detail, from the pedestal to the Medusa's snaky hair, the Perseus is a sort of monumental jewel where chiseled perfection sustains an unrivaled inventive synthesis.

GIAMBOLOGNA

(Jean de Boulogne)
Douai 1529 – Florence 1608

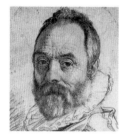

Hendrik Goltzius *Portrait of Giambologna* 1591. Haarlem, Teylers Museum.

Giambologna
Equestrian Monument to Cosimo I
1594-98, bronze, detail.
Florence, Piazza della Signoria.

The basic scheme is that of the statue to *Marcus Aurelius*, which was thought at the time to represent Constantine, the first Christian emperor. The decision to portray Duke Cosimo in this way was thus highly significant.

The artistic career of Giambologna is a tangible sign of the vital cultural exchange that took place, throughout the Renaissance, between the lands of Flanders and Italy. Trained in his homeland, the artist arrived at Rome in 1550 with the precise intention of studying ancient statues and the works of the divine Michelangelo. Passing through Florence on his journey home, he was introduced to the Court of the Medici, who assigned him a salary starting in 1561. In return Jean, who had now been nicknamed Giambologna, produced theatrical scenes and sculptures for festivities, and small, refined decorative marbles and bronzes, including the famous series of "portraits" of animals sculpted from life to adorn the grotto of the Villa Medicea of Castello (now in the Bargello National Museum). He also worked in Lucca, Genoa and Bologna.

Giambologna
Mercury
c. 1580, bronze.
Florence, Bargello
Museum.

The winged Mercury
resting on the tip of one
foot, held up by
a powerful gust of
wind, is a miracle of
equilibrium. His whole
body seems in fact
absorbed in holding this
elegant but arduous pose.

GIUSEPPE ARCIMBOLDI

Milan 1527 – 1593

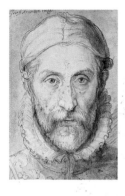

A unique case in the history of art, Giuseppe Arcimboldi invented a stylistic approach that was to make him immediately recognizable, and to bring him swift success and lasting fame. After beginning to paint, entirely within the canons of the norm, in the Monza Duomo (his is the *Tree of Jesse*), and designing the cartoons for the stained-glass windows in the Milan Duomo, he abruptly changed his style in 1562 when he was called to Prague by Rudolph II of Hapsburg, the erudite alchemist king who immediately appointed him court painter. It was then that Giuseppe began to conceive of human heads (which may also be portraits) composed of fruit, flowers, vegetables, animals or objects suitably chosen in relation to the meaning to be attributed to the image. "Discovered" by Surrealist painters, the work of Arcimboldi has become widely known in our time.

Giuseppe Arcimboldi
Self-portrait
c. 1575. Prague, Národní Galerie.

Giuseppe Arcimboldi
Summer
signed and dated 1573, canvas. Paris, Louvre.

This head forms part of the series dedicated to the seasons which was, in turn, to have served as *pendant* to one portraying the four elements and thus creating, between the one and the other, a precise symbolic correspondence. The choice was obviously dictated by the interests of Rudolph II (1552-1612) who dabbled in alchemy. In any case, the female head of *Summer* (whose dress is made of woven straw adorned at the neck with ears of grain) is composed of seasonal fruits and vegetables, ranging from peaches to cucumbers, from pears to cherries, while pinned to the front of her dress, like a rose, is an artichoke.

309

TINTORETTO

(Jacopo Robusti)
Venice 1518 – 1594

Tintoretto
Self-portrait
c. 1548, detail.
London, Victoria
and Albert Museum.

The son of a silk dyer or *tintore* (the derivation of his pseudonym), Jacopo, one of the greatest artists in the Venetian figurative culture of the 16th century, probably trained in the Pordenone milieu, although 16th century literature on art traditionally considered him to be a pupil of Titian, of whom he was to become the great antagonist. A prolific artist, often working with numerous assistants, he was endowed with abounding energy and a marked capacity for assimilating new trends in art which allowed him to absorb Mannerist modes while Titian was still ignoring or rejecting them. Expert at depicting crowded scenes, mythological compositions and luministic effects, he was able to involve the spectator emotionally. He received a great number of important commissions, such as the paintings for the Scuola Grande di San Marco (1562-66) and for the Scuola di San Rocco.

Tintoretto
*Venus, Vulcan
and Mars*
1545-50,
canvas, whole and details.
Munich, Alte Pinakothek.

In fifteenth and sixteenth century symbology, the dog alluded to fidelity. The one in this painting must have tried in vain to defend this value, for

it is desperately barking at Mars who, despite the helmet he is wearing, is hiding under a table in the hackneyed style of the lover trying to avoid being caught in the act. But Vulcan must have suspected something, if he leaps suspiciously toward the nuptial bed to examine the linen, still warm, in which his wife

Venus is wrapped. Venus, in truth, seems quite unworried, confident as she is of her overpowering fascination. The only personage not involved in the embarrassing incident appears to be Cupid, who is sleeping. But it is an insidious sleep, since it is he who has arranged the rendez-vous.

PAOLO VERONESE

(Paolo Caliari)
Verona 1528 – Venice 1588

Paolo Veronese *Presumed Self-portrait dressed as a Hunter* 1561. Maser, Villa Barbaro, last room in the western wing.

Paolo Veronese
Decorative cycle at Villa Barbaro
1561, fresco, details.
Maser, Villa Barbaro.

Villa Barbaro represents one of the highest moments of the encounter between two artists: Palladio the architect of the villa (completed in 1559), and Veronese. The painter's use of perspective and *trompe-l'oeil* provides a pictorial comment to the work of Palladio.

With Titian and Tintoretto, Veronese is the third outstanding personality in the panorama of sixteenth century Venetian painting. The son of a stone-cutter, Paolo took his pseudonym from the name of his native city, where he worked in the shop of Antonio Badile. Trained in the Mannerist style of Parma's figurative culture (Correggio and Parmigianino), he very early abandoned them for a style that was less tormented and more radiant. The effect was undoubtedly heightened by the lowered viewpoint utilized with great skill in the paintings for the Hall of the Council of Ten at Palazzo Ducale (1553-54). This was to be a highly successful stylistic approach, later emulated by Tiepolo. One of the painter's great masterpieces is the *Marriage in Cana*, a work of costume, as well as of religious subject.

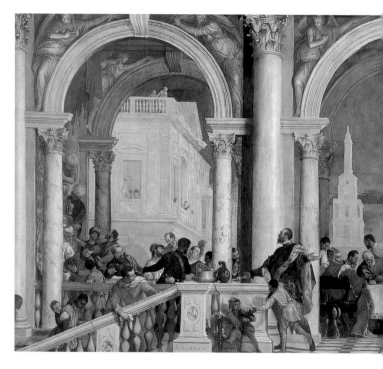

Paolo Veronese
Supper in
the House of Levi
1573,
canvas, whole and details.
Venice, Gallerie
dell'Accademia.

For this painting the
artist underwent, on July
18, 1573, if not a real trial,
a procedure of
investigation conducted
by the Inquisition.
The immense canvas
(over 5 meters high and
over 12 long) was
conceived as a *Last Supper*

for the Dominican
refectory of Saints John
and Paul at Venice.
The disapproval of the
Inquisition, which judged
highly irreverent the
presence of jesters, dogs
and black servants, forced
the artist to change the
name of the painting to

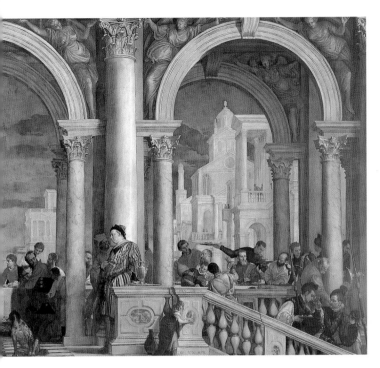

Dinner in the House of Levi, a title less charged with religious implications. The work was created to replace a canvas of similar subject that had been painted by Titian and destroyed in a fire.

ANDREA PALLADIO

(Andrea di Pietro) Padua
1508 – Maser (Treviso)
1580

"Guided by natural inclination, I turned in youth to the study of Architecture...". With these words Palladio began the Preface to his treatise entitled *The Four Books of Architecture*, published at Venice in 1570. He, the son of a miller, had been passionately interested in architecture since boyhood. Having gone to Vicenza to work as stonecutter, Andrea found a protector in the man of letters Gian Giorgio Trissino, who allowed him to travel by his side and to visit the great Italian architectural works. The reconstruction of the Palace of Reason at Vicenza (1549) gave Palladio his first important chance to show his talent. Architect of the magnificent country villas around Venice, he designed the churches of San Giorgio Maggiore (1566) and the Redentore (1577-92) in Venice.

Francesco Zucchi
Portrait of Andrea Palladio
engraving, perhaps from
a lost portrait of
Giambattista Maganza.

Andrea Palladio
The Maser Templet
1580.
Maser, Villa Barbaro.

This is one of the Paduan architect's last works. Palladio returned to Maser at the request of Marcantonio Barbaro, Procurator of Saint Mark's, who planned to embellish his villa with other constructions. One of these, the *Templet*, offered the elderly Palladio a chance to confront the problem of the structure with circular plan according to the aesthetic and proportional canons he had studied in Vitruvius and theorized in the *Five Books*. It is easy enough to see in the *Templet* a sixteenth century version of Agrippa's Pantheon in Rome. Unlike the latter, however, the *Templet* has a lantern on the dome.

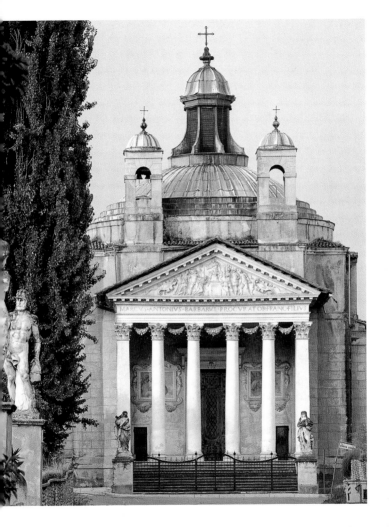

MAR·S·ANTONIVS·BARBARVS·PROCVRATOR·FRANK·FILIV

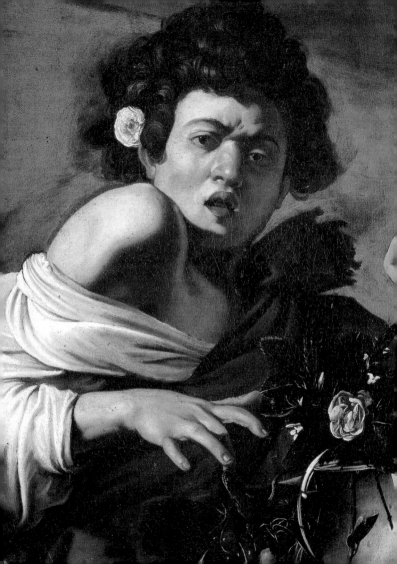

The XVII Century

A lthough relegated to a political role of minor importance (apart from the international presence of the Church), Italy in the 17th century was not torn by the long, extenuating conflicts that were then sweeping through central-northern Europe. On the peninsula the presence of foreign powers was now to some extent taken for granted and, apart from the insurrections of Masaniello (1647) and those of Messina (1674), the small Italian states had come to terms with the great powers of the times, France and Spain, which boasted extensive possessions in Italy. But this substantial political and military subjugation was by no means reflected in the position Italy occupied in the world of art. First of all, our country was famed as a jewel-casket overflowing with artistic and archaeological treasures from a more or less distant past.

Already by the late 16th and early 17th century the "voyage to Italy" was deemed indispensable to the pictorial, sculptural and architectural training, or rather the cultural education of any good artist. Very few indeed were the great artists who did not make their tour of the peninsula, according to a custom that was continue down to the late 19th century. Starting with Bruegel the Elder, Italy was visited by Rubens, Velazquez and Van Dyck, to mention only the most famous. In Rome there was even to emerge an artistic current, that of the Bambochades, composed of foreign painters, headed by Van Laer.

The great fabric of painting had begun to split up into genres – from historical painting deemed the most important (to the point of fascinating the young Rembrandt) to the still life that was to meet with such success in the French-Flemish area. The latter even began to diversify into still further genres: from the still life with fruit culminating in Caravaggio's masterpiece,

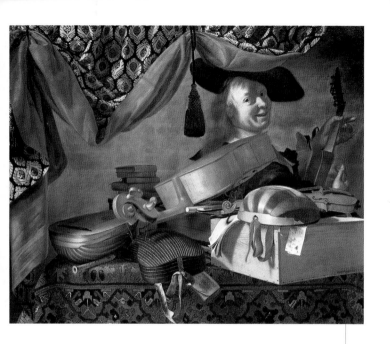

**Evaristo Baschenis
and Salomon Adler**
*Musical Instruments with
the Portrait of a Man*
c. 1675, painting found in 1996
in the storage deposit of the
Brera Academy.

the *Chest of Fruit*, to the one composed of musical instruments, at which Baschenis excelled. The role of Italy was not, however, that of simple "reservoir" of the European collective imagination, but was much more active. In Rome especially, that international artistic language (exported from Spain as far as South America) which goes under the name of Baroque was developing rapidly. The term – which originally indicated pearls of irregular form, gibbous pearls, or those ambiguous syllogisms codified by rhetoric, was to be used only at the end of the 18th century, and with a negative significance.

The most recent critics have entirely rehabilitated the Baroque style, even tending to consider it one of the categories of the human spirit. Certainly, the new style did not emerge contemporaneously in all of the arts. On the contrary, its various currents and trends were to interweave continuously throughout the course of the century. In architecture, for instance, the façade of Santa Susanna in Rome, built by Carlo Maderno between 1597 and 1603, can be considered the first manifestation of the Baroque; in sculpture the new trend was well represented by the *St Cecilia* sculpted by Stefano Maderno precisely in the year 1600. The façade of the church, in fact, while inspired by Giacomo della Porta's Church of Gesù, transforms into motion and volumes what had until then been treated as a kind of "curtain", designed and decorated in almost graphic terms. In similar manner, the sculpture of the other Maderno emphasized one of the themes characteristic of the Baroque poetics, that of the inclinations of the soul, aimed chiefly at involving the spectator emotionally. These trends, briefly summarized here, were developed with enormous intensity through such outstanding figures as Bernini, whose contribution is vitally important in both

Salvator Rosa
Rocky Panorama with Waterfall
c. 1640. Budapest,
Szépmüvészeti Múzeum.

sculpture and architecture, as exemplified by the Church of Sant'Andrea al Quirinale and the famous sculptural group of *Apollo and Daphne*. No matter how imposing, however, the figure of Bernini represents only one of the multiple facets of the Baroque.

Equally important roles were those of Francesco Borromini, an architect endowed with inexhaustible imagination, and Pietro da Cortona, architect and painter. And along with these were Algardi and Duquesnoy in sculpture, Rainaldi and Maderno in architecture. The 17th century was one of great architectural initiatives: from the completion of St Peter's with its colonnade to the realization of the dramatic Piazza Navona. The great architecture of the 17th century was not, however, confined to Rome alone. We need only recall the names of Baldassarre Longhena and Santa Maria della Salute in Venice, the work of Guarino Guarini in Turin and that of Cosimo Fanzago in Naples. In like manner, great 17th century painting is not Roman alone, although it began in the city of the Popes with the arrival of the Bolognese painters led by Annibale Carracci, Ludovico and Agostino followed by Domenichino and Guido Reni.

It is hard to identify a specific Baroque current of painting. The Bolognese school tended toward a return to Classicism, although the works of Guercino, including the famous frescoes in the Casino Ludovisi, fell wholly within the Baroque sphere, in-

Gaetano Zumbo
The Triumph of Time
c. 1694, detail with self-portrait.
Florence, Museo della Specola.

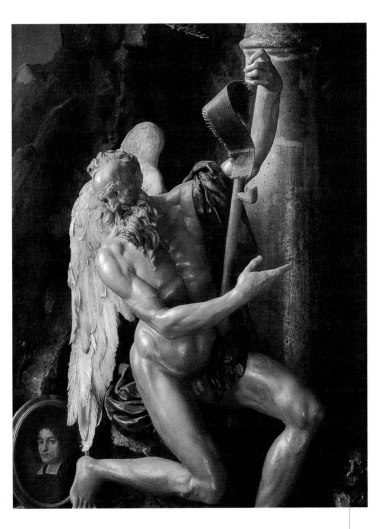

dulging in perspective effects like those which, at the end of the century, were to spread over the ceilings of the Churches of Gesù and of Sant'Ignazio. The entire century was however dominated by the towering figure of Caravaggio, whose luministic approach, although emptied of its original spiritual significance, was to spawn innumerable followers and schools. A broad gulf separates the school of the Carracci from that of Caravaggio. The former emulated the pattern of the Renaissance where pupils were taught directly by the master. Only a few, instead, were the disciples (among them his friend Orazio Gentileschi) working shoulder to shoulder with Merisi, who was to die at the age of only thirty-nine. And yet through artists such as Guido Cagnacci from Forlì, Mattia Preti from Calabria, Bernardo Cavallino from Naples and many others, Caravaggio's style was to spread throughout Italy and beyond the Alps, to Spain and France in particular. The great role of Italian art had been once again renewed.

Alessandro Algardi
Bust of Olimpia Maidalchini
c. 1646. Rome, Galleria Doria Pamphilj.

Gianlorenzo Bernini
The Rape of Proserpine
1621-22. Rome, Galleria Borghese.

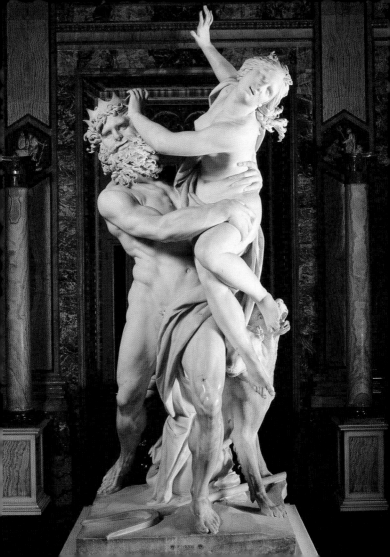

THE CARRACCI FAMILY

Agostino
Bologna 1557 – Parma 1602
Annibale
Bologna 1560 – Rome 1609
Ludovico
Bologna 1555 – 1619

Annibale Carracci
Self-portrait
c. 1585, detail.
Milan, Brera Pinacoteca.

To speak of the Carracci family as a whole is to re-evoke that cultural forum which was the Accademia degli Incamminati (or of Drawing), the lodestone for the artistic life of Bologna, and not for that city alone. Founded in 1582, the Accademia, later re-baptized by the theorist Giovan Pietro Bellori (1613-96) "dei Desiderosi" ... "for the desire they all had to learn", was founded for the express purpose of going beyond that kind of art (painting in particular) which late Mannerism had ultimately congealed into the rules and theoretical precepts of a now vacuous, sophisticated aesthetics. The Carracci school intended to revitalize painting by having theory derive from practice, so that being painting became a committed style of life. Masters, collaborators and pupils were involved in an adventure that put them all on the same level, driven by a single aim: that of breathing life into painting. What made the difference was drawing from life, along with study of anatomy and, obviously, of perspective. The soul of the institution was Agostino, Annibale's elder brother, an ideal master thanks to his vast culture and talent for teaching. In his style echoes of Tintoretto, Correggio and Raphael were blended. Agostino participated in decorating the Farnese Gallery in Rome and in other joint enterprises of the Carracci family. In 1599 he left Bologna after quarreling with his elder brother and remained at the service of Ranuccio Farnese (1592-1622). Annibale is undoubtedly the family genius, the innovator of Italian pictorial language and the least theoretical of the three: "We painters must speak with our hands" he

Annibale Carracci
Venus and Cupid
c. 1592,
canvas.
Modena, Galleria Estense.

The work emulates in a foreshortened view the pose of the *Dawn* sculpted by Michelangelo for the Medici Tombs, but the monumentality which Annibale confers on the figure is softened by a gentle femininity reminiscent of Correggio and the Raphael of the Farnesina.

answered Agostino one day. In addition to the decorations of Palazzo Fava in Bologna (1583-84) and those of the Farnese Gallery (1595-1600), he painted such unrivaled masterpieces as *The Butcher Shop* (1582-83, Oxford, Christ Church) and the *Bean Eater* (1583-84, Rome, Colonna Gallery). Already in their subject matter those paintings renewed the language of art at the end of the century. Ludovico, the cousin of the other two artists, dedicated himself to religious themes in particular.

Annibale Carracci
Landscape with the Flight into Egypt
c. 1604, canvas.
Rome, Galleria
Doria Pamphilj.

The famous lunette is a milestone in the development of 17th century landscape painting in Rome. Even the lesson taught by Poussin (1594-1665) would be incomprehensible without Carracci's masterful precedent. The painting comes from the Chapel of Palazzo Aldobrandini al Corso, where it completed the decoration along with five more paintings of the same form, according to Bellori. Its original collocation is enough in itself to explain the innovatory character of the composition. Instead of concentrating attention on the sacred episode, Carracci sets the Gospel story within a fluvial landscape of gently sloping hills, thus restoring to the event all of the flavor of daily life.

Annibale Carracci
*Venus, a Satyr
and Two Cherubs*
c. 1588, canvas.
Florence, Uffizi Gallery.

A curious episode told in
relation to this painting
clearly illustrates the spirit
of the Carracci Academy.
According to Malvasia
(1616-83), the model who
posed for Venus was
Ludovico, who did not
hesitate to bare his body
down to the hips to favor
his cousin's work. This was
the atmosphere of
collaboration that bound
the members of the
Carracci artistic coalition.
In a symbolic reading , the
satyr and the littler Eros at
the lower left represent
vulgar love, Venus and
Anteros celestial love.

Ludovico Carracci
*The Preaching
of the Baptist*
c. 1589, canvas, detail.
Bologna, Pinacoteca
Nazionale.

The work shows that
turn in the direction
of chiaroscuro and vivid
highlighting already
displayed in the well-known
Conversion of St Paul in the
same Pinacoteca.
The lowered viewpoint
and the insistence on
diagonals, which appear
to mark the direction of
the light, confer great
dynamism on the painting.

Ludovico Carracci
Rinaldo and Armida
c. 1602, canvas.
Naples, Capodimonte
National Museum.

The work belongs to
Ludovico's Roman stage.
He was called to Rome by
Annibale and by him
stimulated to explore the
terrain of a rediscovered
Classicism. A canvas
depicting the same subject,
preserved in the same
museum, is in fact
attributed to Annibale. The
one shown here is thus an
exception of a kind in
Ludovico's production.
Apart from collaboration
with his cousins in Palazzo
Fava at Bologna, where he
painted mythological
subjects, Ludovico
dedicated himself to
religious and devout
subjects, to some extent
anticipating the calm
equilibrium of Andrea
Sacchi (1599-1661), who
was to study his work
thoroughly.

Annibale Carracci
Jove and Juno
c. 1597,
fresco, detail.
Rome, Palazzo Farnese.

The painting forms part of the frieze that runs along the base of the barrel-vault ceiling in the gallery where the most important scenes are frescoed. The stories of four famous pairs of mythological lovers, designed to illustrate the concept of profane love, appear in the panels on the false cornice. The suggestions of Classicism are evident. Annibale looks in one direction toward Raphael's figures in the Psyche Loggia at the Farnesina, while in the other he is inspired by the famous sculpture group of the *Laocoonte*, discovered at Rome in 1506, and already copied by the Florentine sculptor Baccio Bandinelli in about 1520. The head of Jove shown here is clearly inspired by the Hellenistic statue of the Laocoonte.

Annibale Carracci
Apollo and Marsyas
c. 1597,
fresco.
Rome, Palazzo Farnese.

The arrangement of the decoration with the medallion in the center, the atlases in false marble or stucco at the sides and the nudes seated below, clearly reiterates the motifs experimented by Michelangelo in the ceiling of the Sistine Chapel. The mythological episodes represented are taken mainly from Ovid's *Metamorphosis*. The image of Marsyas flayed by Apollo who has defeated him in a musical contest (*Metamorphosis* VI, vv. 382-400) recalls the theme of divine vengeance, already confronted by Raphael in the frescoes on the ceiling of the Stanza della Segnatura.

CARAVAGGIO

(Michelangelo Merisi)
Milan 1571 –
Porto Ercole 1610

Ottavio Leoni
Portrait of Caravaggio
c. 1600, detail.
Florence, Biblioteca
Marucelliana.

It is only in the last quarter of a century that the true artistic and human dimension of Michelangelo Merisi, known as Caravaggio from the town where he spent his childhood, has been recognized. Undoubtedly, the intriguing cliché of "peintre maudit", based on the artist's irregular life, has been hard to die ; so much so that still today the artist is sometimes considered a kind of miscreant, born of a family that was poor and totally without means. The artist's father Fermo Merisi was instead "master of the household" of the Marquis Caravaggio and, as such, belonged to the local minor nobility. The family left Milan because of the epidemic of plague in which the painter's father and paternal grandparents died. The child Michelangelo – given this name because he was born on September 29, the feast day of St Michael – spent his boyhood at Caravaggio until 1584, when he was apprenticed in Milan to the painter Simone Peterzano. Later, after the death of his mother, Michelangelo, then only about twenty years old, went to Rome where he was given hospi-

Caravaggio
*Boy with a Chest
of Fruit*
1591, canvas.
Rome, Galleria
Borghese.

That this is a youthful work can be recognized immediately by the overly tense right shoulder, which however does not spoil the composition. Undoubtedly influenced by the young Merisi's apprenticeship in the Cavalier d'Arpino's workshop, where he dedicated himself to painting motifs of fruit, the basket is the direct ancestor of the *Still Life* now in the Ambrosiana in Milan. Perfectly inscribed within a triangular scheme, the boy, whose features recall those of the young artist, offers to the spectator a triumph of colors that kindle with light the few tints of the composition.

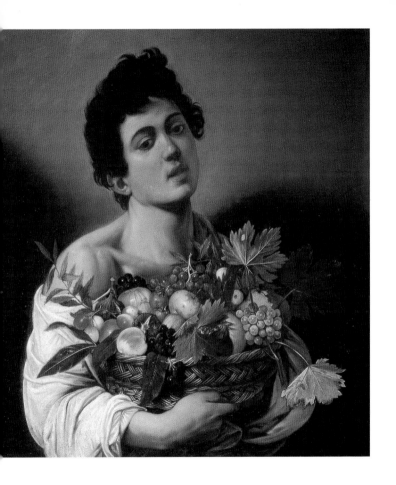

tality and protection by Cardinal Francesco Maria Del Monte, ambassador of the Grand Duke of Tuscany. The Cardinal not only welcomed the artist to his palace and put him in contact with the erudite prelates of the Roman Curia who were to become his patrons, but also procured him his first public commission, that of the Contarelli Chapel in San Luigi de' Francesi. It was in Rome that Caravaggio's artistic and cultural development was perfected. On the one hand he was fascinated by the sophisticated Christological symbolism known to the cardinals and the Roman theologists he frequented, on the other he often ran into trouble with the law due to his violent, rebellious character. From 1603 to 1606, a series of regrettable incidents occurred, culminating in a brawl during which the artist killed a certain Tommasoni. The last years of Caravaggio's life were thus lived as a fugitive, in Naples, Malta, Messina and Palermo, awaiting the pardon that the Pope was to grant him too late.

Caravaggio
The Sick Bacchus
c. 1593-94,
canvas.
Rome, Galleria Borghese.

The painting is a self-portrait showing the painter just recovered from an illness severe enough to require hospitalization in the Hospital of the Consolation in Rome. That the young man portrayed has been ill can be seen from his coloring, his pale face and dry lips. Life in Rome was not easy for Caravaggio at first, before being welcomed to the palace of Cardinal Del Monte. Certainly, eating only salad every evening in Pandolfo Pucci's tavern had not improved his health. But the symbolic decision to present himself as Bacchus, god of life, alludes to a desire for resurrection.

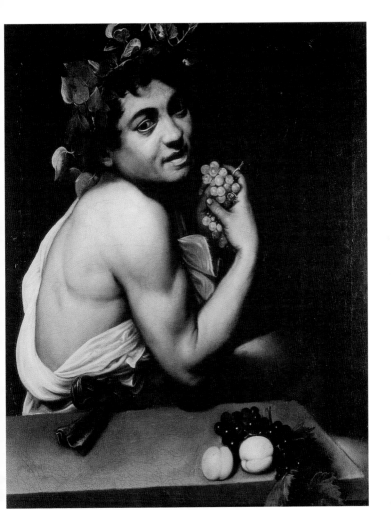

Caravaggio
Judith and Holophernes
1595-96. canvas.
Rome, Galleria Nazionale
d'Arte Antica, Palazzo
Barberini.

According to the story told in the Bible, Judith, by feigning friendliness and compliance, manages to enter the camp of the Philistines, who are about to attack Israel, and the tent of their general Holophernes. Finding him sprawled out on his bed drunk, Judith, the heroine of the Jewish nation, staunchly takes up a saber and beheads him. Caravaggio, like Botticelli and Donatello before him, dramatically portrays the scene as if it were happening in his own day, thus rendering its meaning vitally topical.

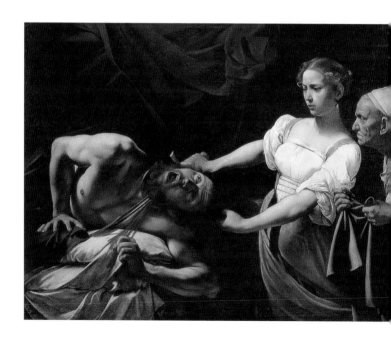

Caravaggio
Medusa

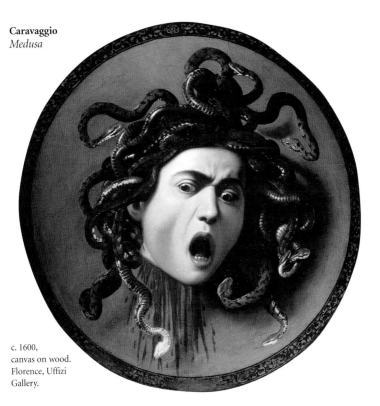

c. 1600,
canvas on wood.
Florence, Uffizi
Gallery.

Painted almost in the style of *trompe-l'oeil*, on a support of canvas-covered wood, the work arrived at the Armoury of Ferdinando de' Medici as a gift from Cardinal Del Monte, the Grand Duke's Ambassador to the Vatican in Rome and Caravaggio's protector. The artist intended primarily to display the horror of Medusa's head only a moment after it has been cut off, spurting bright blood. On closer inspection, the rounded, convex shape of the work is that of a typical tournament shield. The artist is thus alluding to Perseus' shield, on which according to mythology the hero placed the head of the dreadful monster like an ornament.

Caravaggio
The Sacrifice of Isaac
c. 1603, canvas.
Florence, Uffizi Gallery.

Caravaggio synthesizes a profound, complex drama in a single scene, concentrating it into a few gestures. Yahweh has asked the elderly Abraham to sacrifice to him his only son Isaac. The patriarch does not hesitate, and is about to fulfill the will of God. But an angel stops him and a goat offers itself in place of Isaac. All of the diagonals in the composition, consisting of the angel's arm and the patriarch's hand grasping his son's head, lead the gaze to converge on a precise point: the hand holding the knife, placed on the mid-line of the canvas, underlined still further by the grazing light. All of the drama is there, in the gesture suspended between action and non-action.

Caravaggio
Bacchus
c. 1596,
canvas.
Florence, Uffizi Gallery.

As compared to the *Boy with a Chest of Fruit* and the *Sick Bacchus*, the work reveals that the artist is now fully aware of the significance of the symbolism he employs. Bacchus is a paraphrase of Christ, like this one who is offering the cup of salvation. His androgynous appearance is a harmonic image of the union of contraries, male and female. The still life recalls the description in the Song of Songs.

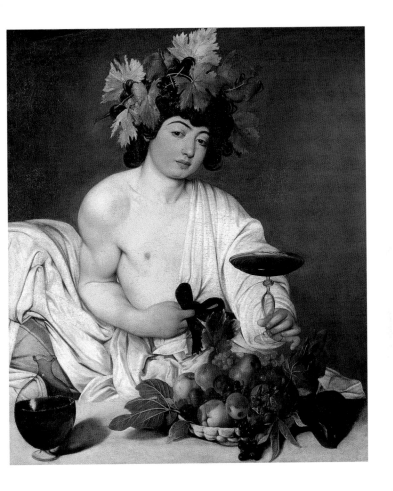

Caravaggio
The Calling of St Matthew
1599-1600, canvas.
Rome, San Luigi de' Francesi,
Contarelli Chapel.

Matthew, the Apostle who
was to become the most
learned Evangelist – the only
one to narrate the Wise
Men's homage to Christ, for
instance – was a publican,
who collected taxes from the
Jews on behalf of the Ro-
man conquerors. As such he
was highly unpopular with
his fellow citizens, and it was
for this very reason that Je-
sus chose him as a follower.

Caravaggio has represented
the moment in which Christ
summons Matthew the sin-
ner, significantly portrayed
at the center of the group,
his hands still soiled by the
money he is counting. Jesus
enters with a beam of light
(since he is the light) the
dark room (life) where
Matthew sits. The publican
gazes at him amazed, won-
dering whether he can really
be the chosen one. The sub-
ject is that of Grace, so sig-
nificant at the time in the
controversy between
Catholics and Huguenots.

Caravaggio
*The Crucifixion
of St Peter*
1601, canvas.
Rome, Santa Maria del
Popolo, Cerasi Chapel.

Caravaggio's art proceeds
toward a simplification and
refinement of the action. As
compared to the excitement
of the *Martyrdom of
St Matthew*, the scene of the
Crucifixion of Peter, painted
slightly later, is marked by
its calm, or it might even be
said, by the premeditated
cynicism with which the
saint is being martyred.
Slowly and deliberately the
executioners ensure that the
cross, planted upside down
(in respect for the cruci-
fixion of Christ), is raised
sturdily, as if it were the
pillar of a roof or the mast
of a ship. Their indifference
seems to intensify the
cruelty of the scene whose
drama is heightened by the
light, the true protagonist of
the work, illuminating the
only face worthy of being
seen: that of Peter. The
others are plunged into
shadow like the souls of
men, prisoners of sin and of
their own incapacity to feel.

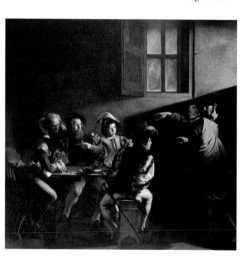

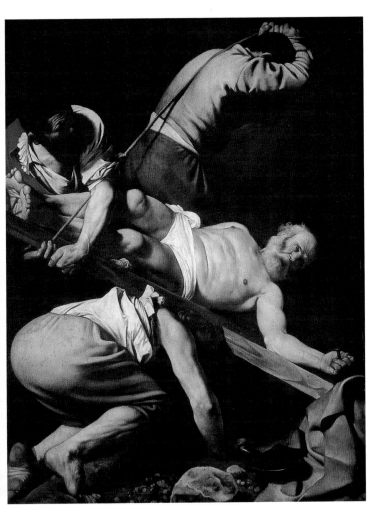

Caravaggio

St Jerome at his Desk

1606, canvas.
Rome, Galleria Borghese.

The artist returns here to
the theme of a man seated
at a desk intent on writing.
A precedent for this had
been the second version of
the *St Matthew and the
Angel* in the Contarelli
Chapel in San Luigi de'
Francesi at Rome. There is,
however, an important
difference between the two
works. In the latter, the
saint is seeking a direct
relationship with the
divine. Gazing upward, he
awaits suggestions

from the angel, who
enumerates the subjects
to be discussed with an
eloquent gesture of
the hands. In the Borghese
painting on the contrary,
the relationship with God
is sought only within the
human condition. This
is thus an introspection.
The saint reflects on
himself and doubtless on
the divine word of the
Holy Scriptures. It is
probable, moreover, that
Caravaggio wished to
show Jerome in the act
of writing the Latin
version of the Bible, edited
by him and known as the
Vulgate.

Caravaggio

Deposition

1602-1604, canvas.
Rome, Pinacoteca Vaticana.

Conceived within the
spiritual climate of the
Oratory of San Filippo
Neri, this great painting,
destined to the Church of
Santa Maria in Vallicella in
Rome, interprets the
feeling of piety that imbues
the Apostolic action of the
Philippines. The figure of
Christ seems a
transposition into painting
of Michelangelo's
sculptural group the *Pietà*,
by which the artist was
deliberately inspired. The
particular viewpoint
confers monumentality on
the cluster of figures,
standing out against an
intense dark background.
The opens arms of Mary of
Cleophas seem the
culminating point of a
long iconographic itinerary
on the theme of the
"lamentation for Christ
dead" which runs from the
Giotto of the Scrovegni
Chapel to Niccolò
dell'Arca.

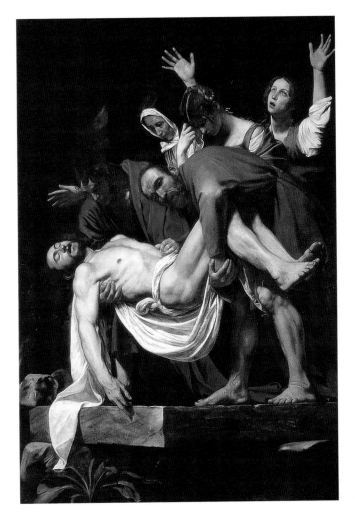

GUIDO RENI

Bologna 1575 – 1642

Guido Reni
Self-portrait
c. 1630, detail.
Florence, Uffizi Gallery.

Guido Reni
*The Slaughter
of the Innocents*
1611-12, canvas, detail.
Bologna, Pinacoteca
Nazionale.

Painted during the artist's
brief stay in Bologna,
which temporarily
interrupted his work on

The young Guido Reni was to have become a musician by profession, since his father Daniele had directed him toward the study of music. His father's choice was justified by the fact that Daniele himself, a musician employed by the city's Signoria, had assured his family a certain well-being and the respect of all. But Guido's passion for painting and art was too strong, and he abandoned his musical studies to enter the shop of the Flemish painter Denijs Calvaert (1540-1619), the head of an important school that was to produce artists such as Domenichino and Francesco Albani. Guido's attention soon focused on the study of Raphael, who was to remain his life-long ideal model. Calvaert's teaching, however, was unable to fully satisfy Guido's aspirations, and at about the age of twenty he entered the Carracci academy. Here he was to remain from 1595 to 1598, tempering with studies from life the classicizing ideal of Raphael, whose *Ecstasy of Saint Cecilia* he copied several

the frescoes in Santa Maria Maggiore (he had left after quarreling with the Pontifical Secretariat), the canvas is unanimously judged to be one of the artist's masterpieces. Originally placed in the Ghisleri Chapel in San Domenico in Bologna, it shows all of Reni's skill at

composition. The artist, exploiting the triangular diagonals dovetailed together, manages to communicate simultaneously both convulsed confusion and motionless tragedy, so overwhelming that not even a scream can issue from the woman's mouth.

Guido Reni
*Portrait of
an Elderly Woman*
c. 1620, canvas. Bologna,
Pinacoteca Nazionale.

Traditionally considered to
be a portrait of the artist's
mother, but without any
documentary basis, the
painting reveals all of
Guido's skill in psycholog-
ical introspection. The half-
bust view and the veil
standing out against the
dark background lead the
spectator's gaze to meet that
of the woman, whose face
seems to open like a flower
between the "petals" of her
collar. The austerity of the
whole arouses a feeling akin
to embarrassment in the
spectator observing this
face which, though marked
by age, shows a hint of past
aristocratic beauty.

times. His talent, rather than winning him friends,
led to conflict within the academy. However, he was
admitted to the Congregation of Painters in 1599.
It was during this period, up to 1602, that he made
frequent trips to Rome, settling there definitively
in 1608. His name was now known thanks to the
famous *Crucifixion of St Peter*, today in the
Pinocoteca Vaticana, painted for Cardinal Aldo-
brandini between 1604 and 1605. The great altar-
piece shows the influence of Caravaggio, which was
to become the other basic component of Guido's
painting. Important commissions were now given
him. The Pope, Paul V Borghese, called for him to
decorate the Palace of Montecavallo and the Basil-
ica of Santa Maria Maggiore. Returning definitively
to Bologna in 1614, Guido was to leave it only for
a journey to Naples in 1622 (frescoes in the Trea-
sury of San Gennaro) and another, in 1627, back
to Rome.

Guido Reni
The Victorious Samson
1611-12, canvas.
Bologna, Pinacoteca
Nazionale.

Designed to hang over the
fireplace in the home of
Count Zambeccari in
Bologna, the painting is a

reinterpretation in modern
key of Michelangelo's
sculptural group the
Victory, from which it
borrows the particular
position of Samson's leg, as
he kicks his defeated
enemy. The artist's mastery
of anatomy appears here at
its finest.

Guido Reni
Atalanta and Hippomenes
1615-25, canvas.
Madrid, Prado Museum.

The work is a perfect copy
by the artist himself of the
better known canvas in the
Capodimonte Museum in
Naples, of which it repro-
duces even the dimensions.
Recorded in the royal
inventories of 1666 as the
work of Guido Reni, it was
instead judged to be a copy
in the 19th century and was
thus relegated to the storage
deposits of the University of
Grenada. Only restoration
conducted by the Prado in
the 1960s has fully
confirmed the authenticity
of the work as had been
indicated by the 17th
century inventory.
Frequently, moreover,
artists replicate a work to
satisfy other requests and to
fill their own coffers.
Certainly this canvas, along
with the one in Naples,
must be considered one of
the masterpieces of the
artist who harmoniously
blended the heritage of
Raphael with that of
Caravaggio.

DOMENICHINO

(Domenico Zampieri)
Bologna 1581 – Naples 1641

Domenichino
Portrait of a Young Man
1603, (presumed
self-portrait), detail.
Darmstadt, Hessisches
Landesmuseum.

omenichino is the diminutive of Zampieri's Christian name, but his real nickname was "the Ox", as he was called by his companions for his stubbornness and constancy. The artist trained in Bologna first with Denijs Calvaert and then at the school of Ludovico Carracci. In Rome, where he went in 1602, he collaborated with Annibale in the Farnese Gallery. His first independent undertaking consisted of frescoes painting in Grottaferrata, where he decorated between 1608 and 1610 the Chapel of the Founding Saints. His career in art was marked by confrontation and conflict with Lanfranco, who went so far as to slander him, and with whom he competed directly in the frescoes of Sant'Andrea della Valle. Disheartened and discouraged, he left Rome for Naples in 1630.

Domenichino
Saint Cecilia
c. 1617-18,
canvas.
Paris, Louvre.

The painting, coming from the Ludovisi collection, portrays Saint Cecilia, patron saint of music, in the act of playing a "psallenda" on a seven-chord "viola bastarda". The subject is justified not only by the interests of the patron (which were, moreover, shared by the artist), but also by the wave of emotion aroused by the finding of Saint Cecilia's body at the end of the preceding century. Domenichino's knowledge of music is revealed by the accuracy with which the instrument is depicted, but also by the fact that the score held up by the angel is a real one.

Domenichino
Triumphal Arch
1609. Madrid,
Prado Museum.

Domenichino
*Saint Mary
Magdalene in Glory*
c. 1620, canvas.
St Petersburg, Hermitage.

That the subject is Mary
Magdalene is shown by the
scourge and the vase
carried by the angel. The
former alludes to
penitence, the latter to the
Magdalene's going to the
Sepulcher to anoint the
body of Christ,
accompanied by the other
two Marys. The worn
garment held up by the
angel in the foreground
alludes to the hermit's life.
The scene in question is
substantially described in
the *Golden Legend* of
Jacopo da Varagine (13th
century): "Every day at the
hour of precisely seven she
was borne aloft by angels
and with her earthly ears
heard the glorious songs of
the celestial armies". The
colors are fresh and
enameled, while the
contrast between the white
blouse and the golden robe
seems to refer to the
liturgical colors of the
saint.

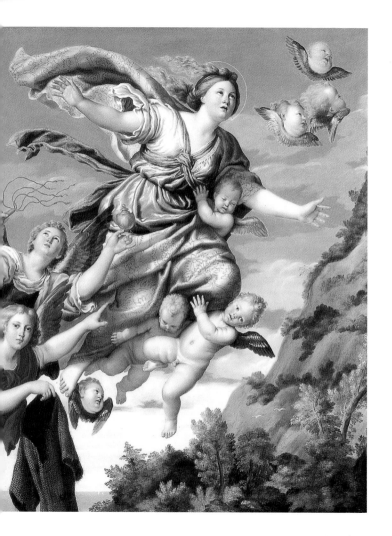

GIOVANNI LANFRANCO

Terenzo (Parma) 1582 –
Rome 1647

It can be stated without exaggeration that the art of Giovanni Lanfranco represents a synthesis of the finest painting tradition of the Po region. A pupil of Agostino Carracci, Lanfranco took from him a love for the Raphaelesque ideal, while from Annibale he draw a firm sense of monumentality, tempered by the softness of Correggio. His closeness to the style of Annibale is demonstrated in particular by a series of drawings, among them an *Apparition of Jove* (Paris, Louvre) which for many years was attributed to the Bolognese artist. After training with Agostino, who involved him in the decoration of the Palazzo del Giardino in Parma, Giovanni then went to work for Annibale, engaged in the undertaking of the Farnese Gallery. His first important commission was for the decoration of the Chamber of the Hermits in the same Palazzo Farnese (c. 1604). In Rome he also worked in collaboration with Guido Reni (frescoes of San Gregorio al Celio, 1608-10) and alone in San Carlo ai Catinari and Sant'Andrea della Valle. From 1634 to 1646 he was in Naples.

Giovanni Lanfranco
Glory of the Virgin
1625-27, fresco, detail.
Rome, Sant'Andrea
della Valle.

This work, Lanfranco's masterpiece, shows the influence of his stay in Parma (1610-12), where he had been able to admire the frescoes of Correggio, of identical subject, in the Duomo. The dome of Sant'Andrea della Valle opens onto a vortex of clouds which seem to draw the spectator up toward the light, here and there broken by spots of color, as in the Virgin's mantle and gown and some of the saint's robes. The viewpoint from which the composition is seen is exaggeratedly lowered.

ARTEMISIA GENTILESCHI

Rome 1597 – Naples c. 1652

Artemisia Gentileschi
Self-portrait
c. 1630, detail of the
Allegory of Painting. Rome,
Galleria Nazionale d'Arte
Antica, Palazzo Barberini.

Only in the last few years have the human vicissitudes of Artemisia Gentileschi been known to the public, through novels and films that have made her a figure of great topical interest, a woman capable of courageously taking in hand her own existence, without stooping to compromise with meanness and hypocrisy. Her life was marked by the scandal of the lawsuit for rape brought against Agostino Tassi Buonamici (1566-1644), a painter from Perugia. A child of art, the daughter of the painter Orazio Gentileschi (1563-1639), Artemisia absorbed from her father the lesson of Caravaggio which Orazio had been among the first to assimilate in the early 17th century, accentuating its realistic components without sparing the spectator any detail. Artemisia worked in the major cities of Italy (Florence, Rome and Naples) and journeyed to England for a brief stay from 1638 to 1639.

Artemisia Gentileschi
Judith and Holophernes
c. 1620, canvas.
Florence, Uffizi Gallery.

The canvas was painted during the artist's stay in Florence. In the Tuscan city where she had taken refuge with her father, a native of Pisa, when the scandal of Agostino Tassi's trial for rape first broke, the painter remained for six years, from 1614 to 1620. Here she was given important commissions, working also for the Medici family, as in the *Magdalene* now in the Pitti Palace. Artemisia arrived in Florence preceded by substantial fame. Her works, known for their fierce brutality, marked a critical change in the Caravaggio style.

360

GUERCINO

(Giovan Francesco Barbieri)
Cento (Ferrara) 1591 –
Bologna 1666

Guercino
Self-portrait c. 1630.

Guercino
*Ammon Driving
Away Tamar*
1649, canvas. Washington,
National Gallery.

Commissioned by Messer
Aurelio Zanoletti, this
painting of moralizing sub-
ject, like the lost *Apollo and
Daphne*, is inspired by the
theme of chastity. Painted
by the artist in his maturity,
it shows those gifts of com-
posure and balance charac-
teristic of the second stage
of his career, when even the
influence of Caravaggio had
been attenuated.

After beginning as a self-taught artist Guercino worked in the workshop of Benedetto Gennari. He also worked for Alessandro Ludovisi, Archbishop of Bologna and later Cardinal, painting four large canvases now in different museums. The artist's great occasion arose when Cardinal Ludovisi was elected Pope under the name of Gregory XV in 1621. Called to Rome to decorate the palaces of the Roman nobility, Guercino frescoed Palazzo Costaguti, Palazzo Lancellotti and, most important of all, Casino Ludovisi, where works such as *Dawn* and *Fame* made his name famous. In 1623 he left Rome to return to his home town, the little Cento, where he soon became a reference point for Emilian painting of the 17th century.

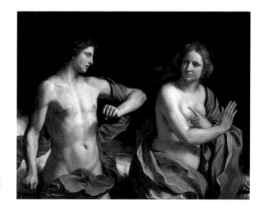

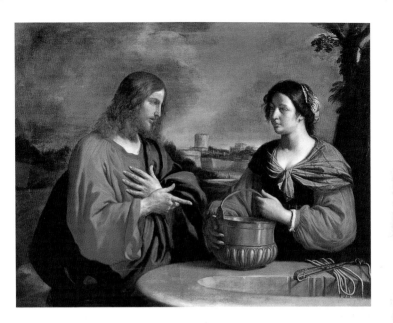

Guercino
*Christ and the
Samaritan Woman*
1647, canvas.
Modena, Banco
di San Geminiano.

The subject, indubitably
one of the most widely
popular in the 17th century,
relates to the later stage of
the artist's career, after the
1630s. The convulsed

excitement of his youthful
works, including the
famous fresco of the
Casino Ludovisi, had now
been replaced by serenity
and equilibrium. The
colors too play a major role
in the composition. Both
Christ and the Samaritan
woman, in fact, wear soft,
flowing robes that balance
each other like the weights
on a scale. Christ's azure

mantle is echoed by the
lapis lazuli of the sky
arching above the Emilian
countryside in the
background. The reddish
cloud, on the contrary,
reflects the tones of the well
and the copper pail held by
the Samaritan woman. The
formal equilibrium is like
that of a chessboard, where
everything has been
calculated.

Guercino
Lament for Christ Dead
c. 1617-18, copper.
London, National Gallery.

Coming from the Borghese
collection, this is another of
the endless reinterpretations
of Annibale Carracci's
canvas known as the *Pietà*
or the *Three Marys*, datable
between 1604 and 1606 and
now too in London (The
Trustees of the National
Gallery). Annibale's work,
which in turn was inspired
by Correggio's *Deposition* in
Parma, was a model for
many painters, and
Giovanni Lanfranco gave a
livid interpretation of it
which calls to mind the
other *Pietà* by Annibale, the
one in the Louvre.
Guercino, instead, avoids
any contaminating
influence and the oblique
body of Christ shows a
precise lineage. Obviously,
there are significant
variations: in place of the
Marys are two angels, and
the accentuation of the
shadows and lights is
reminiscent of Caravaggio,
another inevitable source of
inspiration for the artist.

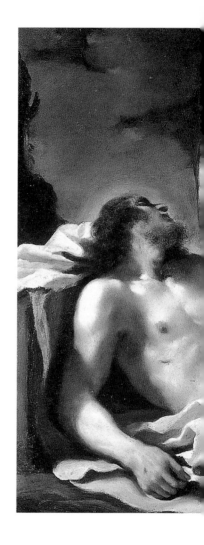

BARTOLOMEO SCHEDONI

Formigone (Modena)
c. 1578 – Parma 1615

As was the case with many other artists of the times, the life of Bartolomeo Schedoni unfolded within the shadow of a noble family. The Duke of Parma and Piacenza, Ranuccio Farnese (1592-1622) invited him to Rome toward the end of the century, and then called him to his service in Parma starting from 1607. Probably trained on the basis of the Mannerism of Niccolò dell'Abate (1509-1571), whom he may have known through the trials for Palazzo Poggi in Bologna, Bartolomeo renewed his style in the light of the Carracci lesson. To this he added the intense luminosity of Caravaggio, which lights up the acidulous tints taken from Mannerism. The result is a style of great personality which can be justly considered one of the interpretations of Baroque that mingles and blends the drama of Caravaggio, the monumentality of Carracci and the soft tones of Correggio, but also the stiffness of Mannerism. Unfortunately the troubled life of the artist, whose violent, quarrelsome nature frequently led him into trouble with the law, prevented any further development of his painting. It is suspected that he died a suicide.

Bartolomeo Schedoni
Deposition
1613, canvas.
Parma, National Gallery.

Coming from the Capuchin Monastery of Fontevivo, not far from Parma, the painting, along with the *Marys at the Sepulcher* now in the same museum, forms part of the decorative program of the building carried out for Ranuccio Farnese in 1605. The extraordinary grazing light emphasizes the volumes and the plastic forms of the personages while simultaneously conferring metallic consistency on the fabrics tormented by folds. All of the great colorist's skill can be seen here in the blinding white of the shroud and the blouses contrasting with the greens and reds of the gowns.

GUIDO CAGNACCI

Sant'Arcangelo di Romagna
(Forlì) 1601 – Vienna 1663

Marino Medici
Portrait of Guido Cagnacci
c. 1752. Rimini, Biblioteca
Gambalunghiana.

Only recently have critics justly reassessed the work of Guido Cagnacci, which was entirely unappreciated by his contemporaries. Cesare Malvasia in fact (1616-83) wrote in his *Lives of the Bolognese Painters* on the subject of Guido Reni: "[...] he worked hard [...] with certain pale and bluish tints mixed among the half tones and the flesh tones; as was later done perhaps too boldly by Cagnacci his pupil". Cagnacci's painting, instead, is warm with the heightened tones of grazing light, rich in the play of shadows and colors. First linked to his native city (where he worked in the Duomo), he went to Venice in 1650, where he assimilated the heritage of Venetian art. Called to Vienna by Leopold I eight years later, he was to remain there for the rest of his life, exerting a major influence on painting beyond the borders of Italy.

Guido Cagnacci
*The Conversion
of the Magdalene*
between 1650 and 1658,
canvas, detail.
Pasadena, Museum of Art,
Norton Simon Foundation.

The crucial point of the scene lies in the two faces in confrontation, which express two different ways of life. Mary Magdalene, entirely devoted to earthly pleasures, lies stretched out on the floor, her face in shadow like her soul. The other woman, her face flooded with light, is her sister Martha who is endeavoring to convert her. Guido exploits the lighting of Caravaggio with his customary skill, imbuing it with further significance. The pearl necklace lying broken on the floor and the other abandoned ornaments are a sign that Martha's words are having an effect.

GIANLORENZO BERNINI

Naples 1598 – Rome 1680

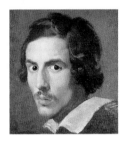

Gianlorenzo Bernini
*Self-portrait of the
Artist as a Young Man*
c. 1623. Rome, Galleria
Borghese.

Painter, sculptor, architect, set designer and playwright, Bernini was considered by his contemporaries the Michelangelo of his time. Pope Urban VIII Barberini (1623-44) even saw in the artist's very existence the sign of a divine project: "A rare man, of sublime intellect, and born by divine disposition, and for the glory of Rome to bring light to the century...", he is reported to have stated. In any case, Gianlorenzo was the most important artificer of the renovation in style of 17th century Italian art, as well as the unwitting founder of the Baroque poetics. The son of Pietro Bernini (1562-1629), a sculptor of a certain talent, Gianlorenzo took his first steps as artist, apart from the wondrous anecdotes related by his biographers, beside his father who, with his acquaintances, could introduce him to the gilded, exclusive world of patrons who were cardinals and popes. At the age of only twenty he began to work for Cardinal Scipione Borghese, for whom he was to sculpt some of the most important groups in Baroque art: the *Aeneas, Anchise and Ascanius* (1618-

Gianlorenzo Bernini
Damned Soul
1619, white marble.
Rome, Spanish Embassy
to the Vatican.

Sculpted for the Spanish priest Pedro de Foix Montoya (1556-1630) who worked in the Curia, the

marble bust of the *Damned Soul* is a companion piece to the one called the *Blessed Soul*, conserved in the same place. The latter portrays a girl, her head adorned with a garland of roses, who is looking on high with an inspired gaze.

The *Damned Soul* could be a self-portrait with exaggerated features contorted in a scream. Of indubitable moralizing intention, the two busts are a modern elaboration of the concept of "a good death" advocated by Catholic doctrine.

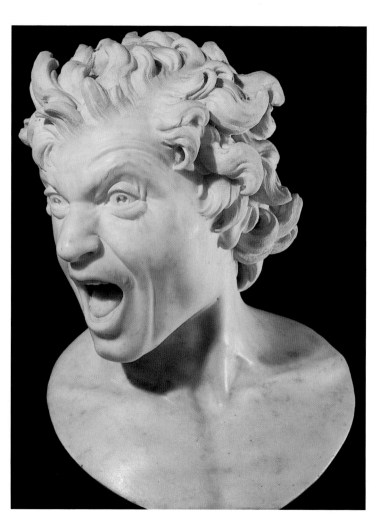

19), the *Rape of Proserpine* (1621-22), the *David* (1623-24) and the *Apollo and Daphne* (1622-25), all now in the Borghese Gallery. At the court of the Cardinal, Gianlorenzo had the chance to meet the future Urban VIII, who commissioned from him in 1624 that Baldachin placed at the center of the transept in St Peter's Cathedral, justly considered the monumental transposition of the ephemeral machines for religious ceremonies which characterized Roman life in those days. From this time on Bernini's career was one success after another. He was appointed master of the Pontifical foundries, superintendent of the Acqua Felice aqueduct and "Architect of St Peter's". A moment of crisis occurred when the bell tower on the façade of the Vatican Basilica collapsed, and only the project for the *Fountain of the Rivers* managed to restore the artist to the favor of Innocent X (1644-55). Under the papacy of Alexander VII (1655-67), Bernini was to create grandiose works such as the colonnade of St Peter's square.

Gianlorenzo Bernini
Apollo and Daphne
1622-25,
white marble, detail.
Rome, Galleria Borghese.

The dating covers a long period due to the fact that Cardinal Borghese decided to commission of the artist, who had already begun the work, a *David* as well. The *Apollo and Daphne* group draws inspiration from Ovid's *Metamorphosis*, where the poet sings of the impossible love of the god for the nymph who, as revealed by her name, preferred to be transformed into a laurel tree rather than yield to his desire. The figure of Apollo echoes that of the *Belvedere Apollo*.

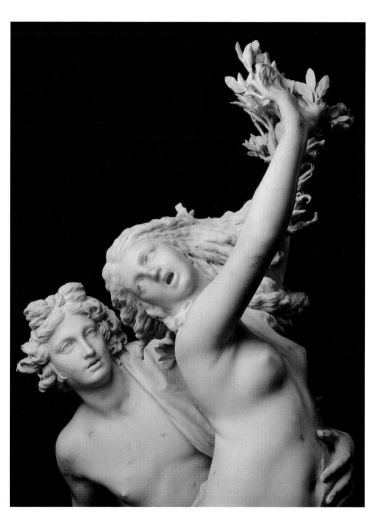

Gianlorenzo Bernini
Fountain of the Rivers
1648-51, travertine
and porphyry, detail.
Rome, Piazza Navona.

The object most highly appreciated by Donna Olympia Maidalchini, the power behind the throne of Pope Innocent X, seems to have been the solid silver model of the fountain given her by the artist. The Pope, for his part, said that he would be able to refuse a project by Bernini only if he had not yet seen it. The occasion for the fountain was created by the discovery of the obelisk, which Bernini then placed above a great open rock surrounded by figures representing the rivers of the four continents known at the time: the *Danube* (illustrated here), the *Nile*, the *Ganges* and the *Rio della Plata*.

Sant'Andrea al Quirinale
by Gianlorenzo Bernini
1658-71, engraving by
Giovanni Battista Falda.
Rome, Biblioteca Casanatense.

Built at the desire of Cardinal Camillo Pamphilj, the nephew of Innocent X, the church was one of the projects commissioned of Bernini by private clients. Distinguished by a strongly projecting prothyreum which vivaciously animates the façade, the building has an ovoid plan.
The interior, with its rich marble inlays, is inspired by the Pantheon, of which its coffered dome is a re-interpretation.

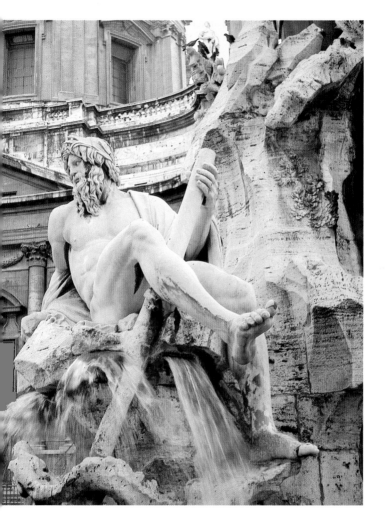

Gianlorenzo Bernini
St Lawrence
1617, white marble.
Florence, Uffizi
Gallery, Contini
Bonacossi Collection.

Sculpted for Cardinal
Maffeo Barberini (the
future Urban VIII), the
statue, which measures a
little over sixty centimeters
in length, is a product of the
artist's youthful stage.
Although small in size the
work displays all of the
monumentality that was to
emerge later in the marble
groups sculpted for
Cardinal Borghese. Closely
linked to the *St Sebastian* in
the Thyssen-Bornemisza
Collection (sculpted for the
same patron), the
St Lawrence re-elaborates in
its pose traditional and 14th
century themes associated
with the art of Michelan-
gelo (as in the *Adam* of the
Sistine Chapel).

Gianlorenzo Bernini
*The Ecstasy
of Saint Teresa*
1647-51, white marble.
Rome, Santa Maria della
Vittoria, Cornaro Chapel.

Built for Federico Cornaro,
the family funeral chapel
is designed like a mystic
stage at the center of
which, in the tabernacle,
is represented the ecstasy
of the saint, compared at
the time to that of St
Francis. The marble group,
one of the masterpieces
of Baroque art, is inspired
by the words of Teresa:
"I saw beside me [...]
an angel in human
form [...] low and most
beautiful [...].
In his hands I saw a long
golden lance [...] with
which he seemed to piece
by heart [...].

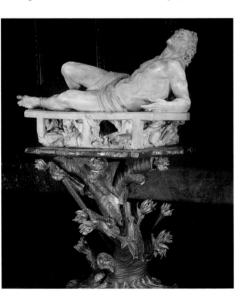

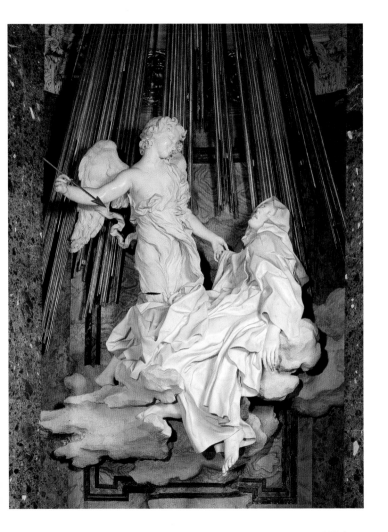

FRANCESCO BORROMINI

(Francesco Castelli) Bisone
(Canton Ticino) 1599 –
Rome 1667

Anonymous
*Portrait of Francesco
Borromini*
c. 1630, detail.

The architect Francesco Borromini indubitably represents the other soul of Italian Baroque art: apparently capricious and far from the balanced artifice of a Bernini. It is no coincidence that the two were fierce rivals. Borromini had worked under Bernini on the Baldachin of St Peter's and both had been assistants to Carlo Maderno (1556-1629) in the construction of Palazzo Barberini. A restless spirit – he was to die a suicide – Borromini designed some of the masterpieces of Baroque architecture. Working almost always in Rome (apart from the Filomarino altar in the Santi Apostoli Church in Naples), he constructed San Carlo alle Quattro Fontane, the façade of the Filippini Oratory, the Church of Sant'Agnese in Agone, the Propaganda Fide Collegiate, and restored the interior of San Giovanni in Laterano.

Francesco Borromini
*Sant'Ivo
alla Sapienza*
1642-62.
Rome.

Originally a chapel annexed to the Papal Archiginnasio (that is, the university, and known for this reason as "alla Sapienza", or Wisdom), the Church of Sant'Ivo was constructed within an established space, the one left by Giacomo della Porta (1553-1602), the architect of the courtyard and the Palazzo della Sapienza. The plan of Borromini's building is inspired by the Salomonic seal of the six-pointed star, a design appropriate to the concept of Wisdom. The phantasmagoric dome is decorated with the visual allegories of Cesare Ripa (1560-1625) which refer to the same sphere: that of the representation of divine Wisdom.

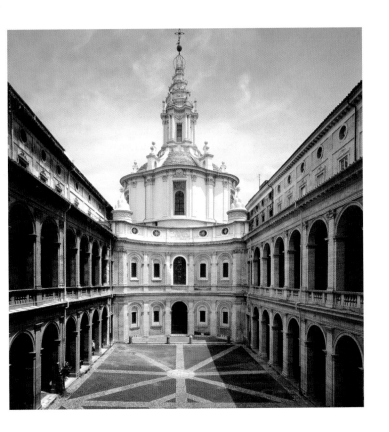

379

BALDASSARRE LONGHENA

Venice 1597 – 1682

Defined by critics as "the only high class alternative to Roman Baroque", the architecture of Longhena renewed the Venetian tradition without betraying it. A pupil of Vincenzo Scamozzi (1552-1616), the architect brought with him the sensitivity acquired in his apprenticeship as sculptor. His first work was that of completing his master's Procuratie Vecchie. He then designed the Church of the Scalzi (1660) and the civic buildings of Ca' Pesaro (1660) and Ca' Rezzonico (1667).

Baldassarre Longhena (attr.)
Façade of the Church of Santa Maria della Salute in Venice
c. 1631. Vienna, Graphische Sammlung Albertina.

Baldassarre Longhena
Santa Maria della Salute
1631-87.
Venice.

Considered by art historians to be the absolute masterpiece of Baldassarre Longhena, the Church of Santa Maria della Salute was erected as a votive temple dedicated to the Virgin to implore the end of the plague of 1630, later recalled by Manzoni in his famous "Promessi Sposi". Completed by Antonio Gaspari in 1687, the building is situated on the point of the Dogana reconstructed between 1677 and 1683 by the architect Giuseppe Benoni. Justly described as a prayer in marble which unites religious devotion and civic piety the church, with octagonal plan and transverse apse, shows a return to Palladio's architectural synthesis, but transposed to Baroque sensitivity. This is apparent in the vitality and imaginative fantasy of original solutions such as the double dome, the connecting volutes between the body of the building and the lantern, and in the swarming proliferation of statues.

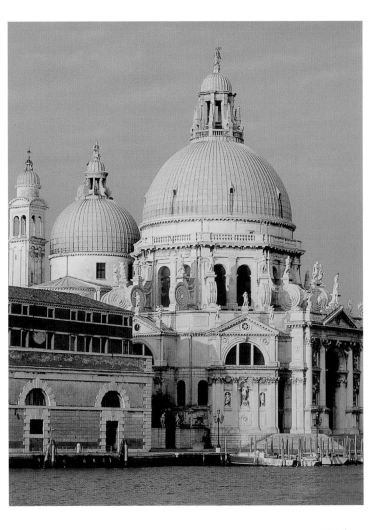

BERNARDO STROZZI

(known as Il Cappuccino
and Il Prete Genovese)
Genoa 1581 – Venice 1644

The artist is one of the outstanding figures in the great 17th century art of Genoa, distinguished by international contacts and by the presence of eminent artists such as Rubens (1577-1640) and above all Van Dyck (1599-1641), who lived there from 1621 to 1626, the year in which he also visited many other Italian cities. Trained in the school of the Sienese Pietro Sorri, a late Mannerist painter, Strozzi later assimilated the lesson taught by foreign artists, as well as by Morazzone (1573-1626) and Cerano (1567/8-1632), to breathe life into a personal, mature, easily enjoyable style of his own. Moreover, Bernardo never banished from his work the traits of Caravaggio, probably assimilated during a hypothetical journey to Rome. Living a rather turbulent life, the artist entered the order of the Capuchin monks and then left it to help his family overcome a moment marked by financial difficulties. In 1630 he left Genoa for Venice, where he was widely successful. He is also known as a painter of still lifes.

Bernardo Strozzi
*Joseph Explaining
Dreams*
c. 1633,
canvas.

The work belongs to the artist's first Venetian period, when he now possessed full mastery of his pictorial means. In it we find the monumentality of Rubens, the skillful luminosity of Caravaggio and the facile drawing ability of Cerano. The painting illustrates, and gives topical significance to, the well-known Biblical episode in which Joseph, the son of Jacob, explains the meaning of the dream of Pharaoh's head steward (Genesis, XL, 9-12). The grapevine that Bernardo has painted in the background of the canvas is itself the subject of the steward's dream.

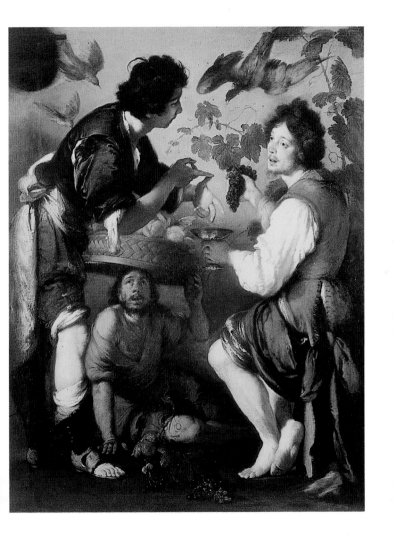

383

BATTISTELLO CARACCIOLO

(Giovan Battista
Caracciolo)
Naples c. 1570 – 1635

The artistic career of Giovan Battista Caracciolo, known as "il Battistello", is a clear demonstration of the driving force and suggestive influence of Caravaggio's painting. Probably trained in the late Mannerist school of Corenzio and certainly his assistant in painting the frescoes at Monte di Pietà, Battistello radically changed his style after Caravaggio's stay in Naples (1606). Attracted by the lesson to be learned from the *Seven Works of Charity* (Naples, Pio Monte della Misericordia Chapel) and the *Madonna of the Rosary* (now in the Kunsthistorisches Museum in Vienna) painted by the Milanese artist in Naples between 1606 and 1607, Caracciolo painted for Santa Maria della Stella the *Immaculate Conception with St Dominic and St Francis of Paola*. Journeys to Rome and to Genoa starting in 1618 rendered the stylistic characteristics of the Neapolitan painter even more articulate, through confrontation with the heritage of the Carracci family and of Guido Reni. He returned to Naples to find himself the unrivaled master in the field.

Battistello Caracciolo
Tobias and the Angel
c. 1622, canvas.
London, Walpole Gallery.

The painting illustrates the Biblical episode of the angel who advises Tobias to take the fish lying on the banks of the Tigris, advice which will be crucially important to the life of the young man and to God's will. The grazing light employed by Battistello in the scene confers an air of mystery to the episode. The artist shows himself attentive to the Biblical text, and the size of the fish is justified by the fact that the beast is reported to have tried to devour Tobias.

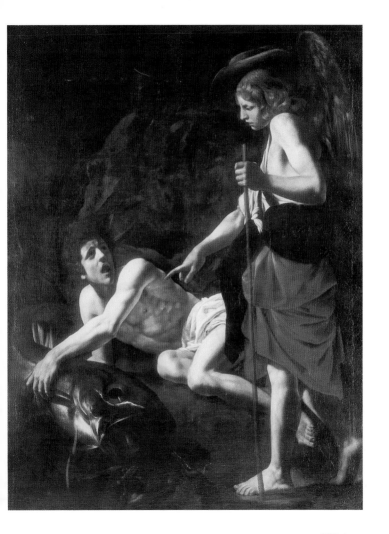

MATTIA PRETI

(Cavalier Calabrese)
Taverna (Catanzaro) 1613 –
La Valletta 1699

Mattia Preti
Self-portrait
1660, detail.
Florence, Uffizi Gallery.

The fact that Mattia was named Knight of Malta when only twenty-nine (1642) caused a sensation, so that he was given the nickname of "Cavalier Calabrese", a name that united his regional origins and the new honor he had received. This recognition was however justified. At that age Mattia had already won a name for himself as painter, journeying to Naples (1630), where he immediately embraced the "Manfredi genre", as Caravaggism was then called, and then to Rome, where he was elected among the Virtuosi of the Pantheon and where he painted frescoes in San Carlo ai Catinari (1642) and Sant'Andrea della Valle. Travelling between Modena and Naples, he moved to Valletta in 1661, where he was to remain, apart from occasional journeys, for the rest of his life.

Mattia Preti
Vanity
c. 1650-70,
canvas.
Florence, Uffizi Gallery.

Purchased in 1951 from a private collection, this canvas may have formed part of a larger composition that has been cut down. The gesture of rejecting riches is accentuated by the inspired gaze and attitude of the subject. The warm natural light that falls from the upper left-hand corner of the painting thus takes on mystic, religious values. The pose and clothing of the figure testify to Mattia Preti's interest in other artists, such as Domenichino whose work he had undoubtedly studied during the periods spent in Rome.

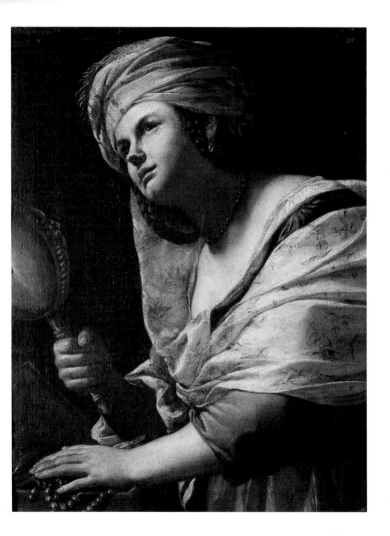

LUCA GIORDANO

Naples 1634 – 1705

Luca Giordano
Self-portrait
c. 1629.
Naples, Pio Monte
della Misericordia.

He was the most versatile and prolific figure in Neapolitan 17th century painting of the second generation, which now took Caravaggism for granted and was turning toward other styles. Son of the copyist Antonio Giordano, Luca worked in the shop of the now elderly Juan Jusepe de Ribera (1591-1652) and assimilated the dramatic intensity of Caravaggio's luminism. Starting in 1652 he traveled through Italy, meeting other painters and viewing their work. In this manner he discovered Correggio and Venetian art, but also Lanfranco and the painters of Emilian tradition; and again, Pietro da Cortona and the Roman figurative sphere. Between 1682 and 1686 he was in Florence, where he frescoed the *Apotheosis of the Medici Dynasty* in Palazzo Medici Riccardi. He stayed for ten years (1692-1702) in Spain, but his last years were spent in his own Naples, where he frescoed the Chapel of the Treasury of San Martino.

Luca Giordano
Flight into Egypt
1684-85, canvas.
Madrid, Santa Marca
Collection.

The particular iconography of this subject (The Flight into Egypt is usually represented as taking place on land)

indicates that the Neapolitan artist was inspired by important works from Roman 16th century art such as Raphael's *Miraculous Catch*, whose cartoon for a tapestry is now in the Victoria and Albert Museum in London. Even the choice of colors

seems to indicate this direction.
Accordingly, we find the return of formal and chromatic elements that, while also common to artists such as Poussin (1594-1665), can be seen as anticipating the airy gracefulness that was to typify Rococo.

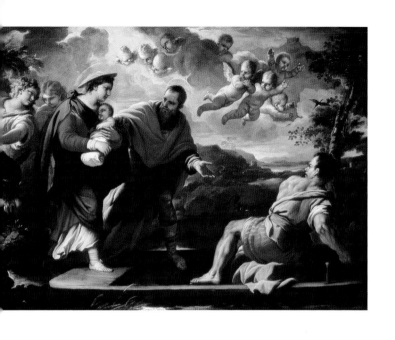

PIETRO
DA CORTONA

(Pietro Berrettini)
Cortona (Arezzo) 1596 –
Rome 1669

Pietro da Cortona
Self-portrait
c. 1630, detail.
Florence, Uffizi Gallery.

P ainter and architect, Pietro represents in both
fields the "third way" as compared to Bernini
and Borromini or Caravaggio and Carracci, which
was to give rise to the phenomenon of "Corton-
ism". Arriving in Rome in 1612 following his mas-
ter, the Florentine Andrea Commodi, Pietro owed
his fortune to contact with the Barberini family, who
commissioned of him major works such as the *Tri-
umph of Divine Providence* (1633-39), frescoed on
the ceiling of the family palace, which had just been
built in what were then the outskirts of the city.
Elected Prince of the Academy of San Luca, the artist
designed the headquarters of the Academy, then sit-
uated in the Church of Santi Luca e Martina. The
Roman churches of Santa Maria in Via Lata (1658-
62) and Santa Maria della Pace (1656-57) are also
his work.

Pietro da Cortona
*Trinity in Glory among
the Saints and Exaltation
of the Instruments
of the Passion*
1648-51, fresco.
Rome, Santa Maria
in Vallicella.

The church is situated at a
short distance from
Sant'Andrea della Valle,
and the interior decoration
of its dome is modeled on
that of the church frescoed
by Giovanni Lanfranco.
Cortona chose, in fact, the
solution of concentric
circles of figures already
experimented by

Correggio. But in his
version the vortex is
accentuated even further.
At the center is a garland of
cherubs surrounding the
Holy Spirit represented in
the form of a dove. In spite
of its spectacular, theatrical
solutions, the painting is
distinguished by balance
and composure.

390

ANDREA POZZO

Trento 1642 – Vienna 1709

Andrea Pozzo
Self-portrait
c. 1680, detail.
Florence, Uffizi Gallery.

Architect, set designer and theorist of perspective, Andrea Pozzo is one of those Baroque artists who, through the force of their brushes and their imagination, broke open the ceilings and vaults of churches to let paradise descend. Not by coincidence, his most famous work is the *Glory of St Ignazio*, in the Roman church of the same name where, if the viewer stands in a certain place and raises his eyes, he will have a marvelous vision of the saints in glory. In 1703 he was called to Vienna where he became a reference point for the German painters of the 18th century. An excellent mathematician, he wrote a treatise on perspective, the *Perspectiva pictorum et architectorum.*

Andrea Pozzo
Perspective Gallery
1681-82, fresco.
Rome, Church of Gesù,
St Ignazio's Chambers.

The problem was both simple and complex: how to render a narrow, irregular space beautiful, ample and attractive. To resolve this problem Giovanni Paolo Oliva, Father General of the Jesuits, called Father Pozzo to fresco the rooms in St Ignazio's house, still open to visitors in Piazza del Gesù. Under the magic of Father Andrea's brush the dark barrel-vaulted ceiling is animated with arches resting on corbels separating scenes from the life of the saint, while on the back wall there even opens out a false chapel with an altar to St Ignazio.

The XVIII Century

Giambattista Tiepolo
*Erection of a Statue
to an Emperor*
c. 1735-36, detail.
Florence, Uffizi Gallery.

In the 18th century Italy, invaded by foreign armies contending its possession, underwent dramatic political/military turmoil and intervals of great poverty. Almost entirely Spanish at the beginning of the century, it was divided between Austria and France in 1763, a date which marks the end of the hostilities. While Venice retained its independence – but only for a brief time: it was to lose it in 1797, when Napoleon granted the city to Austria – Lombardy and Tuscany found themselves directly or indirectly under Austrian control, the Duchy of Parma and the Kingdom of Naples under that of France.

Subjugated by military force and reduced to the rank of diplomatic pawn, Italy nonetheless showed extraordinary artistic and cultural vitality. Never as in the 18th century did Italian artists enjoy international prestige and reputation, being called to this or that court, to this or that sovereign aspiring to make use of their services as painters, decorators, sculptors, and architects. The history of 18th century Italian art is still a history of cities and urban contexts, with a wealth and variety of schools unrivaled throughout Europe. At Bologna the Carracci naturalist tradition still prevailed, renewing itself. In Milan, Bergamo and Brescia, often thanks to the support given the arts by an "enlightened" aristocracy, the premises for a paint-

Filippo Juvarra
The great hall in the hunting lodge of Stupinigi (Turin)
1729-31.

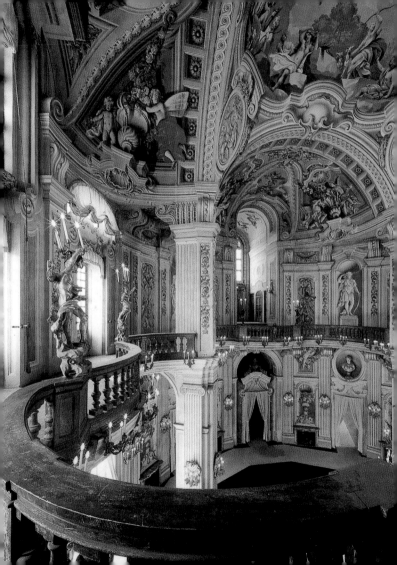

ing of historical and civic nature were laid. In Florence artists from all over Italy, called to court by Ferdinando, the last great patron of the Medici family, were able in the early years of the century to admire Dutch and Flemish art in the Granducal collections, drawing from it lasting inspiration. In Turin expert architects at the service of the reigning family – such as Filippo Juvarra (1678-1736) – were building churches, palaces and splendid country homes modeled on Versailles. In Rome, at about mid-century, new modes of approaching and comprehending antiquity were emerging. In Naples, a city which underwent extensive urban renovation under Charles of Bourbon, the royal manufactures and the porcelain works of Capodimonte were established, at the initiative of this sovereign; for some decades they rivaled those of Sèvres and Meissen. Among the Italian cities Venice was remarkable for its many resident artists and its prosperous art market. It was in this city surrounded by its lagoon that the veduta genre definitively emerged. Accompanied by their consultants, wealthy tourists visited the locales of art, taking home with them souvenirs: images or, more precisely, vedutas. Many painters began to specialize in depicting archaeological sites and architectural complexes, picturesque corners, local characters and costumes. The 18th century was marked by curiosity for what was considered "typical" no less than by interest in fashion and novelty in general, particularly of the technical or alimentary kind – from the colonies of the "new world" coffee and chocolate had begun to arrive. The custom of the cultural journey, the Grand Tour, stimulated the demand for Italian art, both contemporary and from the Renaissance, already considered sublime, especially by the wealthy, cosmopolitan English. The first real international mer-

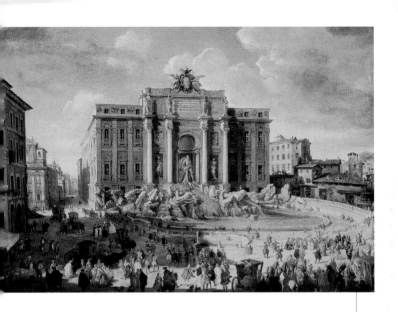

Giovanni Paolo Panini
Benedict XIV Visits the Just Completed Fountain of Trevi
c. 1744. Moscow, Puškin Museum.

Alessandro Magnasco
Pilgrims at Rest
first decade of the 18th century. Florence, Cabinet of Drawings and Prints, Uffizi Gallery, inv. no. 7085.

chants and antiquarians appeared, often collectors themselves. Artists began to present themselves as refined connoisseurs of local tradition, virtuoso interpreters of an elect repertoire (without hesitating to indulge in plagiarism and pastiches: Sebastiano Ricci, a Venetian artist of the generation preceding that of Tiepolo, won fame and success by painting in the "Paolesque manner", that is, by imitating Veronese). The most successful workshops took on large, well-organized dimensions. Several persons could participate in a painting, sharing in the work by depicting a background of landscape or architecture or by adding figures. Existing motifs taken either from tradition and or from a project previously signed by the head artist in the shop were utilized. Optical instruments were sometimes used, in the attempt to learn more about natural phenomena. Full mastery of the art of *chiaroscuro* and perspective was the artists' goal. It is known that, already before Canaletto, Carlevarijs and Crespi were using the *camera ottica*, a device that gave the artist greater control over his subject, making it easier to represent it in precise detail. Interestingly enough, the study of nature was conducted at times with a subtle taste for the deformed image, the visual caprice, in a word, for magic: "the lens having been reversed", wrote Roberto Longhi in regard to Crespi, "[we wait for] some bizarre, extreme 'luministic' effect to appear on the screen, leaping about on the little stage of already prepared gestures". Any succession of images and figures, such as the one presented in this chapter, clearly shows how 18th century Italian art possesses traits less limpid and rational than the luminous views of Canaletto and his nephew Bernardo Bellotto would seem to indicate. Elusive touches, even sinister at times, appear in compositions of often disturbing beauty. The

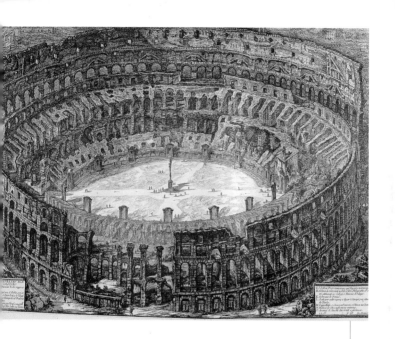

Giovanni Battista Piranesi
Interior of the Coliseum with Aedicules for the Via Crucis
1746-50. Rome, Casanatense Biblioteca.

Canaletto
View from Ca' Bon Looking Toward Ca' Foscari
from the *Notebook of Drawings*, 1730 c. Venice, Gallerie dell'Accademia, c. 17 v-18.

Bernardo Bellotto
*View of the Tiber
at Castel Sant'Angelo*
c. 1742. Detroit, The Detroit
Institute of Arts, Gift of
Mr. and Mrs. Edgar B. Withcomb.

prevailing approach however is inquisitive and caustic, and a glimpse of this can be seen even in the highly respectful society chronicles of Pietro Longhi.

There is an air of kinship in fact, between the *pittori pitocchi* of Magnasco; the beggars, the lame, the poor peasants of Ceruti; and the "entertainment for boys" of Giandomenico

402

Tiepolo, drawings illustrating the life of Pulcinella done while
the Napoleonic armies were already conquering Italy, shoot-
ing their adversaries (a circumstance to which Tiepolo alludes
in a drawing where Pulcinella is executed by a firing squad);
an air of kinship and a kind of fluctuation between farcical
laughter and a sense of civil, human desolation.

FRA GALGARIO

(Vittore Ghislandi)
Bergamo 1655 – 1743

Fra Galgario
Self-portrait
1732. Bergamo, Carrara
Academy.

His father's pupil, a quadraturist and veduta painter, Fra Galgario was apprenticed first at Bergamo, then at Venice, where he arrived in 1675 to don the habit of a Minimite lay brother. After a return to Bergamo, he was in Milan with the German painter Salomon Adler; then in Bergamo definitively as Minorite friar in the monastery of San Galgario – the saint whose name he took. Particularly appreciated, along with Ceruti, by 20th century historians and critics – he is considered one of the "Lombard painters of reality" – Fra Galgario renewed the tradition of great 16th century Bergamo portrait painting (his model was above all Moroni), revealing fine psychological and moralistic gifts. His portraits compose a gallery of characters: the gentlemen, the priest, the courtier, all portrayed with a keen, sober spirit of observation.

Fra Galgario
*Gentleman with
a Cocked Hat*
c. 1737, canvas.
Milan, Poldi Pezzoli Museum.

The portrait of a knight of the Constantinian order – as shown by the emblem appearing on the metal corselet – this is perhaps Fra Galgario's most famous work, admired for a number of reasons: the elegant play of tonal variations on the dominating blue-green color scheme; the execution of the lace-like silver braiding adorning the gentlemen's hat and justicoat; the pungent irony with which the artist, almost anticipating Goya's satirical genius, has caught the arrogant vacuity of the unknown knight. Certainly in the *Gentleman* Fra Galgario displays his own ability for "mellow painting without those borders that make the paintings of many seem dry and harsh", as already acknowledged by his contemporaries.

FRANCESCO SOLIMENA

(known as Abbot Ciccio)
Canale di Serino (Avellino)
1657 – Barra (Naples) 1747

Francesco Solimena,
*Apelles painting
Pancaspe*
c. 1685, detail.
Detroit, The Detroit
Institute of Arts.

Solimena's career began in his father's shop. The artist's first models, in addition to his father Angelo, were Stanzione and Lanfranco. In Naples between 1689 and 1690, engaged in decorating the Sacristy of San Paolo Maggiore, Solimena had the chance to see the innovations introduced in painting by Luca Giordano. In his compositions from this period a radiant light envelops and dissolves the bodies. In dealing with sacred subjects he did not hesitate to arouse profane affections. Near the end of the century he was in Rome, where he met Maratta and the classicists linked to the Academy of France. The artist's Baroque approach underwent an abrupt change. Returning to Naples, he established a successful academy of painting which taught, strictly according to the classical tradition, that "painting is nothing other than drawing".

Francesco Solimena
Self-portrait
c. 1715-20, canvas.
Naples, San Martino
Museum.

Austere and inspired, Solimena portrays himself in the guise of an abbot as well as, recognizably, that of a painter. Piety and moral scruples, he seems to saw, must be accompanied by the search for beauty: "studying the natural",

states one of the principles dear to the artist, "one must reproduce what he sees; but in transferring it to paintings, it must be softened and made courteous, noble and select". The artist's left hand grasps a folder for drawings, his right a stylus; in the background is a still uncompleted canvas. A female figure, soave and chaste, seems to exhort an oddly winged male figure to seek the ideal.

SEBASTIANO RICCI

Belluno 1659 – Venice 1734

Sebastiano Ricci
Self-portrait
c. 1706, detail. Florence,
Uffizi Gallery.

At the age of fourteen Sebastiano was already an apprentice in Venice. Active at Bologna and Parma in the 1680s, he was in Rome in 1691; back in Venice in 1696, at Vienna in 1702 and immediately afterward in Florence. Returning once more to Venice, he stayed there until his departure for England where, between 1708 and 1712, he painted a series of mythological works for illustrious patrons. After a brief stay in Paris he returned definitely to Venice. A successful artist, Ricci was the eminent interpreter of the new "chiarista" tendency characteristic of Venetian painting in the late 17th and early 18th centuries; an approach favorable to clear and luminous painting, reminiscent of Veronese in the lighter ranges of color, the refined architectural or Arcadian/pastoral settings, and the scenographic compositions.

Sebastiano Ricci
The Toilette of Venus
w.d., canvas.
Berlin, Staatliche Museen.

In his paintings of the female nude Ricci shows himself to be a virtuoso of painting and a brilliant connoisseur of the Venetian Renaissance tradition, of which he imitates, casually and self-confidently, the sensual, pleasantly mythological repertoire. The figures are placed in magnificent architectural and natural settings, among opulent gowns, patrician furnishings and decorations. The painter works with rapid, sure brushstrokes. His use of pearly white and yellow-brown tonalities confers a particular luminosity on his canvases. For the drapery the artist employs pure colors in the manner of the great 16th century painters, Titian and Paolo Veronese in particular.

GIUSEPPE MARIA CRESPI

(known as Lo Spagnolo)
Bologna 1665 – 1747

Giuseppe Maria Crespi
Self-portrait
1708, detail.
Florence, Uffizi Gallery.

A highly cultivated artist whose training was complex and prolonged – he visited Parma, Urbino, and Venice in voyages of study; was in Florence between 1708 and 1709, called there by the Grand Duke Ferdinand – the artist owes his curious nickname to the style in which he dressed as a youth. Among the greatest Italian painters of the times, Crespi is appreciated for his genre scenes, which variously reflect his knowledge of 16th century Venetian tradition, of Carracci, Guercino, and the Northern painters. Unusual angles, a wealth of bizarre details, refined tonal harmonies and convincing effects of *chiaroscuro* are combined in compositions surprising for their sophistication masked by an apparent simplicity. Active also as painter of history and mythology, he was the father of painters and the head of a successful school of painting.

Giuseppe Maria Crespi
The Flea
c. 1715, copper.
Florence, Uffizi Gallery.

We do not know whether this small painting on copper depicts an episode from the "life of a singer" which the artist painted for an English client, or "the miserable life of a woman of ill repute", as his son Luigi was to write. In either case, the taste for scenes of "vulgar" nature which Crespi shared with Northern artists of bambocciade tradition is clearly evident.

Giuseppe Maria Crespi
Cupid and Psyche
1707-09,
canvas.
Florence, Uffizi Gallery.

The theme is taken from
Apuleius: Psyche,
overcome by curiosity,
holds a lamp to the face of
her mysterious lover,
Cupid, to know what he
looks like at last. In doing
so she violates a precept:
and will lose her love.
Crespi's nocturnal scene
can be seen as an excellent
neo-Mannerist exercise:
long-limbed adolescent
nudes caught in a twisting
movement, lost profiles,
golden hair, blond
complexions. An extreme
looseness of execution
gives fabrics the softness
and volatile nature of
feathers. Cupid's wing,
half in full light, becomes
almost the emblem of a
mode of painting in
which a careful study of
natural appearances is
resolved on the level of
magic and of style.

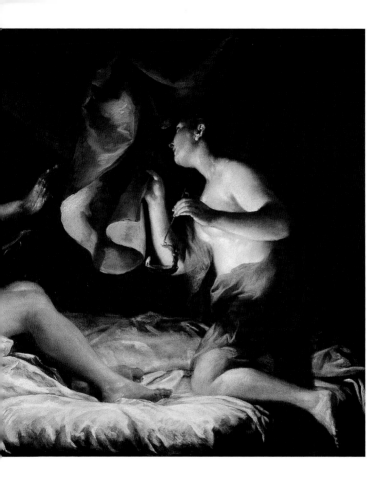

ALESSANDRO MAGNASCO

(known as Il Lissandrino)
Genoa 1667 – 1749

Alessandro Magnasco
Capuchins
around the Hearth
w.d., canvas.

These "friars" scenes
appear recurrently in
Magnasco's work, almost
as if to satisfy his bizarre,
discerning taste. Painted
with quick, virtuoso
brushstrokes, the friars are
shown in the quiet
industriousness of their
days or as they pause to
rest, at the refectory
perhaps or, as in the case of
the *Capuchins around the
Hearth*, around a fire lit in
a dark, dank room. In
contrast to the paintings of
monastic life, crowded and
often grotesque, are those
of solitary hermits. Should
the ascetic monk,
emaciated and led into
temptation, be seen as the
artist's *alter ego*?

Training while still a boy with his father Stefano, he was in Milan by 1677, collaborating with Filippo Abbiati. He launched a production of genre scenes, which were to make him famous as painter of figures, with imaginary veduta and landscape artists (among others Antonio Francesco Peruzzini, Clemente Spera and Marco Ricci). At Florence for long periods between 1703 and 1711, he viewed attentively Callot and the Dutch and Flemish painters of the Grand Ducal collections. He painted episodes from the lives of the poor and of courtiers. He lived in Milan up to 1735. In contact with the families of the "enlightened aristocracy", he concealed satirical intentions – satire against ignorance, lack of reflection, prejudice, greed – in images that are striking for their pictorial motifs. His last period of activity, according to 18th century biographers, was spent in Genoa.

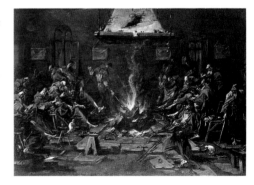

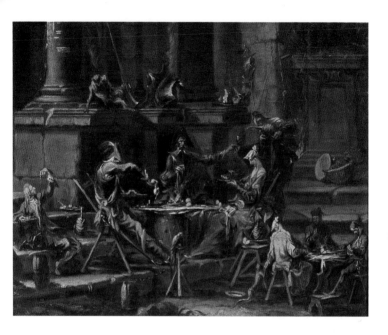

Alessandro Magnasco
The Gypsies' Meal
c. 1710, canvas.
Florence, Uffizi
Gallery.

Magnasco's genre scenes are for the most part images of crowds, with a great number of personages appearing as if called onto the stage.

A reference to the *commedia dell'arte*, although indirect, seems appropriate: brilliant improvisers, *capocomici* it might be said, tread the boards exhibiting their repertoires. Almost invariably, we have the melancholic, the braggart, the fellow guests, the hostess, the old monk, the waiter, the beggar, the

zealot and the soldier. But each of these recites for himself: the action is fragmentary and disassociated, as in the *Gypsies' Meal*, where the personages are eating, ordering wine from the waiter, feeding animals. At the center of the composition a parrot on its perch turns to gaze at the spectator.

ROSALBA CARRIERA

Venice 1675 – 1757

The artist's early training may have consisted of preparing embroidery patterns for her mother. Portraits painted in pastels gave her widespread renown. Commissioned by the aristocracy and by foreigners visiting Venice, she was an interpreter of the new orientation in Venetian painting. Skillful at small formats (also portraits for tobacco boxes, or on ivory) she conferred grace, courtesy and delicacy on her models. In Paris around 1720, she met Watteau and became member of the Académie Royal de Peinture. She left an important collection of letters.

Rosalba Carriera
Self-portrait
1709, pastel on paper.
Florence, Uffizi Gallery.

Rosalba portrays herself in professional stance, holding up to the observer a portrait she has painted of her sister Giovanna. She also indicates a special skill of her own: the pastel rests on the paper precisely at the complex embroidery adorning the collar of her sister's dress. Lightness and mobility of touch, extreme attention to the changing light, subtle psychology: these, Carriera seems to say, are the requisites of the excellent portrait painter.

Rosalba Carriera
Girl with a Parrot
c. 1720, canvas.
Chicago, Art Institute.

Female figures with small animals are not rare in Rosalba's work. While the presence of cats or parrots may be seen as a sly homage to woman's sensuality, it also provides an expedient. In the *Girl with a Parrot* the bird has managed to bare the girl's breast, daring to do what she herself would never have dared. The candor of the skin, the shapely bosom, are thus exposed to admiration without violating the rules of modesty.

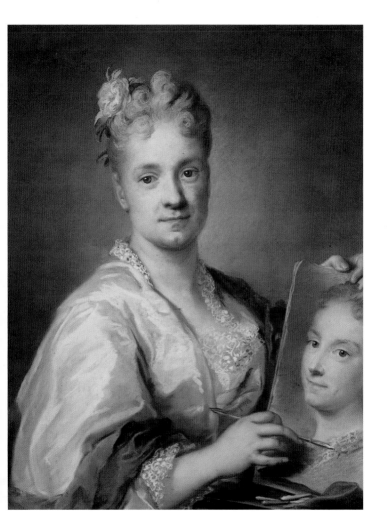

LUCA CARLEVARIJS

Udine 1663 – Venice 1730

Bartolomeo Nazzari
Portrait of Luca Carlevarijs
w.d., detail. Oxford,
Ashmolean Museum.

The artist was in Venice, orphaned of both parents, already by 1679. A journey to Rome first mentioned by his 19th century biographers probably took place around 1690. The impact of viewing Gaspard van Wittel's oriented his style in a new and lasting manner. In contact with Northern veduta artists active in Venice, such as Eismann, probably his master, and Stom, Carlevarijs was one of the first in Venice to abandon the tradition of the imaginary veduta. In 1703 he published his first collection of etchings, signed and dated. It contained 104 "buildings and scenes of Venice drawn, placed in perspective and engraved". Striking for his topographical objectivity, Carlevarijs shows himself equally skillful in the distribution of light and shadow. The evocative *chiaroscuro* effects of his compositions often reveal a careful study of Claude Lorrain.

Luca Carlevarijs
St Mark's Square
c. 1720, canvas.
Madrid, Thyssen-Bornemisza
Collection.

Painted at times with the aid of the *camera ottica*, Carlevarijs' vedutas are distinguished by the scrupulous precision of his rendering of buildings and the great quantity of human types and caricatures depicted. In *St Mark's Square* the foreground is crowed with splendidly dressed ladies and gentlemen and masked figures. A gentlemen turns toward us – dressed in red and beige, he wears a great wig – while a poor woman enters the scene from the right. The light falls abruptly and unevenly, as if passing between one cloud and another after a storm. In the background a *commedia dell'arte* performance is being held.

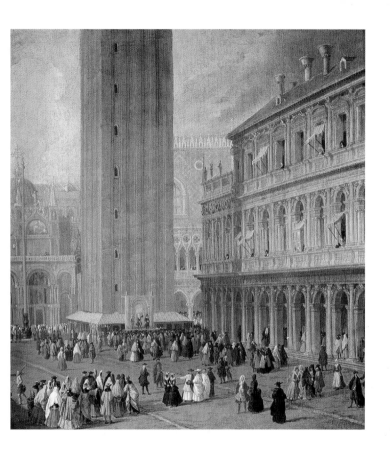

GIOVAN BATTISTA PIAZZETTA

Venice 1683 – 1754

Giovan Battista Piazzetta
Self-portrait
c. 1720.

Son of a modest sculptor, Piazzetta was at Bologna in the early years of the century, where he met Crespi. Settled in Venice starting from 1711, he was first the proprietor of a successful workshop and later, starting in 1750, the head of the school of painting that was to become the Venetian Academy. Renowned for his large religious compositions, he also painted pictures of medium-sized format, portraying mythological subjects or genre scenes. The "great genius of *chiaroscuro*", as he was called, in 1733, by Antonio Maria Zanetti, was not however indifferent to the new trends emerging on the Venetian scene. The attention with which Piazzetta viewed Sebastiano Ricci and the young Giambattista Tiepolo is revealed especially in works from the third and fourth decades of the 18th century, more strongly marked by clear tonalities and great luminosity.

Giovan Battista Piazzetta
Young Sculptor
w.d., canvas.
Springfield, Museum
of Fine Arts.

Skilled at presenting his figures enveloped in an intense, shadowy *chiaroscuro*, in portraits Piazzetta chooses for his models attitudes that are either boldly arrogant (as in his self-portraits) or introspective. The lowered viewpoint adopted by the artist for the *Young Sculptor* confers on the youth, who wears an ostentatious fur hat, reserved elegance and an unexpectedly solemn air.

Giovan Battista Piazzetta
Rebecca at the Well
c. 1738,
canvas.
Milan, Brera Pinacoteca.

The Biblical episode
becomes, for Piazzetta,
a pretext for depicting
a pastoral scene in the

warm, radiant light
of a last Spring or
Summer morning.
The oblong shape of the
composition is typically
neo-Veronesian, as are the
twisted, serpentine
postures of the figures
and their sinuous attitudes;
and neo-Veronesian is
even the feminine type

chosen by Piazzetta for
the personage of Rebecca,
blond, sensual, of whitest,
almost alabaster
complexion. The heads
of animals and some
objects placed in evidence
– the vase, the cord, the
well, the shepherd's stick –
create a lively rustic frame
for the main scene.

GIAMBATTISTA TIEPOLO

Venice 1696 – Madrid 1770

Giambattista Tiepolo
Self-portrait
1753, detail from the frieze
of *Europe*. Würzburg,
Residence.

The son of Orsetta and Domenico Tiepolo, "merchant of naval supply shops", Tiepolo was both artist and adept, sophisticated entrepreneur, the owner of a large workshop engaged in important projects. Two of his seven children, Giovanni Domenico (Giandomenico) and Lorenzo worked with him. Active in Venice, Udine and Milan, Tiepolo preferred the *a fresco* execution of large figurative programs to the individual painting. He painted neither portraits nor vedutas, genres that were particularly in vogue at the time, remaining faithful to the great Venetian decorative tradition – his knowledge of Veronese was profound. At Würzburg between 1750 and 1753, he worked on the Residence of the local Bishop-Prince. In 1762 he went to Madrid, called there by Carlo III, where he was to die after having experienced the insidious rivalry of the younger neo-classical generation.

Giambattista Tiepolo
*The Meeting
of Antonio
and Cleopatra*
c. 1745-48, fresco.
Venice, Palazzo Labia.

Commissioned to paint the walls of the Labia family's Venetian palace, Tiepolo collaborated on this occasion with Girolamo Mengozzi Colonna, a painter specialized in depicting complex architecture in *trompe-l'oeil* or, in the terminology of the times, an expert "quadraturist". The two most famous lovers in Roman history advance in the foreground amid a colorful crowd of pages, elders of the court and servants. They are seen through a stately arch held up by columns and pillows – arch, columns and pillars painted by Mengozzi Colonna. At the upper right, visible only in part, are sails blowing in the wind, rigging, and masts of ships with young sailors climbing aloft.

Giambattista Tiepolo
Africa
1752-53,
fresco, detail.
Würzburg, Residence.

In July 1752 Tiepolo submitted to the Bishop-Prince a project for the ceiling of the Residence: a fresco representing the four continents along the sides surrounding Apollo, the sun god, in glory above them. It was an extremely arduous undertaking due to the immense surface to be frescoed – over 600 square meters; but the theme, relatively rare, left the artist great freedom of imagination. The fresco was completed in November 1753. In the friezes of the continents Tiepolo lavished all of the elements – costumes, flora, fauna, archaeology – most vividly characteristic of the lands known at the time.

Giambattista Tiepolo
Africa
1752-53,
fresco, detail.
Würzburg, Residence.

The allegorical personification of Africa rides on camel-back, regal and imposing; behind her appears the face of a servant. In the foreground a black page, viewed from the back, seems to genuflect before Africa. He holds a parasol, burns incense, and carries a quiver. A great azure vase rests on the ground beside two half-hidden elephant tusks. The edge of a precious fabric hangs from the *trompe-l'oeil* cornice. The attributes of Africa are goods: spices, arms, silk and ivory. In the friezes of the continents the lively commerce between distant peoples is reflected.

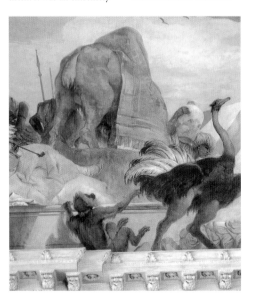

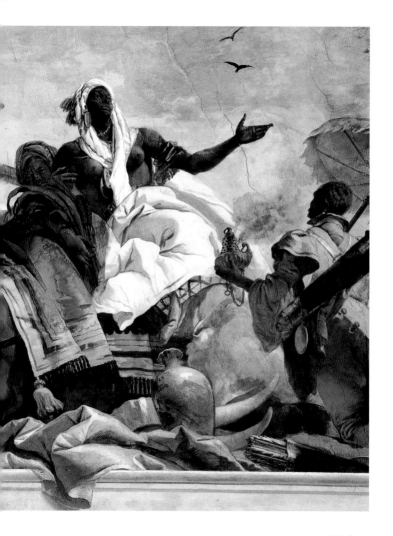

CANALETTO

(Giovanni Antonio Canal)
Venice 1697 – 1768

Antonio Visentini
Portrait of Canaletto
before 1735, engraving by
Giovan Battista Piazzetta
for the frontispiece of the
*Prospectus Magni Canalis
Venetarium*, containing
engravings by
Canaletto.

An internationally famous artist, Canaletto was eminently responsible for the success of the veduta. A child of art – his father, Bernardo, was a theatrical painter – he himself began as set designer. In 1719, however "annoyed by the indiscretion of the dramatic poets", writes Antonio Maria Zanetti, a contemporary historian, "he solemnly excommunicated the theater and left for Rome", where he was to live for one or two years. Having viewed the work of the Flemish veduta artists, he was back in Venice again just after 1720, now a "painter of vedutas", choosing for his subjects famous monumental sites such as St Mark's Square or the Grand Canal, but not neglecting to document the daily life of the city. In great demand by English collectors, he was in London in 1746 where, apart from periodic returns to Venice, he was to live for almost a decade.

Canaletto
*The Marble
Workers' Square*
c. 1730, canvas.
London, National Gallery.

In the veduta known as the *Marble Workers' Square* Canaletto chose not to depict one of the city's elegant sites but rather a small, obscure square, surrounded by the modest dwellings of artisans and the shops of marble workers, most of whom were probably engaged in the reconstruction of the Church of San Vitale. The clear light of early morning on the lagoon touches the fronts of the

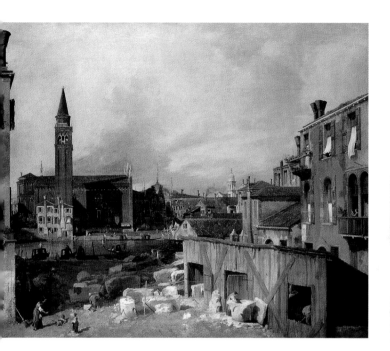

houses, the wooden beams
of the artisans' shops,
the laundry hung out to
dry, the bell towers and
the marble.
The genre scenes are
strikingly vivacious.
Gondoliers are awaiting
passengers, women
are spinning on their
balconies or looking out
of windows, children are
playing in the courtyard
below, stone-workers
are surprised in the act
of cutting and rough-
hewing great blocks
of marble. In the
background idlers are
resting, seated or half-lying
on the steps leading down
to the wharf.

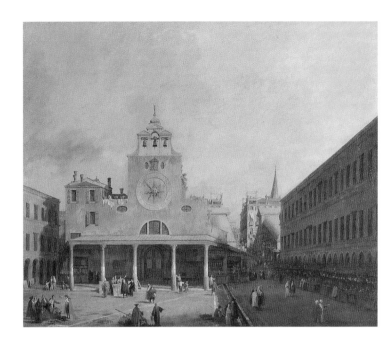

Canaletto
San Giacomo di Rialto
c. 1730, canvas.
Dresden, Gemäldegalerie.

In painting his vedutas Canaletto utilized the *camera ottica*. A precursor of the camera, it was a box with mirrors which projected the subject, through a series of reflections, onto a sheet of paper, allowing the artist to "copy" directly from the real image. It is surprising how the use of a simple optical device yields images pervaded by an intense, radiant light, clearer than that of nature. Canaletto, wrote a contemporary admirer, "universally amazes everyone in this country who sees his works, which are similar to Carlevari's but in which the shining of the sun can be seen".

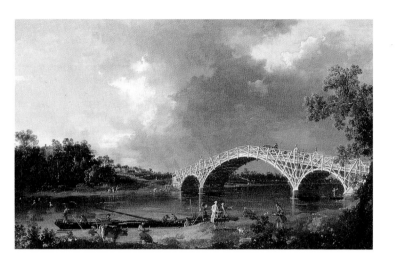

Canaletto
Old Walton Bridge
1754, canvas.
London, Dulwich Picture
Gallery.

"Done in 1754 for the first and last time with all greatest attention" – wrote Canaletto on the back of the canvas – the picture, owned by a friend of the Consul Joseph Smith, depicts a wooden bridge over the Thames about twenty-five miles from Westminster, which no longer exists today.

Supported by three arches, the Old Walton Bridge has a light structure made of painted wood. It seems to vibrate in the luminous country landscape extending all around, bathed in the light falling from above.

Canaletto
*The Grand Canal
with the Church
of San Simeone Piccolo
looking toward the
Fondamenta della Croce*
c. 1729-34, canvas.
London, National Gallery.

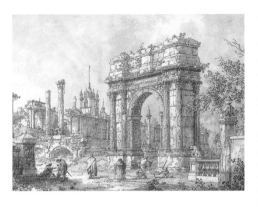

Canaletto
*Caprice with
Roman Triumphal Arch
and Ruins*
after 1748,
pencil, pen, ink and
water color on paper.
New York, The
Metropolitan Museum
of Art.

The triumphal arch is that of Pola, an archaeological site on the Istrian peninsula. Canaletto had never been there; perhaps he took the motif of the arch from an engraving by Piranesi. Finely executed in every detail, the drawing shows columns and ruins of other arches around the main one. An artist sits intent on his drawing while in the background, at the lower right, appears a glimpse of the sea and the mast of a ship.

Daily traffic, the movement of objects and persons, commerce, all take place on the crowded waters of the Grand Canal. Along the banks rise majestic Christian churches and patrician palaces. Canaletto's Venice is not exclusively antiquarian. The city lives its present-day life, vivacious and laborious, rich in initiative. A multiplicity of minor episodes enhances the fascination of the artist's vedutas. Strollers meet, mothers are talking from the thresholds of their houses while children play, church-goers distribute alms to the beggars waiting on the stairway, and little flower-vases decorate the balconies as they had in the past, in the paintings of Carpaccio and Antonello da Messina.

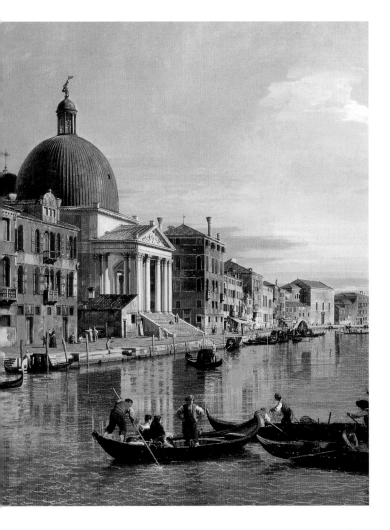

GIACOMO CERUTI

(known as Il Pitocchetto)
Milan 1698 – 1767

Giacomo Ceruti
Self-portrait as a Pilgrim
1737. Abano Terme,
Comune.

Active at Brescia in his youth, Ceruti was at Venice in 1736; later at Piacenza, then again at Brescia and Milan. A successful potrait painter, he also painted works of religious subject and still lifes. He owes his fame, however, to images of the poor – beggars, pilgrims, peasants, minor artisans – engaged in their modest activities or glimpsed during moments of rest. Near to 17th century painters such as Le Nain and Murillo, Ceruti was a refined stylist – his compositions invariably tend toward the monochrome – and a keen observer of social reality. The extreme poverty shown by many of his personages was in fact common to the peasants and urban poor during the decades in which the artist was painting. Ceruti's clientele was aristocratic. The images of poverty were edifying, a proof of philanthropy, and occasionally evocative of laughter (in accordance with the Carracci tradition).

Giacomo Ceruti
The Dwarf
w.d., canvas.

Although indulging in a representation of deformity, the painting is not devoid of human intensity. Unquestionably belonging to the comic genre – to satisfy the expectations of the clients – it nonetheless raises the genre scene to the level of portraiture, depicting an individual psychology. The dwarf's gaze awaits that of the observer; on his fine face, fear and resolution alternate. The background, sketched in with faint hues, is carelessly crude. The farm on the left is taken from an engraving by Callot. The man on the right is defecating, placidly certain that here in the countryside no will can see him.

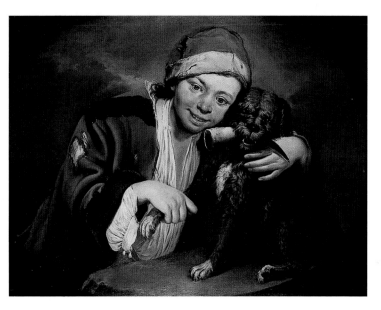

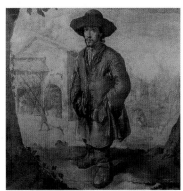

Giacomo Ceruti
Boy with a Dog
w.d., canvas.
Belfast, Ulster Museum.

An allegorical composition
rather than a portrait, as might
be suggested by the search for
verisimilitude in the portrayal
of the face, the hands and the
clothing, the subject of the *Boy
with a Dog* is that of hunting,
to which the horn held in the
dog's mouth, appearing as an
attribute, alludes.

433

LUIGI VANVITELLI

Naples 1700 – Caserta 1773

Giacinto Diano
Portrait of Luigi Vanvitelli
c. 1762.
Caserta, Royal Palace.

The son of Gaspard van Wittel, the renowned Dutch veduta artist residing in Rome, Vanvitelli studied with his father in preparation for a career as painter. Emerging as architect only after 1730, he was active in Rome and in numerous cities of central Italy – Perugia, Siena, Loreto, Ancona. He was called to Naples in 1751 by Charles III of Bourbon. The king, who intended to renovate the city by financing large-scale urban projects, commissioned Vanvitelli to build the new Royal Palace (Reggia) at Caserta. A highly versatile architect, he interpreted with refined sobriety each task assigned him, conducting restoration, acting as civil engineer, erecting military barracks, building villas (such as Villa Campolieto at Resina, 1766) and churches (among them the Church of the Santissima Annunziata at Naples, 1761).

Luigi Vanvitelli
View of the Royal Palace from the Fountain of Venus and Adonis
1752-74.
Caserta.

The Royal Palace, with its elegant, restrained exterior and its ostentatious, pretentious interior, its 1200 rooms, its perspectives, its octagonal central vestibule and its immense monumental stairway, rivals the great royal residences of Europe, first among them Versailles. The building, rectangular in shape, measures 247 meters on the longer sides, 184 meters on the shorter ones. The four courtyards designed as parade grounds are not visible from the exterior. Around the palace extends a park of over 120 hectares. Scattered among the woods, fountains and water games are statues of gods and heroes from classical mythology, placed there by Vanvitelli to surprise visitors. Most of the sculptures in the park celebrate hunting, an activity particularly beloved by the Bourbons.

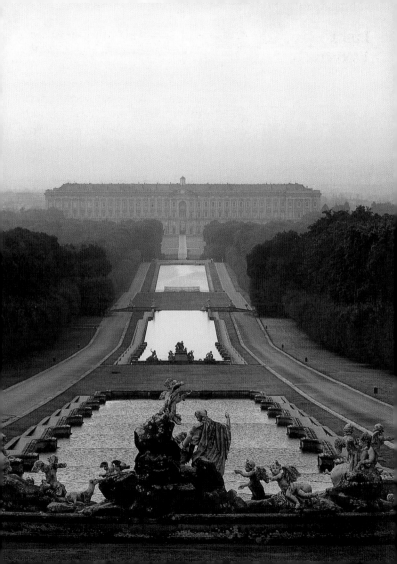

PIETRO LONGHI

(Pietro Falca)
Venice 1702 – 1785

Anonymous engraving
Portrait of Pietro Longhi

Beginning his career as a painter of history and religion, Longhi changed his approach subsequent to a stay in Bologna and an encounter with Crespi's work. His abandonment of the "grand manner" dates from 1732. His son Alessandro relates: "he changed his thought, and having a brilliant and bizarre spirit, began to paint [...] conversations, with jests of love [and] jealousy". Acclaimed as a brilliant figurative chronicler of the city's life – the Venetian aristocracy and middle class are portrayed in his paintings with keen observation and vivid irony – Longhi dedicated extreme care to painting the scenes of contemporary subject which were to make him famous. He made numerous drawings and preparatory studies, reproducing a multitude of atmospheric effects (he was familiar with the work of Watteau, perhaps through Rosalba Carriera).

Pietro Longhi
*The Hairdresser
and the Lady*
c. 1755-60, canvas.
Venice, Correr Museum.

Playing on refined variations in the tones of blue-green, blue and red, the composition shows a Venetian *nobildonna* engaged in the ritual of hairdressing. Seated at her toilette, she receives the attentions of the hairdresser while a companion, or more probably a nurse, brings her a little girl. The faces are cool, composed, and somewhat conventional; the poses are stiff. Longhi's attention is not focused on individual psychology, but rather on details of costume.

He faithfully and acutely describes the clothing which reveals, in its greater or lesser opulence, the rank of the person wearing it. His gaze pauses on the objects scattered over the top of the dresser, each of them depicted with extreme precision. On the floor, particularly evident, lies a spool of thread.

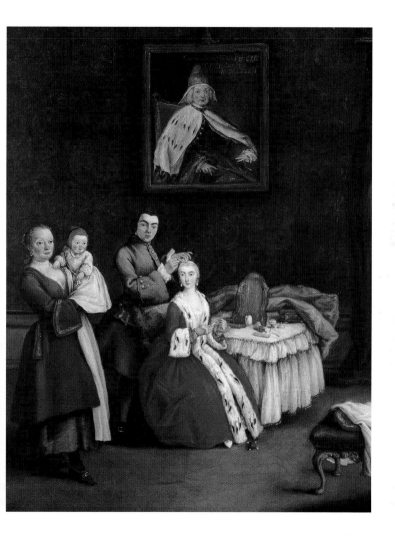

Pietro Longhi
The Duck Hunt
c. 1755, canvas.
Venice, Pinacoteca
Querini Stampalia.

The painting has the grace
and humor of a brief
account of customs: a
minor episode, a duck
hunt, serves as pretext for
subtle social and moral
observations. In the silence
of the lagoon, veiled by an
early-morning fog, the
archer, elegantly dressed,
his hair well-powdered, is
about to shoot his arrow.
Behind him the rowers,
wearing their everyday
working clothes, are
waiting to judge the
hunter's skill. Among the
participants in the
common undertaking, a
secret rivalry exists for a
moment. Admirable details
include the cushions in the
bottom of the boat and the
dead fowl lying on the
crossboards.

POMPEO BATONI

Lucca 1708 – Rome 1787

Pompeo Batoni
Self-portrait
c. 1773-87, detail.
Florence, Uffizi
Gallery.

Pompeo Batoni
*Achilles and Chiron
the Centaur*
1746, canvas.
Florence, Uffizi
Gallery.

After early training in drawing with his father, a goldsmith, Batoni was at Rome in 1727, where he was assisted financially by patrons of the arts from Lucca. He made drawings of ancient statues which he sold to foreigners. He studied Raphael and the great 17th century Classicists, from whom he learned balanced naturalness. Starting as collaborator of successful landscape artists, specializing in painting figures, by the middle of the century Batoni had become one of the most successful artists in Rome. He was ranked on the same level as Mengs, with whom he contended the title of first painter of the neo-classical school. Active in religious and mythological painting, a portrait painter of international fame, in great demand by foreigners visiting Rome, he was a highly cultivated but never programmatic artist. He combines sensual irony with a search for easy elegance.

The painting reflects a very attentive, even zealous knowledge of the great 16th-17th century mythological tradition. For every detail a source could be indicated, a citation mentioned – the Veronesian herma, Gaspard Dughet's great leafy oaks, Domenichino's pale flesh, Reni's scenes of abduction.

But such a catalogue of historical references would have no particular importance. Batoni choose to lean on a repertoire and to re-interpret it substantially, conferring on it new life. In confrontation with the great Classical-Renaissance tradition, he shows the delicate touch of the archaeologist/restorer.

441

FRANCESCO GUARDI

Venice 1712 – 1793

Specialized in painting figures for the compositions of his brother Gianantonio, head of the family shop, Francesco had a career as lengthy as it was relatively obscure. It is uncertain whether his activity as veduta artist developed already before or only after the death of his brother in 1760, and whether or not he was apprenticed for some time to Canaletto (Guardi's contemporaries called him the "good scholar of the renowned Canaletto"). It is however probable that his most terse and luminous vedutas, painted with the goal of precision, are also his first; and that only subsequently did the artist free himself from the Canaletto model. His name is linked to capricious vedutas in which figures and buildings, arranged in imaginary or entirely invented combinations, seem to dissolve in the atmosphere. Great scenes of crowds, festivals, regattas and concerts were his most famous motifs.

Francesco Guardi
Caprice
c. 1730-35, detail.

442

Francesco Guardi
*The Friars' Cloister
in Venice*
w.d.,
canvas.
Bergamo, Carrara Academy.

Often interpreted as a
melancholy presentiment
of dissolution, Guardi's
vedutas contain no
psychological or literary

considerations.
They reflect instead the
contemporary taste for
picturesque motifs and
Italian "macchiette" –
figurines in typical
costume appearing against
a background of ancient
ruins, painted with
virtuoso technique in rapid
touches of color and
frequently vibrating in the
clear light of day.

BERNARDO BELLOTTO

Venice 1721 – Warsaw 1780

A pupil and nephew of Canaletto (his mother was Fiorenza Canal, the famous artist's sister), Bellotto was in Rome between 1741 and 1742, at Dresden in 1747. The latter city, admired throughout Europe for its light, fantastic Baroque architecture (it was known as the "Florence of the Elbe") was then at the peak of its splendor. Bellotto, who painted numerous views of Dresden applying the conventions of the Canaletto veduta, was appointed court painter by Augustus III. During the Seven Years' War, the artist was in Vienna, at the court of the Empress Maria Teresa of Austria, and in Munich. He painted much admired views of both of these cities showing, at the request of the clients, the abundance of churches and palaces built in recent years. Starting in 1764 he taught painting at the newly established Dresden Academy of Fine Arts. In 1767 he was court painter at Warsaw.

Bernardo Bellotto
Dresden from the Right Bank of the Elbe downstream of the Augustus Bridge
1748-50, detail.
Dublin, National Gallery of Ireland.

444

Bernardo Bellotto
*Caprice with Gate
and a City in Veneto*
c. 1746, canvas.
Parma, National Gallery.

Painted in collaboration
with Francesco Zuccarelli,
author of the "machiette" in
the foreground, the *Caprice*
mimics precise topograph-
ical sites while actually
presenting an imaginary
veduta. The tower seen
through the arch recalls the
Ezzelino Tower in Padua;
the dome, white as the
snowy peaks in the back-
ground, is instead reminis-
cent of St Mark's Basilica in
Venice. The house on the
left recalls Venetian build-
ings painted by Canaletto
while the statue on the right,
the sculptural friezes, and
the arch in the foreground
are the fruit of pure inven-
tion. Bellotto utilizes a
repertoire in composing his
caprice, combining figura-
tive parts of various prove-
nance in a variety of
different combinations.

445

GIANDOMENICO TIEPOLO

Venice 1727 – 1804

Giandomenico Tiepolo
*Pulcinella Painting
a Tiepolo (Pulcinella
Painter of Historical
Subjects)*, 1797-1804.

His father's pupil, and soon collaborator, Giandomenico was a versatile and discerning artist. Resembling Giambattista in his taste for the bizarre and for loose brushstrokes, he reveals in the frescoes of Villa Valmarana and those painted for his father's villa of Zianigo (now at Ca' Rezzonico), as well as in his surprising drawings of "pulcinellas" a full and admirably autonomous artistic individuality. Attentive observer of the phenomena of light, fascinated by the radiant beams of early morning, he confers on his masked figures, even when ugly and deformed, an inexplicable beauty. At Würzberg with his father between 1750 and 1753, he followed the latter to Madrid as well. Returning to Venice at the death of Giambattista, he was appointed president of the Academy of Painting.

Giandomenico Tiepolo
Peasants at Rest
1757, fresco.
Vicenza, Villa Valmarana.

While Giambattista was engaged in frescoing heroic subjects at Villa Valmarana, his son Giandomenico preferred genre scenes, drawing inspiration from the life of peasants and aristocrats to present again in large format the rustic idylls of Veronesian tradition. In the shade of leafy trees, seated or stretched out on the grass in *dolce far niente*, peasants are resting and talking on a Summer afternoon. Behind them a woman is spinning. The front of the house reflects the clear light of day that already bathes the clothing and headgear of the figures in the foreground.
Tiepolo is a painter of light and of details: not of psychology. The clear, almost pearly tones of the composition foreshadow the *plein air* luminosity of the late 19th century.

**Giandomenico
Tiepolo**
The Firing Squad
1797-1804,
ink on paper,
pencil, charcoal.

**Giandomenico
Tiepolo**
Frontispiece
1797-1804,
pencil, charcoal,
ink on paper.
Kansas City, Nelson
Gallery-Atkins Museum
(Nelson Fund).

Dispersed in 1921 during
a Paris sale, the collection
of drawings illustrating
the life of Pulcinella
is a late work of
Giandomenico, pervaded
by a subtle *nostalgia*.

The artist began this series
of 104 folios when he was
seventy years old, and it
concluded with his death
in 1804. It is hard to detect
a linear narrative sequence,
and perhaps it did not exist

in the artist's mind.
Tiepolo confers on a
masked character from
the *commedia dell'arte*,
Pulcinella, attitudes
which are fully human.
He reinterprets the

character outside of the
Carnival tradition, where
its features are immutable
– Pulcinella is a braggart,
greedy, violent, treacherous
– to show him in everyday
situations. Born from an

egg, Pulcinella grows up,
marries, has children,
gets into trouble with the
law, tries different
professions, and lastly
sickens and dies,
surrounded by the

ANTONIO CANOVA

Possagno (Treviso)
1757 – Venice 1822

Antonio Canova
Self-portrait
1792. Florence, Uffizi
Gallery.

A fter an apprenticeship in the Venetian workshop of Giuseppe Bernardi, Canova was in Rome in 1799. A young artist who frequented distinguished intellectual circles – Quatremère de Quincy and Gavin Hamilton, archaeologists and art critics, were his friends- he met with success already in 1787, when his *Funerary Monument to Clement XIV* was inaugurated in the Basilica dei Santi Apostoli in Rome. From this time on, the production of works of mythological subject was interwoven, in the artist's career, with that of funerary monuments. The hint of sensuality in the former won him the admiration of his contemporaries, while the latter provided occasions for civic commemoration or solemn elegy. At the peak of his fame in the Napoleonic era, Canova was assigned discreet diplomatic and cultural functions at the downfall of Napoleon. In 1815 he journeyed to London to see the marbles from the Parthenon.

Antonio Canova
Paolina Borghese Bonaparte as Venus the Vanquisher
1804-08, marble.
Rome, Galleria Borghese.

After having sculpted, between 1803 and 1806, the portrait of Napoleon as *Mars the Peace- maker* (the statue is now in London),

Canova was commissioned to portray Paolina Borghese Bonaparte, the Emperor's sister, in 1804. Here he employed a new and flattering mythological comparison: the woman is represented as *Venus the Vanquisher*. Dressed in ancient fashion and resting on soft cushions, Paolina appears

in her sensuous beauty within the context of a work of great elegance, distinguished not only by the soft modeling of the semi-nude body but also by the care with which the artist confers a lustrous glow, consistency, and singular tactile feel to the various objects sculpted – wood, fabrics.

Antonio Canova
Monument to Titian
1791-95,
terracotta and wood.
Venice, Correr Museum.

In the various models
Canova made for the
monument to Titian, to be
erected in the Venetian
Church of the Frari, the
unifying motif is that of the
pyramid of Caius Cestius at
Rome. Another source of
inspiration may have been
the grandiose temporary
architecture once erected
in Rome for the funerals
of illustrious personages,
the popes for example.
In formulating the project
the artist introduced
profound innovations in
the tradition of the
funerary monument: no
longer a glorification of the
deceased, Canova's
pyramid is instead a
meditation on death and
the darkness that awaits
beyond the threshold.
The pyramid, however,
was not to be used in
the monument to Titian,
planned but never
executed. Canova was
instead to adopt it for
the *Monument to Maria
Cristina of Austria*
(1798-1805), in the
Augustinerkirche at
Vienna.

452

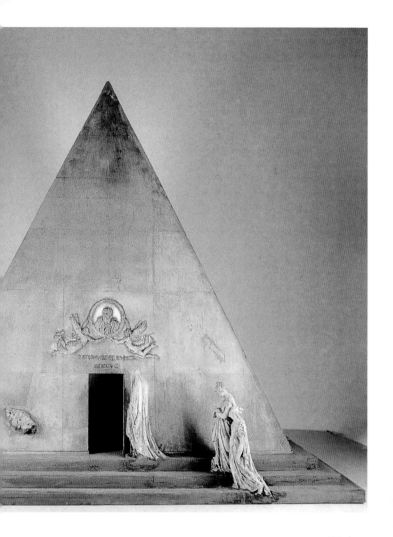

Antonio Canova
Cupid and Psyche
c. 1787,
terracotta.
Venice, Museo Correr.

This small terra-cotta sculpture depicts a youth lying on the ground who seems to push away the female figure above him, almost as if she were trying to seduce him. In obvious formal relationship with the artist's more famous sculptural group, the *Cupid and Psyche Embracing*, now in the Louvre, this sketch portrays not a mythological idyll but more probably a licentious love scene.
In sculpting it Canova seems to take heed of Winckelmann's exhortation to "sketch with fire". When a work is transposed to marble, the intensity of the draft version is sometimes lost.

Antonio Canova
The Graces
1813, terracotta.
Lyon, Musée
des Beaux-Arts.

Canova was fascinated for years by the motif of the three female figures, nude and dancing, who appear recurrently in his drawings and paintings. Here the "idea" - it is Canova himself, in the inscription appearing on the base, to use this term - is modeled in a burst of inspiration. Admired by his contemporaries, the *Graces* were particularly beloved by writers and poets. Stendhal went to Rome purposely to see them, and Ugo Foscolo dedicated an entire poem to them.

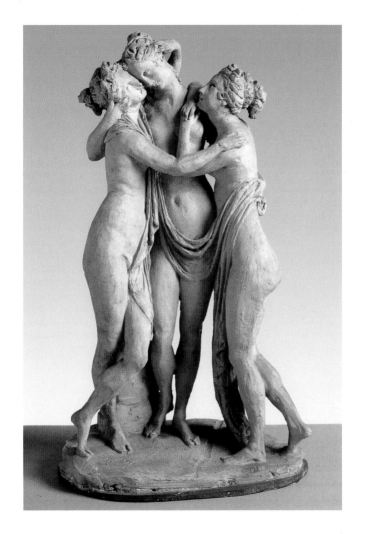

ANDREA APPIANI

Milan 1754 – 1817

A cultured artist who moved in intellectual circles – he was a friend of Parini, who starting in 1776 held lessons on history and mythology at the Brera Academy; and of Giuseppe Bossi – Appiani experimented in his youth with the fresco technique, perfected through his study of Leonardo and Raphael. Precociously approaching neo-classical modes, he conceived his images as sculptural friezes. In his best work the principles of neo-classical "good taste" are tempered by soothing recollections of the Lombard naturalistic tradition. In 1791 the artist visited Parma, Bologna, Florence and Rome to observe the works of the great 16th and 17th century masters. Upon Napoleon's entry into Milan in May 1796, Appiani was one of the most fervent advocates of the Cisalpine Republic, of which he became the official painter. He was to paint a series of Napoleonic portraits widely admired even in France.

Andrea Appiani
Self-portrait
c. 1795. Milan, Brera
Pinacoteca.

Andrea Appiani
*The Genius of Art
and the Envious Ones*
c. 1805, fresco transferred
to canvas. Milan,
Civic Gallery of Modern Art.

The image possesses the lightness of a comic episode studied on Hellenistic vases, appearing in the two-dimensional, softly tonal manner of a Pompeian fresco. The cupid holds a palette and paintbrushes.

Andrea Appiani
Apollo's Chariot
c. 1799,
fresco transferred
to canvas.
Milan, Brera Pinacoteca.

In 1799, at the time when
Appiani was frescoing
Apollo's Chariot in Casa
Sannazzaro, Austrian
troops returned to Milan,

and the artist's public
commission was
suspended. It is easy
enough, however, to see in
the blond and radiant god
who drives the chariot an
allusion to Napoleon, in
the eyes of the artist the
bearer of a new
civilization, rather than
a neutral re-evocation
of the classical myth.
Stylistically the fresco is
striking for the almost

archaic majesty of Apollo,
whose head is a perfect
oval placed at the center
of the solar disk.
The image, conceived
according to strict rules
of symmetry – note
also how the chariot
opens exactly in half,
divided by a vertical
axis – reveals attentive
study of Early Renaissance
masters, Piero della
Francesca in particular.

The XIX Century

Either disparaged as pathetic and provincial or defended with stubborn passion, Italian art of the nineteenth century was long the center of heated debate. If avant-garde art history and the critics allied to it, such as Roberto Longhi and Lionello Venturi, have felt little appreciation for artists intimately linked to contemporary historical events, connoisseurs and collectors have shown a preference for paintings and sculpture not always motivated on the level of international confrontation. Today these works and events can be viewed more objectively. We possess enough knowledge to begin to evaluate our 19th century within the broader context of contemporary European art. We can document the circulation of artists and works – the "trips to Paris", the participation in great international exhibitions, the artists' relations with Italian or foreign gallery owners, the opportunities for exhibition and sale – and make pertinent comparisons, wasting no time over futile questions of national artistic supremacy.

Italian art was discussed, during the 19th century, years before Italy as a sovereign state came into existence. The dramatic process of national unification had inevitable reflections on artistic production, and even on the biographies of the artists themselves. Many among them, we find, fought as volunteers, engaged in politics, held diplomatic positions. The alternating vicissitudes of the Risorgimento first, the decades of monarchy and national unification later – the expectations, the disappointments – conferred significance and urgency on debates, on the stances assumed, on stylistic changes, on consecration or censure.

Geographic and regional components still prevailed. Rome in the first decades of the century, then Milan, Florence and Naples could at various times aspire to the role of capital of Ital-

Vincenzo Cabianca
*Water Bearers
at La Spezia*
1864.

Nino Costa
Girl from Lazio
c. 1863.

ian art, although none of them was to hold this place definitively. While a common Italian language now existed, albeit only on the literary level, the same cannot be said of the visual arts. In Milan the most confirmed Romantic tradition was to re-emerge, in the latter half of the century, in a naturalism marked by strong social accents. In Florence a common traditionalist orientation advocating a return to the origins of Italian art linked, at times unpredictably, Purists and Macchiaioli. In Rome, alongside cultural and archeological tendencies a vivacious popular art was fast emerging. In Naples a local circle of painter/artisans, the Posillipo School, evolved in the direction of modern landscape painting *en plein air*. Dialects, accents, and inflections predominated, considering the interest of the romantic/naturalistic generation in local and native elements (Cecioni, for example, wrote in praise of Lega: "this artist has the great merit of producing a local art that belongs to Florence. His works show not only his own individuality, but the individuality of the country"). Market trends also encouraged this tendency. The production of art for foreign

Odoardo Borrani
April 26, 1859
1861.

Giuseppe Palizzi
Landscape with Figures
1863. Milan, Gallery
of Modern Art.

tourists, English and American in particular, grew at the same fast pace as the number of wealthy travelers who visited Italy. Tourists created a constant demand for souvenir paintings, stimulated a kind of specialization, and encouraged the production of stereotypes. Their taste, no less than that of the local artists, is reflected in genre scenes and vedutas. Along with the flourishing market for the "picturesque" there remained, at times unheeded, at times like a statement of principle, the appeal to an art that was recognizably national, dealing with current events in the terms of the great historical painting, transforming genre painting into popular art, marked by no connotations of locale or school. Among the most fervent advocates of this appeal was Gabriele D'Annunzio and later, in the twentieth century, Filippo Tommaso Marinetti. "Born to a poor family in 1791 at Venice, [Hayez] is neither pagan nor Catholic, nor eclectic nor materialist. He is a great Italian idealist painter of the 19th century", wrote Giuseppe Mazzini from exile in London in 1841, in presenting the Romantic artist to the British public. "He is the head of the School of Historic Painting, which National thought proclaimed in Italy; the artist most deeply immersed in the sentiment of the ideal which is called upon to govern all of the works of the Epoch. His inspiration emanates directly from the People; his power directly from Genius". And Pasquale Villari, illustrious Meridionalist and historian, was to add a few decades later, almost as if to outline a Verist program (and having first traced the artistic/literary parallels Alfieri-Canova, Manzoni-Hayez): "[we must] be modern without being

Tranquillo Cremona
Curiosity
1876-77.

foreigners; be Italian without being of another century; approach the spoken language of the people; seek simplicity, naturalness and truth".

The post-unification decades saw the decline of historical painting of the romantic/literary tradition, and the progressive emerging of naturalistic approaches, accompanied by increasing cultural exchange and commerce in art among the major European nations. A number of Italian artists were to benefit by the establishment, primarily in Paris, of privately owned and managed art galleries, and by the growing phenomenon of active, cosmopolitan collectors. The career of a painter and sculptor could now develop entirely independent of public institutions such as the academies – as demonstrated by the relations between De Nittis and Mancini and the Maison Goupil; and between Zandomeneghi and Paul Durand-Ruel, the art dealer of the Impressionists. Often it was the artists themselves who decided to join forces in order to face a dual competition: the one among ideas and the other, more concrete, among works. While the significance of Lega's opening an art gallery in Piazza Santa Trinita in Florence in 1873, with Odoardo Borrani as partner, is mainly anecdotal, and while Morbelli failed in his attempt to bring the divisionists together in an association, Vittore Grubicy de Dragon, gallery owner, critic and painter himself, provides the first example in Italy of an artistic and cultural entrepreneur. Skillful strategist and refined man of culture, Grubicy, with his brother Albert, introduced the divisionist *vague* to Italy, promoted artists through publications and exhibitions in Italy and abroad – such as the Italian Exhibition, organized in 1888 at London – and stipulated contracts, interpreting his own role as that of urging artists to take immediate action on the level of communication, of address.

Giovanni Fattori
*The Italian Camp
at the Battle of Magenta*
1862. Florence,
Pitti Palace Gallery
of Modern Art.

Plinio Nomellini
Garibaldi
c. 1907. Livorno,
Giovanni Fattori
Civic Museum.

TOMMASO MINARDI

Faenza 1787 – Rome 1871

Tommaso Minardi
Self-portrait
c. 1805. Faenza, Pinacoteca
Comunale.

Born in Faenza but trained in Rome, where he attended first the Academy of the Italic Kingdom, then the Academy of San Luca, Minardi was among the most inventive interpreters of the archaicizing tendency that spread through Italy and Europe as a whole in the early years of the 19th century. His models were eclectic: Perugino and the young Raphael for the precision and linear softness of the drawing, the Flemish primitives for the use of local colors, and the Venetians. Minardi's relationships with contemporary artists were extensive. In contact with the Milanese circle of Appiani and Bossi, Minardi was also close to the Nazarenes, a group of German artists living in Rome who favored a return to the modes and techniques of religious art in the early Renaissance. In 1842 Minardi signed, with Overbeck, Bianchini and Tenerani, the manifesto of Purism.

Tommaso Minardi
*Madonna
of the Rosary*
1840, canvas.
Rome, National Gallery
of Modern Art.

Minardi, appointed director of the Perugia Academy in 1819 and professor of drawing at the Rome Academy of San Luca in 1822, spent the second and third decade of the century in study and travel, mainly through Central Italy. His cult of the origins brought him naturally to Florence and to Assisi, Spoleto, Bologna and Ravenna, on the traces of the old masters. In the meantime he was maturing his Purist approach, favorable to the wedding of art and religion and a return to the Renaissance Umbro-Tuscan tradition. The *Madonna of the Rosary*, with its mingled recollections of Perugino and Raphael, clearly exemplifies the artist's position.

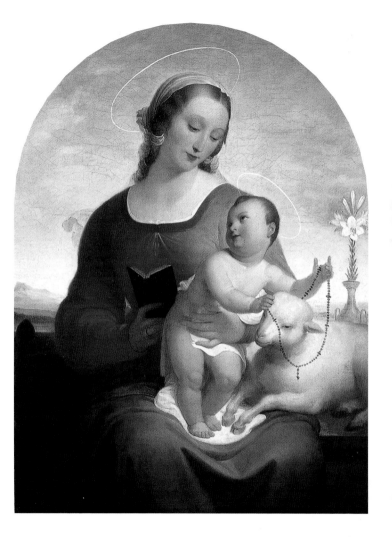

GIUSEPPE BOSSI

Busto Arsizio (Milano)
1777 – Milan 1815

Giuseppe Bossi
Self-portrait
c. 1805, detail.
Milan, Brera Pinacoteca.

A passionate and versatile artist, refined man of culture, historian and art critic, Giuseppe Bossi was both artist and cultural organizer, an Enlightenment intellectual who firmly believed in the morality of the arts, the civil function of images and words. After a strict neo-classical apprenticeship – the artist was in Rome in 1795, where he met Canova and established a friendship with him that was to last a lifetime – he went in 1802 to Paris, where he met David and encountered the first archaicizing trends. Concepts of "energetic language", of figurative eloquence, alternate in his work with soft evasion into the erotic and fantastic genre. Starting in 1807 he was engaged in copying Leonardo's *Last Supper* and in intense philological research on the great master. In 1810 he published a volume entitled *On the Last Supper of Leonardo da Vinci*.

Giuseppe Bossi
*Self-portrait with
Gaetano Cattaneo,
Giuseppe Traversa
and Carlo Porta
(The Portian Chamber)*
1809, canvas.
Milan, Treccani degli Alfieri
Collection.

Self-portraits recur rather frequently in Bossi's work. The artist, portrayed either alone or with others, presents himself to the public involved in some urgent endeavor, and acutely aware of the importance of his role. The *Self-portrait* of 1809 shows him with Gaetano Cattaneo, his first

biographer, and the poet Carlo Porta, which whom he shared an interest in dialect literature (Bossi also wrote poetry in dialect). The four, who pose standing close together, all facing the viewer, seem almost to be boasting of their union in an association.

FRANCESCO HAYEZ

Venice 1791 – Milan 1882

Francesco Hayez
Self-portrait with Friends
1827, detail. Milan,
Poldi Pezzoli Museum.

Venetian by birth, Hayez owed his early training to the years spent in Rome (1809-17) as protégé of Canova and Leopoldo Cicognara, living on a grant from the Venice Academy. It was in Rome that the young artist emerged, through strategic participation in important competitions, as a talent able to restore to Italian art its past glory. Skilled at interpreting historical subjects, imbuing them with current interest; a brilliant portrait painter and creator of sensual nudes, Hayez was acclaimed already in his lifetime as the most important Italian Romantic painter, hailed as national glory in years of foreign domination only to be deprecated as taste changed. His merits are recognized today: a refined stylist, Hayez conferred on painting of the historical genre, through his choice of subjects and execution, gripping epic-popular dimensions comparable to those of the historical romance and melodrama of the same period.

Francesco Hayez
Bathsheba at her Bath
1834, canvas.

This painting clearly exemplifies Hayez' fantastic/narrative tendencies, shared by the Romantic movement as a whole. The historical subject of the composition, King David who falls in love with Bathsheba upon surprising her nude, accompanied by her handmaidens and intent on her bath, serves as little more than a pretext. What really interests the artist are the possibilities of fairy-tale magic, enchantment and erotic development of the Biblical episode. The two halves of the composition, lower and upper, are entirely filled with the images of the nude figure and the forest, so thick and interwoven as to give no glimpse of the sky (King David appears at the upper left). The handmaiden on the left is dressed in Egyptian style and Hayez willingly lingers on exotic details of costume.

Francesco Hayez
*Lion and Tiger
in a Cage with
a Portrait
of the Painter*
1831, canvas.
Milan, Poldi Pezzoli
Museum.

A self-portrait of the
artist as a young man,
the painting shows him
posing before a cage
where a lion and a tiger
are kept in captivity.
A homage to the artist's
talent viewed as instinct,
imbued with animal
furor and elegance, the
self-portrait concretely
displays traits of the artist
that might be called
predatory: the eye that
devours the image as it is
born, the hand that grasps
the borders with the
motion of an acrobat.
Hayez' gaze appears
firmly fixed on the
observer, emblematical.
In the concrete of the wall,
cracks and fissures testify
to the "energetic" qualities
of the sign.

Francesco Hayez
*The Kiss. A Youthful
Episode. Customs
of the XIV Century*
1859, canvas.
Milan, Brera Pinacoteca.

This picture, of which a
second version exists, is
among the most popular in
Italian painting. Plain and
appealing at first glance –
the sugar-sweet motif of
the kiss, a "youthful
episode", is sufficient in
itself to arouse sympathy –
the painting reveals, upon
closer consideration,
complex historical and
political implications.
The colors in which the

garments of the two young
lovers are painted are,
more or less explicitly in
the two different versions,
those of the flags of Italy
and France, two nations
whose history, at the time
when the picture was
painted, was closely
interwoven. It was in fact
thanks to the alliance with
France procured by
Cavour's skillful foreign
policy that Italy won its
independence, precisely in
1859. The lining of the
man's hood is green, his
trousers are red; the lining
of the sleeves in the girl's
dress is white; and the
dress itself is blue.

LUIGI MUSSINI

Berlin 1813 – Siena 1888

Son of a chapel master at the Prussian court, Mussini trained at the Florence Academy and went on to become a highly cultured, cosmopolitan artist. Starting in 1840 he spent three years in Rome, where he adhered to strict Nazarene positions. In Florence he contributed to orienting in the Purist direction the city's figurative Romanticism, opposing its popular patriotic dimension as well as the other trend, naturalistic and sensual, of Giuseppe Bezzuoli, although the latter had been his master. In 1849 he participated as volunteer in insurrections. Between 1849 and 1851 he was in France, at Paris, where he met Ingres, Flandrin, Chassériau, and Gérôme. His youthful approach, dryly concentrated on drawing, took on a new softness. The goal of a kind of stylistic chastity did not, however, cause Mussini to banish grace and sweetness from his painting.

Luigi Mussini
Sacred Music
1841,
canvas.
Florence, Accademia Gallery.

The composition shows how, for Mussini and in accordance with Purist principles, the first Romantic experiences tended to be reconfigured in a more devotional and formal sense. The clearly recognizable homage to Umbro-Tuscan tradition is combined with a refined use of chiaroscuro in the painting, and a heightening of tones which cannot be called neo-Quattrocentesco. In chanting a sacred hymn the angel seems to comment on the edifying, eulogistic function of the arts, which do not flourish in a fully natural environment but rather in the shelter of a simple, typical religious building. The artist's predilection for drawing with pure borders appears emblematic where the image becomes simple notation: in the detail of the score, carefully transcribed on the scroll held up by the angel and the one resting on the floor.

LORENZO BARTOLINI

Prato 1777 – Florence 1850

In Paris between 1799 and 1808, Bartolini was a pupil of Jacques-Louis David. In the studio of the great neo-classical artist, the meeting place of all the young talents on the Parisian scene, he met Ingres, with whom he shared a predilection for pure forms, for a classic, barely archaicizing manner, and for a highly refined combination of Renaissance elements in which the severity of the ideal was tempered by the use of soft chiaroscuro. His objective, he wrote, was that of "approaching unattainable nature". Having settled in Florence, Bartolini soon emerged as interpreter of the Purist approach imposed on sculpture already by the late Canova. Among his most famous works are the tomb of Countess Sophia Zamojska, in Santa Croce, and the *Faith in God*, now at the Poldi Pezzoli Museum in Milan.

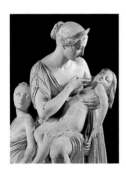

Lorenzo Bartolini
Demidoff Monument
1828-50,
plaster cast, details.
Florence, Accademia Gallery.

Commissioned by his sons Paolo and Anatolio at the death of their father Niccolò, a Russian aristocrat who owned mines in Siberia and was the husband of Princess Matilde Bonaparte, the monument had a long and complicated history.

Bartolini worked on it in several stages. It was executed in marble, after the artist's death, by Romanelli, his pupil. Its installation on the left bank of the Arno dates from 1871. The work is composed of a central group with Niccolò and Anatolio accompanied by a number of allegorical figures larger than life-size, among them *Recognition*, *Charity*, *Siberia*, the *Muse of Festivals* and *Nature Reveals Herself to Art*.

478

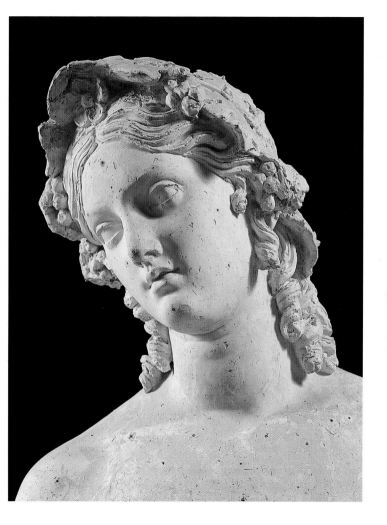

IL PICCIO

(Giovanni Carnovali)
Montegrino (Varese)
1804 – Caltaro sul Po
(Cremona) 1873

Il Piccio
Self-portrait with Palette
1846-50, detail.
Bergamo, Carrara Academy.

Son of a builder expert in constructing water games for fountains, Il Piccio trained at the Carrara Academy of Bergamo, to which he was admitted very young. A passionate admirer of the Venetian and Lombard masters of the 15th-16th centuries, he drew inspiration from them for his naturalistic effects and soft sfumato, predilections that were to be definitively confirmed by his study of Correggio's work at Parma. A legendary walker, he made his first voyages of study on foot: to Rome and to Parma in 1831, perhaps to Paris in 1845, to view the work of Delacroix and the Barbizon landscape artists, then back to Rome in 1848 and 1855. With his sentimental, imaginative talent, Il Piccio excelled in portraits, highly acute, and in great nature scenes, often suggested by literary episodes, where slender, sensual figures appear enveloped in mysterious shadows.

Il Piccio
*Salmace and
Hermaphrodite*
signed and dated 1856,
canvas.

The poets sing of the nymph Salmace, inhabitant of "a pond of water crystal clear down to the bottom", who fell in love with the youth Hermaphrodite; and who, rejected by him,

asked the gods to be joined forever to his body, in an indissoluble embrace. Attracted by the soft, elegant nature of the mythological fable, Il Piccio creates a leafy natural dell, with only a hint of crystalline waters and distant hills, in which to portray the struggle for love. The nymph with her flowing blonde hair,

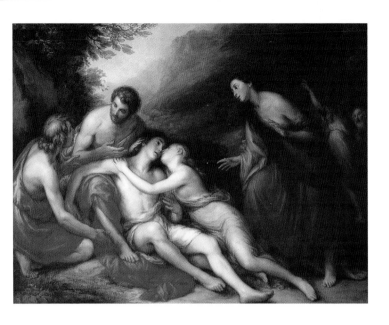

slender and clinging in Mannerist style, draws to herself the reluctant youth, his face reddening in a blush, "holds him close as he struggles to escape, kisses his unwilling lips, caresses him below the belly", in the words of the poet Ovid.

Il Piccio
The Death of Aminta
c. 1835, canvas.
Piacenza, Banca Popolare.

The story of Aminta, narrated by Torquato Tasso when only thirty, has a happy ending. The shepherd Aminta, enamored of the nymph Silvia, wins her favors through various and occasionally dramatic vicis-situdes. Believing Silvia dead, Aminta even arrives a t the point of throwing himself off a cliff, but is saved when a tree breaks his fall. For Il Piccio, Tasso's "bucolic fable" is instead a variation on the theme of love and death. He portrays Aminta dying, with Silvia weeping at having denied her love to such a devoted lover.

481

BARTOLOMEO PINELLI

Rome 1781 – 1835

A child of art – his father sculpted small ornamental bas-reliefs and devotional terracottas – Pinelli began to sculpt and draw while still a boy before regularly attending any school of art. Trained according to neo-classical principles of composition, he preferred clear forms decidedly delineated by boundaries. His fame is linked to engravings with "picturesque" themes – particularly appreciated by cultured tourists and lovers of Rome as well as by foreign artists residing in the city, such as Bertel Thorvaldsen – and to illustrations for popular literary works in the Romanesque dialect, such as *Meo Patacca* by Giuseppe Bernieri and *Il maggio romanesco ovvero il palio conquistato* by Giovanni Camillo Peresio. Among the subjects of the engravings are ancient and popular customs, episodes from Roman history and the lives of the brigands.

Bartolomeo Pinelli
A Brigand having strangled her son, his wife kills him as he sleeps
1823, detail. Rome, Museum of Rome.

Bartolomeo Pinelli
*The Frascati
Camaldolensian
Friars prisoners
of the Brigand
Massaroni's band*
1821, water color on paper.
Rome, Museum of Rome.

Against the background of an impervious Latium landscape, as rocky, rough and wild as the Alps, a band of well-armed brigands poses in picturesque costume along with seven Camaldolensian friars held prisoner. Among the friars, some are supplicating the brigands, some are praying and others are calmly waiting in faith. A pretty young water-seller is pouring water for a thirsty brigand. The spacious blue sky with its scattered summer clouds, glimpsed above, is no less splendid for the crime that is being committed. The episode, in itself dramatic, offers the artist a pretext for displaying local curiosities and natural beauty.

MASSIMO D'AZEGLIO

Turin 1798 – 1866

Francesco Hayez
Portrait of Massimo d'Azeglio
1864, detail. Milan, Brera Academy (in storage at the Modern Civic Art Gallery).

Massimo d'Azeglio
Vendetta
1835, canvas.
Milan, Brera Pinacoteca (in storage at the Gallery of Modern Art).

Politician and man of letters, D'Azeglio approached painting for the first time in 1814, at Rome, where he was then living since his father was a minister of the Vatican. He was later to dedicate himself assiduously to this art. In Rome a second time in 1820, he began to work from life as the Northern artists did. He studied nature in every minimum detail, spending hours outdoors, in direct contact with his subject, walking and riding for miles over the Roman countryside. Success was to smile on him early, thanks also to his relations with important, influential clients (among his admirers were Carlo Alberto and King Carlo Felice). While his contemporaries appreciated in particular the small landscapes composed without literary concerns, his own preference was always for compositions which, as he wrote in his memoirs *Miei ricordi*, "leave ample range to fantasy and to higher concepts".

D'Azeglio's reputation as painter is linked to "historical landscapes", in which famous episodes taken from historical novels are depicted against the background of landscapes painted with extreme accuracy. His works reveal a Romantic taste for re-evocation of the national past along with a surprising familiarity with the picturesque tradition. "The Dutch-Flemish school", he stated, "populated its paintings only with shepherds and animals. I have called to my aid paladins, errant knights and damsels. In literature this was no novelty; in landscape painting it was".

DOMENICO MORELLI

Naples 1823 – 1901

Domenico Morelli
Self-portrait
1860 c., detail.
Florence, Uffizi Gallery.

Domenico Morelli
*The Temptation
of St Anthony*
1878, canvas.
Rome, National
Gallery of Modern Art.

A brilliant, cultured artist, Morelli had a particularly significant and well-articulated development. After training at the Naples Academy he soon came into contact with the Florentine artists of the Caffè Michelangelo. In the early 1850s Morelli became the outstanding representative of the romantic Neapolitan school, with paintings of historical subjects conceived in the manner of Hayez. At Paris in 1855 to visit the great International Exposition, he was struck by the surprisingly imitative attitudes displayed by the painters then in vogue. This was followed by a period in which, while still faithful to the historical theme, the artist placed special emphasis on detail. Morelli's last stage was marked by the increasingly forceful emergence of symbolic attitudes and themes, and the painter came to occupy a place not far from pre-Raphaelite and German-Roman tendencies.

In the final stage of his career Morelli was increasingly interested in mystical/religious themes on the one hand, ethnographic ones on the other. To broaden his knowledge of monotheist religions in the Mediterranean area he assiduously studied the Old and New Testaments and the Koran. With his background as painter of ideas, he executed paintings with the objective of extreme verisimilitude. The historical episode takes place in the most normal daily circumstances, provoking effects of alienation. The *Temptation of St Anthony* can be broken down into the various studies at its origin: studies of Arab or Middle Eastern costume in the figure of the saint, studies of rocks in the surrounding landscape, studies of the nude and of gold-work in the figure of the first temptress, lying on

the ground half-concealed by a mat, and studies of fabrics. Morelli varies his brushstrokes – in frequency, breadth, width – depending on the nature of the surface to be painted, whether tactile or relevant to the phenomena of reflected light. He performs as virtuoso of the brush, displaying the vast range of mimetic effects of which he is a master.

FRANCESCO PAOLO MICHETTI

Tocco Casauria (Pescara)
1851 – Francavilla al Mare
(Chieti) 1929

Vincenzo Gemito
Portrait of Michetti
1873, detail.

Francesco Paolo Michetti
*The Corpus Domini
Procession at Chieti*
signed and dated 1877, canvas.
Piacenza, Civic Museum.

Exposed to cosmopolitan
styles and tendencies, the
artist remained closely
linked to the land of his
birth. Religious rites and
trappings, objects of popu-
lar craftsmanship, even the
regional features of faces
and bodies attracted him.

A pupil of Domenico Morelli at the Royal Insti-
tute of Fine Arts in Naples, Michetti came in-
to contact with the Parisian artistic scene and with
major galleries starting from 1871 – it was De Nit-
tis to introduce him first to Reutlinger, then to the
Maison Goupil. He painted in the manner of For-
tuny, displaying an abbreviated, sure technique and
surprising illusionist effects, with motifs that were
anecdotal and emotionally appealing. As professor
at the same Naples Royal Institute of Fine Arts start-
ing in 1878, he was extremely attentive to what was
happening around him, visiting and participating
in exhibitions held in the major cities of Europe –
Paris, Munich, Vienna and Berlin. His paintings were
exhibited at the first Venice Biennale, held in 1895,
and the four following ones. Starting from the 1880s
Michetti dedicated himself mainly to photography.

Francesco Paolo Michetti
Shepherdesses
signed and dated 1872, panel.
Florence, Pitti Palace,
Gallery of Modern Art.

Two shepherdesses pose
on the banks of stream,
where lambs come down
to drink. The light is
opaque, artificial. The
image seems to have been
assembled in the studio
from various fragments
observed from life.

GIUSEPPE VALADIER

Rome 1762 – 1839

Son of a goldsmith and bronze smelter, Valadier was to emancipate the profession of architect from its customary task of constructing individual buildings. With him the architect became urban planner. Laying aside the guise of exquisite master of elegance, he began to design not only façades and balconies, capitals and gardens, but modes of communication, patterns of collective behavior. Well-versed in the traditions of classical architecture and of Palladio – he was for many years director of important archaeological works, responsible among other things for restoring the Arch of Titus – and simultaneously open to French experience, Valadier directed the most important neo-classical projects carried out in Rome, from the façade of San Pantaleo to the Casina Valadier, from the rearrangement of Piazza del Popolo to the reconstruction of the Valle Theater, and to the façade of San Rocco.

Giuseppe Valadier
Piazza del Popolo
in Rome, 1816-22.

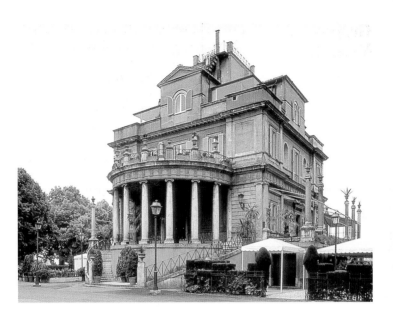

Giuseppe Valadier
Casina Valadier
c. 1830, Rome.

In designing Piazza del Popolo as we see it today, Valadier revealed to the utmost his talent as urban planner, skillfully arranging symmetries and vanishing points in perspective to confer on the square a vastness more apparent than real. He terraced the Pincio hill to blend the work of nature and that of man in a magnificent scenic effect.

In the Casina Valadier his role was more traditional, although he gave the building a semi-circular colonnade that superbly overlooks the open area below. The body of the building, with its dynamic volumes, refrains from any tendency toward the monumental.

Giovanni Dupré

Siena 1817 – Florence 1882

Giovanni Dupré
Self-portrait in half-bust
w.d., detail.
Fiesole, Dupré Museum.

Giovanni Dupré
Death of Abel
1842. Florence, Pitti Palace
Gallery of Modern Art.

Trained at the Siena Academy, Dupré emerged as an artist in the 1840s, carrying the cultured, tempered naturalism of Bartolini toward cruder effects. An eclectic artist of wide renown, capable of conceiving and accomplishing works very different in nature, clientele, and function – the historical monument, the devotional statue, the female nude – Dupré was, in the eyes of his contemporaries, the heir to the great Italian plastic tradition. A member of important international juries, he visited the exhibitions held in Paris and Vienna, presenting his own sculptures although declaring his disappointment with the "monstrous agglomerations of products, machines, raw materials, edible materials, drinkable liquids, religious utensils, war machines" among which the few figurative works seemed lost, in an age distinguished by the triumph of industry.

Dupré himself, in his *Writings on Art and Autobiographical Memoirs*, relates how, disappointed at not being granted "a pension for sculpture" with a ten-year duration, he conceived of *Abel*, his first *succès de scandale*. Determined to win success, "I tried to think of a new, serious, appealing subject in which to put my whole heart, my strength, my will, my hopes, everything; and I found it". With it he also found "good movement and correct expression". Presented to the public, *Abel* was severely criticized as resembling too closely the "real", and was actually thought by the professors of the Academy to be cast from a mould.

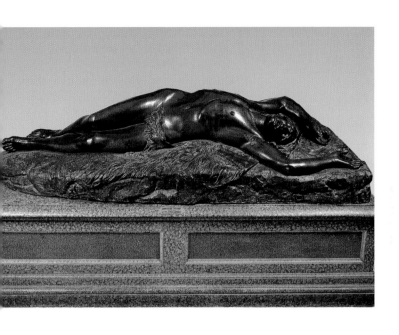

ANTONIO CISERI

Ronco (Canton Ticino)
1821 – Florence 1891

Antonio Ciseri
Self-portrait
c. 1885-90, detail.
Florence, Uffizi Gallery.

Trained at the Florence Academy of Fine Arts and first close to the positions of Bezzuoli, Ciseri later evolved in the direction of a refined Purism. A cultured artist with a wealth of acquaintances among artists – in 1867 he met the pre-Raphaelite William Holman Hunt, and in 1870 Alexandre Cabanel, one of the French painters most in vogue at the time – Ciseri showed himself well aware of the research then being carried out in the international academic world. His most ambitious compositions, mainly of devotional nature, were scrupulously prepared, reflecting the goal of exactness in depicting furnishings, costumes, and architecture. The painter, in his case, was also an archaeologist. An acclaimed portrait painter – even Cavour and Umberto I posed for him – Ciseri had a career starred with victories, such as the gold medal awarded him the Universal Exposition of Vienna in 1873.

Antonio Ciseri
Ecce Homo
1880-91, canvas.
Florence, Pitti Palace,
Gallery of Modern Art.

Commissioned in 1870 and preceded by preparatory studies and sketches, the *Ecce Homo* is clearly the masterpiece desired and planned for years. Ciseri worked on it up to his death, expectant of the success that the painting, exhibited posthumously, would in fact attain. In accomplishing this work the artist placed painting in explicit competition with photography. The foreground of the picture, showing Pilate in the act of offering the crowd to exchange Barabbas for Jesus, is strikingly realistic.

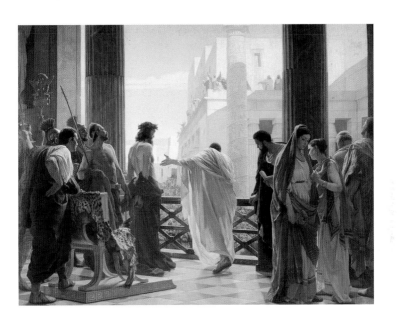

ALBERTO PASINI

Busseto (Parma) 1826 –
Cavoretto (Turin) 1899

Lithographer and owner of a private atelier of painting in Parma, Pasini moved to Paris in 1851. Having seen the works of Eugène Fromentin and the Barbizon landscape artists, he painted landscapes according to a romantic/naturalistic taste. He shared a studio with Théodore Chassériau, who, called upon to participate in a diplomatic mission to Persia, asked Pasini to take his place. Between 1855 and 1856 the young artist thus had the chance

Alberto Pasini
*Caravan to the
Red Sea*
signed and dated 1864, canvas.
Florence, Pitti Palace,
Gallery of Modern Art.

Pasini was in Egypt in 1860, Turkey and Greece in 1867, Constantinople from 1867 to 1869, Spain and Syria in 1869, and Asia Minor in 1873. His reputation as expert on the Southern Mediterranean and the Middle East was solidly established. One of the most popular motifs of the orientalist genre was the caravan, open to various elements of exotic fascination: the

desert landscape, the costumes of the nomads, archaic and adventurous trade, often consisting of barter (blocks of salt, extremely useful to the sub-Sahara populations, were sometimes exchanged for precious stones and ivory).
A comparison between Orient and Occident is implicit. The apparent immobility of the former is contrasted, in the eyes of the "painter-travelers" and their contemporary public, with the industriousness of the latter, in full financial and military expansion.

to visit Turkey, Egypt, Syria, and the Arabian penin-
sula. In his travel notebooks Pasini revealed his gifts
as keen observer of costumes, architecture and land-
scapes. An artist of acknowledged fame and a great
traveler, Pasini participated in the change in ori-
entalism that took place around mid-century and
was consolidated in the following decades: the ro-
mantic evocation of a fantastic Orient was super-
seded by a taste for ethnographic reporting.

GIOVANNI FATTORI

Livorno 1825 –
Florence 1908

Giovanni Fattori
Self-portrait
1894.

Giovanni Fattori
Cousin Argia
1861, cardboard.
Florence, Pitti Palace,
Gallery of Modern Art.

I n Florence to study painting, Fattori was torn between the practice of art and patriotic activism. In 1859 he began a series of scenes of military life that won him his first acclaim, and he was always to remain interested in Risorgimental motifs. An habitué of the Caffè Michelangelo, he was among those who recognized the innovations of contemporary French painting – his chief reference point, at this date, was undoubtedly Degas. "In 1854 or '56", Fattori relates, "upon returning from Paris Serafino Tivoli [...] brought to us young artists an art that was entirely new [...], the first attempts of the *macchia*. Our program was, and is: reality as we see it and love it. Returning to the Quattrocento only with a new address". Professor at the Florence Academy in 1869, Fattori was in Paris in 1875. His fame grew with success in the technique of etching and engraving.

A study of harmony in gray-green and ochre, the portrait approaches the model according to the canons of intimism that pervaded French painting of the mid-19th century. Not by coincidence have the names of Corot and Nino Costa, a refined follower of Corot, friend and admirer of Fattori, frequently been mentioned in connection with it. Intensely aware of the artist's presence, the woman gazes toward us with a decided, almost piqued attitude. The painting, rather than dwelling on the unique traits of an individual existence, fixes the image of a type, a feminine character with strongly regional features.

Giovanni Fattori
Caught in the Stirrup
1880, canvas.
Florence, Pitti Palace,
Gallery of Modern Art.

This painting, as famous
as it was controversial –
already on the occasion
of its first presentation
to the public, in 1880,
Fattori had been
criticized for the soft and

simultaneously sinister
nature of the image –
appears somehow
detached from the
production of Fattori
the painter of battles.
An image of death
both dismal and heroic,
it celebrates the force
of the horse while
portraying with pathetic
but macabre touches the
horrifying fate of the

soldier. Decades after
the Risorgimental
mobilization the artist
considers the event in
terms that are in some way
fatal. The elements of the
drama are biological rather
than historical/social:
the survival instinct, flight
and escape, fear; the quiet
landscape with its low
horizon, desolate and
almost primordial.

Giovanni Fattori
Mending the Nets
c. 1872,
canvas.

The artist aims here at
the apparently facile
execution and skill of the
narrator of sketches – a
skill which, when resolved
on the compositional level
(as in the case of the
strange cap worn by the
net-mender standing on
the right: a simple
biomorphic silhouette;
or the "eye" with which
the nets regard us, at the
lower center of the
composition; and more
generally the drawing of
the figures) is reminiscent
of Mannerist grotesques
and Japanese linear
caprices. The format is that
of a woodcut rather than a
veduta, a loose two-
dimensional manner that
heightens the emphasis on
borders, *aplats* of color;
here and there, appearing
more as expedients than as
convincingly integrated
elements, are concessions
to the third dimension –
the stick tilted to suggest
depth, the terracotta.

SILVESTRO LEGA

Modigliana (Forlì) 1826 –
Florence 1895

A pupil first of Bezzuoli at the Florence Academy of Fine Arts and then, still at Florence, of Mussini, he served his apprenticeship under the sign of romantic historical painting. A republican, he fought in 1848 as volunteer at Curtatone and Montanara. He then began a series of compositions having as subject the Bersaglieri. The war for Italian independence was for him a war of the people. A frequenter of the Caffè Michelangelo, he gradually turned in the direction of the Macchiaioli. Dating from the 1860s are many of Lega's most famous paintings, characterized by intimist themes and a refined, harmonious palette. His predilection for soft borders and light colours reflects his Purist apprenticeship. Starting from the 1880s he painted landscapes of the countryside around Livorno and portraits of peasants, acknowledging a greater importance to colour.

Silvestro Lega
A Visit
1868
canvas, detail.
Rome, National Gallery
of Modern Art.

A barely disguised variation on the theme of the *Visitation*, the painting, so discrete in appearance, has the clarity of a manifesto. For the artist it is a question of returning to the origins of the Italian artistic tradition, interpreting them in the light of contemporary landscapes and costumes. When simultaneously

viewed reductively as a "Verist" painting, *A Visit* is remarkable for its deliberate ingenuousness. "It has a touch of the puerile", wrote Camillo Boito in 1877, "there is a cottage with an arched door and certain windows that seem to have been produced after much study by the hand of an ingenious child; [...], the manner has a certain primitive simplicity which at first glance seems clumsy but which little by little persuades and pleases".

Silvestro Lega
An Afternoon
1868,
canvas.
Milan, Brera Pinacoteca.

The subject of the
painting is a pause, a
glimpse of a quiet familiar
moment within a
women's community: a
minor rite, it could be
said, considering how
Lega attempts to reveal,
hour by hour, the natural
religious sentiment that
pervades existence in
conditions of simplicity.
Painted with apparent
looseness in the parts
depicting vegetation and
landscape, *An Afternoon* is
subtly allegorical. If the
three central figures, the
girl, the young woman,
and the lady with the fan
refer to the ages of life, the
lady herself, who turns
toward the maidservant,
seems to invite us to
considerations that are
both religious and social.

TELEMACO SIGNORINI

Florence 1835 – 1901

The son of a refined veduta painter in Grand-ucal Florence, Signorini painted and drew even as a child. He copied Dutch and Flemish landscapes in Florentine collections, inspired by them with a lasting predilection for the typical and the local. His apprenticeship was Romantic; painting landscapes and views of the Tuscan countryside, he experimented with the historical genre. An assiduous frequenter of the Caffè Michelangelo, he turned increasingly strongly in the naturalistic direction and adopted the technique of the *macchia*. Representation was entrusted to an assembly of tones, in the absence of any chiaroscuro elaboration. A volunteer with Garibaldi in 1859, Signorini was in Paris in 1861, when national unification had now been achieved. His passionate homage to regional landscapes, costumes and populations is similar to that of the Barbizon landscape artists.

Telemaco Signorini
Leith
1881, canvas.
Florence, Pitti Palace,
Gallery of Modern Art.

Signorini visited Edinburgh in the summer of 1881 – Leith is one of the two ports of the Scottish city – and during his visit drew some sketches which were to provide a basis for the painting. Far from being a simple snapshot, *Leith* is a sort of catalogue or repertoire of social types and costumes. We see a policeman, a young nurse, a man wearing a kilt, a water-seller, a vivandier. The large advertising poster completes a narrative related under the sign of the picturesque. An eye-catching invitation to consumerism plastered onto the wall of an old, decaying house, it serves as optimistic emblem of the intense and frequently dramatic transformations undergone by Great Britain in the Victorian age.

Telemaco Signorini
*The Square
in Settignano*
c. 1881,
canvas.

The signs establish places
and customs; they take
the place of narration,
it might be said.
The village scene is painted
almost like a still life.
The individual elements
have no mutual
relationship, recalling the
kit of an assembly set, or
rather a sample collection
of nostalgic goods, of old
memories.

GIUSEPPE DE NITTIS

Barletta (Bari) 1846 –
Saint-German-en-Laye 1884

Giuseppe De Nittis
Self-portrait
autograph of Léontine
De Nittis, dated 1884,
detail.

After training at the Naples Institute of Fine Arts, De Nittis painted landscapes *en plein air* which were appreciated by the Macchiaioli, encountered at Florence in 1867. Moving to Paris in 1868, the ambitious, talented painter made his home a meeting place for artists, intellectuals and collectors, and signed a contract with the Maison Goupil. Although his first Parisian success arrived thanks to costume paintings, De Nittis did not neglect landscapes or contemporary genre scenes. In 1874 he exhibited, although without strong conviction, with the Impressionists. His first pastels date from 1875. De Nittis won definitive recognition at the Exposition Universelle (1878). He was among the most acclaimed "painters of the elegant life", skilled at unusual angles and brilliant society chronicles. In perception and narrative power his paintings rivaled the contemporary novel.

Giuseppe De Nittis
The Racetrack at Auteuil
1881, pastel, central panel
of triptych.
Rome, National Gallery
of Modern Art.

In adopting the triptych form for his *Racetrack at Auteuil*, De Nittis effected a sort of consecration of the contemporary motif. Complimentary and refined, the composition boldly asks for the admiration of the public to which it is addressed. The great variety of types, situations and contexts portrayed reflects the objective of attaining a certain completeness. The artist plastically portrays a set of states of mind, sketches erotic-pathetic plots, displays a sample collection of high fashion clothing, alternates severity and frivolity – as demonstrated by the image of the brazier and the young woman warming her foot, with the poodle sitting near her. On the whole, the artist seems to offer himself in the dual role of *arbiter elegantiarum* and confidant of high society.

FEDERICO ZANDOMENEGHI

Venice 1841 – Paris 1917

After training at the Venice Academy Zandomeneghi, only 18 at the time, took part in the Expedition of the Thousand. In Florence in 1862 he met the Macchiaioli. In 1874, at the conclusion of a "Verist" period, the artist moved to Paris. The support of Paul Durand-Ruel, gallery owner, collector and patron of the arts, ensured him moderate financial well-being. Initially opposed to the most innovative painters, whom he judged excessively formal, he gradually moved closer to Pissarro and Degas. Starting from 1879 he exhibited regularly with the Impressionists and in 1888 experimented with the divisionist technique for the first time. "Looking, listening, discussing", he recalled, "I transformed myself [...]; my artistic life was a succession of infinite evolutions". His first one-man show at Durand-Ruel, with whom he signed a contract for exclusive rights, was held in 1893.

Federico Zandomeneghi
The Reading Girl
c. 1885-90,
canvas.

The motif of a girl reading was dear to those, in the French painting of intimist tradition, who insisted on particular requisites of calm, precision, and absence of ostentation in the painting itself. This emerged from a prolonged practice of observation – it could even be said, of deciphering. In this painting Zandomeneghi is especially attentive to the play of reflections. These, and not the volumes, become the principles of form and composition.

GIOVANNI BOLDINI

Ferrara 1842 – Paris 1931

Edgar Degas
Half-Bust
Portrait of Boldini
c. 1889, detail.

Boldini, who trained with his painter father, was in Florence in 1862. Enrolled in the Academy, he greatly benefited by frequenting the Caffè Michelangelo. At Paris in 1867 to visit the Universal Exhibition, he traveled to London in 1870 to study the aristocratic portraiture of the 18th century. Boldini settled in Paris in 1871, where he was appreciated for his genre paintings and commemorative portraits. A master of the virtuoso brushstroke, of loose, fast execution, and of the international Velázquez style in vogue during the last decades of the century, he traveled frequently and could boast of numerous friendships among artists. He was in Germany in 1876, where he met Menzel; later stayed in Venice, sharing a studio with Sargent; and traveled to Morocco with Degas in 1889. Participating in international salons and exhibitions, he also exhibited at New York in 1897.

Giovanni Boldini
Portrait of the
Young Errazuriz
signed and dated 1892,
canvas.

The composition is
insistently vertical. The
parquet escapes downward
while the woman's legs,
umbrella and hat combine
to render her figure slender
and long-limbed.

Giovanni Boldini
*Portrait of the
Painter Cabianca (?)*
1863,
oil on cardboard.

It is probable that
Vincenzo Cabianca, in
Florence between 1853 and
1863, was the subject
painted by Boldini in an
elegantly Bohemian
attitude.

Giovanni Boldini
In the Garden
1885, panel.

Fascinated by elegance,
wealth and nobility,
Boldini did not often
experiment with intimist
portraiture. Alaide Banti,
portrayed here, was the
daughter of Cristiano, a
Macchiaiolo painter which
whom Boldini had
established a long-lasting
friendship. After having
met Banti in 1862, Boldini
painted several portraits of
him. Banti was Boldini's
guest at Versailles, and
Boldini stayed with the
Banti family a number of
times in Florence. Boldini
was linked to Alaide by an
intense emotional
relationship. He always
considered her his "Italian
fiancée", asking her to
marry him in 1903, only to
withdraw immediately
afterward from the
ceremony he had always
feared.

517

ANTONIO MANCINI

Rome 1852 – 1930

Antonio Mancini
Self-portrait
c. 1929, detail.
Florence, Uffizi Gallery.

A pupil of Morelli at the Naples Institute of Fine Arts, Mancini drew from his master's teaching a strong interest in the 17th century Neapolitan tradition. A studio companion of Vincenzo Gemito, he turned to observation of the popular world of Naples, painting types taken from life. Mancini made his debut at Paris when only twenty years old, in 1872, and established contact with the Maison Goupil in the same year. His first two periods spent in Paris were in 1875 and 1877-78. Awareness of what was happening on the scene in the French capital confirmed the artist in his stylistic approach: loose, rapid execution, pasta painting, effects of light and color. In the attempt to confer greater brilliance on the figurative surface, Mancini added fabrics, sequins, and bits of colored glass. Success came late: after presenting a one-man show at the XII Biennial, he was appointed to the Italian Academy in 1927.

Antonio Mancini
'O prevetariello
1870, canvas.
Naples, San Martino Museum.

Among the favorite subjects of the young Mancini were boys and "scugnizzi", or street urchins, in demand by foreign collectors and artists in search of "souvenirs d'Italie".

Among the first to appreciate Mancini was Hendrik Mesdag, a naturalist painter of The Hague school. Little seminarians and coral-vendors, street children and fragile water-sellers easily satisfied the contemporary taste for pathetic/picturesque images with decidedly local traits.

VINCENZO GEMITO

Naples 1852 – 1929

Vincenzo Gemito
*Self-portrait with
Nude Torso*
c. 1881, detail.

Vincenzo Gemito
Fisher Boy
1877, bronze.
Florence, Bargello Museum.

Exhibited at the Paris Salon in 1877, a first version of the *Fisher Boy* was enthusiastically acclaimed. Gemito was induced to remain in Paris, the guest of Meissonier. Barely dissimulated beneath the facile "Verist" narrative quality of the motif are

A friend of Mancini, with whom he shared a studio, Gemiti owed his first notoriety to a series of small typical figures, mostly beggars, sculpted in clay. As a portrait painter he was highly appreciated also in Paris, where he exhibited for the first time in 1876 – posing for him, along with Morelli, were Verdi, Fortuny, Michetti, Boldini and Meissonier. For the latter, master of costume painting, the artist expressed open admiration. Gemito lived for some time in the French capital, then returned to Naples in 1880 to open a fine-arts foundry that met with growing success. Rather suddenly, however, he went into total isolation, from which he was to emerge only in 1905. Dressed in a redingote, he lay on the floor and stubbornly refused to wash or to leave his home. In his last period of activity, between 1917 and 1925, Gemito dedicated himself to small, refined sculptures in silver and bronze.

cultured, even archaeological elements reflecting the artist's interest in Hellenistic statuary, particularly as regards aspects of daily life and humoristic hunting and fishing scenes associated with figures of children. The result is a gentle, nostalgic re-evocation of the Mediterranean myth. Humanity and nature live side-by-side in happy equilibrium, an equilibrium untouched by the

vicissitudes of history or by technical/industrial evolution. The world of antiquity has never really come to an end. Rich in citations and carefully attentive to naturalistic detail – the cane fishing rod; the net bag; the boy's wet, salty hair; his eyelashes – the statue shows carefully modeled surfaces and particular linear elegance attained on the level of silhouette.

GIUSEPPE PELLIZZA DA VOLPEDO

Volpedo (Alessandria) 1868 – 1907

Giuseppe Pellizza da Volpedo *Self-portrait* 1897-99, detail. Florence, Uffizi Gallery.

Giuseppe Pellizza da Volpedo
An Amorous Walk
1901-1902, canvas
Ascoli Piceno, Civic Pinacoteca.

Between 1896 and 1903 Pellizza dedicated himself to a series of works on the theme of love, to which he gave the name *Idylls*. The artist reveals his objective of attaining narrative completeness, of moving beyond the taste for the fragmentary.

Training first at the Brera Academy, then at the Rome and Florence Academies, the artist went to Paris in 1889 to visit the Universal Exposition. Upon returning to Volpedo, where his family owned land, he painting scenes from life: landscapes and views, still lifes and portraits. In the early Nineties he experimented with the divisionist technique. With Morbelli, a very close friend, he shared an interest in social issues. Close to spiritualist circles in Florence, he was in Rome in 1896, where he studied the Raphael of the *Stanze* in the search for a model of historical painting. He aimed at images that could fix present events, transposing them, through formal elements, to the level of pure beauty. Contemporary history and standard canons are intermingled in compositions meditated at length. Still in Rome in 1906, Pellizza met Balla, Boccioni and Severini. In 1907 he was to die a suicide.

Giuseppe Pellizza da Volpedo
The Mirror of Life
1895-98, canvas.
Turin, Civic Gallery
of Modern and
Contemporary Art.

The subtitle to this painting quotes a verse by Dante from the third canto of the Purgatory: "And what one does, the others do" (or: "And what the first does, the others also do"). Painting, for Pellizza, cannot be reduced to the practice of a refined profession. It is intellectual activity, akin to poetry, music, philosophy. The *Mirror of Life* is presented, in fact, as a reflection on humanity, or rather a meditation, not simply as a painted image. In the arabesque motifs of the frame and the curvilinear profiles of the herd shown in silhouette, it insists on the cyclic nature and recurrence of life, on the perennial alternation of birth and death, on good and evil – among the sheep, one is black – on youth and old age.

Giuseppe Pellizza da Volpedo
The Fourth Estate
signed and dated 1901,
canvas.
Milan, Civic Gallery
of Modern Art.

Already in 1890 and 1891 Pellizza has been attracted by the subject of a crowd of workers advancing. The artist, who for years held roles of responsibility in agricultural/labour mutual aid societies, wished to show his solidarity with the socialist cause. But the reasons behind the painting are only in part "Veristic"; in it are interwoven stylistic and symbolic aspects. This is apparent in the figures of the workers, studied in large cartoons and conceived according to principles of sculptural fullness, and in the absence of emphatic gestures.

ANGELO MORBELLI

Alessandria 1853 –
Milan 1919

Angelo Morbelli
*Self-portrait in a
Mirror with the Model*
1901, detail.

After training at the Brera Academy, Morbelli moved toward Lombard naturalist tendencies. In his first paintings he combined atmospheric observation, freedom of touch and social analysis. Starting from 1890 he experimented with the divisionist technique, soon becoming its strictest interpreter in Italy. His predilection for "Verist" subjects was not however contradicted by the adoption of a more refined pictorial style. Morbelli drew inspiration from observing the world of work and poverty, urban isolation and emotional solitude encountered in the modern industrial metropolis, especially by the elderly – especially touching are his representations of the "old men" in the Pio Albergo Trivulzio hospice. His last years of activity saw a progressive detachment from the civil tension of his most famous compositions and a turn toward landscape painting, for which he made photographic studies.

Angelo Morbelli
The Rice Paddy
signed and dated 1901, canvas.

The painting reveals the artist's dual interests. Sober and forthright in its guise of "social" documentation – we see the harsh conditions under which the rice-gatherers work, bent over the water for hours and hours; their youth; the ardour and the silence that follow fatigue – it is nonetheless vibrant with cultured archaeological references employed to render the subject as beautiful as possible. Ancient Egyptian reliefs and Impressionist landscapes are no less important, for Morbelli, that a scrupulous study of light, of landscape and of local flora.

527

MEDARDO ROSSO

Turin 1858 – Milan 1928

Medardo Rosso
Gavroche
1882, bronze.
Milan, Civic Gallery
of Modern Art.

The original title of the sculpture, more consonant to the verist taste of the young Rosso, was that of *Street Urchin* – the present title, which superseded it, dates to the time of the artist's first stay in France.

A pupil at the Brera Academy in 1882 and '83, Rosso approached the artists of the Scapigliatura, drawing from them a lasting preference for barely suggested forms and insistent effects of light and shadow. Between 1885 and 1886 he was in Paris, at the time when the painting of touch and color generically known as Impressionism was most in vogue. He chose subjects of pathetic/sentimental nature almost as if in flight from any attempt at fashion and affected elegance. He combined an interest in new materials and new painting techniques with his previous "Verist" attitudes. His sculptures rival paintings and illustrations in the unusual angles of the image and the suggestive effects of atmosphere – the border lines tend to dissolve, the figures to blend into their surroundings. If the *Impression d'omnibus* (1884-85) and the *Impression de boulevard. Paris la nuit* (1895-96) have now been lost – only photographs remain – the *Conversation en Plein Air* (1896) remains as witness to the artist's intentions. He breaks out of the limitations of sculpture, experimenting with the urban landscape, the contemporary genre scene.

Medardo Rosso
Ecce Puer
1906, plaster cast.
Milan, Civic Gallery
of Modern Art.

The *Ecce Puer* marks, with other late sculptures, the point of greatest confluence between Rosso's research and the figurative tendencies of the Symbolist movement. The concrete form is almost made to disappear in favour of pure figurative elements, such as lines, which appear to reveal a state of mind.

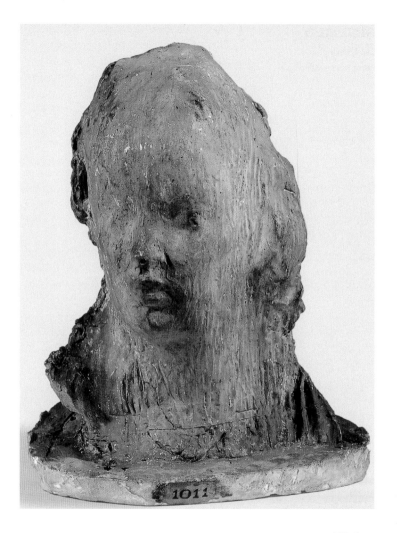

529

GIOVANNI SEGANTINI

Arco (Trento) 1858 –
Schafberg sul Maloja,
(Engadina) 1899

Photograph of
Self-portrait retouched
by the painter, 1895.

Giovanni Segantini
The Two Mothers
1889, canvas.

Effects of light, gently
pathetic action, a study of
nature – note the figure of
the cow with her new-born
calf at her feet; the
chiaroscuro modeling of the
infant's face; the large hands
of the young woman.
Segantini describes the
theme of the nativity in
terms of prosaic daily life.

Trained at the Brera Academy, Segantini was close
to the naturalists and the Scapigliati. In contact with Vittore Grubicy de Dragon, owner of a
gallery in Milan, artist, critic, art theoretician, and
the first to introduce into Italy the divisionist technique, Segantini painted his first works with a pure
palette and divisionist brush strokes in the latter half
of the 1880s. Starting from 1891 he abandoned his
naturalistic approach in favor of allegorical/religious
themes. Invited to exhibit in important international
events, he enjoyed dual fame: appreciated in Italy
as a regionalist painter, and in Europe, especially in
the nations of Germanic language and figurative culture, as a refined and mystical painter. Dating from
his last period are large cosmic/nature compositions:
the Alpine landscape becomes a motive, for the artist,
for reflection on the great cycle of life and death.

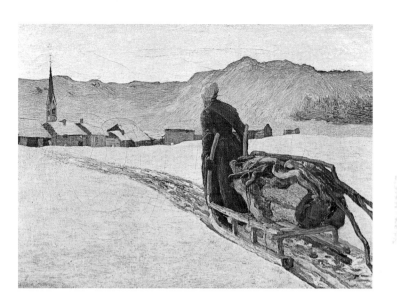

Giovanni Segantini
*Return from
the Woods*
1890, canvas.

The snowy landscape, dear
to the Impressionists,
offers the artist an occasion
for painting without
concern for depth and
perspective. In such a
setting the motif is
naturally reduced to the
two-dimensional quality so
admired in Japanese prints.

A few flat, horizontal
touches of color are
enough to represent the
village toward which the
woman turns with her sled.
Some windows are lighted
by fires burning on the
hearths. Shown from the
back, the figure of the
woman may conceal an
allegorical intent; and the
great trunk lying on the
sled confers on the image
the quality of an Alpine
Pietà.

Giovanni Segantini
Love at the
Sources of Life
1896, canvas.
Milan, Civic Gallery
of Modern Art.

A joint representation,
according to Segantini, of
woman's love, light and
joyful, and virile love,
sterner and more serious,
the painting portrays two
young lovers dressed in
white advancing along a
narrow path bordered by
flowering rhododendrons.
An androgynous angel
extends his wing to protect
and simultaneously
conceal the source of life.
In the eyes of the artist,
water and bare rock, over
which the water flows, are
symbols of eternity. In the
background is a great
Alpine landscape, limpid
and benevolently
primordial, with its snow-
capped peaks, light flowing
into shadow, the sun, the
moon.

GAETANO PREVIATI

Ferrara 1852 – Lavagna
(Genoa) 1920

Gaetano Previati
Self-portrait
c. 1910, detail.
Florence, Uffizi Gallery.

Gaetano Previati
Quiet
1896, canvas.
Milan, Civic Gallery
of Modern Art.

The painting has a dual
nature, being both a
homage and a challenge to
Monet. Although the motif
of the young woman with
the parasol renders explicit

Close to the Scapigliati, the young Previati be-
came known for great canvases of patriotic and
literary subjects. He later adopted the divisionist tech-
nique and emerged as painter of ideas (his first il-
lustrations for Poe's *Tales* date from 1887). His study
of lighting effects became increasingly intense. He
experimented with painting using ample, long fil-
aments of color and a variety of back-lighting ef-
fects, narrowed his range of colours to heighten con-
trasts, sought for his images supra-sensitive di-
mensions, either obscurely stormy or paradisiacal:
"gales", he wrote, "snowstorms, dawns, sunsets. Ten-
uous harmonies of pallid lights, iridescence, bonfires
of purple and gold". Invited to exhibit at the Salon
de la Rose-Croix in 1892, he was among the most
admired artists of European symbolism – audacious
in his choice of subjects, at his ease in complex tech-
niques, adept at theorizing.

homage to the
Impressionist painter,
Previati did not share
Monet's taste for the
naturalistic fragment, for
the fleeting moment of
pure beauty devoid of any
stern morality. *Quiet* seems
to have been born as a
rustic idyll, to transform
itself immediately
afterward into a gentle
allegory.

534

Gaetano Previati
The Creation of Light
1913, canvas.
Rome, National Gallery
of Modern Art.

Painting, for Previati,
meant portraying high
concepts, conferring
perceptible form on the
"ideal [that] wafts through
the dreams of the artist". In
testing himself with such
an immensely difficult
theme as God's dividing
the light from the dark, a
subject certainly not to be
observed while strolling
through the streets, the
artist reveals his desire to
compete with the great
Italian tradition of the 16th
century, with the
Michelangelo of the Sistine
Chapel for instance. His
activity was now
accompanied by complex
figurative programs.

ALESSANDRO ANTONELLI

Ghemme (Novara) 1798 – Turin 1888

Trained as architect and engineer at Milan and Turin, Alessandro Antonelli went on to further studies in Rome between 1828 and 1831. Respectful of the structural elements of the classical tradition such as the arch, the dome and the column, he combined his faithfulness to the antique with a surprising tendency toward experimentation, which urged him to try new techniques and unusual materials. Eclectic like the finest Piedmont architects of the previous century, he conceived bold projects showing a special propensity for vertical constructions. The utilization of iron allowed him to achieve greater structural solidity. Responsible for major civil and religious projects, he was active also as urban planner, devising a plan for transforming the center of Turin which was never to be carried out, and regulatory plans for Novara and Ferrara.

Alessandro Antonelli
The Antonellian Mole
1863-80. Turin.

The construction of the Antonellian Mole began in 1863. The building, designed as a Jewish temple, was purchased by the City of Turin for use as a museum and conference hall. The construction work was finished by the City itself. The Mole, 167 meters high and elegantly composed in its architectural style and structural elements, was the tallest building designed by Antonelli. The dome of San Gaudenzio in Novara, built in 1841, measures instead 125 meters.

The XX Century

Giorgio de Chirico
The Disquieting Muses
1918.

In the early years of the twentieth century a strong tendency toward the international diffusion of common artistic trends began to emerge. This was clearly linked to the development and growth, particularly in Paris, of an art system in the modern sense, with private galleries, critics and collectors, free from any central governmental control. A successful career in art now depended on the support of a private entrepreneur, the gallery owner, and the favor of the public rather than on winning prizes in academic competitions or being appointed to a university chair of painting and sculpture. France, upheld by liberal institutions after its defeat in the Franco-Prussian War, was the leading nation in art also from the economic and social viewpoint, although in the first decade of the century Germany was to become the world's richest market for works of art.

Within the context of evolution in taste and in public and private cultural institutions, the persistent importance of geography in art can still be seen. Italy's first 20th century avant garde, the Futurist movement, proclaimed for itself in fact aggressively nationalistic/cultural traits, and aimed to produce an art that was recognizably Italian. Artists and writers, as was reiterated in the manifestos and journals of this movement such as "Lacerba", proposed to operate within a precise cultural context, the national one, promoting an overall renewal imbued with political and social implications. An imaginary catalogue of works of art from the Italian twentieth century can easily be

Ardengo Soffici
Fruit and Liqueurs
1915.

compiled. In its pages will be found unambiguous geographical indications that make a clear statement, or at least an admission, of territoriality. Both Boccioni's *Rising City* and Balla's *Flags on the Altar to the Fatherland* are, obviously, Italian urban landscapes. The former is an allegorical portrayal of expectations of collective cultural and industrial growth. In the latter a patriotic demonstration surprises a crowd unanimously ranked in favor of entering the war. In both cases the artist is the interpreter of a renewed national unity and grandeur, based on the work ethic in the case of Boccioni, on patriotic interventionism in that of Balla (Carrà as well painted an *Interventionist Demonstration*, in 1914). The artist, in other words, is a prophet, or at least a herald. A vein of continuity, at times surprising, emerged in the first half of the century between artists and movements that were stylistically very different.

The *Italian Piazzas* through which De Chirico wanders, albeit with a troubled air, are still places, and specifically Italian places; but for him this is not the time for new myths nor patriotic fervour. Italian locales are again the industrial districts depicted by Sironi, still in the role of artist/intellectual, artist/prophet, although doubt-ridden and insecure. Strangely enough, Sironi occasionally inserts in his *Urban Landscapes* figures of horsemen resembling Giuseppe Garibaldi – almost as if the "hero of two worlds", the artist's alter ego, had returned to the sites of the nation so recently restored to unity to pon-

Antonio Sant'Elia
The New City
1914.

545

der its destiny, to question himself as to a Risorgimento still to be completed, since it has been interrupted.

The viewpoint from which the present is seen might vary, tending more or less toward involvement or bitterness, toward consensus or ironic reserve – particularly after 1922, the date of the March on Rome. But what remains immutable is the role of the artist, who exemplifies in himself a strongly public image, a kind of oracle, and whose work touches on the sphere of political activity in its broadest sense – as a construction project of national character. Excluded from all this are the eccentrics, the artists who neither desire nor seek institutional responsibilities and mandates, who do not even feel called upon to keep faith with the Italian tradition: De Pisis, for instance, and Scipione, Licini, Fontana, Carolrama.

Burri too will be considered, thus outlining a history of Italian art by themes, attitudes, tendencies and not by styles; a history of art in draft form, traversing the vicissitudes of politics, institutions and war. This brings us up 1949 or 1950, the time of Burri's first experience with *Sacks*. Significantly, some of the sacks he used were those, bearing wording in English, that had contained food distributed by American soldiers to the famished population of Italy just after the war.

Not by chance, perhaps, these sacks appear in elusive metaphysical compositions, where heads recline like those of ancient statues, painfully afflicted by the state of the nation. Is this a caustic reference to the post-war period, perhaps even to the allied aid policy? It may be; but it is also possible that the historical starting point rapidly dwindles to a mere expedient for attracting attention. In the late Forties and early Fifties the activity of artists took on a specific autonomy, a haste to decline

Mario Sironi
*Outskirts of City
with Horseman*
1924.

responsibility, to bury memories, resentment, social duties; to leave behind the artistic and cultural orientation of the years between the two wars. What interests Burri (and what others surely learned from him) is not an evocation of the horrors of war nor the open wounds in the body of a nation divided and defeated; nor even Italy's state of restricted independence under the Marshall Plan. He is much more concerned with focusing attention on the construction of the canvas, on the bare laborious work that precedes the image, and lastly on the private and voluntary nature of the artist's activity.

It is on this level, finely balanced between rhetoric of (and responsibility for) the construction and free play of composition, that the artists of the younger generations encounter Burri – with a decided predilection for playfulness; and the obligation to refer to any historical or social context fades away or vanishes entirely. Proof of this is offered by the two artists who more than all the others – for biography, catalogue of works and sphere of acceptance – exemplified the new artistic and social scenario of the Sixties.

This decade was to see the affirmation of new painting techniques, the establishing of new relations between artists and the public, the mildly authoritarian emerging of a new condition of interest and even of aesthetic evaluation, the demographic age. Starting in the Sixties, self-portraits of artists were to benefit essentially by the fact of being self-portraits of the artist as

Gino Severini
Pulcinella
1924. Rotterdam,
Boymans-van Beuningen Museum.

a young man. Both Piero Manzoni and Pino Pascali seem to personify the *enfant prodige*, even on the level of concrete existence. They were both to die young, either for secret vulnerability or for fragile, insouciant recklessness. Their work, abundant and produced with no apparent difficulty, effort or premeditation, in a state of light-hearted ease, pleasure and superior incompetence, shows none of the painful fatigue, the tragic sublimity of the traditional artist, struggling against a hostile society and the great masters of the past. With seductive skill they move within the shadow of illustrious tutors, artists, art historians, collectors, suddenly grasping, like adolescent demigods to whom nothing is denied, marvellous opportunities – taking from art history whatever they want and making it their own, reinventing it with no concern for the boring, archaic laws of ownership.

As noted by Alberto Arbasino, the early Sixties saw the start of the "youthful tendency to utilize no more tradition and the past to construct new ensembles (according to literary images and figurative emblems: modern dwarfs on the shoulders of classical giants, the plant of new life on the ruins of the ancient world...), but rather to exploit existing elements: institutes, buildings, vehicles, apartments, household furnishings, cultural channels established by others, of which to ask hospitality, complicity and passage (while in older, more restricted epochs, each gen-

Luciano Fabro
Golden Italy
1971.

eration constructed by itself its own institutions and its own structures)...".

Art is neither torment nor genius nor social and intellectual representation, nor even profession. Rejected as such – as the earning of merit through the patriarchal social rules of labour and fatigue – it is rather an attitude permeating existence as a whole, it is irony, exploration and journey, time reduced to pure motion, paradisiacal physiology.

A final comment on the following pages remains to be made. We have attempted to present the individual artists, especially those of the most recent decades, without excessive reference to movements, tendencies, "group poetics". These, with the passage of time, tend to become more remote. In retrospect they no longer seem so influential, as least not such as to allow us to classify artistic activity collectively.

Obviously, consensus has at times reigned between certain critics and certain artists in regard to an artistic/cultural agenda, an issue, a viewpoint; more or less intense, significant relationships have existed; and these have had consequences, at least on the level in which the work (and the discussion of the work) becomes communication.

Here we should recall at least the "poor art" movements that emerged in the late Sixties and early Seventies around conceptual tendencies; and the "Transavanguardia" movement that heralded, in the very early Eighties, the striking return of painting and sculpture to public and critical favor. In the Nineties the panorama of Italian art reflected the neo-conceptual orientation predominant on the international scene: photography, installations, and video became once more the figurative genres most congenial to artists.

Michelangelo Pistoletto
Venus of the Rags
1968.

GINO ROSSI

Venice 1884 – Sant'Artemio
di Treviso 1947

The apprenticeship of the intense, cosmopolitan artist Gino Rossi was predominantly French. In Brittany in 1907, then in Paris, Belgium and Holland, he was close to the Nabis and Symbolist trends. His painting shows characteristics of elegant *cloisonné*, like a lacquer, a Medieval enamel that encompasses within a single plane of representation figures, landscape elements, and details of costume and furnishing. In 1912 Rossi exhibited his works at the Salon d'Automne in Paris along with Modigliani and Arturo Martini. With both of these artists he shared a search for models of strongly synthetic image, where the motion of the lines expresses, without departing from the plane or simulating depth through the traditional techniques of chiaroscuro, the fullness of forms. In the postwar period Rossi moved closer to generically cubist or neo-cubist principles of composition, but without abandoning his basic predilections. In 1926 he was admitted to a psychiatric hospital, and his activity as artist came to an end.

Gino Rossi
Girl with a Flower
1909, canvas.

Presented against the background of a wall painted in deep Marian blue, flanked by two niches holding floral compositions, a girl, probably Breton, meets the observer's gaze with the unflinching steadiness and remoteness of a statue. She has been compared with figurines of Far Eastern idols, and with the Breton and Provençal adolescents painted by Gaugin and Cézanne. Certainly the heraldic maiden of Rossi displays traits of allegorical personification, as she sits at the center of the painting – it might even be said, of the tapestry – almost as if to testify to the archaic, regal composure of a life that is both intensely religious and natural.

ARTURO MARTINI

Treviso 1889 – Milan 1947

After training in Munich at the school of the German sculptor Adolf Hildebrand, Martini soon came into contact with the young Italian artists who were promoting a renewal in national art in the years prior to World War I. A temperamental artist, extremely sensitive to materials, Martini was a friend of Gino Rossi, with whom he traveled in 1912 to Paris, where he met Modigliani and Boccioni. His first sculptures show a provocatory archaicizing plastic orientation: severely two-dimensional, they frequently recur to polychrome effects. In the Twenties Martini joined the general trend toward a return to tradition, distinguishing himself, however, for irony, agility and eclectic capacity to combine or reinterpret sources within a context, the Italian art world of the time, dominated by the hyper-stylistic attitude of sculptors purposely dedicated to imitating classic archeological models.

Arturo Martini
The Prostitute
1913, polychrome terracotta.
Venice, Ca' Pesaro
Modern Art Gallery.

Dedicated to Nino Barbantini, organiser of exhibitions of young artists' work at Ca' Pesaro in Venice, the *Prostitute* reflects the young Martini's caustic, unprejudiced assimilation of generically primitive tendencies in contemporary painting and sculpture, as found in Minne, the Picasso of the blue period, Matisse, and even Kirchner. The female figure, her posture a parody of that of Rodin's *Penseur*, has a decidedly two-dimensional orientation. Like the bow of a ship fending the waves, she seems decorated with elements in high relief.

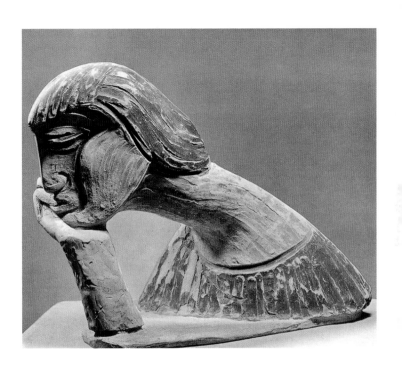

Umberto Boccioni

Reggio Calabria 1882 –
Verona 1916

Umberto Boccioni
Self-portrait
1908, detail.
Milan, Brera Pinacoteca.

Boccioni, like Severini and Sironi a friend and admirer of Balla, underwent a divisionist apprenticeship at Rome and after several trips to Paris settled in Milan. An acute observer of the contemporary world, he exemplified from youth the typical Italian avant garde artist, torn between his own high, urgent expectations and disillusionment with the cultural and social situation of his nation. Immediately joining the Futurist movement, he became, with Marinetti, its most prominent member in the pre-war years. Active as painter and sculptor, he signed many manifestoes; participated in the debate on the avant garde, arguing fiercely with French Cubists and German Expressionists. As cultural organizer, he promoted the new tendencies. As volunteer in the war he changed his approach returning to a more balanced plastic and chromatic composition reflecting the art of Cézanne.

Umberto Boccioni
*States of Mind II:
Farewells*
1911, canvas.
New York, Museum
of Modern Art.

This painting, in reality a second version of the *Farewells* theme, is part of a triptych conceived to illustrate the key locales and emotional dimensions of modernity. The scene portrayed is that of a railway station. A crowd falls back in a double wing before an advancing locomotive; its sharp, menacing

profile, coated with hard metal, is puffing steam into a gray, lowering sky. In the background are glimpses of a semi-urban landscape: electrified hills, railway stations. The entire composition can be viewed as an ensemble of independent narrative elements. The image is not a unitary whole, but springs to life through the associations established first by the artist, then by the observer, between landscapes, figures, and circumstances that may be concurrent but are presented as multiple, listed as within a series – in Boccioni's words, "simultaneous". At the center of the composition stands out a number vividly painted in yellow-orange, almost like a semaphore, a device to attract attention. The "simultaneous" image – this is the meaning of the curious insertion – precludes the traditional requisite of Albertian window to form, as in a code, a conventional aggregate of signs, an inscription.

Umberto Boccioni
*Single Forms
in the Continuity
of Space*
1913, bronze.
Milan, Civic Gallery
of Modern Art.

Boccioni turned to
sculpture after Cubist
experimentation had
deprived painting, in his
opinion, of any reality or
contact with reality. The
level of abstraction reached
in the *Triptych of States of
Mind* represented, for the

artist, an extreme limit
from which he was
prepared to withdraw. The
statue portrays a vigorous
male figure striding boldly

forward – it may be a titan,
a hero or more probably an
athlete. Surprisingly,
Boccioni interprets the
space around the figure as
a part of it, and the figure
as a part of the space,
according to principles of
fluid continuity, and thus,
so to say, baroque. The
motion possesses body and
unfolds in ample,
consistent volutes, in
lateral curls arranged on
closely placed parallel
planes, conceived as in
relief.

Umberto Boccioni
The Rising City
1910-11, canvas.
New York, Museum
of Modern Art.

The painting, which describes and simultaneously commemorates construction work as the model for great collective action, shows a crowd of workers struggling to control the fiery horses used at the worksite. In the background of the composition, still divisionist in technique, appears the great future city, goal and emblem of a conflictual, dramatic modernity. A young nation with unevenly populated regions, upheld by fragile institutions and a poorly representative monarchy, Italy occupied a position among Western European nations, in the opinion of contemporary commentators, that was economically and politically backward. In Boccioni's "rising city" can be recognized Milan at the turn of the century, a place that, in the eyes of the artist, is half utopia, half reality.

561

GIACOMO BALLA

Turin 1871 – Rome 1958

I n Rome since 1895, Balla was a precursor whose importance as such has only recently been recognized. Imaginative experimenter, unconventional but not drastic, he first transferred to the Futurist avant garde the research and sensitivity matured in a divisionist apprenticeship: eminently formal problems such as that of the pictorial representation of light or its processes of propagation. Although long absorbed in the *Iridescent Compenetrations* (1912-14), among the first entirely abstract works of the European avant garde, he never forget his interest in current historical and social issues. The *Futurist Reconstruction of the Universe* manifesto, signed with Depero in 1915, marked a break with the most acute, destructive stage of Futurism, in favor of a joyfully figurative or neo-figurative art, akin to play and even to the elementary plastic activities of childhood, open to design, to fashion, and to the visual arts.

Giacomo Balla
Flags on the Altar to the Fatherland
1915, canvas.

Balla's orientation around 1915, destined to exert a lasting influence on Futurism between the two wars, is clearly evident in this painting. The fragmented, deliberately convulsive images of the first period have now been replaced by a search for more composed, relaxing figurative dimensions, for a plastic world similar to that of construction toys. A bright polychrome

palette confers on the images, regardless of the subject, the nature of toys. In *Flags on the Altar to the Fatherland* the patriotic theme, in itself solemn and charged with allusions to war, is presented without detriment to the limpid formal autonomy of the composition.

The waving tri-colour flags occupy the centre of the painting. Around the crowd, portrayed not directly but through the flags, blue-grey plastic elements rise wave-like toward the sky, transmuting into plastic terms the unanimous voice that rises from the procession.

GINO SEVERINI

Cortona (Arezzo) 1883 –
Paris 1966

Gino Severini
Self-portrait
1907-1908, detail.
Gina Severini-Franchina
Collection.

Already a divisionist painter in Rome, a friend of Balla and Boccioni, Severini moved to Paris in 1906, resolved to become a versatile, refined *peintre de la vie moderne*. He adhered to Futurism at the very start of the movement, participating in the group's first exhibitions; lingering, in his paintings, on the places and customs that characterized the modernity of the metropolis; fervently exploring bold new painting techniques. He experimented with collages, multi-materials, and compositions of words. In the World War I years his attitude changed even more drastically than that of the other Futurists. The return to an art reminiscent of tradition and traditional techniques signified for him, having declared the avant garde experience concluded, a kind of religious issue, a conversion. The profession of artist had become both popular and consecrated.

Gino Severini
The Blue Dancer
1912, canvas.

The composition is painted in the colours of the French flag, blue, red and white, as if in homage to the leading nation in the artistic and cultural world of the times. It portrays an exotic dancer, probably Spanish, wrapped in a mantilla – on the whole, a Manet-like theme. The figure of the dancer is fragmented as if seen through a kaleidoscope, a crystal prism. Minute refractions cause the image to move, impose movement on the eyes of the observer.

CARLO CARRÀ

Quargnento (Alessandria)
1881 – Milan 1966

Born in Quargnento, near Alessandria, of a humble family perhaps of Provençal origin, Carrà arrived late at painting, enrolling in the Milan Academy of Brera in 1906. His participation in avant garde movements was tempestuous, gradually becoming more purposeful. Already by 1910 he was a member of the first Futurist movement. His metaphysical period, starting in 1917, brought him into close contact with De Chirico, Savinio, and De Pisis. In the decades between the two wars the artist was committed to a tradition-based approach of severe ethical and civil implications. Predominating in Carrà's work is a strong desire for solidity and order of composition interwoven with interest in current historical and social themes. Never yielding to the temptation to display a prodigious technique, nor any bizarre attitude or doctrine, he explained that his attention was focused on the mystery of "ordinary things".

Carlo Carrà
The Daughters of Lot
1919, canvas.
Cologne, Ludwig Museum.

This composition, generally considered to mark the beginning of the painter's "Giottesque" stage, seems a version in code of the Christian theme of the Annunciation. The two figures, which the title tells us are the daughters of Lot, the ancient Biblical patriarch, pose like the Announcing Angel and the Virgin Mary in a 14th or 15th century panel. The standing woman places a hand over her belly as if to welcome or to reveal her incipient maternity. Painting – this is the meaning of the picture – makes of itself the womb of purest tradition, welcoming revelation in an attitude of humility.

Carlo Carrà
The Hermaphrodite Idol
1917, canvas, detail and whole.

Carra's "metaphysical" period began in 1917, at Ferrara. The Futurist fragmentation of images was superseded by a desire for well-ordered figuration. The ancient theme of the human figure reappears here, albeit in the ironical form of a mannequin. The idol's room presents an elementary perspective arrangement. The colours are the resplendent local ones of early Renaissance frescoes. Carrà himself was to recall how, in 1917, he conceived of the first compositions with mannequins: "My thoughts about art had arrived at the point in which the soul finds peace in the tranquil contemplation of reality [...]. Finding myself one night [...] wandering through the streets of Ferrara, I happened to see some mannequins abandoned against an old house lit up by a romantic moon. An apparition...".

569

GIORGIO DE CHIRICO

Vólos (Greece) 1888 –
Rome 1978

Giorgio de Chirico
*Self-portrait with Bust
of Euripides*
1923, detail.

Born in Greece of Italian parents – his father was a railway engineer, his mother a Genoese aristocrat – De Chirico, with his brother Alberto Savinio, constitutes an exception in the Italian artistic and cultural scenario of the first half of the century. He was a cosmopolitan who studied at Munich in 1906 and lived at different times and for many years in Paris; a polyglot, a connoisseur of music and literature as well as of the figurative arts, and author of literary and theatrical texts. With his complex experience and wide-ranging curiosity De Chirico fails to fit the *cliché* of the painter dedicated only to his art, devoted to his profession. His career included numerous periods marked by changes, at times radical. In conflict with the Cubist avant garde, De Chirico first conceived his "metaphysical" compositions as an ironic response to the experimentation of Picasso and

Giorgio de Chirico
*Guillaume
Apollinaire*
1914, canvas.
Paris, National Museum
of Modern Art,
Pompidou Centre.

A plaster cast portrait bust wears dark sunglasses and poses in place of the poet, a friend and supporter of the Cubists. The shadow of Apollinaire, with his distinctive profile, appears in the background. The model is curiously absent from the painting, which portrays instead two of his doubles – the bust and the shadow. Beside the plaster case is a fish, inhabitant of the depths and symbol of the Eucharist. Apollinaire, blind and clairvoyant, unites opposites and conciliates the human and the divine as Christ had done before him.

Braque. Between 1917 and 1919-20 he was closely linked to Carrà. In the early postwar period, having moved to Rome, he became the champion of a specifically Italian art, capable of re-establishing a dialogue with the grand tradition. But his classicism was always of abnormal stamp, with elements of mild parody and true kitsch cropping up as if in denial of his declared faithfulness to the canons.

Giorgio de Chirico
The Gentle Afternoon
1916, canvas.
Venice, Peggy Guggenheim Foundation.

In 1916 De Chirico was in Ferrara, enlisted in the army. Practically unknown in Italy, he was still sending his works to Paul Guillaume, his Paris merchant. But it was Italy that the artist thought of as his homeland, Italian culture as his true sphere of action. He alternated compositions depicting mannequins and "metaphysical architecture" with others containing biscuits, loaves of Ferrara bread, match-boxes, spools of yarn, gloves, rulers and squares. He conceived his images as letters, elements in a ciphered correspondence, enigmatic riddles the key to which would be held only by an elect few. Here De Chirico seems to depict, in his usual hermetic way, the objects linked to his present reflections, his current existence. Proposals for action are mingled with melancholy comments on the nation, and nostalgic recollections of the family "interiors" of his childhood.

GIORGIO MORANDI

Bologna 1890 – 1964

Despite Morandi's provocatively Futurist debut, his career is exemplary for reserve and apparent detachment from contemporary culture and the loudly proclaimed politics of the times. Disinclined to involvement in the organisational and promotional aspects of the avant garde, he led a solitary, aloof existence, intolerant and caustic with the artists of his own age or younger who aimed to introduce into art more strongly historical and social aspects, even to the detriment of technique. His entire work reveals the attempt to take his place within an honored historical/ artistic genealogy, that of the modern French masters of still life and landscape. Following a brief "metaphysical" period Morandi became increasingly concerned with problems of light, of the local magic of forms, of a pictorial rendering of surfaces reminiscent of Cézanne and Chardin.

Giorgio Morandi
Bottles and Fruit Bowl
1916, canvas.

Three pieces of household glass are placed against a polychrome blue-brown background, painted in horizontal bands almost in the manner of the most ancient illuminated manuscripts. The space is divided by the different bands of color. The dark brown band in the foreground stands for the thickness of the table on which rest the bottles and the fruit bowl, the light brown band for the table itself, shadowed toward the inside; and the ash-blue band for the back wall. The slight asymmetry conferred by the artist on the two most distinctly characterized objects in the still life – the bottle on the left, the fruit bowl on the right – and the vivid rotatory movement of the fruit bowl animate the forms as if to suggest that they possess an inner, secret existence; as if to mysteriously re-evoke before our eyes ancient battles.

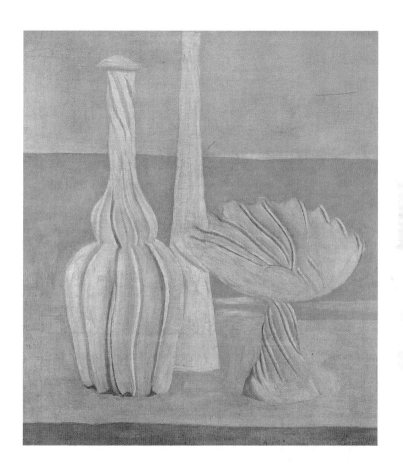

575

Giorgio Morandi
Still Life with Ball
1918, canvas.
Milan, Civic Museum
of Contemporary Art.

*Still Life
with Mannequin*
1918, canvas.
St Petersburg, Hermitage.

Morandi's two most
famous metaphysical
still lifes are companion
pieces to each other.
Within the cases are
the painter's tools of the
trade. Rulers, spheres,
bizarre mannequins,
arranged according to
magic rules of balance,
almost suspended in the
void, and accompanied by
an evocative shadow,
seem to await one who
will make use of them,
while simultaneously
hinting at a revelation.

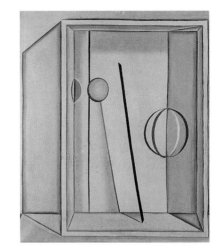

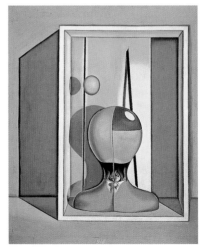

Giorgio Morandi
White Road
1941,
canvas.

Starting from 1927 Morandi spent his summers at Grizzana, a little town in the Apennines above Bologna. Here he walked, painted, and met with a few intimate friends. He worked on landscapes, fascinated by the possibility of transferring to canvas, and thus to a two-dimensional support, a reality made up of three dimensions.

His landscapes present the features, both liquid and cohesive, of enamels and lacquers. The stylizing is not dissimulated: the artist's aim is expressly that of inducing appearance – trees, hills, paths, houses – to show itself as artifice.

AMEDEO MODIGLIANI

Livorno 1884 – Paris 1920

Modigliani's biography seems to possess all the requisites that a *fin de siècle* novelist might ask of an artist: born in Livorno, after apprenticeship with a late Macchiaiolo painter he moved to Paris for a brief fiery career. Beautiful and passionate, unlucky and destructive, his real life soon became practically indistinguishable from legend. Attracted by African and aboriginal sculpture he turned, like his friend the Rumanian sculptor Constantin Brancusi, in the direction explored by André Derain, toward a synthesis between European art, particularly that of 14th century Central Italy, and non-European art. The muted palette distinctive of his compositions, his preference for complementary tonalities, blue-purple and red-orange or ochre, and the slightly caricatured inclination of his figures reveal his unceasing admiration for Cézanne.

Amedeo Modigliani
Red Nude
1917, canvas.

In Italy Modigliani's reputation spread fast after the artist's death, first of all among the young Turin painters who gathered around the art historian Lionello Venturi. An extensive exhibition of his works at the Biennale in 1930 placed Modigliani, within the contemporary canon, somewhere between the isolated figures or eccentrics and the "erotics" – such as Osvaldo Licini, another painter who undoubtedly drew inspiration from Modigliani. Compositions such as the *Red Nude* fully justify the interest in Modigliani, particularly in

the years when the pressure
for an art of historical and
political significance –
"fascist art" was strongest
in Italy. With no desire to
confront the issues of
current events or assume
official poses, Modigliani
chose to deal with the
theme of the female nude,
intimately conjoining
painting, freedom of
expression and desire.

Amedeo Modigliani
*Portrait of Madame
G. van Muyden*
1917, canvas.
São Paulo, Brazil,
Art Museum.

Something of a courtly
routine – this is the aspect
of the artist's activity
communicated to us by this
portrait, painted in tones of
blue and typical, in its
plastic simplification, of
Modigliani's style. The

neck appears elongated and
cylindrical. The face, thin
and pathetically turned, is
reduced to an oval. The
arms hang soft and inert,
almost invertebrate, in the
classic tradition of the
aristocratic portrait.

Amedeo Modigliani
*Portrait of Paul
Guillaume*
1916, canvas.
Milan, Civic Museum
of Contemporary Art.

Guillaume was a well-
known personage in the
Paris of the times, and in
the years between the two
wars: art dealer and editor,
he collected contemporary
as well as African and
aboriginal art, which had
been little studied at the
time. Guillaume supported
Modigliani during his
Montparnasse years. Here
he is portrayed in the dual
dimension of aesthete with
delicate feminine lips and
man of the world, casually
elegant.

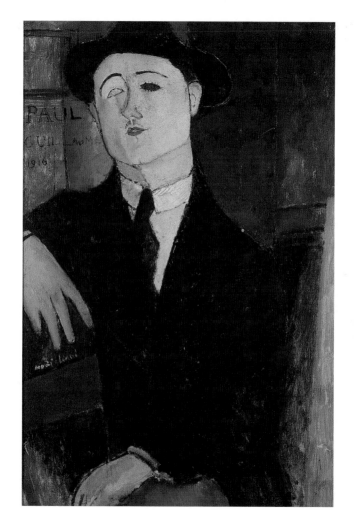

581

FELICE CASORATI

Novara 1886 – Turin 1963

Already present at the Venice Biennale of 1907, the young Casorati showed himself attentive to Central European, and specifically Austrian, figurative tendencies: an extreme care for detail, a preference for sharp, incisive drawing, a moderate inclination for enigma combined with a search for two-dimensional simplification of the image and a polychrome palette as refined as it was strident. Upon moving to Turin at the war's end he participated in the progressive, liberal environment of the Piedmont capital (Piero Gobetti was to write an article on him in 1923). His work evolved first in the direction of metaphysical painting, while his ambition to become a "painter of ideas" and not to operate simply on the level of profession brought him closer to De Chirico. Subsequently he moved toward a moderately archaizing classicism, with ample, soft expanses of colour and forms that are composed and solemn.

Felice Casorati
The Marionettes
1914, canvas.

Four marionettes appear against the dark background of a puppet theatre. Painted like profiles or silhouettes, with no concern for any effect of depth, they are in fact reduced to their costumes and their gaudily made-up faces. A play room, here a puppet theatre, is waiting for someone to come to play, to animate otherwise inert toys. It is awaiting the director of the performance, the Puppet Master, a simple child. Between painting and puppet theatre Casorati constructs, in this painting, a subtle network of analogies and comparisons.

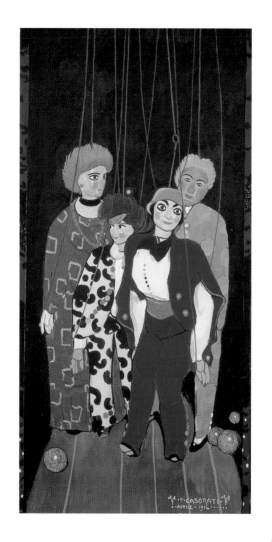

FILIPPO DE PISIS

(Filippo Tibertelli)
Ferrara 1869 – Milan 1956

Carlo Levi *Portrait of De Pisis with a Parrot* c. 1933, detail. Rome, Carlo Levi Foundation.

Filippo De Pisis
Still Life with Sculpture
1927, canvas. Rome, National Gallery of Modern Art.

W ithin the context of Italian art between the two wars the figure of De Pisis is in many ways eccentric: highly cultivated, cosmopolitan, versatile, he showed neither the ambitious extremism nor the scornful, embittered reserve of many of his contemporaries. He was a painter, poet and narrator who shrank from serious, official poses. An acute observer, gently ironic and languidly sentimental, he was singularly unconventional and self-confident. Much is known of his daily life: his vivacity, his urgent and unorthodox loves. His first compositions retain the characteristics of painted collages, of metaphysical puzzles – his meeting with De Chirico and Savinio dates from 1916, at Ferrara. In the latter half of the Twenties he participated in the general return to the painting of touch and colour then characteristic of the Parisian scene (the artist lived in Paris from 1925).

The composition draws an analogy, as brilliant as it is dissimulated, between painting and literature. We find ourselves in a domestic interior, within a private space. On the wall is the painting or coloured print of a classical kneeling faun; a curious scarlet ex libris, resembling the scribbling of a child; a view of an ancient monument, probably an amphitheatre (the Coliseum? – another "souvenir d'Italie", like the faun, for the Parisian De Pisis). The three elements in the composition are not figures, but figures of figures. Differing in scale, in context, in type, they are contiguous and independent like parts of a collage, linked to each other like episodes in a narrative that centers around a central figure, a nude adolescent male appearing in the predominating position. But this narrative is not immediately comprehensible. The task of reconstructing the plot, recognizing the allusions, formulating links and conjectures, is left to our perspicacity as observers.

ALBERTO SAVINIO

(Andrea de Chirico)
Athens 1891 – Rome 1952

Alberto Savinio
Self-portrait
1936, detail. Turin, Civic
Gallery of Modern Art.

Brother of Giorgio de Chirico, he began his career as musician and writer. After a classical education in Greece he lived first in Munich and then, in 1910, in Paris. Here he participated in avant garde figurative, literary and musical circles, displaying his bizarre talent in singular musical performances. In 1916 he was at Ferrara with his brother, engaged in weaving a complex fabric of historical, biographical and cultural references around metaphysical compositions. In the post-war period he was a critic for the most important art review of the times, "Valori Plastici" (for which De Chirico, Carrà and Savinio himself were the most deeply committed and authoritative voices). Savinio's first one-man show in 1927 at Paris, where he was then living, aroused immediate attention for an artist whom the classicists of "Mediterranean" inspiration and the surrealists contended from opposing positions.

Alberto Savinio
Sodom
1929, canvas.

The Bible tells of the ancient city of Sodom and its legendary fornicators. It also tells of the divine ire that struck the voluptuous city, and of how only Lot, a virtuous man, was saved from its destruction. The archetypal name for all future invective against contemporary forms of decadence, Sodom was frequently to re-emerge in the art and literature of the Twenties. It has been seen how Carrà also referred to it indirectly in a painting entitled *The Daughters of Lot*. Savinio portrays Sodom enveloped in high flames, while a bizarre nimbus of toys intermingled with ideographic stelae and a black banner flies through the sky like a destroying deity (or a horseman of the Apocalypse).
Will the new art – either the "ideographic" one of Picasso's emulators or that of his brother De Chirico – save the Western World from its dread "twilight"? Savinio seems both to ask and to parody this question.

MARINO MARINI

Pistoia 1901 – Forte dei
Marmi (Lucca) 1980

Marino Marini
Self-portrait
1942. Florence, Marino
Marini Museum.

Developing during the years when archeological trends were in vogue in Italian art, Marini managed to avoid the most extenuating elegance, the most calculated eclecticism, combining his study of classical/archaic models, those of Central Italy in particular (and thus Etruscan and Roman) with a decided aptitude for "colour" in sculpture, obtained if not by adding pigment, by a painstaking cold-working of the surface, scratched and engraved. The themes of his sculpture are evocative of a mythical Mediterranean world untouched by time or history. In the post-war period the artist moved in the direction of greater abstraction, generically neo-Cubist, purposely omitting the precise historical and geographical references that had marked his earlier work. His multifarious activity now seemed to render homage to international taste.

Marino Marini
Rider
1947, bronze.
Amsterdam, Stedelijk
Museum.

The *Horse and Rider* series occupied the artist for over two decades, starting in 1935. The numerous works bearing this title differ significantly from each other. For Marino the equestrian group possesses no impassive public traits; it is not a monument. What the artist intended to express plastically was a kind of state of mind: horse and rider appear now harmoniously detached, now disoriented, disturbed, even convulsed.

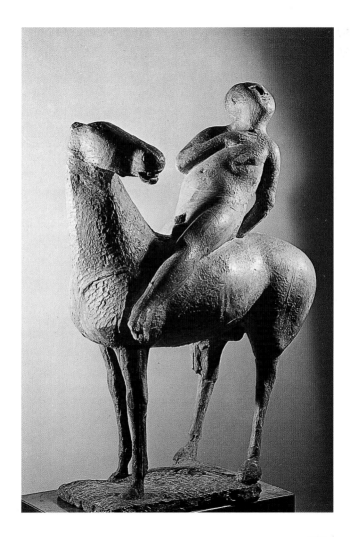

MARIO SIRONI

Sassari 1885 – Milan 1961

Mario Sironi
Solitude
1926, canvas.
Rome, National Gallery
of Modern Art.

Sironi, student of engineering at the University of Rome and pupil of the Academy, was a frequent visitor, with Boccioni and Severini, to Balla's studio. His divisionist and futurist apprenticeship was marked by a caustic, pungent talent that distinguished and sustained him, first in the war years, then in the postwar period, in his activity as illustrator. Still in the postwar period Sironi, with the "Novecento" movement, championed a traditionalist and strictly constructive plastic orientation, banishing from his painting any light narrative dimension or exercise in visual seduction. His compositions are imbued with civic gravity and didactic/allegorical aspects. They are a continuation, in more demanding and openly institutional form, of De Chirico's reflections on the "Italian piazzas", on the historical and social condition of the nation within which the painter carries out his activity, not a merely private one.

Sironi's work in the period between the two wars can be roughly divided into three classes of image: female nudes, compositions on labour themes, and urban landscapes. The female nudes, such as the one in *Solitude*, cannot be considered merely erotic figures. They are instead exercises in an eminent genre of painting, that of the nude, conceived less as the unveiling of a body than as the occasion for a figurative discourse on the goal of any aesthetic activity (on what Sironi considered to be the goal of all aesthetic activity): beauty united to morality, "chaste beauty".

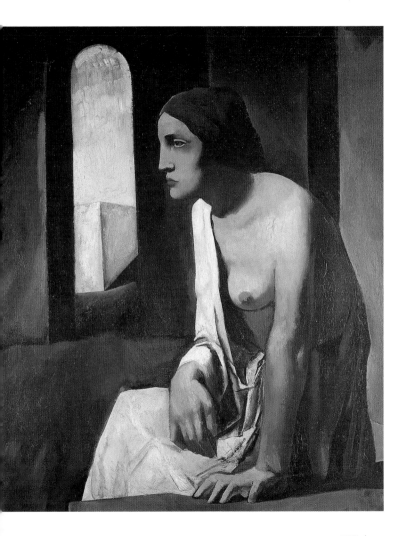

MARCELLO PIACENTINI

Rome 1881 – 1960

Architect and urban planner, Marcello Piacentini was as highly influential in the field of architecture between the two wars as he was later to be harshly criticized. Only recently has his work been approached in more objective terms. It has been possible to extricate the vicissitudes of the architect from those of the academic and polemicist, and to consider his projects and achievements more serenely, acknowledging, within the proper limits, even the motivations for his classicism.

Marcello Piacentini
The Rectorate
1932-35.
Rome, La Sapienza
University City.

Attracted by models of bare secessionist monumentality, Piacentini accepted, of the simplifications introduced by rationalism, only what could be combined with ornamental elements of Graeco-Roman tradition. Architecture could not be reduced, in his opinion, to sober functionality.

GIUSEPPE TERRAGNI

Meda (Milano) 1904 –
Como 1943

Terragni is, with Antonio Sant'Elia, a milestone in the Italian modern movement. A leading figure in the rationalist movement, which he joined at a very young age, he conceived of the new architecture as a severe, heroic correlative of the national character, reawakened – as was first hoped – by the Fascist movement. His need for rigorous design soon put him out of favour with the regime. Drafted into the military service in 1939 and sent to the Russian front, he was to return psychologically and physically destroyed.

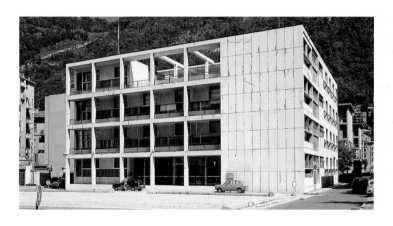

Giuseppe Terragni
House of the Fasces
1932-36. Como.

In designing the Como seat of the party he at first ardently supported,

Terragni showed himself amply familiar with the techniques and methods of European rationalism. The solutions he adopted stem from Le Corbusier and Gropius. Elementary

in form and distinguished by the absence of any façade in the traditional sense, the building is not designed to yield to any commemorative temptation.

SCIPIONE

(Gino Bonichi)
Macerata 1904 – Arco
(Trento) 1933

Scipione
Self-portrait
1928, detail. Prato,
Giuliano Gori Collection.

Surprising, in Scipione, is a singular conjunction of local and cosmopolitan elements. Rome is not only the background of many paintings but also an electively Baroque locale, as if the artist wished it were his own painting – and is archetypal. Nothing of the artistically contemporary Rome, moreover, except for "magic/realistic" touches, appears in compositions distinguished by a palette restricted to yellow-orange tonalities and forms brought to the threshold of disintegration. While the forms seem to dissolve, the compositions reflect instead a knowledge of the European Expressionist tradition (Ensor, Kokoschka, Pascin, Soutine were Scipione's favorite artists, although known to him only through reproductions). With Mario Mafai and Antonietta Raphael, the artist formed a close-knit group, christened the "Via Cavour School" by the critic Roberto Longhi.

Scipione
Roman Courtesan
1930,
canvas.

Scipione's painting provides a real catalogue of types and personalities: the *Catholic Prince*, the *Cardinal Dean,* and this *Roman Courtesan* exist apart from time and history, exist in a state of immutability against the background of a Rome that is both clerical and pagan, entirely given over to sorcery and magic.

RENATO GUTTUSO

Bagheria (Palermo) 1912 –
Rome 1987

Renato Guttuso
Self-portrait
1936, detail. Palermo,
Modern Art Gallery.

One of the most controversial personalities in Italian twentieth century art, Guttuso was as flattered and admired in life as neglected in the *post-mortem* decade. Today his work and cultural heritage seem to be undergoing a more balanced historical and artistic evaluation. Beginning his career in Sicily and Rome, the artist lived in Milan in 1935-37. In 1940 he participated in the founding of the anti-twentieth century movement *Corrente di vita giovanile*. Meanwhile the artistic and civic star of the Picasso of *Guernica (1937)* was blazing for him, urging him to turn toward a style that "can live as an expressive cry and manifestation of wrath, love, justice on the street corners and in the city squares". In Rome in the post war period his outlook grew increasingly more political. Accepting a now institutional role, he became the outstanding representative of partisan orthodoxy in art.

Renato Guttuso
*Still Life
with Red Flag*
1942, canvas.

The composition, apparently sober and detached, could even be erroneously thought to belong to the intimate genre. In spite of this, it reveals the political dimension of Guttuso's art, already evident by this date. The painting is a sort of self-portrait *in absentia* with the red flag, a skull and books scattered about – a self-portrait of the angry artist who refuses to accept censure, who rebels. In the background is what seems to be a detail from a painting by Cézanne, in the foreground a straw-bottomed chair, a simple object of popular craftsmanship. Contemporary art, the artist seems to say, is constitutionally poor, extreme, in a word, protestant.

597

CAROLRAMA

(Olga Carol Rama)
Turin 1918

As a young artist in the Rome of the late Thirties Carolrama was appreciated by many, Casorati among others, but was frequently considered more an eccentric coming from a difficult adolescence than an elusive, refined artist. In 1945 her first show of water colours, portraying with perverse innocence an entire instrumentarium of erotics, was closed by the censors. Near to the abstract-constructionist orientation of the Concrete Art Movement in the Fifties, she later explored the technique of *assemblage*. Her works began to be populated by children's' eyes, fingernails, teeth, needles, syringes, rubbers – materials in some way metaphorical. In the late Fifties Carolrama returned to drawing and to colour. On architect's boards she elaborated "projects designed by friends of mine, so that they can help me invent an image that is erotic, sentimental, private but that is not so closely linked to me".

Carolrama
Appassionata
1940, paper.

The composition has the light touch of an erotic water-colour and the brilliant causticity of an image of crime. Although not devoid of cultural and current references – drawings of the nude from the French *fin de siècle* tradition, *Neue Sachlichkeit* social satires with perverts and persecutors, fetishists and robbers, prostitutes and transsexuals – it possesses a whimsical and singular insouciance, as if of something born of itself. The erotic obsession – enacted? submitted to? – is portrayed with irony and nonchalant license. Everything, in the body of the young woman and even in her scanty clothing, becomes breast, genital zone, orifice – like the leafy fronds that adorn her head or the flagrantly displayed slippers that turn into fur.

FAUSTO MELOTTI

Rovereto 1901 – Milan 1986

Fausto Melotti at Milan
in 1976 in a photograph
by Antonia Mulas.

A pupil of Adolfo Wildt at the Brera Academy, Melotti held his first one-man show in 1935 at the "Milione", the Milanese gallery around which the abstract movement revolved in the years between the two wars. The public and critical success of the show was null. Attracted by the controlled execution and the poetic sophistication of Wildt's works while simultaneously desirous of exploring new paths and rejecting monumental, commemorative aims, Melotti brought the practice of linear drawing to interact with sculpture. Fine lines engrave pure forms or create relief on them, perfect ovals create wombs or projecting forms, line in general begins to exist as plastic element. For this to happen, it was sufficient to create sculptures in the form of harps or tetrachords, consisting of a void and simple stretched wires of stainless steel. In the postwar period he turned to ceramics, confronting the problems of polychrome sculpture.

Fausto Melotti
*The Heresiarchs
and the Holy Bishops*
1952, terracotta.
Milan, collection of
the Melotti heirs.

The figurative objectives of this composition are not disguised by its whimsical subject. While sculpture is traditionally a weighty art, linked to a difficult, heavy material – marble, for example, or another stone – Melotti moves, with terracotta, with the light touch more consonant to the painter's art. He neither breaks nor hammers, but models in small touches, then adds color. Within the ambiance that surrounds the "heresiarchs and the holy bishops" the empty areas predominate over the full ones. The individual figures exist as words, as parts of a visual or even musical notation.

OSVALDO LICINI

Monte Vidon Corrado
(Ascoli Piceno) 1894 – 1958

The great eccentric, along with De Pisis, of Italian art in the first half of the twentieth century – well described, in the title of one of his youthful books, as *errant, erotic, heretical* – Licini cannot be fit into any current art-history scheme. In Paris between 1919 and 1925; with Melotti and Fontana, close to the Milanese abstract painters throughout the Thirties, he was irritated by orthodox positions. He aimed at a painting that would be the "art of colors and of signs", at a "geometry" as "sentiment", but with no intention of abandoning the imaginative. In the early Forties, having exhausted any reason for adhering to the abstract movement, he began to compose by cycles, creating the *Amalasunte*, the *Rebellious Angels*, and the *Flying Dutchmen*, heroes of a personal world of fantasy. Remaining unchanged was his caustic attitude: his compositions were to become pages in a captious diary.

Osvaldo Licini
Rebellious Angel
1950-52, masonite.
Milan, Civic Museum
of Contemporary Art.

A majestic and terribly angry angel strides from the right side of the picture over seas and skies. A dark wing of hair follows him waving in the wind; a promontory at the lower left seems to await him. Strangely enough, he displays digits in place of anatomical details. The number 6 appears twice in place of the eyes, 2 where the right shoulder joins the wing, and 6 again at the naval. The heart, instead, beats steadily on the left side.

AFRO

(Oreste Basaldella)
Udine 1912 – Zurich 1976

The third of three artist brothers – the other two are Dino and Mirko – Afro very early aligned himself with the most innovative trends in Italian art. His neo-cubist apprenticeship took place in the early Forties, while his affiliation with the New Frontier in Art dates from 1947. Afro was a painter both skillful and refined, whose ingenuousness masked a keen awareness. Immediately after the war he was among the first artists to journey to the United States. He went there in 1950, just before exhibiting at the Venice Biennale, and drew long-lasting suggestions from his stay in America. The New York scene encountered by Afro was that of the action painting of Pollock, De Kooning, and Rothko, but it was Gorky above all to whom the artist looked in the attempt to conjoin relaxed, subtle linear exercises and simple expanses of colour. He aimed to reproduce, in his compositions, that loose interference of drawing and colour found in the work of the artists he looked to as masters – Matisse, Klee and Morandi.

Afro
Villa Fleurante
1952, canvas.
Venice, Ca' Pesaro
Gallery of Modern Art.

The painting is a fine example of Afro's interests and compositional tendencies. Fields of color, variously and irregularly polygonal in shape, occupy the entire surface. Terse, concise linear paths are superimposed on the expanses of colour with no apparent relationship to them and almost as if to produce skillful effects of depth and transparency.

ALBERTO BURRI

Città di Castello (Perugia)
1915 – Beaulieu 1995

A military physician, he was captured by the Americans during World War II. He began to paint in a prison camp in Texas, using whatever supports he could find. Returning to Italy, he settled in Rome, abandoning the medical profession to dedicate himself to painting. His first sack-cloth compositions date from 1952. Laying aside his brushes, Burri began to work as a fortuitous tailor, surgeon, patcher and mender. His compositions won international acclaim. Subsequently he worked with wood, burned plastic, iron bars; and then added the cycle of the *Cracks*. Figurative illusions are not lacking in his compositions. Burri seems to have amused himself by evoking pictorial images just while refusing to paint. It may be more useful, however, to view the artist's work in the light of the activity involved, the fervor of construction, than to seek in it recollections of tradition and the museum.

Alberto Burri
Big Red
1956, sack, oil and acrylic on canvas.
Città di Castello,
Palazzo Albizzini
Foundation.

From the morphological viewpoint the composition recalls still life paintings with game: the hanging beef carcasses of Rembrandtian tradition, the hares and fowl of Ensor and Soutine. But Burri states, almost as if to admit a strategy of ambiguity: "in my work there are neither signs nor symbols [...]. Certainly those who look at it always find references, but if I myself wanted to establish references, I would see different ones".

607

Alberto Burri
Sack 5 P
1953, sack, acrylic, vinavil,
fabric on canvas.
Città di Castello,
Palazzo Albizzini
Foundation.

Burri's work, the *Sacks* in particular, never cease to evoke aesthetic emotions, to arouse admiration for what is considered to be specific beauty. Burri was skillful at preserving, in compositions that are non-figurative and non-pictorial, the narrative seeds and memories of painting: in *Sack 5 P* we note some holes, and our attention is immediately captured by them. The holes are looking, the holes are eyes; the holes are asking for penetration, the holes are orifices – and a pendulous strip of colour, a kind of exercise in monochrome.

LUCIO FONTANA

Rosario di Santa Fé 1899 –
Comabbio (Varese) 1968

A pupil of Wildt at the Brera Academy, Fontana was immediately recognized by the master as an artist of great talent. Attentive to what was happening in France, he was also curious about prehistoric art – his first terracottas reveal a knowledge of the Altamira graffiti – and interested in collaboration between the figurative arts and architecture. In the post-war years Fontana became the most authoritative figure, along with Burri, for young Italian artists, with his *Manifesto* (1946) and *Technical Manifesto of Spatialism* (1951), the movement named by him; his *Environments* are installations of lights, colours, and shapes within three-dimensional spaces. *Spatial Concepts*, a series of monochrome canvases pierced by one or more cuts, began in 1951. At the origin of many of the post-informal tendencies of the late Fifties, they also heralded the conceptual trends immediately to follow.

Lucio Fontana
*Spatial Concept,
Awaiting*
canvas, 1960.
Milan, Civic Museum
of Contemporary Art.

The *Concepts* undoubtedly express irritation, annoyance. They manifest what Fontana himself called a "transformation", or better the "end of the painting" considered as a furnishing object finely executed with the skill of the artisan/artist. In contrast to a futile, naively ornamental art, Fontana presents monochrome canvases violated by a cut. What interests him lies beyond the canvas, beyond the representative make-believe, in the direction of artistic experience, of the "nothing...: and man reduced to nothing does not mean that he is destroyed. He becomes a man as simple as a plant, a flower, and when he is this pure, man will be perfect".

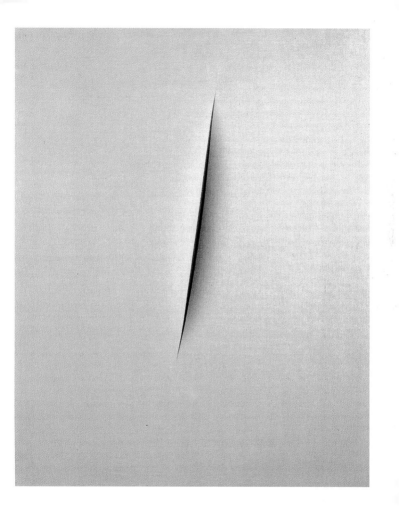

Lucio Fontana
Portrait of Teresita
1938, mosaic.
Milan, Lucio Fontana
Foundation.

Testifying to Fontana's
vivacious propensity for
experiment is the portrait
bust of his wife Teresita.
The archaism implicit
in the choice of
composition – the bust
is the typical genre of
fifteenth century
Florentine sculptural
portraiture – and in the
mosaic-work technique
imposes no restrictive
severity; on the contrary, it
merges fittingly with the
soft curvilinear forms, and
with the modernistic taste
for polychrome sculpture.

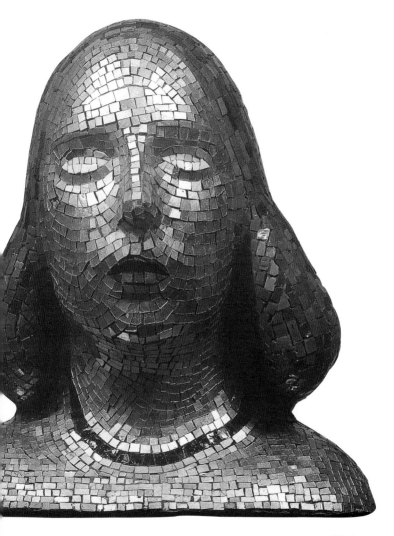

PIERO MANZONI

Soncino (Cremona) 1934 – Milan 1963

*E*nfant prodige of Italian art in the late Fifties and early Sixties, Manzoni was one of the first to grasp the importance of Fontana's work and to interpret his heritage; but he was to go even further than his friend and master in attempting to move beyond any logic of recognizable shapes and formal consistency. He experimented with different techniques, materials and even styles to establish the supremacy of creativity as aptitude, versatility, resource, over art degraded as profession. Emphasising the importance of the peculiar and expressly physiological element in art, he refused to disassociate the dimension of the work from the most concrete experiences of the artist. His monochrome canvases and *assemblages*, performances and installations are always imbued with a keen comic and theatrical sense; but in the pauses between cabaret acts can be felt delicate suspensions, subtly pathetic attitudes.

Piero Manzoni
Achrome
1961-62, canvas.

The composition possesses both the irreverence of fast food and the candid geometric rigour of neo-plastic compositions. Aligned in three horizontal rows of five, fifteen buns in a pure white box seem caught within a dimension of awaiting. Are they waiting to be consumed in a mysterious lunch? We do not know; but the *Achrome* – according to Manzoni inspired by pure chance, on the occasion of a visit to the neighborhood bakery – has a kind of light, white crumbling air, something between the pharmacological and the funereal.

PINO PASCALI

Polignano a Mare (Bari)
1935 – Rome 1968

A pupil of Toti Scialoja at the Rome Academy, already by the early Sixties Pascal had grasped the sense of what was happening in young American art, which seemed to point in the direction of an ironic, disillusioned, brilliant, detachment from action painting. His first works alternate between *assemblages* and playful, showy pop aesthetics: ships in scale weigh anchor on the canvas to which they are glued, great protruding red lips bring to Italy some of the seduction and the mercenary quality of the "American dream". Beginning in 1965, Pascali produced installations, building toy weapons as if for the joy of construction itself, creating portable "seas", exotic landscapes and fantastic animals – spiders, giraffes, whales and worms. Animals interest him insofar as they are "intruders"; to them the complex rituals of recognition that reign within the space of an art gallery are wholly extraneous.

Pino Pascali
in a performance
of the Sixties.

Pino Pascali
Lianas
1968, steel wool.

Pascal displayed a singular ethnographic propensity in an exploration of Mediterranean myths, costumes, and beliefs that was more than a homage to his own origins. The artist, a native of the Apulia region, attempted to express in plastic form the differences existing between his own activity, situated in a certain geographical context, and that of an American artist. The theme of travel is, moreover, implicit in many of his installations – travel as adventure, invitation to lay aside rigidly established roles and cultural identities; in a word, discovery.

JANNIS KOUNELLIS

Peraeus (Athens) 1936

Jannis Kounellis
Without title
1973, photograph
of performance.
Naples, Lucio Amelio
Gallery.

Born in Athens in 1936, he moved to Rome in 1956, enrolling in the Academy. His first compositions, oils on canvas, consisted of numbers and simple alphabetical characters. Starting from 1966 he produced installations of great complexity and visual seduction, utilizing inorganic and organic materials, approaching a kind of poetics of the element – iron, cotton, wool, wood, fire, stone, earth, coffee, cactus and parrots. Poised at the threshold of the picture, of the great painting, he created three-dimensional works that, for their choice of composition, rich colours and allegorical or meta-linguistic aspects, often concealed a reflection on rejected technique. Among the most renowned and influential artists on the international level, he owes his first notoriety to an installation dated 1969 and presented at "L'attico" Gallery in Rome. There the spectators found awaiting them, in place of inanimate objects, twelve pawing horses.

Kounellis, a young man with long hair and a steady, hostile gaze, poses as both dreamy jazz saxophonist and destroying angel. His instrument emits flames, not sounds, and the concert is being held against the background of a gray iron plate rather than in a brightly lit night-club. The iron plate, a metallurgical product, places the artist's activity within the context of a precise industrial landscape – that of Italy in 1973. Contemporary historical and social conflicts are accompanied by this fire music.

Jannis Kounellis
Without title
1960, canvas.

A digit and two letters appear in the white space of the canvas; a fourth letter, deleted, is barely visible. The colored surface and the individual signs are accomplished through a technique in some way reminiscent of Pollock's dripping. The signs seem to carry out the functions of toys that are both linguistic and figurative: macroscopic and devoid of reciprocal links, they stand on the canvas as if waiting to be spelled aloud by the voice of a child, or recited by a phonetic poet, half futurist, half hermetic.

GIULIO PAOLINI

Genoa 1940

His art is distinguished by rigour and restrained, modernistic elegance. Apparently discerning and consistent, not devoid of self-citation and thematic reiteration, it reveals a kind of natural, relaxed inner discourse. His first works are dominated by a meta-linguistic dimension, by reflection on the techniques, materials, and social significance of art. Paolini himself indicated De Chirico and the Fontana of the "cuts" as his primary reference points within recent Italian tradition. Subsequently the need for control persists, but a freer visual and imaginative attitude emerges.

Giulio Paolini
Mimesis
1975, plaster casts.
Turin, Brandolini
collection.

In *Mimesis* we find a different Paolini, more supple and figurative. At a distance of exactly one decade from *Delphi*, no fear is felt before beauty. On the contrary, duplication is employed in the effort to reawaken the enchantment of an ancient statue.

Giulio Paolini
Delphi
1965,
canvas.

The artist poses with
folded arms. Although
his gaze is turned
toward us, we do not
know whether it
reflects on us, his
spectators, or on the
canvas which he has
not begun to paint;
certainly he hides his
face. With its rough
weave and simple
frame of boards the
canvas is, along with
the artist, the theme of
the composition. It
seems turned toward
the wall, as if refusing
to lend itself to the
usual purposes of
pictorial figuration,
deception and
seduction: it is bare,
nude, unaccomplished.
"What should I do?"
seems to be the
question asked by the
artist.

ALIGHIERO BOETTI

Turin 1940 – Rome 1994

Alighiero Boetti
Musical Instrument
1970, detail.

Born and trained in Turin before moving to Rome in the early Seventies – in flight from the artistic and cultural milieu of the Piedmont capital, rejecting control and excessive strategy – Boetti was an elusive, complex artist. He experimented with numerous artistic or artistic/industrial techniques (drawing, weaving, printing, photocopying, photography) and extended the sphere of the visual arts to the point of including letters and telegrams. Interested in the collaborative aspect of art – as shown in the compositions with stamped envelopes and post-cards, or the carpets woven, for example, at Kabul in Afghanistan – he rejected the emphasis placed on the concepts of author and authorship. To the figure of the cultural hero he preferred that of the traveler, the enthusiastic, many-sided observer, or perhaps the gentle madman who splits his own personality (his works were signed Alighiero & Boetti).

Alighiero Boetti
Addition
1984, embroidery on canvas.
Rome, Boetti Archives.

Fascinated by systems of classification, by catalogues, by arbitrary, conventional systematics, Boetti conceived his works as marvelous, but secretly obsessive devices. Virtually interminable, they develop through inner mechanics and processes of serial growth (that is, by "addition"), with the apparent simplicity of a child's game, a singsong melody, a repetitive chant.

622

FRANCESCO CLEMENTE

Naples 1952

"In '68 I was 16 years old. In the evening I fell asleep before Luca Giordano, in the morning I looked at the sleeves of records by Jimi Hendrix, Bob Dylan and the Pink Floyd". Clemente himself, a Neapolitan who now lives in New York, recalls his first figurative experiences. Arriving at Rome in 1970, he met Cy Twombly and Boetti; took photographs; and convinced himself of the plausibility of an artistic approach that inventively explores techniques and images, that unites the cultural and the popular, the community and the individual. Starting in the latter half of the Seventies he made frequent trips to India. In approaching the local art and myths he added a sensual world of images from his own repertoire. Among the first to acclaim the new-found interest in painting – he was in the movement called Transavanguardia – he won international recognition at a relatively early age.

Francesco Clemente
Seeds
1978, tempera,
on fabric-covered paper.
Milan, Alessandro Grassi
Collection.

Recollections of Neapolitan painting are interwoven, in the artist's compositions, with folklore or ethnographic curiosities; with a vivid interest in religious symbols, variously composed; with a predilection for the human figure caught in its specifically promiscuous and erotic dimension – the self-portraits are many. But these compositions are always marked by enigmatic traits. The individual figures are not composed within a unitary setting such as a landscape, but give rise, states the artist, to an "ideogram".

ENZO CUCCHI

Morro d'Alba (Ancona)
1949

Gifted with great talent and inventiveness, he was active in the Seventies as poet and figurative artist. Still very young he gave performances riding a bicycle with inked tires. Great sheets of paper spread over the floor recorded the movement, proffering lines as paths. The artist's interest in art viewed as travel, adventure, emotion, remained vivid when he returned, among the first, to painting near the end of the decade. From then on his best-known compositions presented large formats, traces of feet – as if the artist had walked on them – scenes of desert regions, of navigation and shipwreck painted in the dark, stormy manner of a Romantic artist, with a black and brown-red palette. Citation became the fertile principle of the painting, his compositional machine. Art always repeats the "infinite mass of signs" of which its museum is made up. But its destiny to repeat produces no conflict: the history of art is a plaything.

Enzo Cucchi
Mediterranean Hunt
1979, canvas.
Zurich, Bruno
Bischofberger Gallery.

Predominating among the artists of Cucchi's generation was the desire to divorce the practice of art from any reflections on history, art history in particular. Competitive attitudes were to be avoided, entering into competition with past epochs was to be shunned, the aggressiveness of the avantgarde and its myth of "originality" was to be left behind. "And so dear artists, you who stand among the flames and signs of art at the risk of being crushed", wrote Cucchi in his customary panegyric tones, almost as if to comment on the *Mediterranean Hunt*, "what is it that you marvel at? It is art that, to let herself be tamed, demands that the artist emancipate himself from her and from her evolution".

627

MAURIZIO CATTELAN

Padova 1960

Maurizio Cattelan
Without title
1996.

Involved first in the sphere of anti-functional design, in the late Eighties Cattelan transferred his tendency toward provocation to a specifically artistic/figurative activity. His initiatives aim to bring to light concealed secrets, unwritten rules, the subtly discriminatory attitudes of the art system, based on principles of industrial marketing; or refer to dramatic collective episodes in the historical/cultural context surrounding them. Dating from 1994 is an installation with rubble taken from the Milan Contemporary Art Pavilion, severely damaged by Mafia bombs; and from 1995 is an installation in neon with the star of the Red Brigades. Cattelan alternates the role of artist with that of cultural promoter. Co-editor of a review – "Permanent Foods" – he is at present one of the curators of the First Biennale of the Tropics.

Maurizio Cattelan
Errotin, le Vrai Lapin
1994, performance.
Paris, Emmanuel
Perrotin.

Cattelan rents his own exhibition spaces to advertising agencies; calls on gallery owners to carry out performances in their own galleries – as in the case of Emmanuele Perrotin, director of the Parisian Ma Galery; brings into the art gallery live animals or more frequently stuffed ones as a stimulus to reflection on the limited nature of what is meant by art and collecting, and on a specific form of necrophilia. "We live in the empire of marketing, ostentation and seduction", explains the artist, always finely balanced between critical intuition and skillful self-promotion, "and thus [the task] of artists and critics is that of deconstructing strategies, resisting their logic, using them and/or finding new ways of acting against them".

RENZO PIANO

Genoa 1937

Piano, who graduated in 1964 from the Milan Polytechnic Institute and trained in Philadelphia and London from 1965 to 1970, is especially attentive to the way in which research and technology can harmoniously meet with the needs of the habitat to provide welcoming, concretely human spaces. In 1971 Piano & Rogers was founded. The two architects were to design together the Beaubourg. This was followed by projects for important cultural institutions and museums. The construction of the headquarters of IRCAM, the French institute for musical research, dates from 1977; the Museum built to house the de Menil collection in Houston from 1986; and the new Paul Klee Museum at Berne is now in an advanced stage of study. Particularly famous is the project for the Osaka Airport, completed in 1994. The construction, which rises from the sea like a great flower, called for the building of an artificial island.

Renzo Piano
Beyeler Foundation Museum
1991-97,
Riehen, Basil.

The Beyeler Foundation Museum, inaugurated at Riehen, near Basil, in the Autumn 1997, houses the collection of contemporary art of the gallery owners Hildy and Ernst Beyeler. For Piano "a building to be used as a museum must try to reflect the character of the collection it houses and its relationship with the landscape. Accordingly, it must play a role that is active but not aggressive". Large glass panels, placed at strategic points, offer the visitor a view over the park. White walls and glass ceilings provide the best conditions of visibility for viewing the works.

Renzo Piano
*Kanak Cultural Center
"Jean Marie Tjibaou"*
1991-98,
Nouméa, New
Caledonia.

New Caledonia, a former
French colony which
achieved peaceful
independence, is the land
of the Kanak, an ethnic
group spread over the
Pacific area. The Cultural
Center built at Nouméa, in

a natural scenario of
great natural beauty,
bears the name of a
Kanak leader who died
in 1989. Piano, who
consulted with
ethnographers for this
project, has designed the

Center not as a single
building but as a complex
surrounded on three sides
by the sea. The individual
parts, reminiscent of the
huts in Kanak villages, are
immersed in green and
connected by walkways.

Index of names and works

The numbers in italics refer to the biographical pages dedicated to each artist; the titles of the illustrated works are listed below.

637

639

PHOTOGRAPHIC ACKNOWLEDGEMENTS: Apart from those included in the other acknowledgements, all of the photos are from the Giunti Archives (in particular the following photographers are listed: Cameraphoto, Venice. Claudio Carretta, Pontedera. Pino dell'Aquila, Turin. Stefano Giraldi, Florence. Nicola Grifoni, Antella. Marco Rabatti-Serge Domingie, Florence. Foto Saporetti, Milan. Humberto Serra, Rome). **Other acknowledgements**: Archivio Scala, Florence: 62, 126a, 134, 351, 421, 487, 488b, 491, 536-537, 539, 592, 593. Courtesy Biblioteca Apostolica Vaticana: 42-43. Courtesy Cassa di Risparmio di Firenze: 305. Zeno Colantoni, Rome: 451. Courtesy Fondazione di Studi di Storia dell'Arte Roberto Longhi: 318. Courtesy Massimo Listri, Florence: 9, 36-37. Courtesy Monte de' Paschi di Siena/Foto 3 Lensini, Siena: 75. Franco Cosimo Panini Editore, Modena-foto Ghigo Roli: 24-25, 23, 29. Museumsfoto B.P. Keiser, Braunschweig, Herzog Anton Ulrich Museum: 278. Renzo Piano Building Workshop, Genoa: photo M. Denancé, 631; photo S. Goldberg, 630; photo J. Gollings, 632-633.